A COMPANION TO VICTORIAN AND EDWARDIAN ARTISTS

Atkinson Grimshaw
Tranquility
Oil on canvas, signed and dated 1880. 12 x 10in. Bonhams

A Companion to VICTORIAN AND EDWARDIAN Artists

ADRIAN VINCENT

DAVID & CHARLES

British Library Cataloguing in Publication Data
Vincent, Adrian, 1917 –
 A companion to Victorian and Edwardian artists.
 1. British. Visual. Arts. History
 I. Title
 709.41

ISBN 0–7153–9823–7

Typeset and designed by John Youé
using a Macintosh system
and printed in Hong Kong
by Wing King Tong Co Ltd
for David & Charles plc
Brunel House Newton Abbot Devon

Contents

Foreword

Many people who are interested in art, but are unfamiliar with the work of many of the artists shown here, will be amazed at the rich diversity of talent that existed during the Victorian and Edwardian period. Landscape, genre, animal and marine painters all vied for attention, often without a great deal of success. Some of them are now being brought to the notice of the public for the first time, thanks to the efforts of the picture dealers who, surprising as it may seem to some, are in the business not only for the money but also because they love paintings.

It is hoped this book will kindle the reader's interest in artists of this period, whilst providing a useful reference book for picture dealers and auctioneers.

ADRIAN VINCENT

William Clarkson Stanfield
The Wreck
A detail from the painting reproduced on page 279

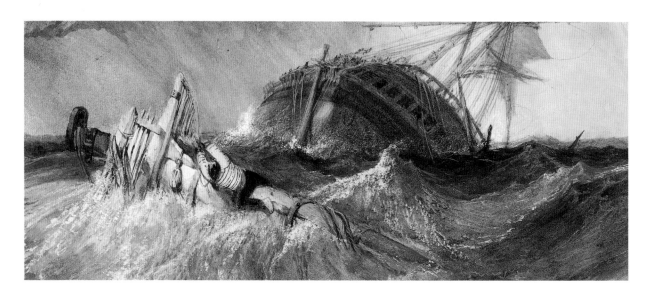

British Art in a Century of Change

The emergence of British painting as a popular art form did not occur until the nineteenth century. Before then, the acquisition of paintings as a hobby was pursued only by the rich landowners or the aristocracy. Apart from the Royal Academy, which was founded in 1768 by George III, there were no public art galleries and, consequently, the general public had little or no chance to see paintings, except perhaps in an auction room that was holding a sale. Art in the eighteenth century therefore existed in a vacuum, with the painter being forced to rely almost entirely upon private or royal patronage.

By the time that Queen Victoria came to the throne in 1837, the whole art scene had already begun to change. A British Institution for the Promotion of the Fine Arts, with the Prince Regent as its president, had been formed in 1805, but little came of it until the National Gallery first opened its doors in 1838, when a collection of 150 pictures was exhibited.

By this time, museums and centres of art education were being formed and established by all the larger towns and cities, notably in Birmingham and Liverpool. A tremendous boost to the encouragement of art throughout the whole country came with the Museum Act of 1845, which enabled town and county councils to found and maintain museums which included paintings in their collections. For the first time the Victorians, with their passion for self-help, were now in the position to make their own assessments of works of art.

For the artists themselves, it was an exciting period of transition. To quote Dickens' famous first line from *A Tale of Two Cities* in another context: 'It was the best of times, it was the worst of times'. On the one hand it was a time when lucrative new markets for works of art had suddenly appeared, thanks mainly to the rapidly growing affluence of the middle-classes who had acquired the habit of buying pictures, often hanging them on their walls from ceiling to eye level, so that their homes looked more like public galleries than private houses.

On the other hand, the Royal Academy, which still considered itself the arbiter of all that was good in the field of art, was still obsessed with neo-classical paintings and huge canvases that portrayed historical subjects. The tastes of the RA were so deeply rooted in the past that it did not even begin to exhibit

watercolours until 1810, let alone look on them with any real favour for some time afterwards. This particular prejudice was deep-rooted and went back to the time of its first president, Sir Joshua Reynolds, who had a poor opinion of both watercolour and flower painting.

With such reactionary attitudes to contend with, the artist found it difficult to make a name for himself in the art world unless he followed the tastes of the RA selection committees. Even if his work sold reasonably well, a good but relatively unknown artist generally received no more than £10-£20 for a painting, which was hardly a fortune. To receive any real recognition, it was necessary for an artist to be exhibited regularly at the RA's annual summer exhibition. Without it, he was in serious danger of sinking into oblivion.

Not surprisingly, artists often tried to supplement their incomes by teaching. The *Art Journal* of the time was generally filled with advertisements couched in servile phraseology, in which artists offered their services as teachers at 'reasonable terms'. Even an artist of the calibre of David Cox found it necessary to advertise for work, offering lessons at 7s an hour. If he left behind the sketch he had made during a lesson, the student paid him an extra 10s 6d. How many of these sketches that were sold at give-away prices still exist today, one wonders?

Despite these discouraging factors, the Victorian artist lived in an exciting age which saw, among so many things, the birth of the railway network, the development of the camera, and the tremendous advances made in colour printing, which enabled such magazines as the *Graphic* and the *Illustrated London News* to produce full-page colour supplements, all areas of progress that were to prove an inestimable boon to the artist.

Those most obviously affected by the coming of the railways were the landscape painters, who were now able to travel with relative ease to parts of the country which previously could be reached only with the greatest difficulty. Their paintings of the rural scene, generally seen through the sentimental haze of the urban dweller, did much to popularise the Victorian landscape. As usual, the Victorians' innate bad taste led to a series of highly romanticised scenes being painted by such artists as Myles Birket Foster, Helen Allingham and a host of derivative followers, who all sacrificed truth on the altar of commercialism. What is perhaps rather sad is that the public who bought these paintings for their sentimental subject-matter did not appreciate that, beneath their sugar-sweet surface of sentiment and prettiness, often lay a formidable talent.

Not all landscape painters were prepared to pander to public taste to the same degree. That solitary and eccentric genius, Joseph Mallord William Turner (1775-1851), probably the greatest landscape painter this country has ever produced, had all but come to the end of his life, but there were others from his period who refused to compromise their art, such as David Cox (1783-1859), whose exquisite landscapes captured the very essence of the English and Welsh countryside; Thomas Creswick (1811-69), whose overall use of a brown tone in his landscapes was being superseded by the use of more vibrant colour by the younger landscape artists; and Samuel Palmer (1805-81), whose richly coloured landscapes often featured sheep and their shepherds. There was also Benjamin Williams Leader (1831-1923), whose *February Fill Dyke* is one of the greatest atmospheric paintings of the last quarter of the nineteenth century, and John Linnell (1792-1882), whose landscapes are often filled with fleecy white

clouds hovering over a brown-toned landscape. One could go on and on, such was the rich diversity of talented artists who had decided to apply their art to landscape painting. Instead, I have referred to only a few whose work has withstood the passage of time, both in artistic and commercial terms. Dozens of others are to be found in the dictionary section of this book.

The sense of honest painting is also apparent in much of the work of nineteenth-century marine artists. From 1672, marine painting had been dominated by the influence of the van de Veldes, a Dutch family of emigré marine artists whose stylised paintings of naval battle scenes had been the model for English artists for so long. Now a genuine attempt to create an English school of marine painters was being brought to fruition by a small army of artists, including such marine painters as John Brett (1820-1902), Henry Moore (1831-95), Clarkson Stanfield (1793-1867) and Edward Duncan (1803-82). Instead of the all-too-familiar painting of some English man-of-war pulverising an enemy vessel, the nineteenth-century marine artist tended to choose quiet but highly evocative subjects. Accepting that this was essentially the period of the sailing ship, there is a far more timeless quality to those marine paintings than in most Victorian art. It is perhaps for this reason that many modern artists prefer to paint the Victorian sailing ships rather than their modern counterparts with their hard, angular lines.

It was inevitable, of course, that Victorian marine art should occasionally reflect the spirit of the empire which pervaded the whole nation and the intense pride the British felt for its navy. What is surprising is that only a small proportion of the marine artists continued to paint pictures glorifying the battle fleets of England.

The one field of painting that remained unchanged throughout almost the whole of the nineteenth century was the narrative or genre picture, in which a story was told in simple and easily understandable terms. The Victorians loved the pictorial value of genre paintings, and it is not difficult to understand why. Story-telling in pictures is a tradition that goes back to classical times, and it has remained with us through the ages, mainly because it has always depicted affectionate scenes from everyday life which are immediately identifiable to the viewer.

The dominant genre painter at the beginning of Queen Victoria's reign was the Scottish artist David Wilkie (1785-1841), whose regional domestic scenes did much in their time to maintain the tradition of genre painting. His Scottish peasants are often drawn with a pawky sense of humour that is generally missing from most other genre paintings, and with a precise line and a staggering sense of self-assurance and talent that made his work respected by some of our greatest artists. On the occasion of Wilkie's centenary, John Everett Millais wrote to the head of the Scottish Academy:

> In the history of Art, there had been no one superior to him for his knowledge of composition, beautiful and subtle drawing, portrayal of character and originality. You may well be proud of your greatest painter.

This may have been an exaggeration, but there is no doubt that Millais was sincere when he wrote that letter.

William Powell Frith (1819-1909) was probably the most popular, and certainly the most entertaining, genre artist of his time. His vast panoramas of Victorian life were always a great attraction at the Royal Academy, where a railing had to be put up to keep the

over-enthusiastic crowds at a safe distance.

People today have little idea of just how much pleasure the public derived from Frith's crowd scenes. The film camera, which selects scenes and situations, then shows them to us in close-up, has made us visually lazy. Imagine, then, the excitement of a Victorian viewer examining one of Frith's enormous canvases, and discovering for himself all the numerous small scenes that were not obvious at first glance.

Paintings like *Derby Day, Ramsgate Sands* and *The Railway Station* are known to almost every art lover in Britain and have now become over-exposed as a result of being reproduced so many times. Personally, I have always enjoyed *Ramsgate Sands,* as I went to school in the town and had my first job as an office boy in the Rates Office overlooking that part of the beach depicted by Frith. The building is still there, as are most of the other buildings on that section of the East Cliff. *Ramsgate Sands* was shown first at the RA in 1854 with the title *Life at the Seaside,* and was sold to a dealer for 1,000 guineas, who then sold it to Queen Victoria at the price he paid for it, while he retained the exhibition and engraving rights.

Frith's *Derby Day* contains enough detail to occupy the viewer's attention for a good half-hour. When it was first hung at the RA a police constable was present all day to keep back the jostling crowds who struggled to look more closely at the mass of detail portrayed in the painting. The critics generally were not over-enthusiastic about its subject-matter, although they admitted that it contained a mass of detail for future generations to study. The general tone of their comments was reflected in the words of one critic who wrote: 'It is destined to tour the provinces when it will give much delight but no "teaching" - at least none of that teaching which is the highest aim and holiest duty of Art.' *Derby Day* may not have aspired to the lofty aims of that particular critic, but where many a painting that would have met with his wholehearted approval is now gathering dust in the lumber room of some provincial museum, *Derby Day* is still one of the most popular exhibits in the Tate Gallery. The eminent Victorian critic John Ruskin was unusually guarded in his response to the painting, saying it was 'a kind of cross between John Leech and Wilkie, with a dash of daguerreotype here and there, and some pretty seasoning with Dickens' sentiment'. Actually, this was not far from the truth.

Although he was not as well known to the general public as Frith, William Mulready (1786-1863) was an important artist in his time, and one who began as a landscape painter before he changed almost completely to painting genre studies in the manner of David Wilkie. As well as being an illustrator, he also designed the first Penny Postage envelope, thereby contributing to the postal system as we know it today. His grandson, Augustus E. Mulready (fl. 1863-1905), is well known for his genre studies of the London poor that helped to bring to the public's attention the desperate plight of the needy since the introduction of the new Poor Laws of 1834, which included sending destitute families to one of the Union Workhouses, where they were fed less than a convicted felon. The Victorians' harsh treatment of the poor was portrayed with even more telling effect by Luke Fildes (1843-1927) in his *Applicants for Admission to a Casual Ward,* which was praised for its Dickensian realism when it was first shown at the RA in 1874, and brought him fame overnight.

Augustus Egg (1816-63) was a different type of genre artist who began by painting scenes taken from literary sources, such as

Shakespeare's plays and Sir Walter Scott's novels, before he turned to depicting aspects of London life with such pictures as his *Travelling Companions,* which he set in a railway carriage, and his famous trio of paintings, *Past and Present,* which portrays the downfall of a woman who has been unfaithful to her husband and pays the price by becoming destitute and having to sleep under the arches of the Adelphi. Although a powerful set of pictures, the reactionary masculine moralising of *Past and Present* seems unpleasant to us today.

Another well-known genre artist was William Maw Egley (1826-1916) who painted in some of the background to a number of Frith's pictures. Like Egg, he began by painting literary scenes before he turned to producing his studies of London contemporary life, such as his *Omnibus Life in London.* Although his work is of an uneven quality, he made a valuable contribution to art by providing a picture of Victorian life.

There were literally hundreds of Victorian genre painters who produced work of a high order, but many of them are now almost forgotten. Taking their work as a whole, however, they gave us a visual document of how the Victorians dressed, lived, worked and played, which has been an invaluable source of reference to those researching the period.

The spirit of the empire was never stronger than in the middle period of Victorian history. The Great Exhibition of 1851, Queen Victoria's little wars, including the first Afghan War of 1839-42 (culminating in the disastrous retreat of the British from Kabul), the Chinese wars and the Crimean War, had imbued the British public with a sense of patriotism never before seen in this country. As a result, the British soldier changed overnight from being known as little better than a drunken scoundrel to being considered a hero who was lauded in songs and paintings. This sudden regard for the British soldier was a godsend to the historical painter who hitherto had confined himself mainly to painting scenes from mythology and classical history. Instead of paintings such as *The Lament for Icarus* by Herbert James Draper (1864-1920), a number of battle pieces began to appear, the most famous of them being Lady Butler's *Scotland for Ever,* portraying a charge of the Scots Greys, and *The Death of Nelson* by Daniel Maclise (1806-70). Paintings like these gave a much-needed boost to a genre that had completely disappeared by the end of the century.

The English love of animals is now legendary, but it really came into being with the accession of Queen Victoria. Her deep affection for animals was reflected by the large number of animal painters who suddenly appeared on the scene, the most notable of them being Edwin Landseer (1802-73), who made his first public appearance in 1815 with his *Portrait of a Mule* and a *Pointer Bitch and Puppy,* and from then on went from strength to strength until he became one of the most popular exhibitors at the RA, a position which he consolidated with his famous *Dignity and Impudence,* which he first exhibited at the British Institution under the title of *Dogs.*

Although somewhat out of favour these days because of the maudlin sentimentality of some of his pictures, Landseer is still an artist of considerable merit whose paintings should be considered in the light of the times in which they were painted. The accusation has been levelled at him that he often showed an unnecessarily cruel streak when painting something like *The Stag at Bay,* but this is unfair; he merely painted what he saw. His *Bull Attacked by Dogs* can still distress animal lovers, although it does not seem to have worried Queen Victoria or the thousands who went to

the RA whenever a new Landseer was exhibited. He still remains to this day an important figure in the field of Victorian art.

Most animal painters were less honest than Landseer, and concentrated almost entirely on pictures of canine pathos such as Briton Riviere's *Fidelity*, which has much in common with Landseer's *The Old Shepherd's Chief Mourner*, or studies of endearing kittens and magnificent cats which were almost invariably produced for the popular market. Such pictures cannot be taken as serious art, but rather as examples of an artist painting with his eye on the market.

Despite his lapses into sentimentality and his unfortunate habit of 'humanising' some of his animals, Landseer's work towers above his contemporary fellow animal artists, sometimes in the face of stiff opposition from such painters as John Macallan Swan (1847-1910), who painted panthers, leopards and tigers in their natural habitat; James Ward (1769-1859), a portrait and landscape artist, who was also a first-rate animal artist whose work in this field is best seen in his *Bull Fighting* and *Fighting Horses*, and J. F. Herring and his son, both of whom painted a number of charming farmyard animal studies. All these artists enjoyed considerable popularity in their time.

Not all artists were successful, however - for example, Benjamin Robert Haydon (1786-1846), who painted two enormous canvases in the hope that he might win a state competition to find suitable paintings for the new Houses of Parliament, after the Palace of Westminster had been destroyed by fire. Haydon submitted two paintings, *The Banishment of Aristides* and *The Burning of Rome*. They were ignored by the judges and badly received by the press, with the exception of *The Times*, who wrote of them 'the drawing is grand and the characters most felicitous'. In

a desperate attempt to earn some money and attract favourable attention from the critics, Haydon hired the Egyptian Hall, where the pictures were put on view opposite a room where the midget General Tom Thumb was playing in the daytime before his evening performance at the Lyceum. Everyone came to see Tom Thumb, but very few came to see Haydon's paintings. Saddled with enormous debts which he had no hope of ever paying, Haydon struggled on until that fateful day in June 1846, when his daughter found him lying dead in his studio with his throat cut and a bullet in his head - the bullet being the first bungled attempt to kill himself. The last entry in his diary read: 'God forgive me! Amen. B. R. Haydon. Stretch me no longer on this rough world. *Lear.*'

The blame for Haydon's suicide lay not with the critics, nor with the public, but with the artist himself, who was a born loser. What little success he had in the beginning he threw away because of his vile temper, which caused him to berate his clients, who soon went elsewhere for their paintings. When he did receive a firm commission he was invariably late in delivering the painting, or he never completed it at all. Loathed by the Royal Academy and most of the critics whom he bombarded with abusive pamphlets, he drifted on, getting deeper and deeper into debt, for which he went to prison three times, emerging on each occasion to continue in the same way, accumulating fresh debts by buying canvases for his paintings which no one wanted. If ever a man was ruined by his own nature, it was Benjamin Haydon.

The eighteenth century had been the great age of portrait painting in this country, but with the passing of artists like Gainsborough, Romney and Raeburn, the popularity of the genre began to wane. From about 1850 until the 1890s when portrait artists like John

Singer Sargent spearheaded a dramatic revival of portrait painting, it was left to such artists as Charles Eastlake, Alfred Ellmore, A. E. Watts and Alfred Stevens to carry on the tradition. All were highly competent artists, but most of their work lacked the magic touch of a Romney or a Gainsborough. Possibly the growing popularity of the camera contributed to the lack of public support for the portrait artist, except among those who had the money to commission a portrait.

Initially, artists were shocked to discover the camera lens could faultlessly capture a scene which often took them days to complete; not only that, the image could be reproduced more than once in a matter of minutes. Many a promising artist who might have gone on to paint well, turned instead to photography. The respective values of painting and photography were endlessly debated throughout the second half of the century, with a hard core of artists remaining against the use of the camera in their work.

The topographical artist Edward Lear was quick to see the advantages of photography and bought a camera for reasons he stated in a letter in which he said, 'it will be of great use to me in copying plants, and in many things which distance, limited time, heat etc. would prevent me from getting'. Whether he actually explored its capabilities to the full is another matter.

Frith used a camera, but without much success, and eventually he employed the services of the famous critic and painter Roger Fry, who took photographs of Paddington Station for Frith, to be utilised in building up his picture *The Railway Station*.

When the photographer Eadweard Muybridge published his famous book, *Animal Locomotion* (1887), which contained hundreds of photographs of a horse frozen in action during the various stages of a gallop, animal artists in particular realised how valuable the camera could be, for they now had at their disposal a tool which could show for the first time how all animals *and* people moved.

By then most artists had acknowledged that the camera was a perfectly legitimate and acceptable tool for them to use, and was no more destructive to the creative process of painting than the various aids that had been used in the early days to find the vanishing point in perspective. If nothing else, photography removed the drudgery of making sketches before the artist could get down to the serious business of painting.

What photography did do to art's disadvantage, however, was to end the great classic tradition of landscape painting whereby the artist assembled the components of a picture to his liking, which did not always coincide too closely with what he actually saw. Having probably already seen what a landscape looked like on a postcard, the public was no longer interested in an interpretation of it.

In 1848, a small group of artists, led by Holman Hunt, John Everett Millais and Dante Gabriel Rossetti, tried to overthrow the old order of things by forming a splinter group called the Pre-Raphaelites. The aim of the Brotherhood, as they called themselves, was to revitalise art by observing the following tenets set down by Rossetti's brother, William Michael Rossetti:

1 To have genuine ideas to express;
2 To study Nature attentively, so as to know how to express their ideas;
3 To sympathise with what is direct and serious and heartfelt in previous art to the exclusion of what is conventional and self parodying and learnt by rote;
4 And most indispensable of all, to produce thoroughly good pictures and statues.

Moreover, the Brotherhood was committed to emulate painters earlier than Raphael, although they knew little about the period and what they did know they had obtained by studying old engravings.

The subjects of nearly all Pre-Raphaelite paintings were highly sentimental or romantic in an extremely detailed way. The Brotherhood selected subjects from Shakespeare, Dante and the bible - subjects they knew from past experience would appeal to the middle-classes. There was nothing revolutionary in their work, except in their use of vibrant colour, which was obtained by applying pigment over brilliant white to give their paintings that glorious colouring reminiscent of medieval illuminated manuscripts.

The critics were far from being wholehearted in their approval of the Pre-Raphaelites until John Ruskin sprang to their defence, saying that they were 'laying in our England the foundations of a school of art nobler than the world has ever seen in three hundred years'. Although it is true that the work of the Pre-Raphaelites has survived and remains immensely popular, their main appeal has always been their use of colour, which makes their paintings exhilarating viewing.

When the Pre-Raphaelites began painting, the Industrial Revolution had already made many of England's cities drab and ugly, the Industrial North being particularly depressing. It was hardly surprising, therefore, that the Brotherhood chose to paint a romanticised medieval world in which broken vows, 'parfait' knights and death for love were often their subject-matter. But in rejecting the artificiality of much of the Victorian academic painting, the Pre-Raphaelites merely substituted a form of sentimentality that could be compared with the sentimental excesses of their contemporaries. It is the treatment of their subject-matter, however, which merits

serious attention, for in sweeping aside all the old conventions, the Pre-Raphaelites produced the qualities of design and colour that have made them so famous. Unfortunately, much attention has been focused on the private lives of the Pre-Raphaelites, which has had the effect of making people more interested in their bizarre personal relationships than in their work.

The Pre-Raphaelite movement was over by 1853. Millais had gone over to the establishment by becoming an RA, and Rossetti had begun painting religious pictures, as well as Hunt, who by then was painting religious pictures in Palestine. Hunt remained faithful to the creed of the Pre-Raphaelites until the day of his death, as well as some of the followers of the movement who made no significant impact on the art world, with a few notable exceptions such as Joseph Noel Paton (1821-1901), a lifelong friend of Millais who is probably best known for his fairy paintings *The Fairy Raid* and *Oberon and Titania*, and William Morris who maintained a lasting friendship with Burne-Jones, and whose reputation rests on the profound influence he had on English industrial design and interior decoration. Morris was the main force behind the Arts and Crafts movement which began during the latter half of the century.

At the turn of the century, an attempt was made to revive the Pre-Raphaelite movement by a group of young artists headed by John Byam Shaw (1872-1919). Other artists belonging to the movement were Eleanor Fortesque Brickdale (1871-1945), Frank Cadogan Cowper (1877-1958) and Frank Craig (1874-1918). Although these artists have a modest place in reference books, only Frank Craig is sufficiently well known to merit a major entry, and the activities of the movement tended to be lost with all that was new in the art world at the time.

Between 1840 and the 1860s much had happened in the field of art. The period had seen the rise of the illustrated magazine and the growing popularity of the novel or work of non-fiction, illustrated with colour plates, both of which brought much-needed work to the talented but struggling artist, as well as supplying a useful addition to the incomes of well-known artists. Millais, Rossetti, Luke Fildes, Ford Madox Brown, Walter Crane, Lord Leighton, and even Whistler, were only a few of the illustrious names who succumbed to the blandishments of editors, most of them commercially minded and with little regard for art, but with enough sense to commission work from the famous and the talented. The activities of such artists in the field of commercial art did no harm to their professional reputations - if anything, it helped to make their names better known to the public.

By 1860 women artists had begun to make an impression on the art world: Rose Barton (1856-1929), Sophie Anderson (1823-98) and Henrietta Ward (1832-1924) were among the most prominent. Although other female artists produced work during this period, they presented no threat to the male domination of the art field. However, most female artists were now accepted as professionals, even though they were the butt of tired jokes in *Punch*, which portrayed them as plain Janes with spinsters' mannerisms.

Many women artists produced still life painting, with the emphasis on fruit and flowers rather than on dead animals and birds which were the favourite subjects for the Dutch and Flemish still life painters of the seventeenth and eighteenth centuries. The delicate brush-work needed for fruit and flower painting suited the sensitive hands of women artists. Still life painting, however, was far from being scorned by male artists who made small reputations for themselves in

this field. Among such artists were James Holland (1799-1870), a landscape and topographical artist who began by painting a number of exquisite flower studies, having been taught to paint flowers on porcelain by his mother; Edwin John Alexander (1870-1926), Oliver Clare (c1853-1927) and Edward Ladell (1821-86), all of whom were considerable practitioners of the genre.

It was not until Elizabeth Thompson, later known as Lady Butler (1846-1933), came on the scene with *The Roll Call* which was first shown at the RA in 1873, that a woman artist presented a serious challenge to male artists, and in a field of art in which one would have thought their position was secure - the historical battle picture. *The Roll Call* became the picture of the year and brought Elizabeth Thompson instant fame. The painting was eventually bought by Queen Victoria from a dealer who had originally paid £126 for it. Thompson's other work continued to show her amazing knowledge of arms, accoutrements and army uniforms in paintings such as *Rourke's Drift* and *Quatre Bras*, which were also bought by Queen Victoria.

Lady Butler's husband, an Anglo-Irish general, who believed in the fullness of time that the Gordon relief expedition was the only war during the Victorian era in which 'the object was entirely noble and worthy', gave his wife much valuable advice during the painting of some of her battle pictures. His views on British military enterprises were not shared by the public, which hung Lady Butler's prints by the thousand up and down the country. The final accolade came from Ruskin who declared the *Quatre Bras* was 'the first fine Pre-Raphaelite picture we have had'. Despite all her popularity and critical recognition, Lady Butler was never elected an RA.

By 1870, there had been little change in the policy of the Royal Academy which was still

supporting the outworn ideas of the past. Nor did the three artists who dominated the Academy during that period - Lord Leighton (1830-96), Sir Lawrence Alma-Tadema (1836-1912) and Sir Edward John Poynter (1836-1919) - do anything to give any real hope that things might change in the near future. Leighton, Alma-Tadema and Poynter strove to uphold everything they held dear - to paint pictures that harked back to the days of ancient Greece and Rome and to paint them with painstaking accuracy and a careful attention to detail. Their thinking may have been governed partly by the interest in archaeology that had sprung up in the latter part of the century, but central to their work was their conscious rejection of their own times.

Leighton had been trained in Florence at the Academia della Bell' Arti, where he had come to love fifteenth-century Italian art. The first picture by which he became known to the British public was *Cimabue's Madonna Carried in Procession through the Streets of Florence*, which appeared at the Royal Academy in 1855 and which was bought by Queen Victoria for £600, on the advice of Prince Albert. After painting other Florentine subjects such as *Tybalt and Romeo*, *The Reconciliation of the Montagues and the Capulets*, and *The Pest in Florence According to Boccaccio*, Leighton turned his attention to themes of classical legend which automatically made him a potential candidate for the RA. In 1878 he was made president of the Academy and a peer in 1896. Within his terms of reference, he was a highly gifted artist and the only painter to be made a baron.

Sir Lawrence Alma-Tadema was mainly interested in painting the life of ancient Greece and Rome and the subjects of his paintings were often centred around a Roman bathhouse, where nubile females wandered or reclined in marble halls in various states of undress. As most of his paintings of this sort were eagerly snapped up by wealthy businessmen, often for reasons that had little to do with art, it is tempting to refer unfairly to Alma-Tadema as a painter of high-class mild pornography, or even to dismiss him as being an artist who would have been at home on the set of a Cecil B. de Mille epic. Certainly his painting *The Pyrrhic Dance*, which was exhibited at the Royal Academy in 1869, would have appealed to de Mille, with its two gladiators prancing before the emperor and his followers.

Alma-Tadema was, however, an artist of great technical virtuosity, with a telling sense of theatre, which is probably the reason that Beerbohm Tree commissioned him to construct the stage designs of two of his productions, *Julius Caesar* and *Hypiatia*. According to Beerbohm Tree, Alma-Tadema brought 'Ancient Rome on the stage'. He was even better known for his skilful representation of marble, which led Thackeray to comment that his work was 'marbellous'.

Harold Osborne, whom I had the good fortune to know before his death in Switzerland in 1987, says of Alma-Tadema in his invaluable *Oxford Companion to Art* that 'his remarkable social and financial success had yet to be endorsed by posterity as an artistic one'. It is fair comment. Like the technically polished paintings of so many of the late Victorians, his work is so much a product of his times that it is difficult to separate the content from the actual execution. But his lively and often vivid reconstructions of classical history, which he meticulously researched from his enormous collection of photographs, are still impressive, whatever the final verdict on his work might be.

Sir Edward John Poynter - the third member of the triumvirate, and an inward-turning and morose man by all accounts - was the son

of the architect Ambrose Poynter and might well have become an architect himself but for a chance encounter with Leighton in Rome. Under the influence of Leighton, and on his advice, he went to Paris to study under Marc Gleyre, who had also given lessons to Monet, Renoir and Sisley. An exponent of mid-nineteenth-century French 'classicism,' Gleyre was also a painter of some standing. It was Gleyre who impressed on Poynter the need to follow the French ideal of learning from the very beginning to draw from life, something that was to remain with Poynter for the rest of his career. Even in his latter years, when he was the Director of Art at the South Kensington Museum, one of the first things he would say to his students was: 'I shall impress but one lesson on students, that constant study from a life model is the only means they have of arriving at a comprehension of beauty and nature, and of avoiding its ugliness and deformity; which I take to be the whole aim and end of study.'

This precept was really no different from the aims of Leighton and Alma-Tadema, though in Poynter's case it had its disadvantages: without a life model in front of him, he was lost.

Poynter's devotion to the classical world of Greece and Rome originated from the time that he met Leighton in Rome in 1853, when he was still a young man. His unswerving allegiance to the Victorian classical school of painting became a secondary consideration in his life only with his deep involvement in teaching and with his work as a director of the National Gallery from 1894 to 1906. But Poynter continued to paint right up until the end of his life, saying on his deathbed 'I must get up and go to my studio, I have left some work unfinished.'

Unfortunately so much Victorian painting is no longer available for us to see - a point made by Quentin Bell in his book *Victorian Artists*, published by Routledge & Kegan Paul in 1967 and taken from a series of lectures he made at Oxford two years earlier. Many Victorian paintings now lie in the vaults and cellars of our major art galleries and have never been photographed, let alone seen. Each generation reassesses its heritage of art, and although most of these paintings would be considered of little value today, it would be useful to be able to judge for ourselves.

What has been rescued is the work of hundreds of lesser known nineteenth-century artists which dealers have saved from obscurity and brought to the fore, (for which we owe them thanks, if only for the way their prices have risen together with other works of art). Many of these artists are included in the dictionary section of this book, together with colour illustrations of their work.

By the 1880s a period of great change was about to occur in the art world. In France the first Impressionists' exhibition had been held in 1874. The name 'Impressionist' had been given to a group of young artists by a journalist working for the magazine *Charivari*, who had seen one of Monet's paintings, *Impression Soleil Levant*. The term was originally used disparagingly, but the artists belonging to the group were happy to adopt it as being representative of their aims, which were to give an impression of what the eye sees in a particular moment, and to depict the way light is reflected from a subject. Initially, the group consisted of Monet, Sisley, Renoir, and Bazille, who was killed in the war with Prussia and is less well known. The Impressionists' work caused something of an uproar in the art world and prompted *Le Figaro* to write 'Someone should tell M. Pissarro forcibly that trees are never *violet*, the sky is never the colour of *fresh butter*, that nowhere on earth are things seen as he paints them.'

The lay person should not confuse these artists with the Post-Impressionists, a term coined by Roger Fry (1866-1934), the English critic and painter, who used it to describe such painters as Vincent van Gogh, Paul Gauguin, Georges Seurat and Paul Cézanne, all of whom had expressed their dissatisfaction with the naturalistic aims of the Impressionists. The first exhibition of their work was held at the Grafton Galleries in London in 1910.

Impressionism was introduced into England by a young English painter named Bastien-Lepage, who had been to France and seen the work of the Impressionists. It was mainly thanks to him that the first Impressionist exhibition was held in this country in 1905, where its impact was small to begin with and only affected the work of a handful of artists such as George Clausen (1852-1944) and William Mark Fisher (1841-1923), who both greeted it with enthusiasm.

Clausen has been accused of being sentimental in some of his paintings of rural and farming life - a criticism to which Clausen would have responded by saying that he was in good company with Millet and Courbet, who both strove to give a rough dignity to their French peasants. If Clausen was occasionally sentimental, it was deeply felt, and not the work of a facile artist deliberately playing on the emotions of a public brought up on the sanitised paintings of nineteenth-century rural life by artists like Birket Foster. Some of Clausen's work has a wonderful feeling for light.

William Mark Fisher was an American artist who, like Poynter, had studied under Marc Gleyre and had come to England after his lack of success as an artist in the United States. His work as a landscape artist was praised by Lucien Pissarro and his friend George Clausen, who said of him that 'Fisher could find beauty everywhere'. He seems to have been one of the few artists working in this country who completely assimilated everything that was best in the work of the French Impressionists.

Whistler has often been described as an Impressionist, but if he can really be called that, his work must be looked at in a different way from that of the French artists. The latter painted in the noonday sun, whereas Whistler was far more interested in achieving harmony in tones. When Millais saw one of Whistler's *Nocturnes* he commented: 'It's clever; a damned sight too clever.' Millais' comment reflected the general attitude of the public at the time to anything new, as well as a large number of English artists who were reluctant to accept any new ideas. But despite the art world's slow acceptance of Impressionism, both in this country and in France, it has become acknowledged as the most important development in art during the nineteenth century, principally in landscape painting in which *plein air* artists working outside in front of their subjects have sought to capture the fleeting impressions of light on a landscape.

The year 1886 saw the formation of the New English Art Club. This was a coalition of sixteen artists which included Frederick Brown (1851-1941), Edward Stott (1859-1918), George Clausen and Walter Sickert (1860-1942), who were in revolt against the selective traditions of the RA committee which was still following its old-fashioned 'picture of the year' policy to the detriment of artists with more adventurous ideas. When the club held its first exhibition in 1911 it proved a financial failure, and soon after whatever influence it had was temporarily taken over by the Camden Town Group, which was formed in the same year. Despite Lord Leighton's prophecy that the NEAC would not last more than three years, it managed to maintain a

foothold on the art scene, and is still in existence today, holding annual exhibitions.

By Victorian standards, the work of the Camden Town Group was depressing and ugly. Headed by Sickert, its artists painted drab scenes of London working-class life. Their rejection of everything that was romantic in favour of social realism is not to everyone's taste, but there is no doubt that the group had a considerable influence on the art scene at the time.

A movement that was to exercise a powerful influence on one aspect of English art was the emergence of the Newlyn School of painters in the last quarter of the nineteenth century. Its members were a group of like-minded artists who were drawn to the attractive little Cornish village of Newlyn, and who began painting there in 1882, before they were discovered by the critics. The excitement that was generated by the critics began in 1885 when Stanhope Forbes' *A Fish Sale on a Cornish Beach* was first shown at the RA. Nearly all its followers were devoted *plein air* painters, although there were some who confined their attentions almost entirely to painting domestic scenes of the local fishing people, while others were more interested in depicting the activities of the herring and pilchard fishing fleets.

Although Stanhope Forbes is often erroneously referred to as the father of the Newlyn group of artists, it was the Birmingham artist Walter Langley (1852-1922) who was the first to set up his easel in the Cornish village. He was followed by a host of talented artists, including Henry Scott Tuke (1858-1929), Fred Hall (1860-1948), Edwin Harris (1855-1906), Frank Bramley (1857-1915), and others of varying degrees of talent. Information on these artists, together with examples of their work, may be found in the dictionary section of this book.

Although the work of the Newlyn painters was not innovative, it was not derivative either - at least only to the degree that most of them followed the creed of *plein air* painting and supported the new feeling of revolt against all the old academic traditions. Their work was like a breath of fresh air after so much nineteenth-century conventional art which so obviously showed its studio origins. The Newlyn artists' belief in the importance of *plein air* painting was central to most of their work. As Norman Garstin (1855-1926), who lived in Newlyn for many years, drily commented: 'Your work cannot be good unless you have caught a cold in doing it.'

Apart from Stanhope Forbes' *A Fish Sale on a Cornish Beach*, other important paintings from the group were *All Hands to the Pump*, which was bought by the Chantrey Bequest and is now with the Tate Gallery, Fred Hall's *End of the Day*, Bramley's *A Hopeless Dawn*, Percy Craft's *Tucking a School of Pilchards on the Cornish Coast* and Stanhope Forbes' *The Health of the Bride*.

Although much that was going on in the art world was new at the beginning of the twentieth century, none of it radically changed the course of British traditional painting beyond the fact that it saw the end of genre painting, whose demise had been escalated by the arrival of the silent cinema in Britain in 1896, when the Lumière brothers screened their first film show at the Regent Street Polytechnic in London. From then on visual story-telling was basically in the hands of the cinema.

In the field of Edwardian landscape painting, Impressionism might well not have happened as far as many landscape painters were concerned, who continued to paint their carefully constructed scenes of country life, while ignoring the appalling conditions of the rural community which was dominated by rich landowners, abetted by the local parson. In-

stead, they continued to paint their highly romanticised country scenes, recalling the worst excesses of Birket Foster.

Why was there no Millet or Courbet in this country, or a painting like Vincent van Gogh's *The Potato Eaters* to bring home the realities of English rural life? Even the Social Realists who had revolted against so much of the 'prettiness' of nineteenth-century art strove to impart a Zola-like realism to their work, rather than show what was going on behind the backcloth of English country life.

The reason that no English painter was producing work depicting the realities of country life probably lies in the fact that many artists saw Edwardian rural England as a symbol of the power and seeming permanence of the old social order, where those who toiled in the fields were hard-working, honest people who were content with their lot. To have considered that the day might come when there was equality between the master and servant would have been an anathema to these artists. But then, few Victorian and Edwardian artists saw themselves as social crusaders.

Their social attitudes notwithstanding, the Victorian and Edwardian artists had a common intention, which was not appreciated until recent years. It was the idea that their work should be based on solid craftsmanship - something that was often contemptuously thrown out of the window by certain artists who were pursuing one of the new art forms that were so prevalent during the early part of this century.

Dictionary
of
Artists

ABBREVIATIONS

ARA	Associate of the Royal Academy
ARE	See ARPE
ARPE	Associate of Royal Society of Painters and Etchers (later known as RE)
ARSA	Associate of the Royal Scottish Academy
ARWS	Associate of the Royal Watercolour Society
ASWA	Associate of the Society of Women Artists
FRBA	Fellow of the Royal Society of British Artists, Suffolk Street (SS)
FRGS	Fellow of Royal Geographical Society
H	Honorary
NEAC	New English Art Club
NGS	National Galleries of Scotland
NPS	National Portrait Society
NWS	New Watercolour Society
OM	Order of Merit
OWS	Old Watercolour Society
P	President
PS	Pastel Society
RA	Royal Academy, Royal Academician
RBA	Royal Society of British Artists
RBC	Royal British Colonial Society of Artists
RBSA	Royal Birmingham Society of Artists
RCA	Royal College of Art
RCamA	Royal Cambrian Academy
RE	See RPE
RHA	Royal Hibernian Academy, Dublin
RI	Royal Institute of Painters
RMS	Royal Society of Miniature Painters
ROI	Royal Institute of Painters in Oil-Colours
RP	Royal Society of Portrait Painters
RPE	Royal Society of Painters and Etchers (later known as RE)
RSA	Royal Scottish Academy
RSW	Royal Scottish Watercolour Society
RWA	Royal West of England Academy
RWS	Royal Watercolour Society (previously OWS)
SS	Society of British Artists, Suffolk Street
SWA	Society of Women Artists
V & A	Victoria and Albert Museum
VPRI	Vice President of the Royal Institute of Painters

Wherever possible, public art galleries that hold an example of an artist's work are listed at the end of each entry, unless otherwise stated. The Cambridge art gallery is listed as Fitzwilliam, and the Oxford art museum as Ashmolean.

EDWIN AUSTIN ABBEY, RA
1852-1911

Born in Philadelphia, Edwin Abbey was educated at the local Academy of Fine Arts from 1869 to 1871, after which he joined the staff of *Harper's* magazine in New York. In 1878 the magazine sent him to England and, with the exception of a fleeting visit to America, he made his home in Chelsea, London, before settling at Morgan Hall, Fairfield, in Gloucester. Like so many artists of his time, he travelled widely on the Continent. Specialising in costume, he soon acquired a reputation for being a fine draughtsman and illustrator of such books as *The Comedies of Shakespeare* and *She Stoops to Conquer*. He painted the official picture of the coronation of Edward VII (1903-4) and a mural for the Royal Exchange (1904). Towards the end of his life he returned to Philadelphia, where he painted a series of murals for the Pennsylvania state capital which he competed the year before his death.
REPRESENTED: ASHMOLEAN, V & A.

WILLIAM AFFLECK
b. 1869 fl. 1890-1915

A London artist who painted idyllic rustic scenes, William Affleck was one of the many artists who tried to continue the traditions of Birket Foster by depicting characters in an unreal world. In his paintings, spotlessly clean children play quietly in the countryside where the sun always shines, and demure and extremely pretty young women wander alone or pose decoratively for the artist. Like Birket Foster, Affleck gave no indication in his work that rural life could often be cruel and uncomfortable.

Born in Rochdale, Lancashire, William Affleck studied at Heatherley's School and at the Lambeth School of Art. His work began to appear before the public a year after Birket Foster died. He exhibited at the RA from 1891 to 1915, as well as at the SS, the NWS, the RBA and elsewhere. Among the paintings he exhibited were *Sweet Summer Time, Autumn Glow* and *The Village Stream*. His first known address in London was at

CHARLES JAMES ADAMS
1859-1931

A genre, landscape and animal artist, Charles Adams worked mostly in oils, often painting subjects that are suffused with a quiet poetic quality. In his paintings, ploughing teams and flocks of sheep or herds of cattle make their way home at the end of the dying day as the sun sinks in the west. As in the work of the French artist Maurice Utrillo, whose figures are always portrayed walking away from the viewer, Adams also portrayed his figures and animals walking into the distance at sunset, adding an elegiac touch to many of his pictures, as in the example of his work illustrated here.

Adams was born at Gravesend, Kent, and studied at the Leicester School of Art where he received the Mulready gold medal for life drawing. He exhibited at the RA thirty-seven times and at most other important art galleries. He lived at various times in Leicester (Percy Street), Sussex, Kent and Surrey.

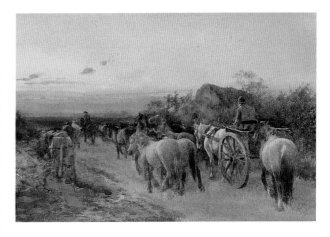

Charles James Adams
Going to the Horse Fair - Dawn
Watercolour. 9½ x 14¾in
Fine Line (Fine Art)

William Affleck
The First Bloom of Youth
Watercolour. 24¼ x 18¼in
Bonhams

66 Warner Road, Camberwell; later he moved to
Leppoc Road, Clapham. After 1915 there seems
to be no trace of what happened to him, probably
because, with the advent of World War I, his style
of painting was out of step with those grim war
years when people on the Home Front had little
time for pretty postcard views of the countryside.
His watercolour shown opposite is representative
of all that was best in his work.

CECIL CHARLES WINDSOR ALDIN, RBA
1870-1935

Cecil Aldin was an animal painter whose work is
known to thousands of people through the many
prints that were made from his drawings and
paintings. Essentially a humorous artist, his work
first became familiar to the general public in such
magazines as *Punch, Queen* and the now defunct
Windsor Magazine, and many other publications
that belong to the past. He supplied colour plates
for a large number of books, such as *A Dog's Day*
(1902), *Hunting Countries* (1912-13) and *The
Romance of the Road* (1928). He also supplied
the *Pall Mall Budget* (1894-5) with the illustra-
tions for Kipling's *Jungle Book*.

Aldin was born in Slough, Middlesex, and
studied under the sporting artist Frank Calderon,
who brought his pupils down from London to
Midhurst, Sussex, for the summer. Aldin lived for
some years in Purley, near Reading, but as he grew
older he began to develop arthritis in his hands,
and in an attempt to alleviate his complaint, he
departed with his wife for the warmer climes of
Mallorca, where he lived from 1930 to 1934. He
then decided to return home, but on the return
journey he suffered a heart attack, which he sur-
vived until he reached England, when he was
taken to the London Clinic. His death there on
6 January 1935 was mourned by many.

Although a hunting man who had been Master

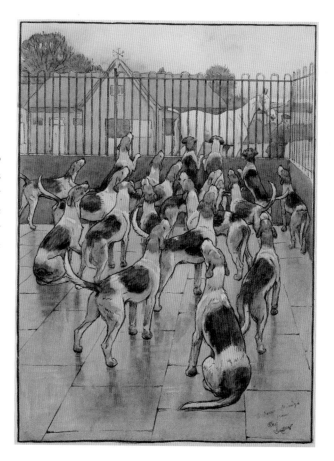

Cecil Aldin
*The Hounds Began Suddenly to Howl in
Chorus*
Pencil, pen and ink and watercolour. 11 x 8in
Signed and inscribed to Dennis Aldridge. Spink

of the Southern Berkshire Foxhounds in his time,
Aldin was especially devoted to dogs, and painted
them many times, especially two of his own pets,
Cracker the bull terrier and Mickey the Irish
wolfhound, who were always drawn with an
affectionate eye. In his watercolour shown above,
Aldin combined his two major interests in one
painting. The pack of hounds reacting to the
passing horse could be called a hunting picture,
while at the same time it is essentially a study of
hunting dogs painted in his immediately recognis-
able style. Even the figures of the horse and groom
could have been painted by none other than Cecil
Aldin. The inscription is to Dennis Aldridge, a
fellow hunting man and artist who also painted
huntings scenes, dogs and equestrian subjects.
REPRESENTED: ASHMOLEAN, BM, LEEDS, V & A.

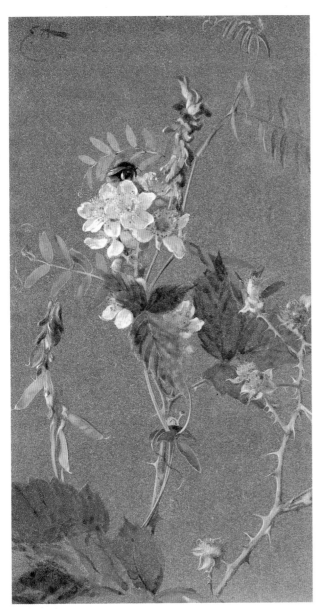

EDWIN JOHN ALEXANDER, RSA RWS
1870-1926

Edwin Alexander was a Scottish artist who painted a variety of subjects in watercolours, including birds, animals, flowers, landscapes and desert scenes, most of which were produced on some form of fabric or on textured paper. He was born in Edinburgh, the eldest son of Robert Alexander, an animal artist who had exhibited at the RA a number of times and who was therefore well qualified to teach his son. At the age of 17, Edwin visited Tangier with his father and Joseph Crawhall, an artist whose output was small but who was notable for his excellent studies in watercolours of birds and animals. With two such artists as his mentors it is hardly surprising that Edwin's art followed the course that it did.

In 1891 Edwin went to Paris to study under Emmanuel Fremiet, the French sculptor and animal artist, whom he left a year later to go to Egypt, where he lived in a tent in the desert in order to paint the sands. He returned to Scotland, and married and settled in Inveresk in 1896, where he kept his own private zoo in order to have a supply of models for his animal studies. One way and another, he seems to have been a dedicated artist who was prepared to go to great lengths to pursue his art. For the last eight years of his busy life Alexander was dogged by ill health, and he finally died in 1926 in Musselburgh.

An artist who worked almost invariably in soft muted colours, Alexander's work was often influenced by the Glasgow School, which derived some of its decorative ideas from Japanese art. He also produced colour plates occasionally for books, such as *The Wild Flowers* (1909) and *Wild Sports and Natural History of the Highlands* (1919). His watercolour *Bramble and Purple Vetch*, shown on this page, is typical of his economical but detailed style in painting botanical subjects.

REPRESENTED: ABERDEEN, BM, BRADFORD, DUNDEE, GLASGOW, NGS.

Edwin John Alexander
Bramble and Purple Vetch
Pencil and watercolour heightened with bodycolour on oatmeal paper
12¾ x 6⅞in. Signed with initials
Spink

HENRY ALKEN
1785-1851

A prolific painter of hunting and coaching scenes, Henry Alken's name and reputation were made by the many prints of his work that were published before Queen Victoria even came to the throne, although he continued to paint until shortly before his death.

Alken was born in Soho, London, and began to study art at an early age under the miniaturist John Thomas Barber (1774-1841). Little is known about Alken's movements from then on, except that he moved to the Ipswich area after his marriage in 1809. It was soon after this that he began to make a successful living as a graphic journalist under the pseudonym of Ben Tally-Ho. It has never been clearly established whether he hunted or not, but he certainly understood horses.

Despite the qualities of his work as a sporting artist, Alken exhibited only two pictures at the RA, and those were portrait miniatures.

In his later years Alken became a well-known figure on the streets of London, wearing old-fashioned clothes, which included a rustic jacket with large pockets in which he carried his sketch-books. By then his work had declined in quality and he was forced to send out art work speculatively, rather than working purely on commission as he had done in his more successful years.

Alken died on 7 April 1851 at his home at Ivy Cottage, Highgate Rise, where he had moved nine years earlier from Kentish Town, after the death of his wife. He was penniless when he died and his son-in-law paid for the funeral. He was survived by two sons who also became sporting painters, but not in the same class as their father had been at the height of his career.

REPRESENTED: BM, FITZWILLIAM, LEEDS, LEICESTER, V & A.

HELEN ALLINGHAM, RWS
1848-1926

Helen Allingham (née Paterson) was born near Burton-on-Trent, Derbyshire, and received her training as an artist at the Birmingham School of Design and then at the RA Schools. She began her career as an illustrator for the *Graphic* and the *Cornhill* magazines; she also produced colour illustrations for such books as *A Flat Iron for A Farthing* and *Jan of the Windmill*, both by Mrs Ewing, a leading author of children's books. For a time Helen Allingham lived with Kate Greenaway in Hampstead, London, and the two women went on painting excursions together.

In 1874 Helen married the Irish poet William Allingham, a close friend of Rossetti, which enabled her to enter the closed circle of the Pre-Raphaelites. She edited for publication her husband's diary, which was published in 1907 and contains many interesting reminiscences of Tennyson, Carlyle and other famous contemporaries, including John Ruskin, who wrote kindly of her work in his book *The Art of England*, which was published in 1884. In 1881 the Allinghams moved to Witley in Surrey, where Birket Foster was living. Rapidly becoming friends, the two painters began to make Witley a centre for rural artists.

William Allingham died in 1889, but his wife remained at Witley. She worked continuously until her death, painting in her own inimitable style studies of rural cottages and country gardens, in which the blooms grow naturally out of the foliage, leading to a frequent blurring of detail within the flowers themselves. At the turn of the century she supplied colour illustrations for *Happy England* (1903), *The Homes of Tennyson* (1905) and *The Cottage Homes of England* (1909). She died at her home on 25 September 1926, aged 78. She is considered today to be one of the leading watercolourists who specialised in painting cottage and rustic scenes (see p28).

REPRESENTED: BM, MAIDSTONE, MANCHESTER, ULSTER, V & A.

Helen Allingham
A Cottage at Shere
Watercolour, signed. 7 x 9in. Priory Gallery

SIR LAWRENCE ALMA-TADEMA, OM, RA, RWS
1836-1912

Few artists enjoyed the success that the Dutch-born painter Lawrence Alma-Tadema achieved in this country with his studies of semi-nudes, which were set against a background of daily life in ancient Rome, Greece and Egypt. Born in Dronryp, his art training began at the Antwerp Academy, and was completed with Baron Leys, an historical painter whose careful reconstructions of life in the sixteenth and seventeenth centuries made him the ideal teacher for a painter like Alma-Tadema, whose choice of subject-matter had always been similar. But it was left to Ernst Gambert, the Belgian international art dealer to realise that in Alma-Tadema he had found himself a first-class artist. After seeing his work, Gambert immediately commissioned forty-four paintings which were eventually shown in England, where they caused an instant sensation.

The Victorians had already been conditioned to accept nudes as an art form after Lord Leighton had exhibited his paintings in the 1860s. But Alma-Tadema's work went a step further. After

painting a number of subjects in which his semi-nude females were merely decorative adjuncts to his vivid reconstructions of classical history, he overreached himself with his painting *A Sculptor's Model*, which is shown on this page. This uncompromising, full-frontal view of the model deeply offended the prudes and caused something of a furore, and from then Alma-Tadema confined himself to portraying his models semi-draped. His work became enormously popular in the United States, where it did much to forge Hollywood's conception of life in ancient times. His pictures were all numbered with Roman numerals, starting with No I when he was 15, and ending with CCCCVIII.

A genial and uncomplicated man, Alma-Tadema enjoyed his success and money, living an extravagant life-style at Townshend House in Tichfield Terrace, Regent's Park, which he redesigned to resemble a Pompeiian villa. Unfortunately, it was partially destroyed in 1874, when a barge carrying gunpowder on Regent's Canal exploded near the house. After the house was rebuilt, Alma-Tadema moved to a larger house in St John's Wood, which had once been owned by Tissot (see entry).

Alma-Tadema's life was an enormously successful one in which he was made an RA, knighted and showered with honours from many countries. By 1911, however, his popularity began to wane. Realising that his work was becoming unfashionable he resigned from the RA committee, after serving on it for thirty-one years. In the following year he went to take the waters at Wiesbaden, Germany, where he was suddenly taken ill and died on 25 June 1912. His body was brought back to England and interred in the crypt of St Paul's Cathedral, where it lies in the company of fellow artists, Millais, Holman Hunt and Lord Leighton. Like so many artists before him, the grim realities of World War I helped to finish off whatever popularity his work had enjoyed, and it is only recently that his reputation as a major Victorian artist has been restored. (For further details, see also p16.)

REPRESENTED: BM, BIRMINGHAM, GUILDFORD, MANCHESTER, V & A.

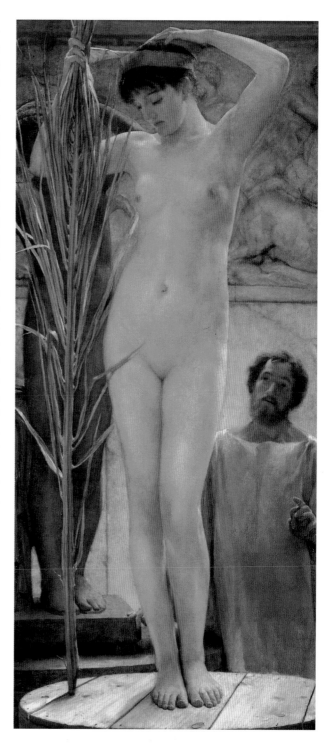

Sir Lawrence Alma-Tadema
A Sculptor's Model
Oil on canvas. 77 x 33in
Christies', London

SOPHIE ANDERSON
1823-98

The French-born Mrs Sophie Anderson studied under Eleanore Anne Steuben, a portrait painter who worked in Paris. Her studies were cut short by the outbreak of the 1848 revolution, and she and her family went to America, where she established herself as a successful portrait painter and married the English artist, Walter Anderson, a painter of domestic scenes. In 1854 they came to England and settled in London at 21 Merton Road, Kensington Gate, before moving to Bramley, near Guildford. In 1871 ill health forced her to move to Capri, until her eventual return to England, when she moved to Falmouth in Cornwall, where she ended her days.

Sophie Anderson began to exhibit genre pictures at the RA from 1855, where she showed nineteen pictures. Her paintings carried titles that were typical of the period, such as *I am Helping Mama*, *Baby's Pony*, and her better known *No Walk Today*, which depicts a little girl dressed up to go out, looking wistfully out of a window.

RICHARD ANSDELL, RA
1815-85

Richard Ansdell was born in Liverpool and educated at the local Bluecoat School. He then studied for a short while with W. C. Smith, a profile and portrait painter who lived and worked in Chatham, Kent, and continued his training at the Liverpool Academy. At the age of 21, Ansdell set himself up as a full-time artist in his home town, where he stayed until 1847, supporting himself by painting historical and animal subjects in the manner of Edwin Landseer.

Ansdell was one of those fortunate artists who was lucky or astute enough to gauge the public's taste at the time. The ready sale of his paintings plus the profits from the sale of the many engravings that were made from them, netted him a very comfortable income until his death. In the last quarter of the century he showed 181 pictures in London, receiving on average £750 for each pic-

ture - a considerable sum in those days. Towards the latter part of his life he settled in a house called Collingwood Towers in Farnborough, Hampshire, where he died in 1885.

Although his pictures never achieved the standard of Landseer's, Ansdell was still a distinguished figure in his lifetime, having been president of the Liverpool Academy from 1845 to 1846 and made an RA in 1879. His oil shown below illustrates how similar his paintings were to much of Landseer's work.

REPRESENTED: LIVERPOOL.

JAMES ARCHER, RSA
1823-1904

Like so many nineteenth-century artists, the Scottish painter James Archer began by painting scenes from romantic poetry, such as Tennyson's *Idylls of the King*. His first important oil painting, *The Last Supper*, appeared at the Royal Scottish Academy in 1849. In 1862 he came to England and settled in London, where he began painting portraits and sentimental historical scenes which were often notable for a rich glow in their colour- ing, which was somewhat influenced by the work of the Pre-Raphaelites. By the time he died in Haslemere in 1904 he had become the oldest member of the RSA, where he exhibited 108 pictures.

REPRESENTED: BIRMINGHAM.

Richard Ansdell
Deer Stalking in the Highlands - the Kill
Oil on canvas. 28¾ x 44¼in
Spink

GEORGE ARMFIELD
fl. 1840-75

A London artist who specialised in painting terriers, Armfield was a rarity among the animal artists of the Victorian period because he did not portray his dogs with sentimentality. He generally painted, on a small scale, savage little pictures of terriers in pursuit of small wild animals such as cats, rats, or game on the wing. He exhibited thirty-two times at the RA and his paintings include: *The Rat Cage, Puss in a Fix* and *Dogs Attacking an Otter*. He lived at Air Lane, in Clapham and later at 4 Durham Cottages, Leipsic Road, Camberwell.
REPRESENTED: BIRMINGHAM.

JOHN ATKINSON
1863-1924

John Atkinson was born in Newcastle and did not become a full-time professional artist until about 1912, although he had studied previously at the Newcastle School of Art, under the marine painter William Cousins Way and Wilson Hepple, the animal artist. After living for a while in Yorkshire, he returned to Newcastle where he taught art at Upshaw College and at Morpeth Grammar School. An artist who worked both in oils and watercolours, he painted many rural scenes which included horses, as in his watercolour of a horse fair shown right. As a result of his obvious understanding of horses, the RSPCA commissioned him to paint a number of posters. Towards the end of his working career he designed a number of village and inn signs. A posthumous exhibition of his work was held at Armstrong College, Newcastle, in 1925. Today he is considered to be one of the finest animal artists of the North East.

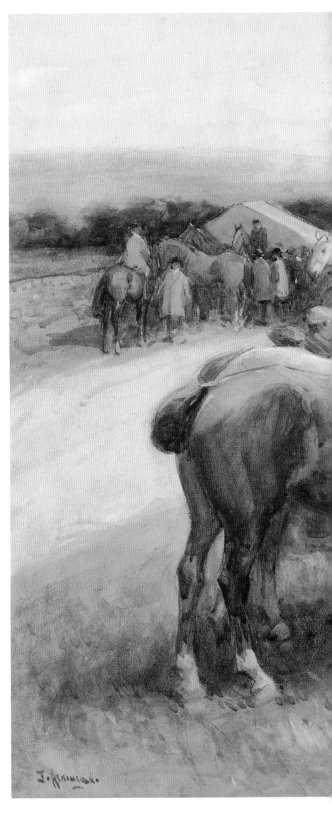

John Atkinson
The Horse Fair
Watercolour, signed. 10 x 14in
Priory Gallery

A COMPANION TO VICTORIAN AND EDWARDIAN ARTISTS

Borough Hill.

Albert William Ayling
Tired Out
Watercolour, signed and inscribed with the title
on the back. 21 x 30in. Sotheby's, Sussex

JAMES AUMONIER, RI, ROI
1832-1911

A landscape painter in oils and watercolour, James
Aumonier was born in Camberwell, London, and
received his art training at the Birkbeck Institution
and the South Kensington Schools. Originally a
calico print designer, he turned to painting in 1862
and started exhibiting at the RA from 1870. He
was also awarded medals at many international
art exhibitions. His landscapes, which range from
views of Surrey to North Wales, were often sold
for as little as £8-£10, although *A Cornish Or-
chard* was sold in 1880 for £200. He was known
for his paintings of lush green meadows where
cattle and sheep roamed.
REPRESENTED: BM, BRIGHTON, MAIDSTONE.

ALBERT WILLIAM AYLING, RCA
exh. 1853-1905

Albert Ayling was brought up in Guernsey, where
he studied under Peter Jacob Naftel, who painted
many landscapes of the Channel Islands and was
father of the more famous Maud Naftel (see
entry). After a brief spell in London, Ayling moved
to 12 King's Street, Chester, from where he made
many excursions to North Wales to paint land-
scapes of the local scenery. After moving briefly to
19 Pepper Street, Chester, he made his final move
to 71 Bridge Street Row, Chelsea, where he painted
A Bend in the River, *Noontide Refreshment* and
Autumn, which were all painted between 1880
and 1882.

A genre and landscape artist who also liked to
paint studies of pretty girls, Ayling exhibited
eighteen paintings at the RA between 1843 and
1893, and another forty at the SS between the
same dates. His painting *Tired Out*, shown above,
was probably painted in North Wales.

SAMUEL HENRY BAKER, RE, RBSA
1824-1909

A landscape painter, etcher and watercolourist, Samuel Baker started his artistic career in the unusual occupation of a magic lantern slide painter. He lived at Hampsden Place, Icknield Street, West Birmingham, and for fifty years was a contributor to the local Art Society. Although by no means an important figure, Baker was a sound artist who shared the enthusiasm of many for the Welsh countryside, which he painted many times, as well as the Midlands. He used a stipple technique and often signed his work S. H. B.
REPRESENTED: BIRMINGHAM. (8)

F. H. BALL
1871-1939

Frederick Hammersley Ball was born in Sheffield but went to Nottingham very early in life and stayed there until his death. He began his career as a lace designer - a not unusual occupation in the city of Nottingham, as it had been producing lace since 1809, when a lace-making machine invented by John Heathcoat arrived in the city. Ball then started to design posters that were very much influenced by Alphonse Mucha, the Czech designer. As well as painting in oils and watercolours, he was also very involved in the activities of the city. He designed a triptych for All Saints' Church, a fresco for a building in Friars Lane, and belonged to the Nottingham Playgoers' Club, being a keen amateur actor himself. He exhibited a number of paintings at the RA, including *The Foolish Virgins*. His watercolour shown right is a marvellous painting which superbly evokes the spirit of the 1920s. A year before his death he was injured in a street accident, but it is not known if this contributed to his death.

F. H. Ball
The Black Fan
Watercolour, heightened
with white, signed. 18 x 15in. Priory Gallery

GEORGE BALMER
1805-46

George Balmer was born at North Shields, the son of a house-painter. Intending originally to become a house-painter himself, he went to Edinburgh where he found work and painted watercolours in his spare time until he was good enough to take part in an exhibition of watercolour drawings which was held in Newcastle in 1831. Soon afterwards he visited Holland, Germany and Switzerland, and on his way home he stayed in Paris so that he might study the paintings in the Louvre. On his return he settled in London at 58 Seymour Street, Euston Square. In 1842 he inherited property and retired to Ravensworth, Durham, where he gave up painting as a profession, and from then on pursued it only as a hobby in his retirement. He died at the age of 40.

Known mostly for his coastal and river scenes, Balmer painted many attractive watercolours, such as *On the Coast of Fife – Morning, The Old Lighthouse – Moonlight*, and *A Collier Stranded – Tynemouth*.
REPRESENTED: BM, GATESHEAD, LEEDS, MANCHESTER, NEWCASTLE, SHIPLEY, V & A.

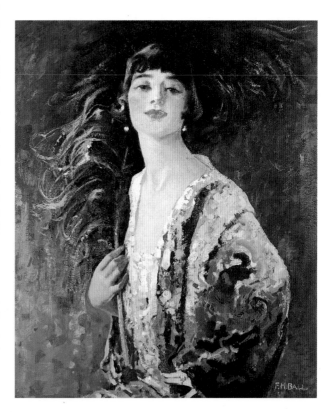

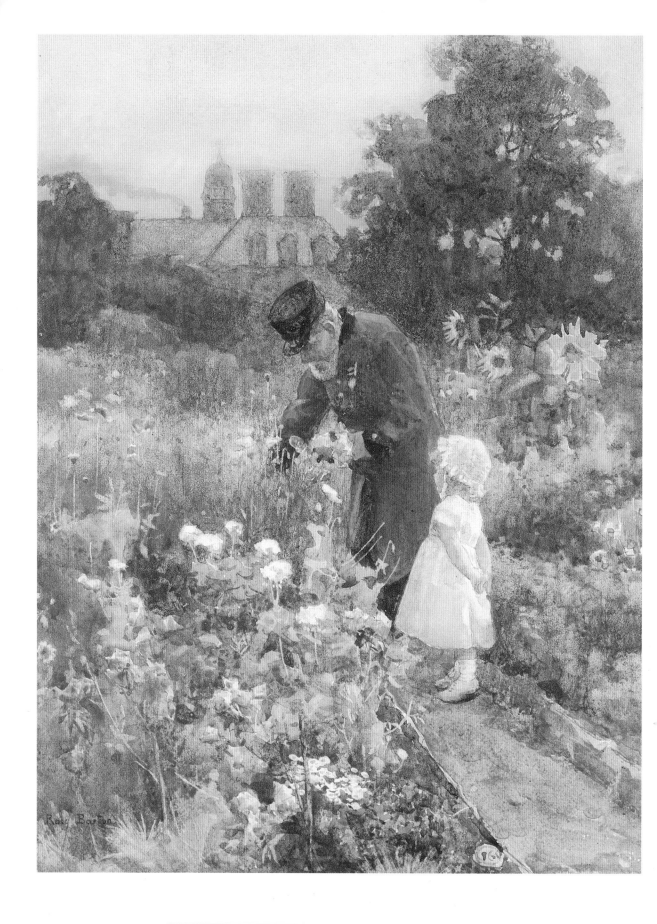

A COMPANION TO VICTORIAN AND EDWARDIAN ARTISTS

Rose Barton
Grandpa's Garden
Watercolour. 14 x 10in. Priory Gallery

ROSE MAYNARD BARTON, RWS
1856-1929

Rose Barton was an Irish painter of genre and landscape scenes, and was also fond of painting children. A talented and largely self-taught artist, she was probably best known in her time for her atmospheric city views which appeared in *Familiar London*, published by A&C Black in 1904. She also supplied the text for her illustrations in an earlier book, *Picturesque Dublin Old and New*.

Born at Rochestown in County Tipperary, Barton studied under Henry Gervex, a history, portrait and genre painter who had acquired a popular reputation with his sensuous treatment of the female nude, which was very different from Rose Barton's type of painting. The watercolours *Child in White Cap*, and *Grandpa's Garden*, shown left, are delightful examples of her work, although her reputation rests far more on her foggy London scenes. Barton remained largely forgotten until Christie's held a sale at Elvedon Hall in Norfolk, when thirty of her paintings were offered for sale.

A sufferer from asthma for much of her life, Barton died at 79 Park Mansions, Knightsbridge on 10 October 1929.
REPRESENTED: ULSTER.

ARTHUR BATT
fl. 1879-92

A painter of genre and animal scenes, Arthur Batt exhibited only four pictures at the RA and another twenty-four at the SS before he vanished into obscurity. His animal pictures in particular are charming, especially those featuring donkeys,

Arthur Batt
Farmyard Friends
Watercolour, signed and dated 1879
10½ x 14½in. Sotheby's, Sussex

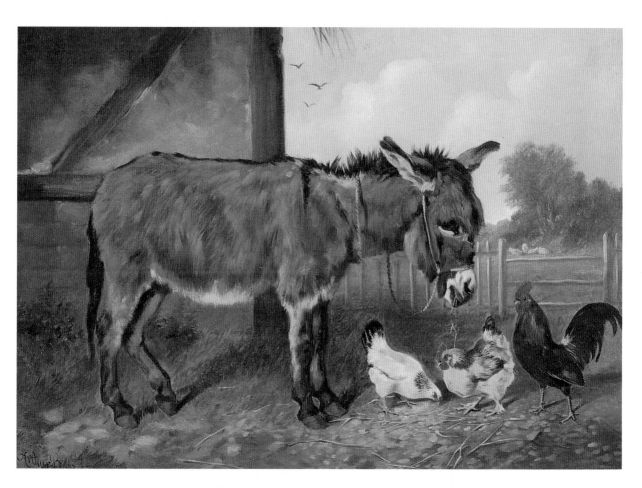

which he was fond of painting. His *Farmyard Friends* shown on p37 and painted in 1879 is a typical example of the attractiveness of his work. His paintings include *Friends from the Common*, *Feathered Friends*, *The Midday Meal* and *Leisure Moments*. He lived first at Romsey, then at Lyndhurst and finally in Brockenhurst, Hampshire.

CARL BAUERLE
1831-1912

A genre and portrait painter, Carl Bauerle was born at Endersbach, Wurtenberg, and entered the Stuttgart School of Art in 1859. After living in Munich for some years he went on a sketching tour of Italy. In 1869 he came to England, where,

Carl Bauerle
Posy for Grandma
Oil on canvas. 24 x 20in. Priory Gallery

through the patronage of Count Gleichen, he managed to get an entrée into the royal court. He painted portraits of a number of the members of the court and some of the royal children, including Prince Arthur (this last being exhibited in Paris in 1878). He exhibited thirty-five paintings at the RA and another forty at the SS. Although he is not well known, Bauerle painted a number of appealing genre pictures, which include *Happy Childhood*, *The Toy Shop Window* and *After the Toil of Battle*, as well as a number of extremely attractive child studies, such as *Posy for Grandma*, shown opposite.

FANNY JANE BAYFIELD, RBA, SWA
fl. 1872-97

A drawing teacher who taught from her home at 34 Magdalene Street, Norwich, Fanny Bayfield numbered Alfred Munnings among her pupils. She was also a highly individualistic flower painter who worked in a loose, broad style that was far removed from the Dutch School of flower painting. Her work therefore makes a welcome change for those who have become bored with the 'waxed' look that so many paintings in this genre have. Bayfield exhibited between 1872 and 1897 and was still painting into the late 1920s, as the dated example of her work shown left testifies. She lived in Norwich until 1889, when she moved to London, and she returned to Norwich in 1897.

Fanny Jane Bayfield
A Bunch of Roses
Watercolour, signed with mono and dated 1926. 11 x 7½in
Fine Lines (Fine Art)

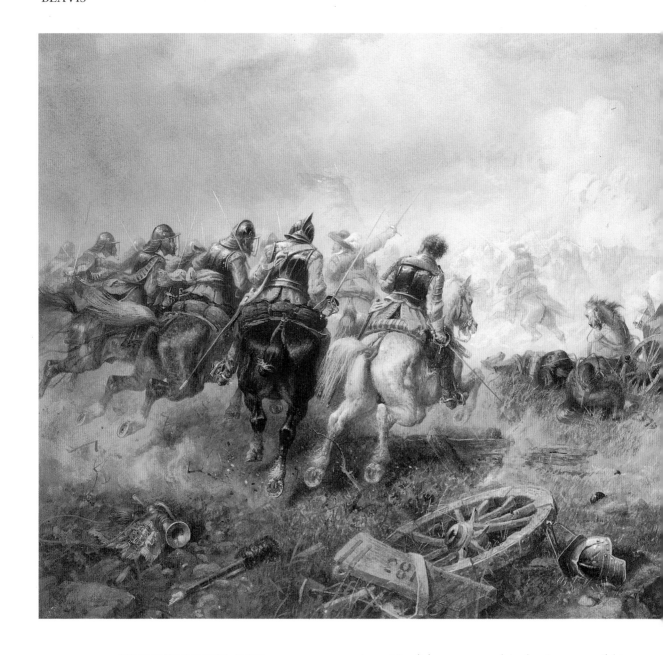

RICHARD BEAVIS, RWS
1824-96

Richard Beavis was born at Exmouth, Devon, but spent his early years in the nearby coastal town of Sidmouth. His early aspirations to become a painter were firmly suppressed by his father, and it was not until 1846 that he was able to go to London, where he became a student at the Government School of Design. In 1850 he became a designer for Messrs Trollope, a firm of decorators in Parliament Street, while he continued to paint in his spare time. He did not succeed in having any of his paintings exhibited at the RA until 1862, when he showed two pictures, *A Mountain Rill* and *Fishermen Picking up Wreck at Sea*, which made his reputation.

As time went by Beavis became a prolific painter of landscapes and genre pictures, including his *Attack on the Baggage Train*, a visually exciting battle piece which is shown above. He was influenced by Millais and the Barbizon School of painters, who were united in their opposition to all the classic conventions in painting, and who had

Richard Beavis
Attack on the Baggage Train. Battle of Edgehill
Watercolour. 18 x 30in
David James

ROBERT ANNING BELL, RA, RWS, RBC, NEAC
1863-1933

Robert Anning Bell seemed able to turn his hand with equal success to anything in the art field. Not only was he a talented artist in oils and water-colours, but he was also a designer in mosaics and stained glass, a sculptor, and an illustrator for a large number of books, including the famous Yellow Book, whose art editor for the first two years of publication was Aubrey Beardsley.

Born in London, Bell received his initial art training under Fred Brown, the landscape and genre artist, and one of the best art teachers of his time in Britain. Bell finished his studies at the RA Schools, and then spent a brief time in Paris studying under Ernest Victor Morot, the genre painter. Few artists could have had a better train-ing.

Bell first began to exhibit at the RA in 1885, but did not become an RA until 1922. In the intervening years he kept himself very busy painting a number of pictures, including *Mary in the House of Elizabeth*, which is now owned by the Tate Gal-lery, producing mosaics for the Houses of Parlia-ment and Westminster Cathedral, and teaching at the Glasgow School of Art and the Royal College of Art as Professor of Design from 1918 to 1924. He also produced dozens of illustrations which are similar in style to those of Walter Crane (see entry). He died in London on 17 November 1933.
REPRESENTED: BM, BRADFORD, PRESTON MANOR (BRIGHTON), MANCHESTER, V & A.

settled in a small village outside the forest of Fontainebleau.

Beavis lived in Boulogne from 1887 to 1888 and travelled to Egypt and Palestine via Venice. He died on 13 November 1896, probably at his last address at 36 Fitzroy Square, London (Ford Madox Brown had lived at No 37, at one time a regular meeting place for Rossetti and other members of the Pre-Raphaelites).
REPRESENTED: BM, HARTLEPOOL, PORTSMOUTH, V & A.

JAMES GEORGE BINGLEY
1840-1920

A London-born landscape painter in oils and watercolours, James George Bingley did not begin to exhibit at the RA until 1871. He lived in Midhurst, Sussex, for some years, where he painted many country scenes, which were mercifully free of the romantic image of the countryside that had been perpetuated by nearly all of the Victorian artists. In his later years he went to live at 26 Princess Road, South Norwood, London, where eventually he died on 25 July 1920. In his retirement he is said to have devoted himself to literary studies. Although by no means a major artist, his work was popular in his lifetime and he is still appreciated for the sound painting that is evident in all his work - for example, *The Mill* shown right. REPRESENTED: BM.

James George Bingley
The Mill
Watercolour, signed. 14 x 10in. Priory Gallery

SAMUEL JOHN LAMORNA BIRCH, RA, RWS, RWA
1869-1955

Samuel John Lamorna Birch was the most English of artists whose talent for capturing the very essence of the English landscape was not fully realised until he visited Newlyn and met Stanhope Forbes, the leader of the Newlyn School of painters. Unlike the Newlyn artists, Birch did not succumb to its picturesque qualities, but chose to stay in the nearby village of Lamorna, where he finally bought Flagstaff Cottage, which was to be his home for the rest of his life.

Born in Egremont, Cheshire, Birch moved in his teens with his family to Manchester and then to Halton, near Lancaster. Although largely a self-taught artist, he did spend a useful year studying under Filippo Colarossi, the sculptor and artist who ran an atelier in Paris in his declining years. Birch began to visit Cornwall from as early as 1889, but did not settle there until 1902, the year of his marriage. Until then he had been known as Samuel Birch, but as there was another artist of the same name living in Newlyn, he took the additional name of Lamorna to avoid any confusion between them. Although a well-known figure in the area, he was a man of modest pretensions who loved to go fishing with the local people.

All those who are familiar with Birch's work will know of the many paintings he did of Lamorna stream. Slightly less known are his paintings of rural England which could have been painted by only someone with a deep feeling for the English countryside, such as the example shown on p43. REPRESENTED: EXETER, GLASGOW, MANCHESTER, NOTTINGHAM, PENZANCE.

ARTHUR JOHN BLACK, ROI, RBC, PS
1895-1936

A Nottingham landscape and figure painter who also painted the occasional coastal scene, Arthur John Black studied in Paris under Benjamin Constant, the French portrait painter who had first made his reputation with his pictures of historical scenes. When he had finished his training, Black came to London, where he lived for many years. He worked in oils and watercolours, and was also a mural decorator and a painter of stage scenery - which involved far more than slapping paint on backcloths and has engaged the attention of some very important artists in their time.

What Black painted for his stage work is lost to us, but fortunately his work as a landscape and figure painter is not. An example of one of his many attractive scenes, which is redolent of the Edwardian times in which it was painted, is shown on p44.

Samuel John Lamorna Birch
There'll Always Be an England
Oil on canvas, signed and dated 1941.
25 x 30in. Priory Gallery

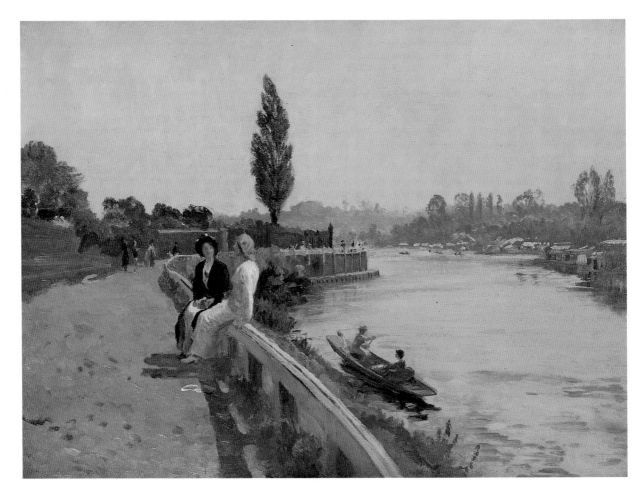

Arthur John Black
The Thames at Hampton Court
Oil on canvas. 16 x 22in
Priory Gallery

WILLIAM KAY BLACKLOCK
fl. 1897-1922 (b. 1872)

Many of the Victorian and Edwardian artists seemed to have in common a restless spirit that drove them to move from place to place. William Blacklock, for instance, was born in Sunderland and lived in London, Walberswick in Suffolk, St Ives in Huntingdonshire, and was last recorded living in Leicester in 1922, after which he was not heard of again, no doubt because he had moved once more.

Blacklock was a landscape and genre painter who worked in oils and watercolours, and re-

William Kay Blacklock
The Shepherdess
Oil on canvas. 20 x 30in
Priory Gallery

ceived his training at the School of Art in Edinburgh. He began to exhibit at the RA in 1897, where he showed some eighteen pictures over the years. He won a prize in an exhibition of art which was held in Brighton in 1909 with his painting *The Window Seat*, and his work frequently appeared at exhibitions held by the London galleries. From the evidence of the painting below, he was an artist who knew his craft, especially when he painted rural scenes in which his sheep are far more convincing than those of Thomas Sidney Cooper, for example, who generally painted sheep in a stylised manner.

REPRESENTED: LIVERPOOL.

SAM BOUGH, RSA
1822-78

A Scottish landscape painter, Sam Bough was born in Carlisle, the son of a shoemaker who had migrated to the North from Somerset. The young boy's early efforts at drawing were encouraged by his father, who sent him to a modest academy of art run by John Dobson, a local cobbler who was also an amateur artist. Once Sam's father felt that Dobson had taught his son all he could, he sent him to London to study under Thomas Allom, the topographical artist who had exhibited at the RA. However, by the time that Bough was 18, he had already returned to Carlisle. He managed to earn a living by painting the occasional picture, and by accepting a commission to draw topographical illustrations for a book published by a local bookseller.

By 1845 Bough was working as a scene painter at the Theatre Royal, Manchester, for the princely sum of £1 15s a week. He then moved to Hamilton in Glasgow, where he began to paint in earnest. Eventually, six of his paintings were accepted by the Royal Scottish Academy.

By the time that Sam Bough was in his late forties, his work was being accepted seriously. Although an irascible man who was quick to give anyone the rough edge of his tongue, he welcomed visitors to his house when he was working. Overfond of using abusive language, and always ready

to take offence, he was the sort of man to be found laying down the law in the local tavern which he visited frequently. Although he was abusive, argumentative, and at times difficult to handle, there was another side to his nature. He was scholarly and well-read on a wide range of subjects and could play a variety of musical instruments. If it had not been for this dichotomy in his character, people like Robert Louis Stevenson would surely have shunned him, but instead the novelist became a firm friend and wrote a moving epitaph on the man and his work when he died.

Although Bough painted both in oils and watercolors, his best work was mostly in watercolours, and it is on those that his reputation rests. In his application of broken colour and in his ability to capture the atmosphere of a scene, his work resembles that of David Cox. *Moonlight, St Monans*, shown below, captures all that is best from the many watercolours that Bough produced.

REPRESENTED: ABERDEEN, FITZWILLIAM, GLASGOW, LEEDS, MANCHESTER, NEWPORT, NGS, ULSTER, V & A.

Sam Bough
Moonlight, St Monans
Watercolour, signed and dated 1878. 16 x 21in
Moss Galleries

THOMAS SHOTTER BOYS
1803-74

Thomas Shotter Boys was born at Pentonville, London. After serving an apprenticeship with the engraver George Cooke, he went to Paris in 1823, where he worked as an engraver and then as a lithographer. It was during this period that he met Richard Parkes Bonington, who died of tuberculosis at the age of 26. Their meeting played an important part in turning Boys away from lithography to paint watercolours, mostly of topographical scenes. Boys also taught people like William Callow and the architect Ambrose Poynter, whose son, Edward, became one of the leaders of the Victorian classical school of painting. In 1837 Boys returned to London when he took up lithography again and eventually became the first artist to exploit chromolithography. In 1837 he published a set of his chromolithographs entitled *Picturesque Architecture in Paris, Ghent, Antwerp, Rouen etc*. At this point he was at the peak of his career which culminated with a set of tinted lithographs of London sites which he produced in 1841.

Although Boys had been ill since 1840, he continued to exhibit topographical watercolours until his death. He remained technically proficient to the last, but his work lost much of its sparkle, and he was finally driven to produce hack work as an engraver. Ruskin, on whose word the fate of many artists depended, ignored Boys in his book *Modern Painters*, although he had produced some of the plates for Ruskin's *Stones of Venice*. He died, virtually a forgotten man, at St John's Wood, London, on 10 October 1874.

REPRESENTED: ABERDEEN, ASHMOLEAN, BEDFORD, BM, CHESTER, FITZWILLIAM, LEEDS, LIVERPOOL, NEWCASTLE, NOTTINGHAM, PORTSMOUTH, SHREWSBURY, ULSTER, V & A.

BASIL BRADLEY, RWS
1842-1904

Basil Bradley was born in Hampstead, London, the son of the artist William Bradley who had a small measure of fame in his time for painting a horse that was 63 years old. Although Basil Bradley painted a wide range of subjects, he is best known for his equestrian subjects and some very fine dog portraits, including the one shown on p49. He worked mostly in watercolours and pastels and is considered to be one of the better painters of his time.

Bradley studied at the Manchester School of Art and exhibited at major galleries, including at least seventeen pictures at the RA. He became chief equestrian artist for the *Graphic* in 1869 and also contributed illustrations to *Once a Week* and *Cassell's Magazine*. His last years were spent at 4 Park Hills Studio, Haverstock Hill Hampstead, London.

REPRESENTED: ACCRINGTON, BM, HAWORTH, MANCHESTER.

FRANK BRAMLEY, RA, NEAC
1857-1915

Frank Bramley's reputation rests almost entirely on his painting *A Hopeless Dawn*. When it was first shown at the RA in 1888, it was referred to by one critic as 'a perfect blend of simple but profound drama and of beautifully executed and very carefully observed effects of light and colour and tone. It avoided melodrama or sentimentality; it was almost reticent in its appeal to the feelings; it lacked artificiality and had instead 'actuality'; it was about the problem of painting.' This was fulsome praise indeed, and perhaps was not entirely justified. *A Hopeless Dawn* is a typical genre painting of the period which looks like a scene from a Victorian stage drama at one of its curtain-falls, and in that respect it is no better and no worse than some of the other genre paintings of the time. On the other hand, it is superbly executed and one can see why the Victorians liked it so much. It was bought by the Chantrey Bequest and given to the Tate Gallery, where it may still be seen. Bramley

Frank Bramley
A Hopeless Dawn
Oil on canvas, dated 1888. 24 x 36in
David Cross Fine Art

painted a smaller version of the same picture, which is reproduced left.

Bramley was born in Sibsey, Lincolnshire, and was trained at the Lincoln School of Art. Around 1879 he went to Antwerp, where he completed his training under Charles Michael Verlat, the animal painter, who was an influential figure in the art world at the time. In 1883 he went to Venice, but found the winter mists that swirled around the canals unhealthy and unpleasant. The following year he settled in Newlyn, where he took rooms in a small thatched cottage where his concentration was frequently disturbed by an armless woman who occupied the downstairs rooms, together with a number of small children whom she was constantly chastising by holding a large cane under the stump of one of her arms. It was in this bizarre household that Bramley did some of his best work. In 1891 he married, and four years later he left Newlyn and went to live in Droitwich in the Midlands for a while, before he settled in Grasmere, near his wife's family home. He died at Chalford Hill, Gloucester, on 9 August 1915.
REPRESENTED: TATE, TRURO.

FRANK BRANGWYN, RA, RWS, PRBA, RE, HRSA
1867-1956

Frank Brangwyn was born in Bruges, Belgium, and received his first lessons from his father who owned an establishment which sold church embroideries and other ecclesiastical objects. When the family moved to England, he attracted the attention of William Morris, who was so impressed by the drawing that Brangwyn was working on at the South Kensington Museum, that he asked him if he would like to work for him. He worked for some time in Morris' studio, and then went to the Far East, where the rich colours of the Orient changed his whole idea about colouring, and his paintings became full of a sumptuous richness. He exhibited at the RA from 1885, including several marine paintings, two of which were *All Hands Shorten Sail* and *Outward Bound*. Later his

paintings and etchings grew progressively more modern in treatment. Like Edward Burne-Jones (see entry), he also worked in many fields of the applied arts, and made admirable designs for book decorations, furniture, stained glass, metalwork and pottery. From the 1890s he enjoyed an international reputation. Brangwyn died on 11 June 1956, leaving behind an enormous output of work.
REPRESENTED: BM, FITZWILLIAM, GLASGOW, V & A.

Basil Bradley
Untitled watercolour
signed and dated 1901. 19 x 13½in
David James

Basil Bradley, R.W.S. 1891.

CHARLES BROOKE BRANWHITE
1851-1929

Charles Brooke Branwhite was born in Bristol, the son of the artist Charles Branwhite, who taught his son the rudiments of painting before he sent him to study art at the South Kensington School of Art. Charles Branwhite jnr developed into an interesting landscape artist whose paintings were generally full of atmosphere, especially when he was dealing with a snow scene in which he captured admirably the feeling of stillness and the sense of desolation that is to be found in a frozen landscape. He painted mostly in watercolours and exhibited at the RA from 1873, when his work also began to be shown at a number of London art galleries. Among his atmospheric watercolours that were exhibited were *Sunset, near Barmouth, North Wales; Cornfield in Gower, South Wales; Early Moonlight*; and *Winter Scene*, illustrated below. He seems to have painted a companion picture to *Winter Scene*, as a very similar scene painted by him appears in *A Hundred Years of Traditional Painting* published by David & Charles.

Charles Brooke Branwhite
Winter Scene
Watercolour, signed. 14 x 21in
Priory Gallery

WILLIAM BREAKSPEARE
1855-1914

A genre painter who lived at 2 The Mall, Haverstock Hill, London, William Breakspeare trained at the Birmingham School of Art, and later in Paris. Although he was a member of the Newlyn School of painters in Cornwall for a while, he is better known as a Birmingham artist, and was a member of the Birmingham Art Circle. He painted many excellent genre pictures including *A Sunny Day, Brittany*, which was painted while he was studying art at Verlat's Academy in Antwerp, where Frank Bramley, and Edwin Harris, his lifelong friend, were also students at the same time. Other works include *By the Sea-shore, Japonica* and *Waiting*, which were all painted while he was living in London. By then he had begun to exhibit at major London galleries, but he did not exhibit at the RA until 1891, even though by then he was a well-established and popular artist. His oil painting shown above is full of rich colouring in which purple and gold predominate.

William Breakspeare
The Sleeping Beauty
Oil on board, signed. 5¾ x 9in
City Wall Gallery

ALFRED DE BREANSKI, RBA
1852-1928

A landscape artist who painted in oils and watercolours, Alfred de Breanski's output was large, and consisted mostly of scenes that were painted in Wales and the Highlands, as well as a number that were done along the Thames. He exhibited eight paintings at the RA and another fifty-one at the SS. His paintings include *Early Morning - South Wales, The Valley of the Dee* and *The Shepherd's Craig*. His painting of Windsor Castle shown on p52 is an attractive example of his work, with the last of the evening sun illuminating the top reaches of the castle, while also bathing the river in a golden glow. He lived at 22 Stamford Street, off the Blackfriars Road, London, before he moved to Arthur House, Queen Elizabeth's Row at Lewisham.

Alfred de Breanski
Windsor Castle, Evening
Oil, signed and dated on reverse 1897.
39¼ x 69¼in. Sotheby's, Sussex

A COMPANION TO VICTORIAN AND EDWARDIAN ARTISTS

JOHN BRETT, ARA
1830-1902

A London painter of coastal and landscape scenes, John Brett first came to the attention of the public when his painting *The Stonebreaker* was shown at the RA in 1858 and favourably commented on by Ruskin. Brett's painting *The Glacier of Rosenlaui* had appeared in 1857 at the Academy, but had been received with indifference both by the public and by the critics. It was Brett's first landscape painting, and the beginning of his interest in geology which occurs again in his *Val d'Aosta* which was shown at the RA in 1858. His obsession for detail, fostered by the work of the Pre-Raphaelites, and Ruskin's interest in his work, led him to ply up and down the south coastline and the Channel Islands in his yacht, trying to put down on canvas in minute detail everything he saw.

Born in Bletchingley, Surrey, John Brett studied at the RA Schools. He was an eccentric man in many ways. In about 1892 he built himself a house in Putney which he called Daisy Field. It was one of the first centrally heated houses of the period and was built around a strong central pillar. His seven children were discouraged from wearing clothes in the house - which may have been the reason that he had central heating installed.

Brett's sister, Rosa, also a painter, exhibited at the RA from 1858-96 (see entry, below).
REPRESENTED: LIVERPOOL.

ROSA BRETT
fl. 1858-89

The sister of John Brett, Rosa was a flower artist who first made her appearance in Dublin under the name of Rosarius. When she moved to England in 1883, she settled in Maidstone, Kent, and began to paint under her maiden name. Although basically an amateur artist, she was still talented enough to exhibit at the RA from 1858-96. She painted a large number of charming studies of fruit and flowers, animals and landscapes which appear occasionally in the auction rooms.

HENRY BRIGHT
1814-73

A watercolourist of landscape scenes, Henry Bright was brought up in Norfolk, where he became a dispenser at the local hospital in Norwich. Deciding to take up art, he went for lessons with John Berney Crome, the eldest son of the famous Norwich painter John Crome, and later studied with John Sell Cotman. As a result Bright became a first-class watercolourist, although it has to be admitted that his later watercolours are slightly garish, which tends to detract from the quality of his draughtsmanship.

Henry Bright exhibited at the RA from 1843, mainly scenes of East Anglia and Holland. After living in London for many years, ill health forced him to retire to Ipswich, where he died. A number of his paintings are to be found in the Norwich Castle Museum.
REPRESENTED: BRIDPORT, DUNDEE, LEEDS, NEWPORT, NORWICH, PORTSMOUTH, V & A.

FORD MADOX BROWN
1821-93

Although not a member of the Pre-Raphaelites himself, Ford Madox Brown's name has always been closely associated with the group and their precursor, the Nazarenes, a group of German painters which was formed in Vienna in 1809 to paint religious subjects in the manner of the fifteenth-century artists before Raphael.

Born in Calais, Brown trained as an artist in Antwerp under Baron Wappers, the first of the German colourists and also the first to break with the traditions of French classicism which had dominated painting in Belgium since David. In 1845 Brown went to Rome where he met the Nazarenes, who were so called because they wore their hair long and dressed in long monastic robes, emulating their fifteenth-century idol, Fra Angelico, who was noted both for his piety and his religious

paintings. Already an enthusiastic supporter of the work of the Nazarenes, Brown returned to England in 1846, where he fell under the influence of the Pre-Raphaelites, whose aims he saw as an extension of those of the Nazarenes. It was during this period that he produced some of his best paintings, including *Work* and *The Last of England*, which was inspired by the sight of Thomas Woolner, the sculptor, departing for Australia. When he painted another of his famous works, *Wyckliffe*, Rossetti was so impressed by it that he asked to become a pupil of Brown's, which took the artist into the circle of painters that he so admired. In his later years he turned to historical and romantic subjects, but none of his output from this period made the same impact on the public as the three paintings already mentioned.

Although an important figure in British art through his connection with Morris and the Working Man's College, Brown was never a popular artist in his time, nor was he highly paid for his work. From 1868 he suffered from gout which eventually led to a fatal attack of apoplexy. He died in London on 6 October 1893.
REPRESENTED: ASHMOLEAN, BEDFORD, BM, BRADFORD, MAIDSTONE, MANCHESTER, V & A.

WILLIAM MARSHALL BROWN, RSA, RSW
1863-1936

A Scottish painter of figure, landscape and coastal scenes, William Marshall Brown was born in Edinburgh and studied art at the Royal Institute and the Royal Scottish Academy before completing his training at the South Kensington Schools. In his book *Scottish Painting Past and Present, 1620-1908*, Caw describes Brown as an artist who is undistinguished in technique and whose scenes are carefully studied but commonplace in conception, although they are well developed in atmosphere. These comments are condescending and unfair to an artist whose work was exhibited regularly at the RSW and no less than 171 times at the RSA, even though he exhibited only twice at the RA.

On the evidence alone of his oil shown right, Brown was a pleasing painter who was strong on anatomy, for which he had won a bronze medal at the Kensington Schools. He travelled to Holland and France, where he painted *A Breton Washing Pool* and *Concarneau*, among other canvases. He lived in Edinburgh for most of his life, but resided for a while at Cocksburnpath, Berwickshire.

William Marshall Brown
Sailing the Boats
Oil on board, signed and dated 1902. 10 x 12in
Priory Gallery

SIR EDWARD COLEY BURNE-JONES, ARA, RWS
1833-98

Although he was not a member of the Pre-Raphaelites, Edward Burne-Jones was a firm supporter of their ideals and a close friend of Rossetti, whom he had first met in 1857 when he had helped him to decorate the walls of the Oxford Union Debating Society with frescos. Under Rossetti's influence he painted a number of highly romantic subjects taken from the Arthurian legends, as well as myths and scenes from the Bible.

Born in Birmingham, Burne-Jones was originally destined for the ministry but changed course when Rossetti urged him to devote himself entirely to painting. The medieval and mystical elements in the paintings of the Pre-Raphaelites clearly appealed to someone like Burne-Jones who had always been fascinated by the mythology of the classics, which he had attempted to bring to life in such medieval romance paintings as *The Beguiling of Merlin*, *Fair Rosamund* and the *Madness of Sir Tristan*. Most of Burne-Jones' work was a romantic dream. As he said himself in a letter that he wrote to a friend:

I mean by a picture a beautiful romantic dream of something that never was, never will be - in a light better than ever shone - in a land that no one can define or remember, only desire - and the forms divinely beautiful. . .

By the 1880s Burne-Jones was already an international figure, and he remained so until his death on 17 June 1898 at Fulham, London. He left this world laden with honours. He had been given the Legion of Honour, been made a baronet, and awarded many European prizes. He exhibited only one picture at the RA, *The Depths of the Sea*, which depicted a mermaid carrying down through the sea a youth whom she had thoughtlessly drowned in the impetuosity of her love. Burne-Jones' forte lay in the field of decorative design: tapestries, ceramics and stained glass; he also illustrated many books, a number of them published by the Kelmscott Press, which was founded by William Morris.

Edward Burne-Jones was survived by his son, Philip (1861-1926), who became a portrait painter and was knighted, but being a highly emotional and unstable man, he committed suicide in 1926. REPRESENTED: ASHMOLEAN, BEDFORD, BIRMINGHAM, FITZWILLIAM.

HECTOR CAFFIERI, RI, RBA
1847-1932

Hector Caffieri was born in Cheltenham and studied art in Paris under Léon Bonnat, the French portrait artist and painter of historical scenes, and under Jules Lefevre who painted allegorical, mythological and historical tableaux. He worked in London and France, mostly in the Boulogne area where he painted many scenes of the local fishermen at work. Almost all of Caffieri's work is of considerable charm and painted in his own inimitable style, which always seems to capture the very essence of what he is painting, such as *Marlow Lock*, an English boating scene, illustrated right. He exhibited thirty-eight pictures at the RA and another fifty-eight at the RBA from 1875 to 1901. He is also known to have exhibited in Paris at the Salon des Artistes. He lived at 24 Montpelier Walk, Chelsea, and at 8 Camden Studios, Camden Street, London. Hector Caffieri is not, as one might be tempted to think, descended from the talented Caffieri family who worked in Paris in the eighteenth century, with Jacques Caffieri the sculptor at its head.

Hector Caffieri
Marlow Lock
Watercolour. 17 x 23in
Bourne Gallery

WALTER WALLER CAFFYN
1874-99

Walter Caffyn was one of the many excellent landscape artists of the Victorian period. Although his paintings fetch good prices in the auction rooms today, his work has never received the critical attention it deserves. His paintings bear some resemblance to those of John Glover, who used his split-brush technique to paint trees and foliage. Caffyn's landscapes are generally more pleasing to look at than those painted by Glover, whose work is weighed down by his technique and his habit of using dark greens and sombre colours.

Caffyn came from Dorking, Surrey, and painted many landscapes in the area; he also painted scenes in Sussex and a lesser number in other parts of the country, such as his oil that was painted outside Huddersfield (see p58).

Other paintings include *On the Mole, Norbury; Near Castle Mill, Dorking;* and *Springtime, Homwood Common*. He is known to have exhibited twenty-six paintings at the RA and another twenty-six at the SS.
REPRESENTED: BIRMINGHAM.

PHILIP HERMOGENES CALDERON
1833-98

Philip Calderon was the leader of the 'St John's Wood Clique'. He was born in Poitiers in western France, and educated by his father, a renegade Spanish priest who had joined the Protestant Church and later became Professor of Spanish literature at King's College, London. Calderon received his art training from James Matthews

Walter Waller Caffyn
Among the Hills near Slarthwait, Huddersfield
Oil, signed, dated and inscribed on reverse.
23 x 35in. Sotheby's, Sussex

Leigh, a painter of historical subjects, and from
Françoise Picot, also a painter of historical scenes,
who ran an influential teaching atelier in Paris.
Calderon began to exhibit at the RA, and in 1857
made a name for himself with his painting *Broken
Vows*, now in the Tate Gallery, which depicts a
broken-hearted woman overhearing her lover
flirting with another woman. At a glance one can
see that it was painted under the influence of the
Pre-Raphaelites. In 1867, Calderon won a gold
medal at the Paris International Exhibition.

Philip Calderon was a very popular artist in his
time, although many Roman Catholics were deeply
offended by his *Renunciation of St Elizabeth*, which
depicts Elizabeth kneeling naked before the altar.
REPRESENTED: LIVERPOOL, TATE.

WILLIAM CALLOW, RWS
1812-1908

Very few artists saw so many changes in the social
and cultural fabric of England as did the marine
and topographical watercolourist William Callow,
who lived to be 96. He was on speaking terms with
Constable and Turner and most of the other
famous artists of the time and had travelled the
length and breadth of Britain and the Continent
before the advent of the railways.

Callow was born in Greenwich, the son of a
builder who had French prisoners-of-war work-
ing for him during the Napoleonic wars. At the age
of 11, the young Callow obtained work with
Theodore Fielding, the brother of the well-known
artist Copley Fielding. Theodore was an aquatint
engraver by trade and it was Callow's task to help
him with the colouring of prints and to make
himself useful around the offices. Theodore moved
his premises to Camden Town in 1825 and took
Callow with him as a pupil, whom he instructed in
the art of watercolouring.

The turning point in Callow's life came when a

customer asked Theodore if he knew anyone who might be suitable to work for him as an assistant in the production of a large number of engravings for a book. The job was in Paris and Callow accepted it immediately. It was in Paris that he met Thomas Shotter Boys (see entry) with whom he shared a studio. When Boys returned to England in 1837, Callow took over the studio and set up in business as an art teacher, taking as his pupils a large number of the French aristocracy. He returned to England in 1841 and settled in London. Before his death in Great Missenden, Buckinghamshire, in 1908, he had exhibited 1,152 watercolours at the OWS, most of them marine subjects. His

William Callow
Palace on the Grand Canal, the Rialto Bridge
in the Distance
Pencil and watercolour heightened
with body-colour. 8⅛ x 11⅛in. Spink

watercolour, shown below, was painted early in his career when he was studying in Italy.

REPRESENTED: BIRMINGHAM, BRADFORD, BRISTOL, BM, EXETER, FITZWILLIAM, GLASGOW, MARITIME MUSEUM (GREENWICH), NEWPORT, PORTSMOUTH, V & A.

EDWARD CALVERT
1799-1883

The son of a naval officer, Edward Calvert was born in Cornwall and spent a short time at sea before he abandoned the idea of a naval career in order to study art under a West Country artist named Ambrose Johns, who had made a local reputation for himself as a landscape artist. Calvert then studied at the RA Schools in London, where he met Samuel Palmer, a painter of pastoral landscapes and a follower of William Blake, the painter and mystic, who died in poverty and was

buried in a common grave.

Calvert began his career as an illustrator-draughtsman on wood, but he was so unsure of his work that he destroyed many of his blocks and plates, so that any prints of his work are now extremely difficult to find. He became interested in Greek art after a visit to Greece, and from 1827 to 1829 he produced a number of excellent engravings on pagan themes, which upset Palmer who wrote: 'Calvert is in deliberate hostility to the gospel of Christ.' It was a harmless affair, even though Calvert took his paganism seriously enough to have an altar to the great god Pan erected in his back garden. He last exhibited at the RA in 1836.

Calvert painted in oils and watercolours, mostly mythological subjects. Because of his habit of destroying so much of his work, surviving paintings are hard to find. He died on 14 July 1883, probably at 17 Russell Street, Brixton, which was his last known address.

REPRESENTED: BM, EXETER.

Claude Cardon
Springtime
Oil on canvas, signed and dated 1915.
18¾ x 29in
Brian Sinfield

CLAUDE CARDON
exh. 1892-1915

A London artist who lived at Rochester Square off the Camden Road, and in Manchester for a time, Claude Cardon painted rural and domestic subjects. He exhibited only nine paintings at the RA, although this small number does not reveal the quality of his work, but rather shows how easy it was for a capable Victorian artist to be overlooked or ignored in the struggle for survival among the thousands of Victorian artists who were striving to make their name. His oil shown above is an extremely attractive painting, with the cattle grouped around the apple tree which is in full blossom, and with the paint so finely applied that at a glance, it could be taken for a watercolour.

JOHN WILSON CARMICHAEL
1800-68

John Wilson Carmichael was born in Newcastle-upon-Tyne, where he lived for the greater part of his life. He was the son of a ship's carpenter and was apprenticed as a ship builder and thus had a thorough knowledge of ships before he took up his artist's brushes. He may well have been a pupil of Thomas Miles Richardson, the landscape artist, who had a studio in Blackett Street, where Carmichael first set up as a painter in 1823. He exhibited at the RA from 1835 to 1858, where he exhibited twenty-one paintings. In 1854 the *Illustrated London News* employed him as a war artist to record the Crimean War, when he accompanied the Baltic Fleet into battle for the summers of 1854 and 1855.

The death of Carmichael's son in 1862 greatly saddened him. He never painted again and retired in 1865 to Scarborough, where he died three years later on 2 May 1868. Before his death he crowned his relatively short painting career by producing *The Art of Marine Painting in Watercolours*, which was published in 1859. He was not a great marine artist, but he was certainly superior to many of his contemporaries.

An example of Carmichael at his best is seen in his painting illustrated below. This magnificent canvas shows the setting sun glancing off the Rock of Gibraltar with a strong westerly wind blowing through the straits. On the right are two men-of-war under reefed topsails sailing away from Gibraltar. Close behind is a frigate hauling on the port tack, while in the foreground is a rowing boat containing a mixed party out for an evening row. REPRESENTED: ASHMOLEAN, DARLINGTON, GATESHEAD, MARITIME MUSEUM (GREENWICH), SHIPLEY, V & A.

John Wilson Carmichael
Warships under Sail off Gibraltar
Oil on canvas. 35 x 47in
Royal Exchange Art Gallery

GEORGE CHINNERY, RHA
1774-1852

George Chinnery was an odd character who was in constant flight from his creditors, while at the same time he was pursued by a woman who would not let go of him. His marriage was a disastrous union. Chinnery's wife, Marianne, found that she had married a wayward eccentric who spent money on a prodigious scale and who eventually deserted her and went to India to paint.

Chinnery remained in India for twenty-three years, where he became a well-known figure to the British Raj. As a portrait painter he was in great demand, earning as much as £500 a month. When Mrs Chinnery tracked down her husband in India, he immediately fled to China. It was here that he painted the hundreds of exquisite watercolours and sketches of life in China for which he is most remembered today.

Chinnery's not unpleasant way of life was abruptly disturbed when his wife arrived unannounced at his home four years later. Chinnery then left China and travelled to Macao, pursued once again by his wife. However, Mrs Chinnery discovered that European women were not allowed on the island, so, banned from going ashore, she was forced to stay on board ship, where she contracted smallpox and died.

Chinnery settled down happily to his painting, to his daily pipes of opium to which he had become addicted, and to eating in excess until he became a gross figure who had to be carried everywhere by four 'coolies', a travesty of the man he had once been. His eccentricity bordered on madness and, not surprisingly, he died of apoplexy. Sir Henry Russell, one of his sitters and the Chief Justice of Bengal, described him as 'very odd and eccentric, so much so at times to make me think him deranged'.

As a portrait painter Chinnery was highly regarded in his time. Occasionally, he would submit a picture to the RA from Macao until the year of his death. In all, he exhibited only nine pictures at the Academy, as he was too busy with private commissions. His *Portrait of a Lady* illustrated opposite shows him to be an accomplished portrait artist. He was an industrious and highly talented artist who worked in oils, watercolours, gouache and pastel, and drew countless sketches in pencil.

REPRESENTED: ASHMOLEAN, LEEDS, NGS, V & A.

George Chinnery
Portrait of a Lady
Oil on canvas. 29½ x 23½in
Spink

OLIVER CLARE
1853-1927

Oliver Clare was one of the many fruit and flower painters of the nineteenth century, when this form of painting became popular again, after it had fallen out of favour after Sir Joshua Reynolds had expressed his dislike of it. This style of painting had its roots in the Dutch 'breakfast pieces' and the Flemish School. After Reynolds' death in 1792, flower painting gradually began to be accepted again. Even then, it was not until the middle of the nineteenth century that it actually became fashionable.

Oliver Clare and his brother Vincent were latecomers to the competitive field of nineteenth-century flower painting, and had difficulty in establishing themselves when faced with competition from artists such as Walter Hunt. The exquisite example of Oliver's work shown on p64 makes this fact surprising, as the painting could surely not have been bettered by any of the fruit and flower artists of that period.

REPRESENTED: BIRMINGHAM.

Oliver Clare
Still Life
Oil on canvas. 14 x 10in
Priory Gallery

A COMPANION TO VICTORIAN AND EDWARDIAN ARTISTS

Edwin Cockburn
An Auction in a Village
Oil on canvas, signed and dated 1853.
24 x 32in. Spink

EDWIN COCKBURN
fl. 1837-68

A genre artist whose paintings were mostly of domestic scenes and situations, Edwin Cockburn exhibited more than sixty paintings at the main galleries - the RA, the BI, and the SS. He lived in London at various addresses, including 83 Newman Street, 42 Rathbone Place and 63 Tottenham Court Road, as well as in Whitby, Yorkshire, where he painted *Landing Herrings on the Sands, Whitby*. Like so many Victorian artists, he was in the habit of adding a few lines of a poem to a painting, which only made him sound portentous and confused the viewer. The following is a typical example:

A DINNER PARTY

With musing, deep astonish'd stare,
I viewed the heavenly seeming pair
A whispering throb and witness bear,
Of kindred sweet,
When with an elder sister's air,
One did me greet.

An Auction in a Village, shown above, is fairly representative of Cockburn's work, which often looked like an eighteenth-century rather than a Victorian painting.
REPRESENTED: BM, WHITBY.

GEORGE COLE
1810-83

Whatever claim to fame George Cole might have today lies in the fact that he was a very popular artist in his time, who had exhibited 223 times at the SS and thirty-five times at the RA. However, this does not say a great deal for the selection committees of these two bodies, for the truth of the matter is that George Cole was no more than a competent artist. At his best he could paint a pleasing landscape, and his animal paintings, which he took very seriously, could be surprisingly good.

A Plymouth-born self-taught artist, Cole began his career by painting a large number of canvases advertising a travelling circus. Anxious to study animal painting more seriously, he went to Holland to examine the Dutch masters, who often

A COMPANION TO VICTORIAN AND EDWARDIAN ARTISTS

William Stephen Coleman
Gathering Lotus
Watercolour, signed. 16 x 24in
City Wall Galleries

HELEN CORDELIA COLEMAN
1847-84

The sister of William Stephen Coleman (see entry and painting) Helen Coleman, who later became Mrs John Angell, was a watercolour artist who painted charming studies of flowers and fruit. Like many nineteenth-century artists who painted subjects of this kind, she worked on a small scale and was very precise in the way that she executed her paintings. William Henry Hunt, who is considered to be the best in his field of art, regarded her as his natural successor. Her watercolour illustrated below is a deceptively simple painting in which each item is carefully defined.

Helen Cordelia Coleman
Mignonette and Azalea in China Bowl
Watercolour, signed. 4 x 6in
Fine Lines (Fine Art)

featured animals in their paintings. Among Cole's numerous paintings are *Near Esher, Surrey*; *The Last Load*; *A Mountain Pastoral*; and *A Welsh Farmyard*. It was a measure of his popularity that most of his paintings always fetched good prices, whereas his son, George Vicat Cole (1833-93), who was the better artist, had to content himself with more modest sums.

WILLIAM STEPHEN COLEMAN
1829-1904

An artist who painted genre and pastoral scenes and occasionally neo-classical scenes in the manner of Albert Moore, William Coleman was born in Horsham, Sussex, the son of a physician. He trained originally for the medical profession, but abruptly changed course to become a professional artist.

An artist whose forte lay in painting idyllic scenes which often feature children, rather in the manner of Birket Foster (see entry), Coleman's rural paintings reflect his love of nature, which initially had attracted him to painting as a profession. His watercolour *Gathering Lotus*, shown on pp66-7, is a typical example of his work. He was also a popular illustrator of natural history books, including *On Woodlands, Heaths and Hedges; British Butterflies* (1860); *The Book of the Thames* (1859); and *The Book of South Wales*. In 1869 he took up pottery decoration and in 1871 established Minton's Art Pottery Studio in Kensington Gore.

William Coleman was the brother of Helen, the flower artist (see p67), and Rebecca Coleman, who painted genre and figure subjects. He died on 22 March 1904 in St John's Wood, London.
REPRESENTED: BLACKPOOL, GLASGOW, V & A.

THOMAS COLLIER, RI
1840-91

Thomas Collier was one of the few Victorian artists who had private means which allowed him to paint where and when he wanted. A watercolourist of considerable power, Collier's paintings were always of a consistently high standard. A dedicated artist, he often worked outside in inclement weather, even to the extent of painting with snow on the ground until his brushes were too frozen to use. Although Collier suffered from tuberculosis for much of his life, he painted for longer and harder than a man in his financial position needed. He seemed to know that he was living on borrowed time and therefore wanted to

paint as much as possible before his untimely end.

Little is known about Collier except that he attended the Manchester School of Art and exhibited his first painting when he was 23. He was not a prolific exhibitor, and showed only four of his paintings at the RA. Towards the end of his life he lived in a large house that he had built in Hampstead Hill Gardens. Ill health confined him increasingly to his house, which he named Etherow after a stream near Glossop that he had known in his childhood. He died at home at the age of 50, respected and greatly missed by the discriminating few.
REPRESENTED: ABERDEEN, BIRKENHEAD, BIRMINGHAM, BM, BURNLEY, HARROGATE, LIVERPOOL, MANCHESTER, V & A.

CHARLES COLLINS, RBA
fl. 1867-1906 (d. 1921)

Collins came from Dorking, a popular place with painters, no doubt because of its close proximity to the Surrey countryside. Unlike Claude Cardon (see entry and painting), who tended to make his paintings a little too warm in their colouring, Collins always aimed to make his pictures more realistic, both in their colour application and in the way that he approached his subject - see, for example, *May Blossom* illustrated on p69. He showed thirty-two exhibits at the RA from 1867, as well as another 235 at the RBA and many others at all the major galleries. Collins' work is highly regarded by collectors who appreciate his straightforward, unpretentious style.
REPRESENTED: BM, LEEDS.

Charles Collins
May Blossom
Watercolour, signed. 10 x 14in
Priory Gallery

WILLIAM COLLINS, RA
1788-1847

William Collins was a well-known landscape artist who helped to maintain into the Victorian era the traditions of rustic landscape paintings that had been developed during the Georgian period. He had his first lessons in art from George Morland who depicted the English countryside and its inhabitants with the sort of truthful eye that is missing in most Victorian landscape paintings. Understandably, many of Collins' landscapes are low-toned and in keeping with the work of Morland. In other paintings the colouring is bright and cheerful and finely executed and often enhanced by little studies of children involved in some sort of activity, as in the oil shown on p70.

Collins entered the RA Schools in 1807 and began to exhibit the same year. In 1822 he married the daughter of the Scottish painter Andrew Geddes, who exhibited more than a thousand paintings in his lifetime.

Collins exhibited 124 pictures at the RA and another forty-five at the BI. However, not all of his work is of a high quality. He painted widely in such places as France, Holland, Italy and in the Shetland Islands. Following a visit to Norfolk and Hastings he even tackled marine painting, when he produced such attractive oils as *Cromer Sands, Norfolk; Prawn Fishing;* and *Morning - Fishermen on the Look-out.* His greatest successes, however, were with his paintings of rustic life. An attack of rheumatic fever left him with heart disease, to which he finally succumbed fifteen years later in London.

Collins had two sons - Charles Allston, who was friendly with Millais and influenced by the Pre-Raphaelites, and Wilkie Collins, the famous Victorian writer who is best known today for his novel *The Woman in White.*

REPRESENTED: BM, MANCHESTER, V & A.

William Collins
Children Climbing a Cliff
Oil, signed and dated 1845. 25¾ x 35¾in
Sotheby's, Sussex

CHARLES EDWARD CONDER
1868-1909

Charles Conder, a portrait and landscape painter, was born in London but spent his early childhood in India. When he was 15 he emigrated to Australia, where he became a major exhibitor in an Impressionist exhibition held in Melbourne. Unlike so many of the Heidelberg School of painters, he was not interested in painting the Outback and worked in the vicinity of the cities, rather than in the bush. After being employed for a while on the *Illustrated Sydney News*, he travelled to France, where he became closely associated with such painters as Toulouse-Lautrec, Walter Sickert and Aubrey Beardsley.

In 1897 Conder finally settled in England and married. By then he had grown in stature as a painter. His paintings attracted the attention of the artist Sir William Rothenstein, who wrote to him expressing his appreciation of his work. A year later, John Rothenstein echoed this praise in his book *The Life and Death of Charles Conder*, published in 1938, in which he wrote:

> He created an Arcadia peopled by dreamy, capricious figures who lead lives of luxurious idleness. They wander at dusk on the margins of tranquil lapis-lazuli seas, of lakes cerulean under the midday haze, or dally in the shade of richly foliaged trees.

Despite the somewhat ornate prose, it does

A COMPANION TO VICTORIAN AND EDWARDIAN ARTISTS

capture something of the feeling of Conder's painting. *An Arcadian Idyll*, shown below, summarises everything that both the Rothensteins admired in Conder's work. He took the essence of Watteau, Fragonard and Boucher and transposed it to some effect into a kind of romantic Impressionism.

REPRESENTED: BM, FITZWILLIAM, LEEDS, LIVERPOOL, DUBLIN.

THOMAS SIDNEY COOPER, RA
1803-1902

A landscape and cattle painter who was born in Canterbury, Kent, Thomas Cooper was encouraged to paint by a scene painter named Doyle who taught him all he knew before he encouraged him to take further lessons at the BM, where he studied until he won a place at the RA Schools which he entered in 1824. He left the RA Schools after only nine months for reasons which have never been explained, but which were probably economic. He returned to Canterbury where he supported himself by giving art lessons and by the sale of his paintings. In 1827 he went to Brussels in the company of William Burgess, a well-known painter. While he was in Brussels Cooper married, and

Charles Edward Conder
An Arcadian Idyll
Oil on canvas. 28 x 36½in
Bonhams

studied under Eugene Verboeckhoven, the famous Flemish animal artist who specialised in painting cattle and sheep in their natural surroundings. Verboeckhoven obviously had a tremendous influence on his pupil as he became famous for his own highly finished studies of cattle and sheep, of which a particularly fine example is shown below. In 1831 Cooper returned to England and began to exhibit at the RA two years later. In a way he was a victim of his own success as he continuously varied the same subjects until eventually his work became over-familiar and repetitious. Even so, the quality of Cooper's work did not begin to decline until the 1890s. As he was by then moving into his nineties, he may be forgiven if his work was somewhat less accomplished than it had been in his heyday.

REPRESENTED: ACCRINGTON, BLACKBURN, EXETER, LEEDS, MAIDSTONE, MANCHESTER, NEWPORT.

WILLIAM SIDNEY COOPER
fl. 1871-1908

Despite the close similarity of their names, there is no conclusive evidence to prove that William Sidney Cooper was a son or relative of Thomas Sidney Cooper. William was a landscape painter who lived in London and Herne Bay and painted a number of charming landscapes, such as the example shown opposite. He worked in oils and watercolours and exhibited at most of the major galleries, including the RA. His pictures include *On the Medway; Sunset on the Ouse, Sussex; Twilight on the Thames;* and *A View From the Thames.* The latter painting may be seen in Reading Museum.

REPRESENTED: MAIDSTONE, READING.

Thomas Sidney Cooper
Watercolour, signed and dated 1860.
17¾ x 25¾in
David James

William Sidney Cooper
Maytime on the Thames
Oil on canvas. 20 x 16in
Bourne Gallery

David Cox
Calais Pier
Watercolour, signed and dated 1832.
7¼ x 10¼in
Spink

DAVID COX, RWS
1783-1859

Considered by many to be one of the leading masters of the British school of landscape painting, David Cox was born in Deritend, a poor suburb of Birmingham, and was brought up in a small house attached to a forge where his father worked as a blacksmith. He was taken from his school at an early age and set to work in the smithy and taught how to wield a large hammer. The work proved much too hard for him and he was sent to work for a firm that produced such luxury goods as lacquered buckles, painted lockets, ornate snuff-boxes and other similar items. Cox was just beginning to acquire some skill in painting miniatures when his employer committed suicide and he was forced to seek work elsewhere. He took a job as a colour grinder and scene painter at the Birmingham Theatre, which was then under the management of W. C. Macready, father of the well-known stage tragedian. Cox toured with him around the provincial theatres under Macready's management until they quarrelled and Cox went to work with Astley's Circus in London, where he met and married Mary Agg, his landlady's daughter. Although she was twelve years older than her husband, Mary Agg was exactly the partner he needed. Mary provided her husband, a quiet, unassuming man, with the comfort and drive he required to sustain him through the difficult years that lay ahead for them both.

In 1808, Cox settled with his wife in a small cottage in Dulwich, where he supplemented his modest income from his paintings by giving art

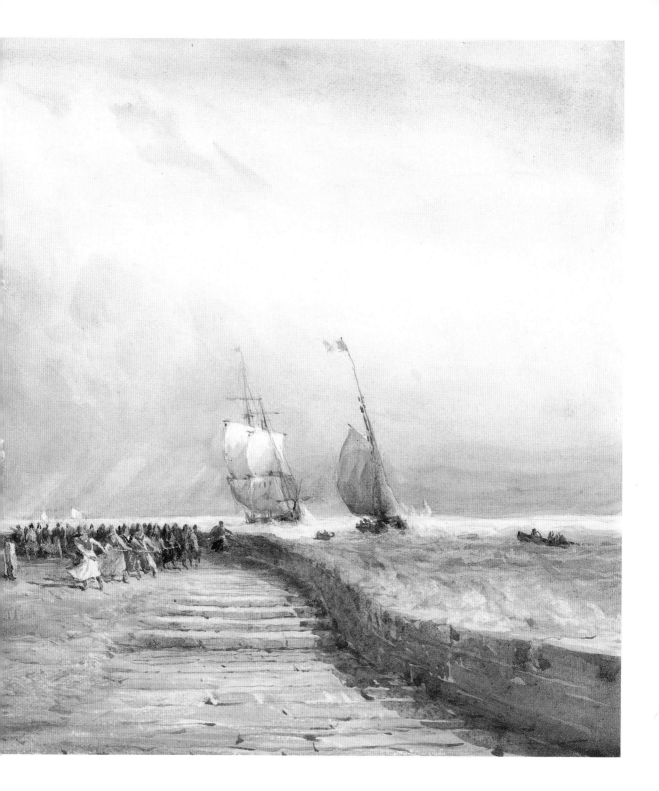

lessons. Although he had exhibited once at the RA in 1805, Cox was still experiencing great difficulty in selling his paintings, and he had to exercise the most stringent economies in order to survive, even covering his unsold paintings with others rather than buy new strainers or stretching boards. Fifty years later when some of these pictures were examined before they were resold, they revealed layers of paintings one on top of another. Cox was so poor in those days that he sold his pictures for £2 a dozen. Shortly after he was 30, however, his luck changed marginally for the better when he

was offered the sum of £100 per annum to teach art at a lady's college in Hereford.

In 1829 Cox and his son visited Paris, and on the way they stopped at Boulogne and Calais, where he painted some excellent scenes such as the marvellous picture on pp74-5.

In 1836 Cox discovered a special kind of paper which he used afterwards for so many of his drawings and which gave such a distinctive touch to many of his paintings. It was a form of wrapping paper which came from Dundee, and a paper of a similar quality is still produced to this day and is known as 'David Cox paper'. The paper's surface was marred with little brown specks which presented a problem when Cox painted a sky. He solved the problem by adding wings to the specks, thus creating birds in the sky.

Cox's output was enormous. He produced hundreds of paintings annually for nearly fifty years, but he never made a successful living throughout his whole life. It was only after his death that his paintings began to fetch enormous sums.

Much of Cox's painting was done in North Wales, especially around Betws-y-Coed, which he helped to popularise. Although he worked for much of his life in watercolours, he later turned to painting in oils but with never the same success. He finally retired to Harborne, near Birmingham, where he resided until his death on 7 June 1859. He was succeeded by his son David who also became a painter, although he was never in the same class as his father.

REPRESENTED: ASHMOLEAN, BIRMINGHAM, BM, COVENTRY, MAIDSTONE, V & A.

WALTER CRANE, RWS
1845-1915

Although he is best known for his book illustrations, Walter Crane also painted a number of watercolours that varied in subject-matter from landscapes to portrait and figure subjects. He was more of a watercolourist than an oil painter, his best known picture being *The Renaissance of Venus*. Because his wife objected to his using a female model for the figure of Venus he was forced to use a male model named Alessandro di Marco, who was recognised immediately in the painting by Lord Leighton, even though Crane had made the necessary anatomical alterations to the painting.

Born in Liverpool, Walter Crane eventually became one of the leading designers of the Arts and Crafts movement which was formed by Ruskin and William Morris in 1888 to produce art for the people by the people as a form of protest against the mass-produced factory products that were being produced. The movement lasted well into the twentieth century. A staunch socialist, Crane threw himself into every aspect of teaching art to those who were unable to attend the rarified classes of the RA. He was an examiner in design to the Board of Education in London, and was also on the Scottish Board of Education and a Master of the Arts Workers' Guild, as well as being principal of the RCH for a brief period. His particular style, with its elaborate decorative borders and highly detailed pen work was often copied by lesser artists. His pictures lack emotional content, and the decorative work that so often surrounds them can be as uninteresting to look at as some wallpapers.

REPRESENTED: ASHMOLEAN, BEDFORD, BM, DUNDEE, FITZWILLIAM, GLASGOW, V & A.

THOMAS CRESWICK, RA
1811-69

Thomas Creswick was a landscape artist who came from Sheffield but trained in Birmingham under Charles Vincent Barber, whose father had taught David Cox. In 1828 Creswick went to London, where he immediately began to exhibit at the British Institution and at the RA. His early works were chiefly of Welsh scenes, such as *A Trout Stream in Wales*, which he painted in 1833. In 1842 he was elected an associate of the RA and became a full Academician in 1851.

Creswick's paintings are worthy rather than inspired, and are typical of the type of work popularised by the RA at the time in that they are

well executed, with much attention to the brush-work, but using a dull palette, full of the various shades of dark green. Creswick was an industrious and prolific artist who produced a steady stream of work and numerous illustrations for books, such as Izaak Walton's *The Compleat Angler, Songs and Ballads of Shakespeare* and *Favourite English Poems of the Last Two Centuries*. A genial, bulky man, who looked somewhat unpreposessing in his later years, he died at his house in Bayswater after several years of ill health.

REPRESENTED: BM, GLASGOW, MANCHESTER, WHITBY.

HENRY EDGAR CROCKET, RWS
1874-1926

Henry Crocket was one of the many artists who maintained the traditions of Victorian landscape painting well into the first quarter of the twentieth century. A student of the RCA and then of the Académie Julian in Paris, where so many of the Victorian artists studied, he was elected an RWS in 1913 and exhibited fourteen paintings at the RA. His work rarely appears in the auction room, so it is difficult to judge how consistent it is. From the evidence of the painting shown below, he was a highly competent artist, as one might expect from a painter who had received such excellent training. He lived in Lewes, Sussex for many years before he moved to Bournemouth in 1920.

Henry Crocket
The Picnic
Watercolour. 19 x 28in
Priory Gallery

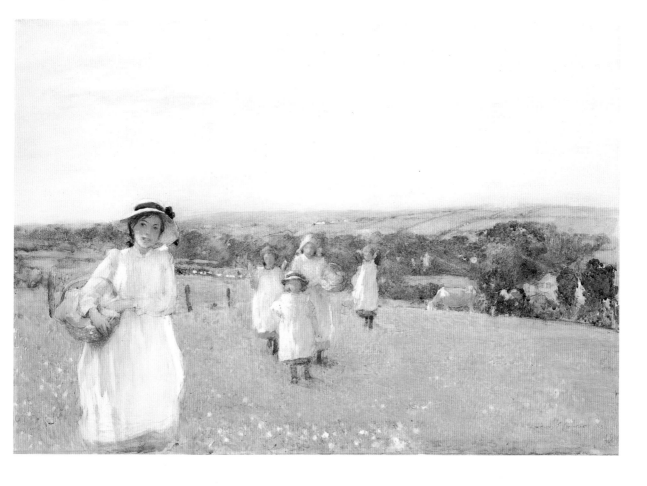

A COMPANION TO VICTORIAN AND EDWARDIAN ARTISTS

James Shaw Crompton
Portrait of a Young Girl Wearing a Bonnet
Watercolour, signed and dated 1887
9¾ x 7½in
Sotheby's, Sussex

JAMES SHAW CROMPTON, RI
1853-1916

A genre artist who worked in watercolours, James Crompton was born in Bootle, Lancashire, and studied under John Finnie, the landscape artist and illustrator, and also at Heatherley's Art School. He exhibited at all the major galleries and produced a number of book illustrations. For much of his life he lived in London at Hartham Road in the Camden area, and then at Haverstock Hill. He was the chairman for the famous Langham Sketching Club. He died on 16 April 1916.

A highly professional artist whose work is always pleasing to look at, Crompton carried on the traditions of Victorian genre painting right up to World War I, when his style of painting became unfashionable. A typical example of his work is shown opposite.
REPRESENTED: MAIDSTONE, V & A.

William Cruickshank
Bird's Nest and White Harebells
Watercolour, signed. 7½ x 9in
Fine Lines (Fine Art)

WILLIAM CRUICKSHANK
fl. 1866-88

Of the many nineteenth-century artists who specialised in still life painting, only a handful are known: William Hough, Edward Ladell, the brothers Oliver and Vincent Clare, and Walter Hunt, are the most obvious names that come to mind. Behind them came a host of talented imitators, William Cruickshank among them.

A London artist who lived at 102 Kennington Road, Cruickshank exhibited seven paintings at the RA and another twenty-two at the SS between 1880 and 1886. Very little is known about his life, so one can only speak of his work and not of how he became a painter of still life studies. Looking at his watercolour on p79 and comparing it with the work of Hunt, it would appear that only a fine distinction separates the two artists' work.
REPRESENTED: BRIGHTON.

Richard Dadd
A Seated Arab
Watercolour and Chinese white on paper.
Signed and dated 1880. 10 x 5in
Spink

RICHARD DADD, RI
1819-87

Few stories are more tragic in the history of nineteenth-century art than that of Richard Dadd. Born in Chatham, the son of a chemist, his career began normally enough when he studied at the RA Schools before he embarked on a career as a professional artist. His work consisted for some time of rather ordinary landscape and marine paintings. In 1841 his work changed in an extraordinary way which anticipated his astonishing world of fairies, goblins and the like, all of them painted in obsessive detail. Dadd's madness, which had been lurking beneath the surface for some years, suddenly became more obvious after his return from the Middle East in the company of Sir Thomas Phillips, a well-known art connoisseur of the time. In 1843, Dadd began to display all the signs of schizophrenia: he told everyone that the Pope and Sir Thomas Phillips were devils and secretly wrote a long list of the people he intended to kill, including his father. While he was walking with his unsuspecting father in Cobham Park he brutally murdered him and then fled to France, where he was apprehended in Fontainebleau trying to cut the throat of a stranger. He was brought back to England and spent the rest of his life under restraint, first in Bethlem Hospital and then in Broadmoor. He continued to paint, producing pictures of allegorical subjects in an almost surrealist style, for which his work is most known. His famous painting *The Fairy Feller's Master Stroke* took him nine years to paint and is now in the Tate Gallery, London.

The watercolour shown opposite was painted in Broadmoor six years before his death and shows how Dadd was still preoccupied with his Middle East journey undertaken nearly forty years previously. As such, it is a rare collector's piece.

REPRESENTED: BEDFORD, BM, FITZWILLIAM, NEWCASTLE, NEWPORT, V & A.

HENRY DAWSON
1811-78

Henry Dawson was born in Hull but moved at an early age to Nottingham, where his first job on leaving school was in a lace factory. A self-taught artist, he began by selling his pictures for 2-3s each, his first customer being a local hairdresser who had an eye for a good picture. In 1884 he moved to Liverpool, where he spent the next five years trying to build up a reputation for himself as a landscape painter. Finding that he was not making much headway there he moved to London, eventually taking a house for himself and his family in Croydon, Surrey.

In later life Dawson's work showed something of Turner's influence, although he still maintained his own distinct style. He painted the occasional sea piece, which should not be confused with the work of the marine painter Henry Thomas Dawson. He exhibited thirty-three pictures at the RA. His portrait painted by S. Redgate hangs in the Nottingham Art Gallery.

Dawson's work was unjustly neglected for most of his life, as it still is today. He could never be referred to as a top-ranking landscape artist, but his views of London from the Thames, and a number of his woodland scenes certainly merit attention.

REPRESENTED: NOTTINGHAM.

JANE M. DEALY, RI
exh. 1879-1931

A genre painter and illustrator who studied at the RA Schools, Jane Dealy is well known for her studies of children, who are often portrayed in the company of their mother or an adult, as in the example of her work below. She exhibited at the RA from 1881 to 1903 and later married Sir Walter Lewis. She illustrated a number of children's books, including *The Land of the Little People*, and did a large number of illustrations for *Little Folks*, a well-known and very popular magazine with young children in its time, and to which Kate Greenaway contributed during the period 1873-80. Dealy's paintings, which include *Watching the Fairies*, *A Wee Bit Doleful* and *Mary, Mary, Quite Contrary*, were far less 'twee' than the titles would indicate. She was born in Blackheath in London and died there on 23 February 1939.

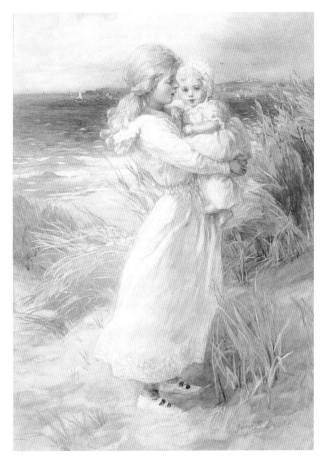

Jane M. Dealy
The Sisters
Watercolour, signed. 21½ x 15in
Fine Lines (Fine Art)

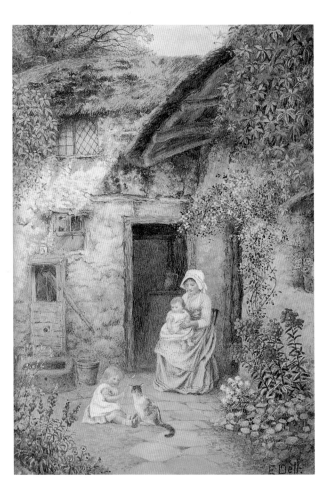

ETHELDINE EVA DELL
exh. 1855-1923

Etheldine Eva Dell belongs to that long line of Victorian artists who romanticised English rural life with their paintings of spotlessly clean little girls playing in front of their cottages. It is the type of painting that has often been criticised by people who make the mistake of judging a painting out of its historical context.

Whatever else might be said of Dell's work, her paintings were always done with careful attention to detail, as can be seen in her watercolour shown left, in which the ancient thatching on the roof of the cottage has been painted with meticulous care, as has the foliage around the upper reaches of the cottage. She exhibited rarely at the RA and lived in New Malden, Surrey.

Etheldine Eva Dell
Mother and Family Outside their Cottage
Watercolour, signed. 11½ x 8in
Fine Lines (Fine Art)

SIR FRANK DICKSEE, PRA, RI
1853-1928

Frank Dicksee was born in London, the son of Thomas Francis Dicksee, who painted portraits and period genre pictures. Having been taught the basics of drawing by his father, Frank was sent to the RA Schools where he stayed for five years before he became an illustrator for the *Cornhill Magazine* and the *Graphic*. In 1879 he began supplying book illustrations, first for Mrs Oliphant's *Within the Precincts*, and then for Longfellow's *Evangeline*, which was published in 1882, and *The Four Georges*. His reputation as an artist came when his painting *Harmony* was shown to the public. Bought by the Chantrey Bequest and now in the possession of the Tate Gallery, the painting was greatly influenced by the Pre-Raphaelites, as was *The Magic Crystal*, which was also bought by the Chantrey Bequest.

In the 1890s Dicksee turned increasingly to portrait painting, striving to find in his female sitters an ideal of beauty that was derived from the traditions of the Royal Academy and the Paris Salon. He died in London on 17 October 1928.
REPRESENTED: BM, MANCHESTER, NEWPORT, TATE, V & A.

CHARLES EDWARD DIXON, RI
1872-1934

For a long time Charles Dixon was a seriously neglected marine artist. Time did not redress this situation until 1973, when three major exhibitions were held of his paintings. Since then he has become one of our most popular seascape artists, whose work always sells quickly whenever it appears in the auction rooms.

The son of the genre and historical painter Alfred Dixon, Charles first exhibited at the RA at the age of 16 before he became a regular contributor to the *Illustrated London News*, the *Graphic* and the *Sphere*. Because he happened to be the friend of Sir Thomas Lipton, whose grocery stores were so much a part of the English scene at one time, he was allowed to travel with him on each of the five Shamrock boats that Lipton entered for the America's Cup races.

Some of Charles Dixon's paintings bear some resemblance to the work of William Wyllie. Although his work never quite matched Wyllie's standards, Dixon's draughtsmanship is accurate, and, generally speaking, he was a worthy practitioner of maritime painting. He died in Itchenor, Sussex, in 1934.

For those who have become a little too familiar with Dixon's famous paintings of shipping on the Thames, his paintings of vessels standing off Tangier will make a welcome change.
REPRESENTED: ABERDEEN, BLACKPOOL, MARITIME MUSEUM (GREENWICH), NEWPORT.

Charles Edward Dixon
At Tangier
Watercolour and gouache
Signed and dated 1911. 11½ x 30½in
Fine Lines (Fine Art)

THOMAS MILLIE DOW, RSW
1848-1919

The son of the town clerk of Dysart in Fifeshire, Scotland, Thomas Millie Dow studied law for a while before he turned to painting. He studied in Pairs under Jean Léon Gérôme, a pillar of the French art establishment in the second half of the nineteenth century. After returning to Scotland he became closely associated with the Glasgow School, a group of young men who were determined to avoid the 'subject pictures' which they considered were far too sentimental. His connection with them seems rather strange as he was an artist who often painted romantic and allegorical subjects, which were certainly 'subject pictures'. After living in Fifeshire for nine years while maintaining a studio in Glasgow, Dow moved to St Ives, Cornwall, in 1896, where he seems to have lived until his death on 19 July 1919.
REPRESENTED: BIRMINGHAM, LIVERPOOL.

HERBERT JAMES DRAPER
1864-1920

A popular painter in his day, Herbert James Draper was born in London and received his art education at the St John's Wood School of Art, and then went on to the RA Schools, where he won the Landseer Scholarship which enabled him to travel to Spain and Morocco, Italy, France, Holland and Belgium. Setting himself up in a studio in Kensington as a neo-classical painter of mythological and historical subjects, he began to exhibit at the RA in 1887, achieving his first real success there in 1894 with his painting *The Sea Maiden*.

Although Draper found great favour in his lifetime, and his enormous essay on mythology, *The Lament for Icarus*, was bought by the Chantrey Bequest and is now owned by the Tate Gallery, his work is now largely forgotten and seldom seen in the auction rooms.

Mary Elizabeth Duffield
Geraniums, Fuchsias and Daisies
Watercolour. 5 x 4½in
Fine Lines (Fine Art)

MARY ELIZABETH DUFFIELD, RI
1819-1914

Born in Bath, one of the daughters of Thomas Elliot Rosenberg, a landscape painter and a miniaturist who had a large teaching practice in the city, Mary Elizabeth Duffield was a flower painter of some talent, as were her brothers and sisters. In 1850 she married William Duffield, a still life painter who died in rather bizarre circumstances at the age of 47 (see entry below). After winning a silver medal for painting at the age of 15, she went on to exhibit her flower paintings which were invariably of a high quality. In 1856 she published a book, *The Art of Flower Painting*, and was elected a member of the NWS in 1861. An example of her work may be seen opposite.
REPRESENTED: V & A.

WILLIAM DUFFIELD
1816-63

William Duffield, a still life painter, was born in Bath. An artist of some considerable talent, he must be the only painter who was ever unwittingly killed by his subject-matter. On one occasion he was painting a dead stag that had been in his studio for some time. Having lost his sense of smell owing to a recent illness, Duffield was unaware of the miasma coming from the animal and continued working, oblivious to the danger to his health. As a result he contracted an infection which led to his death, putting an abrupt end to what had been a promising career. His wife, Mary Rosenberg, was also a painter (see entry above).

Laurence Duncan
Untitled watercolour. 20 x 16in
Priory Gallery

LAURENCE DUNCAN
fl. 1860-93

The son of a well-known marine artist, Edward Duncan, who was famous for his scenes in which ships and sailors battled against the elements, Laurence Duncan chose to paint landscapes and quiet genre pictures. A lesser known artist than his father, he still managed to show eighteen of his paintings at the RA between 1860 and 1863. Although he did not follow his father's path in painting, he still liked to paint along the shores of Brittany and do the occasional genre painting with a nautical feel to it, such as the one shown right.

WILLIAM DYCE, RA, HRSA
1806-64

A Scottish artist who painted in oils, William Dyce was born in Aberdeen, the son of a well-known local doctor who wanted him to take up medicine or to enter the church. While paying lip service to his father's wishes by taking an MA which would have qualified him to enter either profession, he studied art secretly until he had saved up enough money to take himself to London with a letter of introduction to Sir Thomas Lawrence, the portrait painter. Sir Thomas was so impressed by the young artist's work that he persuaded Dyce's father to allow his son to pursue a career as an artist. As a result Dyce was allowed to go to the RA Schools where he studied for a short time before he went to Italy to study the great masters, such as Titian and Poussin.

During a second visit to Italy, Dyce came under the influence of the Nazarenes (see under Ford Madox Brown). For a young man who was eager to embrace anything that was new and innovative in art, it was a natural step for him to give his support to the Pre-Raphaelites. He was, incidentally, one of the few artists outside the group who supported their aims. Although he became an RA in 1848, ten years after he had come to London, his talents were more suited to painting mural decorations, with the result that he was commissioned to do a number of frescos at Buckingham Palace, the House of Lords and Osborne House on the Isle of Wight. Today his work is far better known to the general public for his painting *Pegwell Bay, Kent*, which was first exhibited at the RA in 1860 and can now be seen in the Tate Gallery.

Although he was kept busy with his work as an inspector for the Government Schools, and was head of the Government School of Design, Dyce still found time to paint and exhibit forty-one pictures at the RA. An aspect of his work which is less well known is his contribution to the decorative arts as a painter and designer of stained glass. As such, he played an important part in the work of the Arts and Crafts movement.

REPRESENTED: ABERDEEN, ASHMOLEAN, BM, FITZWILLIAM, GUILDHALL, NGS, TATE.

EDMUND EAGLES
fl. 1851-77

Although Edmund Eagles was more than just a competent artist, he would still have been in danger of sinking into oblivion if his work had not been promoted by the picture dealers of today. A typical Victorian genre artist, he concentrated on painting subjects that were likely to appeal to an unpretentious household that would have had little time for the work of artists such as Alma-Tadema or Lord Leighton, with their nubile neo-classical nudes. The following subjects give an idea of the market he was aiming for: *The Little Prisoner, Come in My Child, The Way to make a Pancake*, and *The Hobby Horse*, shown below. He exhibited eighteen paintings at the RA.

Eagles originally came from Great Missenden in Buckinghamshire, where he lived at Hanenfield Lodge. He came to London between 1866 and 1869, where he resided at 38 Kepple Street in Bloomsbury.

Edmund Eagles
The Hobby Horse
Watercolour , signed and dated 2 August 1875.
27½ x 49½ in. Sotheby's, Sussex

HENRY EARP
1831-1914

Henry Earp is probably the best known of a family of artists whose work has never been considered particularly distinguished. He exhibited in London from 1871 to 1884, devoting his time equally to painting either cattle or pure landscapes. He never exhibited at the RA, a fact that could not have worried him unduly as he seems to have made a good living from the numerous oils and water-colours he painted, many of them of local scenes. He spent his whole life in Brighton, living first at 16 Upper St James Street, and then at 16 Buckenham Road.

Other members of the Earp family included Frederick Earp, George and Vernon Earp, and Edwin Earp. The work of the Earp family appears from time to time in the auction rooms (see p88). REPRESENTED: MARITIME MUSEUM(GREENWICH), HOVE.

A COMPANION TO VICTORIAN AND EDWARDIAN ARTISTS

Henry Earp
Carting
Oil. 36 x 25in
Priory Gallery

SIR ALFRED EAST, RA, RI, PRBA, RPE
1849-1913

Alfred East was born in Lower Street, Kettering, in a house which has since been demolished, but he is remembered there by the large collection of his works which is housed in the local art gallery in Sheep Street. He studied art first at the Glasgow School of Art and then in Paris from 1875, under Adolphe Bouguereau, a professor at the Ecole des Beaux Arts and a reactionary figure in the art world because he discouraged the Impressionists. East returned and settled in London in about 1883 and rapidly established himself as a landscape painter and watercolourist of some note. He travelled widely, painting numerous excellent watercolours of the many places he visited in France, Italy, Spain, Morocco and Japan. He was knighted in 1910 and died in Kettering. He was made an RA on his deathbed. He was one of the few artists of his day who applied the principles of decorative design to his landscape paintings.
REPRESENTED: ACCRINGTON, ASHMOLEAN, BM, DUDLEY, EASTBOURNE, KETTERING, LEEDS, NEWPORT, WAKEFIELD.

SIR CHARLES LOCK EASTLAKE, PRA
1793-1865

Charles Eastlake was born in Plymouth, the son of a solicitor who worked for the Admiralty. He was one of the first pupils of Samuel Prout, the topographical watercolourist, whose work was far more popular in his time than it is today. Eastlake then studied at the RA Schools in London, but was lucky enough to be back in his home town in time to see Napoleon arrive there on board the *Bellerophon*. From the quick sketches he made, he eventually painted a life-size picture of Napoleon standing at the gangway of the ship, attended by his officers.

After travelling extensively, Eastlake lived in Rome from 1818 to 1830, where he painted genre scenes of the local peasantry. He returned to England in 1830, when he was made an RA. Although by then he was a member of the establishment and one of Prince Albert's favourite painters, he was not made a knight until 1850, when he also became president of the Royal Academy. Five years later he became director of the National Gallery, of which he had been keeper since 1843.

Eastlake's subject-matter was far ranging because he painted biblical and historical scenes as well as Italian genre scenes and portraits. As an artist his work is academic, with the exception of the paintings he did in Italy, which are far more relaxed and entertaining.

In 1865 Eastlake left England on his usual annual tour with a view to acquiring more paintings on the Continent for the National Gallery. In Milan he became extremely ill, but managed to continue his journey to Pisa, where he died on 24 December 1865. He was buried in the English cemetery in Florence, but was later reinterred at Kensal Green, London.
REPRESENTED: EXETER, NEWPORT, PLYMOUTH, V & A.

AUGUSTUS EGG, RA
1816-63

A London genre painter, Augustus Egg is best known for *Past and Present*, a trilogy of paintings that trace the downfall of a woman whose husband has discovered her infidelity and who is depicted in the final painting sitting huddled and

destitute beneath the arches of a bridge near the Strand in London. It is a typical Victorian set of paintings portraying the alleged dire consequences of female adultery.

Egg was born in London, the son of a well-known gunmaker who had his premises in Picca-dilly. Although the young boy was fond of drawing, he does not appear to have taken up art as a profession until he went to Sass' Art School in Charlotte Street, Bloomsbury, which was run by Henry Sass, an indifferent portrait painter, but considered to be a good teacher. Egg learned enough there to encourage him to study at the RA Schools. His first work of importance, *The Victim*, was exhibited at the Liverpool Academy of Arts. From then on he exhibited in London at the British Institution and the RA, where he had twenty-eight paintings selected for exhibition.

Egg was fond of taking as his subjects scenes from the works of Shakespeare, Sir Walter Scott and Alain Le Sage, the French novelist and dramatist. Due to ill health, Egg was forced to live abroad for much of his life in the South of France, Italy and Algiers, where he died at the age of 47.
REPRESENTED: GUILDHALL, LEAMINGTON SPA.

WILLIAM MAW EGLEY
1826-1916

The son of William Egley the miniaturist, William Maw Egley was a London artist who painted historical and genre scenes. Initially, he largely confined himself to painting scenes from Shake-speare and Molière, but he extended his field to include scenes from contemporary life and eight-eenth-century costume and historical paintings. According to his diaries which are in the Victoria and Albert Museum, he painted over a thousand pictures. The titles of a few of his pictures include *Going to the Fair, Guinevere* and *The Little Maid, The Light of Other Days*, and *A Personal Reflection*. He died in London on 20 February 1916, his last known address being 26 Bassett Road, Notting Hill.
REPRESENTED: BM, FITZWILLIAM, V & A.

John Emms
Dartmoor Ponies
Oil on canvas. 12 x 13in
Bourne Gallery

EDWIN ELLIS
1841-95

Edwin Ellis was a landscape and marine artist who was born in Nottingham, where he worked in a lace factory. He studied art under Henry Dawson, the marine artist and grandfather of Montague Dawson, one of the most famous of all the twen-tieth-century marine artists. Ellis settled in London in the 1860s when he lived for a while at 41 Fitzroy Square. Apart from his marine paintings, for which he is perhaps best known, he also painted a number of scenes in Guernsey, including several of the interior of Hautville House, now a museum in memory of Victor Hugo, who lived there from 1851 to 1870 and wrote his *Toilers of the Sea* while he was in residence. Apart from these pic-tures, Ellis' landscapes were painted mostly on the Welsh and Yorkshire coasts. A gifted poet and a staunch supporter of William Blake's poetry, he also found time to contribute illustrations to such magazines as *Punch, Cassell's Magazine* and *London Society*, which was first published in 1862, and printed between ten and twenty illustrations in each monthly issue.
REPRESENTED: MAIDSTONE, MANCHESTER, NOT-TINGHAM.

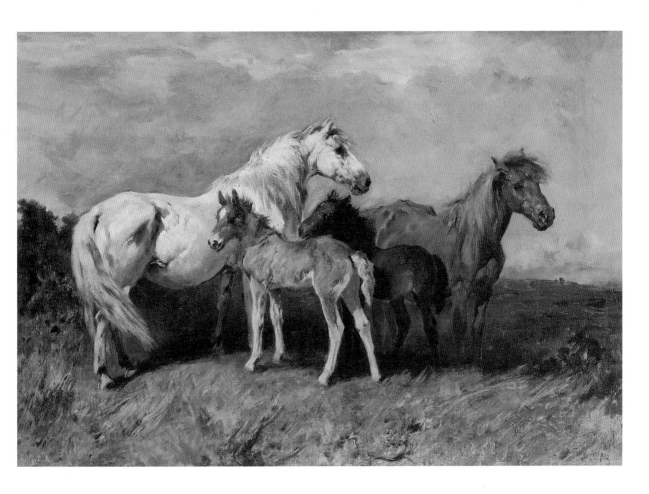

JOHN EMMS
1841-1912

John Emms was one of the more interesting equestrian painters, both as an artist and as a person. Born at Blofield, Norfolk, he was an exceptional horse painter who had no difficulty in obtaining commissions, partly because he was an accomplished horseman, which gave him access to a wide circle of friends and acquaintances. He first exhibited at the RA where he showed twenty paintings, and a further fifty paintings at the SS over the next twenty-odd years. After a period in London, he moved to Lyndhurst, the administrative centre for the New Forest in Hampshire, where he married Fanny Primmer, some fifteen years his junior, and settled with her in a house named The Firs. By then Emms had become an eccentric personality who affected a long black coat and a wide-brimmed hat, and led a Bohemian existence, spending money lavishly whenever he was in funds.

During the early part of the next century Emms' fortunes changed for the worse. In ill health and unable to work, he was forced to pay the tradesmen with his paintings and eventually he became destitute and had to sell his home. Deserted by his friends, a kind landlady let him a house at a reasonable rent which he managed to pay, although often only with difficulty.

Emms was a prolific artist who worked mostly in oils and occasionally in watercolours. As with so many artists, he did not make any provision for the future, preferring to live extravagantly whenever he had the money. He painted a number of excellent dog pictures and a large number of horse paintings which were extremely competent, such as the one shown above. After he died on 1 November 1912, aged 71, he was buried in Lyndhurst cemetery, where Alice Liddell (Mrs Hargreaves), who was the model for Lewis Carroll's Alice, now lies.

REPRESENTED: NGS.

ALFRED EDWARD EMSLIE, RWS
1848-1918

Alfred Emslie studied at the RA and at the Ecole des Beaux Arts in Paris, and first began to make a reputation for himself as an illustrator for a number of magazines, including the *Illustrated London News*, for which he drew a regular double spread of illustrations which van Gogh admired when he visited England as a young man. Emslie worked for this particular magazine for five years. He then visited Japan and afterwards lived in New York for five years.

Although Emslie produced a large number of illustrations for magazines, he was also an extremely talented watercolourist of portraits and genre pictures, including his charming study of two young children, which is illustrated opposite. He exhibited at the RA and at many of the major galleries. He lived in Kent for a number of years before he went to London where he resided at 47 Gray's Inn Road. He was married to the artist Rosalie M. Emslie, who was a member of the *Salon des Artistes Français*, where she exhibited *The Lace Bonnet* in 1929.
REPRESENTED: MANCHESTER, V & A.

NELLY ERICHSEN
fl. 1883-1901

A first-class figure painter and illustrator who exhibited eleven paintings at the RA, Nelly Erichsen tended to show her figures set in a landscape rather than against a plain background, as she has done in her pastel illustrated on p94. Her style, at least in this picture, is something of a precursor to the type of painting that was often produced by the Edwardians. Erichsen contributed to a number of magazines, including the *English Illustrated Magazine* (1886) and *North of England* (1896-7). She also illustrated a number of books such as *The Promised Land* (1896) and *Medieval Towns*, published by Dent between 1898 and 1901. She lived in 20 Mornington Road, Regent's Park, for a while and then at an address in Upper Tooting.
REPRESENTED: WHITBY.

Alfred Edward Emslie
Spring Offering
Watercolour, signed. 11½ x 8½in
Fine Lines (Fine Art)

WILLIAM ETTY, RA
1787-1849

The son of a miller, William Etty was born in York and was apprenticed to a letter-press printer in Hull, although he wanted to become a painter. He served seven years with the printer before he finally made his escape to London, where he joined the RA Schools in 1807. Recognition did not come to him until 1821, when his painting *Cleopatra's Arrival in Sicily* was shown to the public. He became a successful painter almost overnight, and began to concentrate on painting the nudes for which he became so famous. His paintings frequently scandalised the Victorian public, although much of his work was accepted without comment once he began to paint large-scale canvases in the manner of Rubens and Titian. His preoccupation with the female nude lasted for the whole of his life, and may be partly attributed to a rebellion against his strict Methodist upbringing. He was made an Academician in 1828 and lived in London until the year before his death, when his failing health forced his retirement from painting and his return to his native city, where he died on 13 November 1849.
REPRESENTED: ASHMOLEAN, BOURNEMOUTH, EDINBURGH, LEEDS, MANCHESTER, PRESTON, PRESTON MANOR (BRIGHTON), SCARBOROUGH.

Nelly Erichsen
Golden Hair
Pastel, signed (painted 1888). 39 x 22½in
Fine Lines (Fine Art)

THOMAS FAED, RA, HRSA
1826-1900

A Scottish artist who was born in Burley Mills, Kirkcudbrightshire, Thomas Faed was the son of a millwright. He was taught art initially by his elder brother who had studied art in Edinburgh. Faed then studied with Sir William Allan, the distinguished painter, and one of the pioneers of Scottish history painting, and later with Thomas Duncan, who had been head of the Trustees' Academy of Art and an artist whose painting techniques were in advance of their time.

When Faed came to London in 1852 he had already acquired a reputation for himself as a genre painter of Scottish scenes of peasant life and had been made an associate of the Royal Academy. He consolidated this reputation with what could be considered the first of his really impor-

FREDERICK McNAMARA EVANS
fl. 1886-1930

The son of Henry McNamara Evans, a painter of little note, Frederick was a more successful artist. He exhibited at major galleries, including the RA. A student of the RA Schools, he emerged as an accomplished genre painter who worked in London from 1884 to 1895, when he went to live and work in Penzance. As can be seen from his watercolour shown right, his work was far removed from the old-style genre painting in which characters were made to look more attractive than they really were. Even very poor people dressed in rags, whose appearance was often far from attractive, were painted with sensitivity by Evans. Although the watercolour is not dated it was clearly painted after the turn of the century when the emphasis was on realism.
REPRESENTED: PENZANCE.

Frederick McNamara Evans
A Welcome Break
Watercolour, signed. 13 x 9in
Priory Gallery

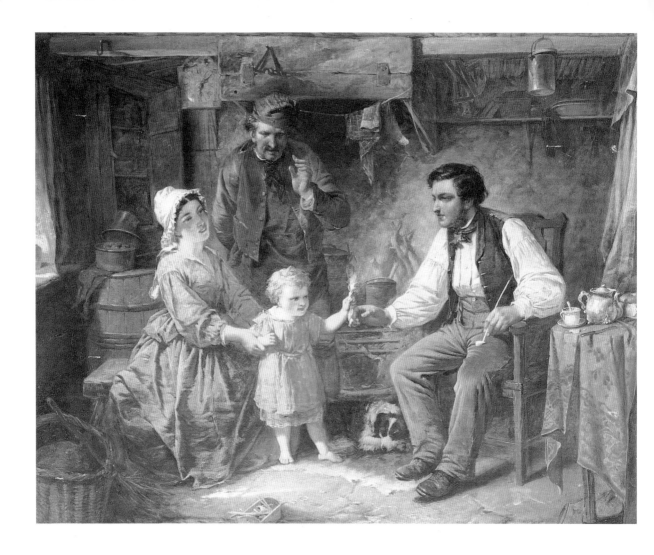

Thomas Faed
Lighting the Pipe
Oil on canvas. 25 x 31in
City Wall Galleries

tant paintings, *The Mitherless Bairn*, which was made into an engraving. From then onwards he never looked back. He became an RA in 1864, where he exhibited nearly a hundred paintings before his death, in 1900.

As an artist who depicted simple, homely and often primitive Scottish peasant life, as in his painting shown above, Faed had few equals. Although he outlived his popularity, his work marked an advance in realistic painting: his peasants were painted living in surroundings of unredeemed squalor, although his subjects still tended to veer towards the sentimental, as in his famous painting *Faults on Both Sides*, which is owned by the Tate Gallery. Faed retired in 1893 because of his failing sight, and spent the last few years of his life totally blind.

REPRESENTED: BLACKBURN, BRADFORD, DUMFRIES, GLASGOW, SOUTHPORT, TATE, WOLVERHAMPTON.

A COMPANION TO VICTORIAN AND EDWARDIAN ARTISTS

MRS ALEXANDER FARMER
fl. 1855-67

Mrs Alexander Farmer was a genre and still life painter who produced a small body of work which was never less than highly competent, and often quite charming. She lived in Porchester in Hampshire, and exhibited at the RA between 1855 and 1867. Her still life painting was a field of art that became debased with the passage of time.
REPRESENTED: V & A.

JOSEPH FARQUHARSON, RA
1846-1935

A Scottish landscape artist who excelled in painting snow scenes and capturing the bleak aspects of the countryside in the depths of winter, Joseph Farquharson was born in Edinburgh and studied under Peter Graham, RA, a distinguished painter of landscapes and seascapes. In direct contrast to his winter scenes, Farquharson occasionally painted an oriental mosque or Eastern market place, following a trip he had made to the Far East. He was made an RA in 1900, having been overlooked for years in favour of lesser artists. Sickert was a great admirer of his work and compared him to Courbet, preferring Farquharson of the two artists. There is no doubt that his chill landscapes with shepherds fighting their way through a blinding snow blizzard and his sunsets casting a weak golden light over snowy wastes are extremely effective in their way, although one might find them depressing to live with. Farquharson resided in Aboyne, Aberdeenshire.

SIR SAMUEL LUKE FILDES, RA
1843-1927

Among the best of the Victorian genre painters, Samuel Luke Fildes would wander the streets of London at night in search of subject-matter for his art. The inspiration for his most famous painting, *Applicants for Admission to a Casual Ward* (1874), no doubt came to him during one of these nightly forays and is an indictment of the social conditions of the time. The picture is housed at the Royal Holloway and Bedford New College at Egham, Surrey. His *Houseless and Hungry* was another such picture which appeared as a wood engraving in the first number of the *Graphic*. From this drawing he painted another picture of the same subject which was exhibited at the RA in 1874.

Fildes was born in Liverpool and studied art at the Warrington School of Art for three years, before he went to the South Kensington Schools. He then worked as an illustrator for several years for some of the most popular magazines of the time, including the *Graphic* and *Once a Week*. When he saw *Houseless and Hungry*, Dickens recognised in Fildes a kindred spirit and commissioned him to produce the illustrations for his last novel, *The Mystery of Edwin Drood*. Fildes also drew twenty excellent sketches for Victor Hugo's *By Order of the King*, and illustrated Trollope's *The Way We Live Now* and Charles Reade's *Peg Wolfington*, to name only a few of the many books he worked on.

When he eventually tired of working as an illustrator, Fildes returned to painting in oils and watercolours. Even in that late period in Victorian history, the public's taste for pictorial story-telling was undiminished, and a new painting from Fildes was always something of an event, as Frith's had been. The natural successor to Frith, although he painted on a less ambitious scale, Fildes was one of the last of the great genre painters. His last work, *The Doctor* (1891), was an enormous success, as almost all his paintings had been.

Fildes painted three distinct types of paintings. There were his genre paintings, in which he worked as a social realist, his Venetian genre paintings and his portraits. In 1894 he painted the Princess of Wales which led to a series of royal portraits, including the state portraits of Edward VII (1902), Queen Alexandra and George V (1912). However, Fildes is best remembered for his paintings of the London poor.
REPRESENTED: GLASGOW, HOLLOWAY COLLEGE, V & A.

Joshua Fisher
Happy Thoughts
Watercolour. 14 x 10in
Fine Lines (Fine Art)

JOSHUA FISHER
1859-1933

Joshua Fisher was born in Liverpool and studied under John Finnie. A landscape and figure painter, he exhibited from 1844 until the year of his death, mostly at the Walker Gallery in Liverpool. His entire life was spent in Liverpool, so he is best known in the North, although he exhibited in London at the RA, where he showed twenty-four pictures.

As with most of the Victorian artists who had any talent at all, Joshua Fisher was able to find work as an illustrator for some of the dozens of magazines that proliferated during the latter part of the nineteenth century. He illustrated *The Tyrants of Kool Sim* by J. McClaren Cabbin which was one of those immediately forgettable works of Victorian fiction in which the illustrations accompanying the writing were often far better than the contents themselves.

Fisher was a pleasant and competent artist whose work is not well known in the South. He was a typical Victorian artist who used well-established subjects, such as his garden scenes, decoratively enhanced by a pretty girl, as in the picture shown left.

WILLIAM MARK FISHER, RA, RI
1841-1923

Born in Boston, Massachusetts, William Mark Fisher came from a humble background and was apprenticed to a sign- and house-painter. In the wintertime when business was slack he attended classes at the Lowell Institute, where his teacher was a well-known landscape painter named George Innes. In 1863 Fisher sailed to Paris and studied under Gleyre. Impressed initially by the work of Corot and the Barbizon School of painters, he later turned his allegiance to Boudin, the French painter of beach scenes and seascapes.

Unable to make a living in either America or Paris, Fisher came to England in 1872 and finally settled in Steyning, Sussex. He became friendly

with George Clausen, who admired his paintings and wrote a touching tribute to his work in Fisher's memorial catalogue. In 1911 Fisher moved to Hatfield Heath, Essex, by which time he was an established figure in the art world. Even so, he did not become a full Academician until 1919, when he was 78. He died on 30 April 1923.

REPRESENTED: BLACKBURN, EXETER, ULSTER, V & A.

STANHOPE ALEXANDER FORBES, RA
1857-1947

Stanhope Forbes' name is always associated with the Newlyn School of painters, and he is considered, quite erroneously, to be the founder of the school. He was not the first painter to settle in Newlyn, and Forbes denied that he was the father of the movement: 'The Newlyners are followers of no one - simply a body of painters who paint in the open air.' It is therefore more appropriate to see him as the spokesman for a group of artists who worked in Newlyn at the same time as he did. The force of his personality and the fame that came to him after his *A Fish Sale on a Cornish Beach* appeared in 1855, ideally fitted him for the role that the critics and the public had given him.

Born in Dublin, Forbes was the son of an English father who was the manager of the Midland and Great Western Railway in Ireland. His mother Juliette de Guise, was French, and as she was relentlessly ambitious on his behalf, she had a powerful influence on him. He studied at the Lambeth School of Art under a talented teacher named John Sparkes, who later became head of the South Kensington Schools. Forbes then joined the RA Schools in 1876, after which he spent two years in Paris studying under Bonnat. After spending a holiday in Brittany in the company of the *plein air* painter La Thangue, who had a considerable influence on his work, he eventually gravitated to the Cornish village of Newlyn, where he married Elizabeth Armstrong against his mother's wishes. The rest belongs to one of the most interesting periods of English art, when the Newlyn School of painters was an important force in the art world. A *plein air* painter of tremendous talent, Forbes met many fellow artists, including Whistler and Sickert, both of whom he despised. As he painted realistic pictures that were very much a part of the Victorian age of genre painting, it was hardly surprising that he did not like them.

Forbes' wife died in 1912 and his son was killed in World War I. The loss of these two people, who had been central to his life, affected him greatly. In 1915 he married the painter Maudie Palmer, who cared for him until his death in Newlyn on 2 March 1947 at the age of 90.

Forbes left behind a considerable legacy. He was a founder member of the New English Art Club, formed as a protest against the Royal Academy - a surprising move as the Academy had done so much to advance his career - and he founded a teaching school of painting with his first wife in 1894. He also painted two great examples of late Victorian genre paintings, *The Health of the Bride* and *A Fish Sale on a Cornish Beach*, both of which are well known and loved and may be seen in the Tate Gallery.

REPRESENTED: BRISTOL, LEICESTER, LIVERPOOL, MANCHESTER, PENZANCE (10), TATE, WORCESTER.

W. B. FORTESCUE
c. 1855-1924

One of the lesser lights of the Newlyn School of painters, W. B. Fortescue was originally an engineering designer in Birmingham before he abandoned his job to become an artist. He studied in Paris, and then returned to Birmingham where he painted a number of subjects which he exhibited locally, such as *Autumn* (1880), *St Cecilia* (1881) and *Going Home* (1884). He then went to Venice in 1883 and returned to this country with a series of Venetian scenes which he exhibited at the Royal Birmingham Society of Artists.

Fortescue arrived in Newlyn in 1885, and, being a talented cello player, quickly became involved in the social life of the village, often taking part in the private evening entertainment that was organized by the artists. Nothing very

MYLES BIRKET FOSTER, RWS
1825-99

Few nineteenth-century artists have been more attacked in recent years than Myles Birket Foster. He has been accused of being too sentimental, of making his rural scenes unduly pretty, and for creating a false impression of what life was really like for those working on the land. It is true that he painted a world of Arcadian innocence, where

W. B. Fortescue
Dolly's Portrait
Oil on canvas. 10 x 14in
Priory Gallery

startling came from his brush during the five years he was in Newlyn, except perhaps *The Fish Fag* which was inspired by Stanhope Forbes' famous painting *A Fish Sale on a Cornish Beach*. In the mid-1890s he left Newlyn and settled in St Ives, where he started to paint rural subjects and genre pictures, such as the one shown above.

Myles Birket Foster
The Water Lily
Watercolour. 10 x 14in
Priory Gallery

rosy-cheeked children in spotless white pinafores played happily together against a background of golden stooks, in fields where the sun shone and no rain or mist swept across sodden fields. What he was really painting, of course, was a rural England which the urban population wanted to see when they went on a day trip to the countryside, which was now accessible to them with the advent of the railway. Foster interpreted the wistful dreams of the town dweller who yearned for the green of the countryside and the sight of thatched cottages with old world gardens in full bloom, while carefully omitting from his paintings the mud and squalor in which the farm hands often worked. In this he was no different from the other rustic artists of the nineteenth century, apart from the fact that he was a better painter than all of them. However, because he is so well known, Foster has always been an easy target for criticism by people who seem unable to see his pictures in

the context of the times in which they were painted.

Foster's work was greatly admired, not only by the public, but also by some of the best artists of the day. Walter Sickert admired both his work and his choice of subject-matter, which was surprising for an artist whose music hall and theatre interiors, which were painted in the last years of Foster's life, were far removed from the rural scene. On one occasion Sickert wrote: 'Oh, for one hour with Birket Foster! Birket Foster with his charming little girls playing at cat's cradle or figuring on their little slates . . .' This may have been no more than one craftsman lifting his hat to another, but at least he acknowledged Foster's craftsmanship, which is more than some artists would have done.

Born in North Shields, Birket Foster was brought to London at the age of 5 and given a Quaker upbringing before he became an apprentice engraver to Ebenezer Landells, a well-known wood engraver and pupil of Thomas Berwick. His success is probably due to the vigorous training he received from Landells, who encouraged him to draw and sketch outside. Many of these drawings and sketches still exist, though are not widely known, and they are entirely different from his studio work.

In 1846 Foster became a freelance illustrator of books, and he also provided illustrations of rural subjects for the *Illustrated London News*. By 1859 his first work was exhibited at the RA - a conventional scene of a farmhouse near Arundel, Sussex, in which there was little hint of the flood of charming rustic scenes that were to come from his brush. After his reputation had been established, he travelled a great deal on the Continent, including a trip to Venice in the company of William Quiller Orchardson (see entry). When Foster made a second trip to Venice, it was to carry out a commission to paint fifty Venetian scenes, for which he was paid £5,000.

Foster eventually settled in Witley, Surrey, where he had a house built on a large plot of land, near which he lived to watch the building's progress. He personally supervised the interior decoration, having obtained the advice of his old friends. William Morris acted as consultant and Burne-Jones painted seven canvases which were used as a frieze around three walls of the dining-room. In some of the upstairs rooms the windows were inscribed with extracts from the musical scores of madrigals and carols. These inscriptions were done at the suggestion of Charles Keene, a well-known illustrator and one of the many artists who helped to design the interior of the house. When it was finished, Foster filled the house with paintings by his friends, including four small drawings by Millais and a series of eight drawings by Turner. One suspects that the total effect may have been overpowering, especially as the house was filled with specimens of blue and white porcelain that Foster had bought cheaply from Rossetti.

Birket Foster loved the house which he had created for himself and he remained there until 1893. He retired to Weybridge, Surrey, where he lived quietly, only too conscious that the years and his life were slowly ebbing away. He died suddenly on 27 March 1899, leaving behind him a large body of work for future generations to enjoy *The Water Lily*, shown on pp100-101, is a typical example of his work.

REPRESENTED: ABERDEEN, ASHMOLEAN, BLACKBURN, HITCHEN, NEWCASTLE.

Edward Reginald Frampton
Spring
Tempera on board, signed and dated 1911.
14 x 16in
Bonhams

EDWARD REGINALD FRAMPTON, ROI, RBA
1872-1923

Edward Frampton was a painter of religious subjects, a sculptor, a muralaist, and a worker in stained glass. His paintings were influenced by Burne-Jones until he was drawn to the early Renaissance paintings. Apart from his religious paintings, his subject-matter was limited to allegorical themes and subjects taken from poetry, especially that of Tennyson. Later in life he turned to landscape painting.

Frampton was born in London and studied at the Westminster School of Art and also in France and Italy. He began to exhibit at the RA from 1895. His painting illustrated below is interesting because it is a repetition of an earlier idea. Painted in 1911, it is a pallid version of the picture he completed in 1902 which illustrated a scene from Tennyson's *Idylls of the King*. The painting shown here belonged to the artist's widow, who received it as a wedding present, and it is typical of its period. His other work includes *Ridophe*, which is painted in a similar style, and *A Carol*, a religious painting.

REPRESENTED: BRADFORD, CARDIFF, V & A.

JOHN FRASER, RBA
1858-1927

John Fraser was a marine artist whose work was influenced by Thomas Somerscales and the Chevalier Edouardo de Martino, the Italian artist who brought a new realism to British maritime painting. When de Martino became overloaded with commissions he would ask Fraser to paint them and then add the finishing touches himself and his own signature. When the Italian died, payment for half a dozen canvases was still owing to Fraser who had to take legal action to recover the debt.

Fraser was born of a nautical family and lost both his brothers at sea. After sailing to North America in 1885, where he stayed for three years, he spent the next twenty years sailing around the world. He first exhibited at the RA in 1880 and became a regular exhibitor from 1885 to 1919. In his later life he kept a print ship in Grosvenor Road, Westminster, until he died outside his shop on 25 April 1927. The residue of his pictures were sold between 1954 and 1956 to the National Maritime Museum, Greenwich, by his widow who was almost destitute. The museum was thus able to acquire sixty of Fraser's oils and over a hundred watercolours, as well as a large number of his sketch books.

Although the painting illustrated right is basically a beach scene, it is not without nautical interest. The ship sailing into Whitstable harbour is an oyster smack, with two other smacks in the distance. A brigantine is seen against the jetty with her yards pulled down so that the wind will help secure her by pressing her against the pilings, while beside her is yet another oyster smack, waiting for the tide.
REPRESENTED: MARITIME MUSEUM (GREENWICH).

PIERRE EDOUARD FRERE
1819-96

Although Pierre Edouard Frere was a French artist who did not reside in England for any length of time, he nevertheless exhibited in London so frequently at the London galleries and at the RA, that he must have paid long visits to this country. It therefore only seems right that he should be included in this book, as his work frequently comes up for sale in British auction rooms.

Frere was born in Paris and entered the Ecole des Beaux Arts in 1836. He won various awards for his work during the early part of his career and he was made a member of the Legion of Honour in 1855. He exhibited at the Paris Salon between 1842 and 1886.

John Fraser
Low Tide at Whitstable Harbour
Oil on canvas, signed and dated 1885
20 x 40in
Royal Exchange Art Gallery

ALFRED DOWNING FRIPP, RWS
1822-95

When Frere's work was first shown in England it immediately attracted the attention of Ruskin, who said of his paintings that they were of 'quite immortal beauty'. In his usual highflown speech, Ruskin asked: 'Who would believe it possible to unite the depth of Wordsworth, the grace of Reynolds and the holiness of Angelico?', thus providing a good quotation for the picture dealers of today. But there is no doubt that much of Frere's work is impressive. He belonged to a period of French painting that so far has hardly been touched upon - the French artists of the nineteenth century and the Belle Epoch that ended in 1914 (see p106).

The younger brother of George Alfred Fripp, a watercolourist and a founder member of the Old Watercolour Society, Alfred Fripp was born in Bristol and was greatly influenced by the work of W. J. Müller, a widely travelled artist who specialised in painting Venetian and Middle East scenes. Fripp studied in the sculpture galleries of the British Museum and at the RA. He visited Italy and went three times to Ireland, where he painted some of his most charming studies, including *Irish Reapers Meeting Friends after Travelling in England*, and *Pleading His Cause*, shown on p107, in which an Irish peasant lays siege to the heart of a demure Irish colleen.

Pierre Edouard Frere
The Little Drummer
Watercolour, signed and dated 1873. 10 x 12in
Priory Gallery

Fripp painted many scenes of Italian life and scenery, peopled with the rural characters he painted so well and which formed the major part of his work. He exhibited 265 paintings at the Old Watercolour Society, of which he was secretary, but he succeeded in being shown only once at the RA. Three of his paintings are owned by the National Gallery in Ireland. A superb watercolourist who painted in muted colours, the deceptive simplicity of Fripp's work hides his sheer professionalism.
REPRESENTED: BRISTOL, DUBLIN, HARROGATE, V & A.

WILLIAM POWELL FRITH, RA
1819-1909

William Frith was born in the Yorkshire village of Aldfield, where his parents were in service. In 1826 the family moved to Harrogate where William's father became the landlord of the Dragon Inn and the young boy began his education at a school which, he said, was run very much on the same lines as Dickens' Dotheboys Hall. Fortunately, Mr Frith had a talent of sorts for drawing and had it in mind that his son should become an artist. After spending two years at St Margaret's, near Dover, William was sent to Henry Sass' School of Art in Bloomsbury and completed his art training with two years at the RA Schools. When *Malvolio, Cross-gartered Before the Countess Olivia* was exhibited at the Royal Academy in 1840, Frith became an established artist. The years that followed were notable for a succession of successful paintings. Frith was made an RA in 1853, when he was chosen to fill the vacancy caused by Turner's death.

During the middle part of his career Frith changed course when he saw how delighted the

Alfred Downing Fripp
Pleading His Cause
Watercolour, signed and dated 1865
Circular. 23¼inches in diameter
Fine Lines (Fine Art)

public was with his paintings that portrayed contemporary life. From then on he concentrated on painting large canvases in which he recorded the social scene. (For more details of this aspect of his work, see pp9-10 in the Introduction.) A pictorial painter of some power, his work stands up well against the other genre painters of this period. He published two volumes of his reminiscences which provide a valuable insight into his character. He died on 2 November 1909 at his home in St John's Wood, London.

REPRESENTED: BIRMINGHAM, TATE.

CHARLES TREVOR GARLAND
fl. 1874-1907

A landscape, portrait and child painter as well as an illustrator, Charles Garland was best known for his studies of children. A number of his paintings also feature domestic pets together with children - an irresistible combination in Victorian times. He worked in London from 1874 and exhibited regularly, while also contributing frequently for the *Graphic*, a weekly illustrated magazine that was first published in 1869 and used some of the best artists of the time, such as Sir Hubert von Herkomer, William Small, Luke Fildes, Kate Greenaway and Helen Allingham. These were just a few of the famous artists who perfected their craft through the pages of this illustrious magazine which did much to promote English art.

By 1889 Garland was living in Rome, where he stayed for a year before he returned to London. He continued to exhibit his pictures, the RA being one of the outlets for his work. He moved to Penzance in 1892, where he stayed until 1903. He died in Colchester in 1907.

Charles Trevor Garland
Drink to Me Only With Thine Eyes
Oil on canvas. 22 x 16in. Priory Gallery

OSWALD GARSIDE, RI, RCamA, RBC, RWA
1879-1942

A Lancashire painter who was born in Southport, Oswald Garside was a watercolour artist who took up painting at the age of 23 and began to exhibit his work almost immediately at the RA and at the Paris Salon. After gaining a county scholarship, he was able to go to Paris to study at the Académie Julian and in Italy where he studied for a year before he returned to England. He travelled all over England for his subjects, but his best work was probably done in Lancashire and the nearby county of Cheshire. He seemed to work in two styles: either in a tight technique in which his paint is very carefully laid down, or in a loose but effective style as he used in the watercolour shown opposite which was almost certainly painted during a trip to Holland.

Oswald Garside
Unloading the Catch
Watercolour, signed
21 x 14in. Priory Gallery

HENRY GASTINEAU
c. 1791-1876

A landscape and topographical watercolourist, Henry Gastineau began his career as an engraver, but changed to oil painting and finally to water-colours. It is believed that he was a student of the RA, where he eventually exhibited twenty-six paintings. His work was competent but uninspired, drawing as he did on all the scenes and situations that had already been explored by the thousands of artists who had preceded him. Gastineau was nevertheless an indefatigable worker. He exhibited at the Pall Mall Galleries for fifty-eight consecutive years, providing them with an average of twenty-three paintings each season. He also taught a great deal, travelling from the Highgate area to Sydenham in the course of a day to give lessons. Enthusiasm rather than need must have spurred him on, for taking into account the cost of the journeys he made, apart from the time he expended on getting from place to place, it could hardly have been worth the trouble, considering the modest fees art teachers charged in those days.

Gastineau also produced topographical drawings for a number of publications, such as *Wales Illustrated* and the *Surrey Tourist, or Excursions Through Surrey*.

REPRESENTED: BIRMINGHAM, BLACKBURN, BRAD-FORD, BM, CARDIFF, FITZWILLIAM, MANCHESTER, NEWPORT.

DAVID GAULD, RSA
1866-1936

As an artist David Gauld was initially influenced by the work of Rossetti, which explains why so many of his paintings depict wood nymphs or pale young women loitering in the woods. He also painted young dreamy women against a background of flowers or foliage - in fact, the type of subjects that appealed to the Pre-Raphaelites. These paintings were a far cry from Gauld's early landscapes that prominently featured Ayrshire cattle, about which he became an expert (see *Calves in a Barn* illustrated opposite).

David Gauld
Calves in a Barn
Signed oil on canvas. 24 x 36in
Bourne Gallery

Born in Glasgow, Gauld was apprenticed to a local lithographer and first came to the attention of the public when his pen drawings began to appear regularly in the *Glasgow Weekly Citizen*. He then designed stained-glass windows, which occupied him for some years to the exclusion of his painting. He did not take up art again until he visited Grez in France, when he reverted to painting landscapes that featured cattle. He exhibited almost entirely in Scotland.

REPRESENTED: BIRMINGHAM.

SIR JOHN GILBERT, RA, PRWS
1817-97

John Gilbert was born in Blackheath, London, and it was intended that he should follow his father into business as an estate agent. However, he was so disinterested in the estate agency business that he begged his parents to allow him to become a professional artist. He failed to get into the RA and placed himself under the tutorship of George Lance, a still life painter.

Gilbert sent his first painting to the Society of British Artists at the age of 19. The painting, a watercolour entitled *The Arrest of Lord Hastings*, was accepted and from then he became steadily more famous. He was president of the RWS in 1871 and was knighted the following year. A watercolourist of historical genre and rural landscapes, Gilbert worked in a style that received the RA's approval almost immediately.

REPRESENTED: ASHMOLEAN, BM, MANCHESTER, NGS.

ALFRED GLENDENING, RBA
1861-1907

Born in Greenwich, just outside London, Alfred Glendening was the son of the artist Alfred Augustus Glendening. Glendening jnr was taught by his father and he worked in oils and water-colours, both as a genre and landscape artist. The work of father and son often bears a striking resemblance.

Glendening began exhibiting at the RA in 1881 and exhibited twenty-eight pictures there, including his most famous painting *Haymaking*, which was bought by the Chantrey Bequest for the nation in 1898. A facile rather than a highly imaginative painter, he nevertheless exhibited at all the major galleries and enjoyed a great deal of popularity in his time, mainly because he knew what the public liked and composed his paintings accordingly (see *The Flower Seller*, illustrated on p112).

Later in his career Glendening became a the-atrical scenery painter, as so many of the Victorian artists did to give them a regular income and some sort of security, while allowing them to carry on with their painting in their spare time. Apart from a visit he made to New York in 1901, his life seems to have been an uneventful one. He died in Southend on 6 January 1907.

JOHN GLOVER, OWS
1767-1849

An enormous man who weighed nearly 20 stone John Glover was born with the tremendous disad-vantage of two club feet, yet he still managed to travel around England, Wales and Scotland in pursuit of suitable subjects to paint. His energy and agility were astonishing and his afflictions seemed to act as a spur rather than as a deterrent to his activities. He not only painted almost ceaselessly, but also found the time to be a highly successful drawing master, a keen musician, and a

Alfred Glendening
The Flower Seller
Watercolour. (Size not available).
David James

student of all forms of animal life, which he observed purely as a hobby rather than as an aid to his painting; he was also a bird tamer, a strange talent that he had developed to an extraordinary degree when he was young, so that he had only to call to birds and they would come winging to him from the woods.

At the age of 63, with a successful painting career already behind him, Glover took his family to Australia, where he settled in Tasmania, then known as Van Diemen's Land. Mention should be made also of Mrs Glover, who was 70 when the family set sail and had to endure the six months' journey to Australia; then, having reached their destination, she found herself responsible for running a large sheep station while her husband and son went painting. Glover named the estate 'Patterdale' after one of his favourite spots in Cumbria, and from there he continued to send his work to London until his death at the age of 82. By then he had become something of a patriarch to the land he had adopted. His vision of the land was

John Glover
Lowther Castle, Cumbria
Pencil and watercolour. 23½ x 35⅜in
Spink

very different from that of later artists such as Tom Roberts and Arthur Streeton, and all the other painters who became part of the famous Heidelberg School in Melbourne. However, Glover's vision of Australia was seen with great clarity, which is even more remarkable when one considers how different it was from his homeland.

The son of a small farmer, Glover was born in Houghton-on-the-Hill, near Leicester. He was largely a self-taught artist who had contented himself with having seven lessons with William Payne, a fashionable landscape artist at the time, and one lesson from James Burrell Smith, whose forte was painting waterfalls. Armed with the little he had learned from those few lessons he went confidently out into the world. By 1794 he had set himself up as a drawing master in Litchfield, Hampshire, and in the following year he began to exhibit at the RA. His subjects were mostly landscapes, such as *Skiddaw, Cumberland*; *Evening with Cattle*; and *Shanklin Chine and the Wye and Severn, with Chepstow Castle from Wind Cliff*. Glover was the inventor of the famous split-brush technique, in which the hair of the brush is divided by thin wire so that the artist is able to achieve double strokes, a device that is particularly effective when painting foliage, as in the striking example of his work shown on p113.

REPRESENTED: ABERDEEN, ASHMOLEAN, BRADFORD, BM, CHESTER, LEEDS, MANCHESTER, NEWPORT. V & A.

JOHN WILLIAM GODWARD, RBA
1861-1922

John William Godward was one of the best of the followers of Alma-Tadema (see entry). He devoted his whole life to painting girls in classical robes, usually posing decoratively on a marble terrace. Unlike many of Alma-Tadema's followers, Godward painted well and at his best was almost as good as, if not sometimes better then, Alma-Tadema. Unfortunately, he had come into an area of painting that was already overcrowded with artists who were striving to find new variations on a theme that was overworked by the turn of the century.

By the 1920s most Victorian paintings had become a subject of mockery, and none more so than the neo-classical subjects, which seems absurd when they are compared with the almost brutally realistic paintings of the Bloomsbury School of artists. Unlike William Stephen Coleman (see entry), for example, who could paint a good

John William Godward
Girl with a Tambourine
Oil on canvas. 22 x 12in. Priory Gallery

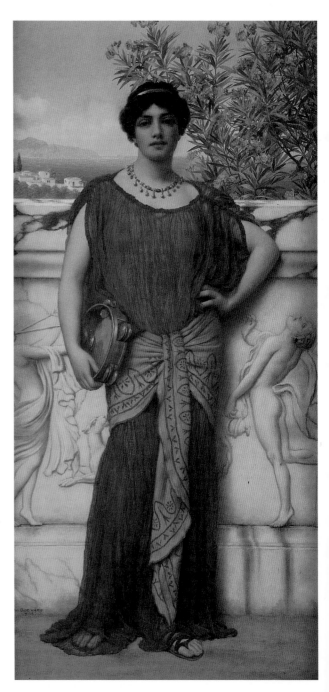

STRAND ON THE GREEN.
FRED.E.J.GOFF.

genre picture, Godward could only paint the one subject. When he was no longer able to sell his pictures, he committed suicide by putting his head in the gas oven.

Very little is known about Godward except that he exhibited nineteen pictures at the RA between 1886 and 1916 and that he lived for some time at 1 St Leonard's Studios, Smith Street, Chelsea, London. His paintings include *Poppaea, A Reverie, Lone Maid* and *Girl with a Tambourine*, shown left.

FREDERICK E. J. GOFF
1855-1931

An artist who worked mainly in watercolours, Frederick Goff painted landscapes and river scenes. He was the son of a wholesale grocer who wanted him to join the family business, but Goff had already made up his mind to become a painter. Making the best of the situation, his father offered him a room in Clapham to adapt as a studio. It

Frederick E. J. Goff
Strand on the Green
Signed watercolour. 4 x 5½in
Fine Lines (Fine Art)

was here that Goff did all his paintings, even after he had moved to Upper Tooting when he married. Travelling backwards and forwards every day he was able to maintain a steady output of work without having to become too deeply involved in bringing up his young daughter.

Although Goff's eyesight was very poor, he managed to overcome his disability by using a magnifying glass, which may account for the fact that much of his work is so detailed. He painted a great deal along the Thames and also in Kent in his later years after his daughter had married and moved to Cranbrook. From 1900 he exhibited only three paintings at the RA, but he showed thirteen pictures at the Glasgow Institute of Fine Arts. *Strand on the Green*, which gives some idea of Goff's highly detailed brushwork, can be seen above.

FREDERICK GOODALL, RA
1822-1904

At the height of his career Frederick Goodall was earning over £10,000 a year for his paintings of biblical and Egyptian scenes set along the Nile. He had been made an RA in 1863 and was a favourite artist with the public at the Academy's annual summer exhibitions. At the turn of the century, however, his fortunes began to wane and in 1902 he was declared bankrupt, the unhappy victim of the rapidly changing tastes of the viewing public.

Frederick Goodall was the son of Edward Goodall the engraver, and the brother of Edward Alfred Goodall, who also became an artist. He began his career by studying engraving under his father, and he might well have become an engraver himself had it not been for the fact that Ruskin and Turner were visitors to the house and encouraged him to paint. He began to take sketching trips along the Thames and to the Zoological Gardens, and in 1837 won a silver medal for his work at the Society of Arts.

After making a trip to Italy and then to Ireland in the company of Frank Topham, the genre artist, Goodall went to Egypt where he spent eight months in Cairo and shared a house with Carl Haag, the Bavarian artist who numbered the English royal family among his patrons. It was a trip that was to change the course of Goodall's painting career.

Frederick Goodall
Portrait of a Young Arab Boy
Oil on panel, signed with monogram and dated 1870. 22 x 15½in
Bonhams

Before his visit to Egypt he had confined himself to genre and landscape painting, which had made very little impact on the art world. When he returned to England, however, he began to paint the Egyptian and biblical scenes which were to make him famous, and were probably the best of their kind.

In 1870 Goodall revisited Cairo with one of his brothers. On his return to England he arranged for Norman Shaw, the famous architect, to build him an exotic house in Harrow Weald, in which he surrounded himself with strange plants, while Egyptian sheep roamed the grounds outside. By then he had either become slightly eccentric, or he was beginning to take himself too seriously, in the same way that Alma-Tadema had done with his Pompeiian villa in Regent's Park. Goodall's painting of a young Arab shown opposite was one of his rare portraits that was painted when he was in Cairo.

REPRESENTED: BEDFORD, BM, GUILDHALL, LEICESTER, LIVERPOOL, MANCHESTER, V & A.

MAUD E. GOODMAN
exh. 1880-1920 (d. 1938)

Although women had been accepted as painters by the last quarter of the nineteenth century, they still refrained from portraying scenes of social realism, which would have been considered unbecoming for female artists. When they did eventually break away from flower painting and still life, it was generally to paint historical scenes, as Rebecca Solomon had done (see entry), or to produce inoffensive and often charming genre paintings, such as Maude Goodman's *A Little Coquette; Like This, Grannie; Innocence*; and *The Music Lesson*

shown on p118. Such paintings were produced in an age when small children were considered lovable creatures incapable of causing any strife in a well-run household. Maude was portraying, of course, middle-class families who had servants, so that Mama had plenty of time to play with her children before Papa came home from work, which was the signal for their immediate departure to bed. It was a well-ordered world which Maude Goodman captured accurately in her paintings. She exhibited fifty-two pictures at the RA and lived for much of her life in London at various addresses.

Maude Goodman
The Music Lesson
Watercolour, signed with initials. 12 x 8in
Priory Gallery

Albert Goodwin
Lucerne
Watercolour, signed with monogram,
inscribed and dated 1891. 17¼ x 11in
Bonhams

ALBERT GOODWIN, RWS
1845-1932

Albert Goodwin received his training from Arthur Hughes, the genre and historical painter who later became an important force in the field of book illustrations when he realised that a drawing should not merely be an illustration, but should also be an integral part of the text. He also studied for a while under Ford Madox Brown (see entry).

A landscape painter of considerable ability, Goodwin began working in oils and then turned to painting almost entirely in watercolours. He was a great admirer of Turner and he liked to paint studies of misty dawns and the way that the first light of day illuminated the landscape. Conversely, he enjoyed depicting the landscape at the slow dying of the sun. In *Lucerne*, shown opposite, he grappled with a similar problem - this time a panoramic view of Lucerne.

Goodwin travelled extensively, not only in Europe but also as far away as India and the South Seas. He also visited Italy in the company of Ruskin.

REPRESENTED: ABERDEEN, ASHMOLEAN, BLACKBURN, BM, CARDIFF, FITZWILLIAM, LEEDS, MAIDSTONE, MANCHESTER, PORTSMOUTH, PRESTON.

WILLIAM HENRY GORE, RBA
fl. 1880-1920

William Henry Gore belongs to that enormous band of watercolour artists who saw the English countryside and those who worked in it through a romantic haze. His was the sort of painting in which sturdy young men moved agilely as they reaped the golden corn, while the women waited for their return with the setting of the sun. More often than not the women worked beside their

Lucerne.

men in the fields, doing back-breaking work under the watchful eye of a farmer who paid them meagre wages and housed them in appalling conditions. Gore's watercolour shown opposite perpetuates the myth of nineteenth-century rural life, while it remains an attractive painting.

Gore was a genre artist who had originally lived in London at 55 Princess Park Road before he moved to Newbury, Berkshire. His work appeared in all the important London galleries. Most of his titles reflect the romantic mood of the paintings – *Down the Vale of the Years, Nigh upon that Hour, When the Lone Heron Forgets his Melancholy* and *A Lover and His Lass.* He exhibited thirty-four paintings at the RA.

WILLIAM GOSLING, RBA
1824-83

William Gosling took up painting late in life and did not become a member of the Society of Artists until 1852. He then exhibited 217 pictures over the years at all the major galleries, including 13 that were shown at the RA. He painted a wide range of rural subjects, many of them around the Thames countryside. Gosling always painted with self-assurance, generally on a large scale. His work inevitably varied in quality, although at its best it equalled anything that was done by Thomas Collier, who was considered to be one of the better nineteenth-century watercolourists. The watercolour shown below is an excellent example of this

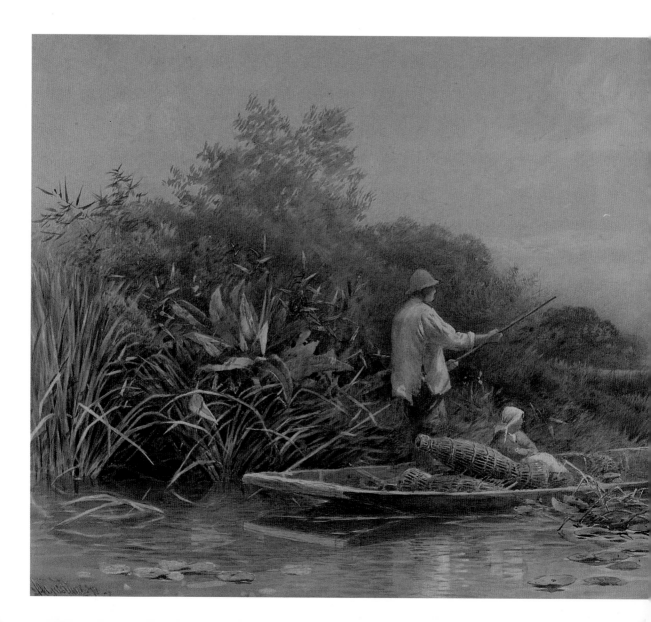

highly prolific artist who is almost as popular with the art dealers of today as he was with the public of his time. He died at Wargrave, Henley-on-Thames, on 6 December 1883.

William Henry Gore
Eventide
Watercolour. 12 x 8in
Priory Gallery

William Gosling
The Eel Trapper
Oil on canvas, signed and dated 1880
18 x 30in
Bourne Gallery

CARLETON GRANT
fl. 1885-1902

A landscape and genre painter who originally came from Liverpool to live in the South, Carleton Grant moved to a number of addresses before he finally settled in Shanklin, Isle of Wight. A variable artist who worked in watercolours, his work can occasionally be rather bad, as it can just as easily be very good. He exhibited ten landscapes at the RA between 1893 and 1897, and from that date his work seemed to disappear for a while, before it reappeared in the auction rooms. Although Grant's paintings come up for auction at picture sales all over Britain, his work is still not as popular as it might be. His charming little genre painting entitled *Don't be Afraid*, shown on p123, is one of the better examples of his work in which the subdued colours of which he was so fond are predominant.

121

WALTER GREAVES
1846-1930

More than one art critic has written of Walter Greaves' almost slavish devotion to Whistler, who repaid him by saying to his friends that Greaves had just enough knowledge of painting to keep a studio clean. This reflects an unfair and uncharitable side to the great man's nature, and one can understand why so many people hated him on sight. Greaves may not have been one of the best painters of the time, but he certainly merited something more complimentary than Whistler's churlish comment.

The son of a Chelsea boat-builder, Greaves grew up to be an enthusiastic amateur painter who took it in turns with his brother Harry to ferry Whistler across the river. The two of them became Whistler's unpaid studio assistants, buying his materials for him and preparing his canvases. Like two acolytes, they accompanied him everywhere, even copying his manner and style of clothing. The upshot was that Harry eventually disappeared into obscurity and Walter Greaves is now remembered only for his painting *Hammersmith Bridge on Boat Race Day*, although in 1911 an exhibition of his work was held in the Goupil Gallery which was a great success.

HENRY TOWNELEY GREEN, RI
1836-99

Henry Towneley Green started his career in banking, but gave it up to become a watercolour artist. He was the brother of Charles Green who had built up a considerable reputation as an illustrator working for the *Graphic*. Van Gogh, who seems to have been a regular reader of the magazine while he was in England, was a great admirer of Green's work. He also did a great deal of work for various magazines, such as *Once a Week* and the *Cornhill Magazine*, which were both founded in 1860 and had both strived from the beginning to get the best artists to work for them. The *Cornhill*, whose first editor was Thackeray, had Millais and Lord Leighton as regular contributors.

Carleton Grant
Don't Be Afraid
Watercolour, signed and dated 1888. 17 x 27in
Fine Lines (Fine Art)

Green exhibited his watercolours regularly from 1855 to 1893, eight of them at the RA. Among his watercolours are *The Gamekeeper's Cottage, The Skirts of the Woods*, and *On the Beach at Ecclesbourne*, and *After School*, shown below right.
REPRESENTED: V & A.

KATE GREENAWAY, RWS, RI
1846-1901

Although there were literally hundreds of first-class artists illustrating books for children in the Victorian period, none of them achieved the fame of Kate Greenaway, whose name is almost as famous today as it was in her own time. When Ruskin praised an artist he liked it was couched in such effusive and flowery terms that it cannot be taken too seriously. With Kate Greenaway, however, he was completely accurate:

> . . . deep meadowed, happy, fair with small orchard lawns, a land of flowers and gardens, of red brick houses with dormer windows, peopled with toddling boys and little girls clad in high-waisted gowns, muffs, pelisses and frocks of dimity chintz.

This sums up her work exactly and does much to explain why she was so popular with parents and children. Like Birket Foster and his unreal world of rural harmony, she created a child's world where rosy-cheeked boys played happily with

Henry Towneley Green
After School
Watercolour, signed and inscribed
Sketch Club, dated 1867
5 x 7½in. Priory Gallery

flaxen-haired little girls in a world of complete innocence.

Kate Greenaway was born in Hoxton, London, and trained at the Slade School of Art. She had been a children's book illustrator for some time before she made the break-through with *Under the Window*, for which she also supplied the text. It sold 100,000 and from then on her books were produced in editions of no less than 10,000 copies, and were sold widely in America. From 1883 to 1895 she produced an annual almanac as well as producing book plates and portraits. She had at least six paintings shown at the RA (1877-95), which were all drawings of children.
REPRESENTED: ASHMOLEAN, BM, LEEDS, MANCHESTER, ULSTER, V & A.

JOHN ATKINSON GRIMSHAW
1836-93

When John Atkinson Grimshaw appeared on the art scene, the subject-matter of his paintings was innovative: night scenes, lit by moonlight, reflected on the wet cobbled streets where the horse-drawn traffic moved, wraithlike, through the mists; dockyard scenes with the spiky outlines of the ships' masts rearing up against a darkening sky, hansom cabs and people scurrying through rain-swept streets lit by a golden glow from the shop windows; rural lanes flanked by sad, leafless trees - it was from such unlikely subjects as these that Grimshaw extracted his unique form of poetry. His paintings are examples of late Victorian romanticism, which were different from anything that had gone before. Even in the paintings of Sebastian ('Moonlight') Pether, who had specialised in painting moonlit scenes, the poetic quality that Grimshaw succeeded in extracting from a scene is missing.

Grimshaw's style, which makes nearly all his pictures immediately recognisable, was influenced by photography, which was already beginning to make its impact on landscape painting and was to contribute to the downfall of genre painting. In the 1860s, a Frenchman named Antoine Claudet had developed a photographic process which involved

Atkinson Grimshaw
Under the Moonbeams
Oil on canvas signed ,and dated 1882
29½ x 20in
Christie's, London

throwing a photographic image onto a canvas with a camera obscura. Many artists had begun to use this idea in a number of different ways, often using an enlarger as Grimshaw did for most of his paintings. Many saw this as the death-knell of creative painting, while others saw it as a way of getting rid of the drudgery of making detailed sketches before they could concentrate on the business of actually painting. The impact of photography on art is too involved to go into here, except to say that its use in art was eventually accepted as perfectly valid.

Grimshaw was born in Leeds, the son of a retired policeman and a self-taught artist who had first begun to paint when he was working as a clerk for the Great Northern Railway. In 1858 he married the cousin of Thomas Sidney Cooper (see entry) and then settled down seriously to art, with the intention of becoming a professional painter. Although his work was vastly different from what the picture-buying public was used to, he soon became a highly successful artist who could afford to live in Knostrop Old Hall, near Leeds.

Grimshaw exhibited only five paintings at the RA, which could not have bothered him unduly as his work sold well without being exhibited. His oil *Liverpool Quay by Moonlight* was painted in 1887, during the period he rented a studio in Chelsea, where he had become a friend of Whistler, and is on show in the Tate Gallery.

There was another aspect to Grimshaw's work which seems to have been forgotten after he had established himself with his moonlight pictures. In his early years he painted landscapes and he returned to them again during the last thirteen years of his life, producing several which by themselves would have marked him as a major Victorian artist. The contrast in the two styles is so remarkable that two of his paintings are illustrated, one on p125, the other as the Frontispiece.
REPRESENTED: BLACKPOOL, LEEDS (BEST COLLECTION IN THE COUNTRY).

A COMPANION TO VICTORIAN AND EDWARDIAN ARTISTS

Nellie Hadden
A Bird Fancier
Watercolour heightened with white,
initialled and dated 1895. 14 x 20½in
Bonhams

ARTHUR HACKER, RA, RI, ROI
1858-1919

Arthur Hacker was born in London, the son of
Edward Hacker, the line engraver. He went to the
RA Schools before studying in Paris under Leon
Bonnat, who was internationally famous as a
portrait painter and a lifelong friend of Degas.
Bonnat was the ideal teacher for Hacker who
became a fashionable portrait painter himself. His
early work consisted of genre and historical scenes,
such as *The Waters of Babylon* and *The Annun-
ciation*, which was bought by the Chantrey Bequest
in 1892. As an indirect result of the success of this
painting he was elected an associate of the RA and
soon after began teaching at the Academy, when
he partially abandoned subject painting in favour
of portraiture, in which he achieved considerable
success. He was elected an Academician in 1910
and began to paint a series of London street scenes,
including *A Wet Night in Piccadilly Circus*, which
met with a mixed reception from the critics who
were not prepared for a painting of this nature,
which was far more modern in its treatment than
anything else Hacker had produced. In his later
years he returned to painting mythological and
allegorical subjects. He died on 12 September
1919 in London, where he had resided all his life.
REPRESENTED: LIVERPOOL.

Joshua Anderson Hague
Hayfield, near Llandudno
Oil, signed. 20 x 24in
Fine Lines (Fine Art)

NELLIE HADDEN, RMS
fl. 1885-1920

A miniaturist and a painter of genre pictures, Nellie Hadden was more versatile than most women artists, who tended to concentrate on small-scale flower painting and still life studies. She was essentially a watercolour artist who painted in a tight, realistic manner, as in *A Bird Fancier* shown left, which depicts a marauding cat hunting in the snow and halting, motionless in its tracks, when it sees its prey. Although not an artist of great note, her work has always been worth collecting. She exhibited at the RBA and the RI, and also a a number of the leading London galleries. She lived in Berkhamsted, Hertfordshire, and later in Sunningdale, Berkshire.

JOSHUA ANDERSON HAGUE, RI, RBA,
1850-1916

A landscape painter who worked in oils and watercolours, Joshua Hague was born in Stockport, near Manchester, where he trained at the local Academy of Art. He first began to exhibit his pictures at the RA in 1873. Nearly all his paintings are of quiet, pastoral scenes, often of great beauty, and always well composed. One of his oils, *Hayfield, near Llandudno*, which was executed in his usual broad style, is shown below. It was painted in Wales where he spent the latter part of his life. Most of his work was painted in North Wales, where he produced his best work. He died on 24 December 1916 at his home at Deganwy.

FRED HALL, RBC
1860-1948

Fred Hall was born in Stillington, Yorkshire, where he lived until he was 15, when his family moved to Stoke Newington, London. Two years later they moved to Wragby, near Lincoln, where Hall studied at the Lincoln School of Art. He completed his studies at the famous Verlat Academy in Antwerp, where so many of the best Victorian artists did their training.

Hall first exhibited in London in 1883, and in the following year he went to the Cornish fishing village of Newlyn. An artist of considerable talent, he painted a number of *plein air* pictures, together

Fred Hall
The Last Rays of the Sun
Oil on canvas. 24 x 32in
Courtesy of the Bourne Gallery, reproduced by kind permission of Barbara Hall

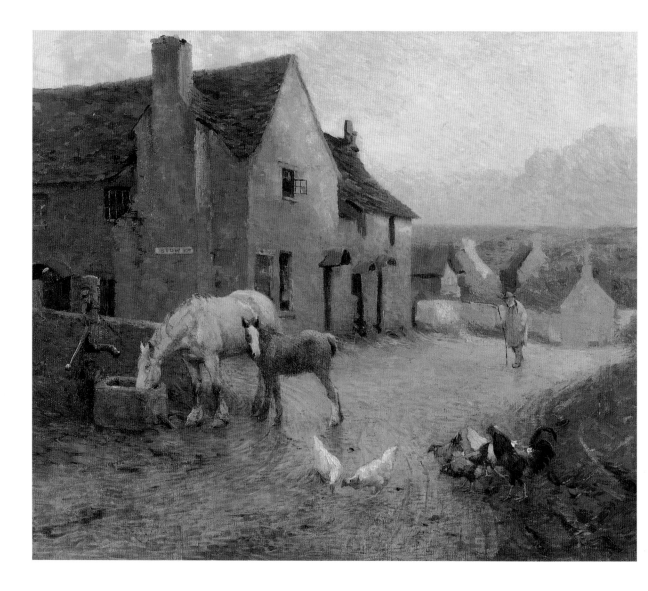

A COMPANION TO VICTORIAN AND EDWARDIAN ARTISTS

with a number of interiors, before he left Newlyn around 1897 and eventually settled in a cottage near Newbury, Berkshire, where he lived for the rest of his life. Although he was on close terms with the Newlyn artists, little is known about Hall's work in Newbury, except that he tended to waste his talents by pandering to popular taste by painting genre pictures that told a story, such as *The Result of High Living* and *Adversity*, a bleak and depressing scene that depicts an evicted family trudging through the snow, preceded by the family dog. This type of painting might have wrung the hearts of the Victorians and earned Hall a living, but they hardly enhanced his reputation in academic circles. One of Hall's best oil paintings is *The Last Rays of the Sun*, illustrated left, in which his use of light transforms a routine subject.

James Duffield Harding
Persano, Bay of Naples
Pencil and watercolour. 4½ x 7in
Spink

JAMES DUFFIELD HARDING, OWS
1798-1863

A landscape artist who painted in oils and watercolours, James Duffield Harding started to train as an artist at the age of 15, when he went to Samuel Prout (see entry) for lessons. Striving to be a perfectionist even at that early age, he was so unhappy with his early efforts that he gave up painting and went to work for a lithographer, John Pye. His work in this field also disappointed him and he returned to painting, after which his situation improved. In 1818 he was awarded a medal by the Society of Arts, and in the same year he exhibited his first painting with them. From then on he was never without work. He was a teacher, a writer of books on art, a painter of landscapes both here and abroad, and a lithogra-

pher. He taught Ruskin, who incorporated many of his ideas in *Modern Painting, Volume II*. He was one of the busiest artists of his day and an excellent watercolourist whose work is seen at its best in his Italian views, such as *Persano, Bay of Naples*, illustrated on p129. He hoped to be invited to be an RA with his Italian scenes, but was unsuccessful. However, Queen Victoria asked him to paint the Crystal Palace to commemorate the Great Exhibition of 1851. His talents were considerable, but not enough to make him a great painter.

Hall exhibited 35 paintings at the RA and another 143 at the OWS. Ruskin referred to him as being 'after Turner, unquestionably the greatest master of foliage in Europe'.

REPRESENTED: BIRMINGHAM, DUBLIN, LEEDS, NGS, V & A.

DUDLEY HARDY, RBA, RI, ROI
1867-1922

The son of a well-known and highly prolific marine painter, Thomas Bush Hardy (see entry), Dudley Hardy was born in Sheffield. He studied briefly under his father before he went to the Düsseldorf Academy in Germany, which he left because he disagreed with their teaching methods. He then studied in Paris, where he fell under the influence of French poster art which had been revolutionised by Toulouse-Lautrec's graphic poster studies of the music hall and brothels of Paris. On his return to England Hardy began to design posters for the productions at the Savoy Theatre of the Gilbert and Sullivan operettas, as well as for a number of their other productions. He also contributed to many of the most popular magazines of the time, including *Punch, Illustrated Bits,* the *Idler,* the *Sketch* and the *English Illustrated Magazine*. He painted many Eastern scenes in oils and a number of Breton genre scenes. *A Slight Difference of Opinion*, illustrated opposite, shows the influence of the French poster, with its flat application of colour, combined with an effective use of black line.

REPRESENTED: LEEDS, NEWPORT.

HEYWOOD HARDY, ARWS, RP, RE
1843-1933

Although he painted a large number of coaching scenes in which his characters are generally dressed in eighteenth-century costume, Heywood Hardy is far better known for his horse paintings, which rival in quality the work of the best horse painters of the time. He was born in Bristol and received his main art training in Paris and Antwerp before he came to London in 1870. He lived there for many years, although he spent the last part of his life in Littlehampton, near Worthing in Sussex. He painted in oils and watercolours, but he was also an engraver and an illustrator who contributed to the *Illustrated London News* and the *Graphic*.

Hardy's work was never less than highly competent, even when he painted one of his many colourful coaching scenes, which were basically purely decorative pictures, and belong rather to that type of painting known as 'Finsbury Park Flash' in which Regency bucks and their host gather around a roaring fire to chat. His horses are another matter. They were seen with an observant eye, which has made much of his work very popular with the racing and hunting fraternity. *A Ride on the Beach* is illustrated on p132.

Dudley Hardy
A Slight Difference of Opinion
Crayon, black ink and heightened watercolour
Signed and dated 1894. 15½ x 11in
Fine Lines (Fine Art)

Heywood Hardy
A Ride on the Beach
Oil on canvas, signed. 14¼ x 18in
Spink

THOMAS BUSH HARDY, RBA
1842-97

With perhaps the exception of Charles Napier Hemy and William Wyllie, no marine artist has achieved the popularity of Thomas Bush Hardy, whose work is found in most picture galleries that handle marine paintings. One of the reasons for his popularity is that his pictures are still inexpensive, unlike the work of some marine artists. It is only fair to add, however, that when Bush Hardy was painting on one of his off days, or was working for cash, he produced some very bad pictures. But this was the exception rather than the rule, and he painted dozens of seascapes that were very good indeed, such as *Off Calais*, which is shown below.

Hardy was born in Sheffield and travelled widely in Europe, painting as he went, in France, Italy and Holland. He did not make any serious impact on the London galleries until 1870, when he began to exhibit his paintings. In the following year he exhibited for the first time at the RA, and continued to do so throughout his career, exhibiting in all thirty-two oil paintings.

REPRESENTED: BRADFORD, DUNDEE, EASTBOURNE, HARTLEPOOL, LEEDS, MANCHESTER, NEWPORT.

Thomas Bush Hardy
Off Calais
Watercolour, signed. 5 x 14in
Priory Gallery

EDWIN HARRIS, RBSA
1855-1906

Whenever interest is shown in the work of Edwin Harris it always seems to be centred around the years he spent in Newlyn in the company of Stanhope Forbes and the other Newlyn artists. This has meant that his work before he went to Newlyn has tended to be ignored, even though he was already exhibiting at the RBSA in 1877.

A landscape, genre and figure artist, Harris was born in Ladywood, Birmingham, where he was educated locally and met W. A. Breakspeare (see entry) who was to become his lifelong friend. After receiving his initial training at the Birmingham School of Art he went to Verlat's Academy in Antwerp, where he met Breakspeare again, who was already a student there.

After returning to Birmingham in 1880 Harris made several exploratory trips to Newlyn, and finally settled there in 1883. He spent twelve happy years in Newlyn, which were marred only by the death of his wife. During that time he painted mostly scenes of pretty girls against a background of a cottage interior, or anecdotal subjects which sometimes featured old men, as in *Resting*, shown below. Unlike Stanhope Forbes, Harris did not seem to have any empathy with the local fishing folk. Fred Hall (see entry) painted an excellent portrait of Harris which shows him as a heavily moustached, faintly lugubrious-looking man with a pipe drooping from his mouth. The portrait is now in the possession of the Tate Gallery.

Edwin Harris
Resting
Oil on canvas, signed. 22 x 30in
Priory Gallery

Harold C. Harvey
A Cornish Boy
Oil on canvas, signed.14 x 18in
Priory Gallery

HAROLD C. HARVEY
1874-1941

A landscape and portrait painter, Harold Harvey studied in France under Benjamin Constant, a fashionable portrait painter who had first achieved fame with his oriental pictures and the with J. P. Laurens, a historical painter and one of the last artists to gain fame in this particular genre before it became unfashionable. Harvey returned to England and settled in Newlyn, which became his home for many years. Although the Newlyn School of painters was already well established, Harvey was never really part of it, although he did have lessons from the Newlyn painter Norman Garstin, who was not successful at producing saleable pictures, but who wrote much about the Newlyn School.

Harvey began to exhibit at the RA from 1898 and also in the provinces and abroad. His RA pictures included *In a Cornish Village* and *The Milkmaid*. *A Cornish Boy* is illustrated on p135. After a successful painting career, mostly as a portrait painter, he died on 14 May 1941.

HELEN HOWARD HATTON
fl. 1879-91

A figure painter who worked in pastel and water-colour, Helen Hatton was born in Bristol. She studied art at the RA Schools and in Paris and lived for some time at 14 Tichfield Terrace, Regent's Park, London. In the 1880s she exhibited a number of pictures, including *Sunflower; The Duck Pond, Witley, Surrey; Shelling Peas*; and *A Pert French Maid*. She exhibited at the RA from 1885, with paintings such as *Poppyheads and Hemlock* and *Love if thy Tresses be so Dark*. *Before Bedtime*, shown opposite, belongs to a later period, and is painted in near-Impressionistic style.

She married the artist William Henry Margetson and they lived in Wallingford-on-Thames, Surrey.

Helen Howard Hatton
Before Bedtime
Oil. 36 x 28in
Brian Sinfield

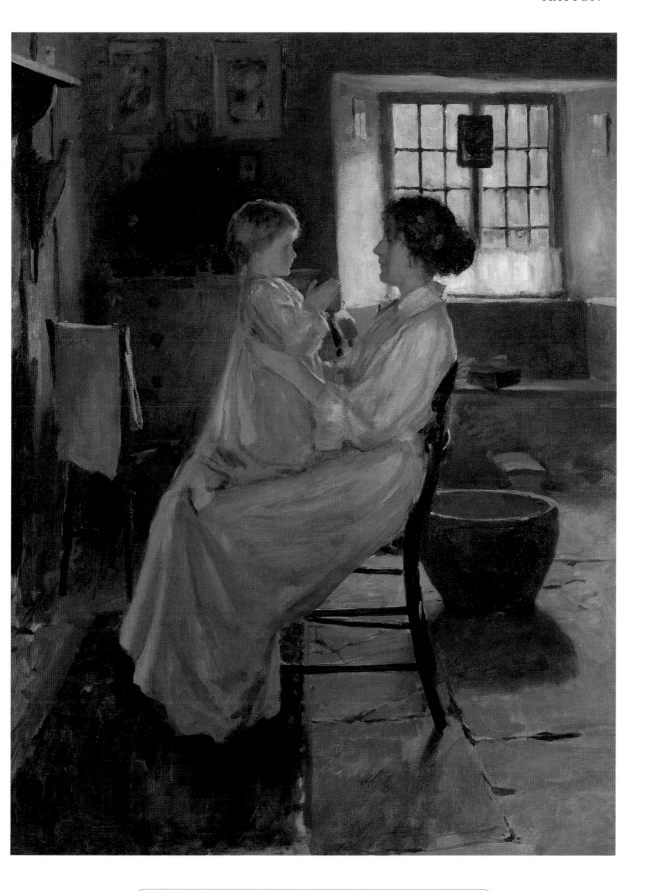

WILLIAM HAVELL
1782-1857

A landscape and portrait painter in watercolours, William Havell was born in Reading, Berkshire, the son of a harassed drawing master who had fourteen children to bring up and did not want William to become an artist. Finally winning his father's grudging approval, William went on a sketching trip to Wales and the Wye Valley, where he met the landscape artists John Varley and Joshua Cristall, who became his close friends. He began to exhibit at the RA in 1804, and was a founder member of the OWS, formed that year; but he made the decision to go to Cumberland to paint there. He spent two years living in a small Cumbrian village and perfecting his craft before he returned south, where he began to paint river scenes in and around his home town of Reading. In 1812 he published a set of twelve coloured aquatint plates under the title *A Series of Picturesque Views of the River Thames*.

By then Havell had gained sufficient stature as a painter to be invited to accompany Lord Amherst on a mission to China. He subsequently went to India, where he stayed for some years, earning his living by painting many of the local notables, including the portrait of Charles Egerton Dukinfield illustrated opposite. He returned to England in 1825, and, after a visit to Italy, devoted himself entirely to oil painting.

Although Havell had travelled extensively, with the passage of time he had lost touch with the art scene in England. From then on his work no longer sold and he lost what little savings he had; he became destitute and was dependent on the fund that Turner had left for the Royal Academy to administer for needy artists. Although he died a forgotten man, Havell now occupies a prominent position among the founders of the English watercolour scene.

REPRESENTED: NEWPORT, READING, V & A.

William Havell
Portrait of Charles Egerton Dukinfield in an Officer's Uniform
Watercolour and pencil, signed, inscribed Madras and dated 1819
10¼ x 7½in
Spink

EDWIN HAYES, RHA, RI, ROI
1820-1904

Born in Bristol, Edwin Hayes was a notable nineteenth-century marine artist, who could give a dramatic intensity to a subject which would have been missing in the hands of a lesser artist (see his watercolour of Dutch pinks close to the shoreline illustrated on p140). He worked in Dublin for a number of years and was known there long before his work began to appear in the London galleries in 1854. It was while he was in Dublin that his son (later to become equally famous as a landscape painter) was born.

By the time of his death in 1904, Hayes had acquired a reputation as one of the foremost marine artists, and consequently his work has retained its popularity up to the present day. A prolific artist, he painted mostly in watercolours and only occasionally in oils, and exhibited 152 paintings at the RA.

REPRESENTED: BRISTOL, CARDIFF, LEEDS, MARITIME MUSEUM (GREENWICH), SHIPLEY.

W. Havell
DELt
Montreal 1819

Edwin Hayes
Dutch Pinks Returning to Kawijk from the Dogger Bank
Watercolour, signed and dated 1877. 20 x 30in
Walker Galleries Ltd

KATE HAYLLAR
exh. 1883-1900

A painter of still lifes and flowers, Kate Hayllar was a member of the well-known Hayllar family of painters, which included James Hayllar at its head and his four daughters who also painted. At one time the work of all five members of the family was exhibited at the RA. Kate Hayllar exhibited twelve paintings at the RA and some of the other major galleries. Although a sound artist in her field, she was never as dedicated to painting as were the rest of the family, and in 1900 she gave up art to become a nurse. From the titles of some of her earlier pictures such as *Tommy's Orange* and *Tommy's School Hamper*, it seems that a few of her paintings were almost genre pictures. She lived at Castle Priory, Wallingford, Berkshire.

Kate Hayllar
Eastern Presents
Watercolour, signed and dated 1884
4¾ x 6½in
Fine Lines (Fine Art)

A COMPANION TO VICTORIAN AND EDWARDIAN ARTISTS

CHARLES NAPIER HEMY, RA, RWS, RI, ROI
1841-1917

Charles Hemy was one of the best, if not *the* best, of the nineteenth-century marine artists who were still painting strongly up to World War I. He was born off the coast of Brazil in a ship bound for Australia. Having grown up in South America, he decided that his fortunes lay elsewhere and he returned to England around 1885. He served on a merchant brig for a while, after which, for some reason which has never been explained, he entered the Dominican monastery in Newcastle, where he seems to have spent most of his time working on decorating the church rather than involving himself in the sort of monastic duties carried out by the other brothers. He was sent by the order to Lyons, where he did similar work to his duties in Newcastle. Having served three years with the Dominicans, he left the order to take up painting seriously and he was soon exhibiting in London.

Hemy seems to have been an artist who was undecided about his future, as he then went to Antwerp to study under Baron Leys, who encouraged him to paint historical scenes modelled on the way that Leys had made a name for himself with his depictions of sixteenth- and seventeenth-century life.

It was not until 1880 that Hemy found his true *métier*, when he began to paint the marine pictures which were to make him famous as the leading maritime artist of his time. In his painting *Sailing Free*, shown on p142, his skill as a marine artist is apparent, particularly his treatment of the sea, which was always painted to look deep and dangerous and therefore a force to be respected. He died in Falmouth, Cornwall.

REPRESENTED: BIRMINGHAM, BLACKPOOL, BRISTOL, MARITIME MUSEUM (GREENWICH), LEEDS, NEWCASTLE.

JOHN HENRY HENSHALL, RWS
1856-1928

A Lancashire-born artist who spent his early working life in London, John Henshall painted genre, figure and historical pictures in oils and watercolours. He trained at the South Kensington and the RA Schools and began to exhibit his pictures in 1879. A popular artist with the public and the RA, who showed seventy-two of his paintings before he died, his work was considered good enough to be purchased by a number of the northern galleries for their permanent collections. He won a bronze medal in Paris in 1900 and in the following year became a member of the Manchester

Charles Napier Hemy
Sailing Free
Watercolour heightened with body-colour, signed with initials and dated 1911
14½ x 27in
Fine Lines (Fine Art)

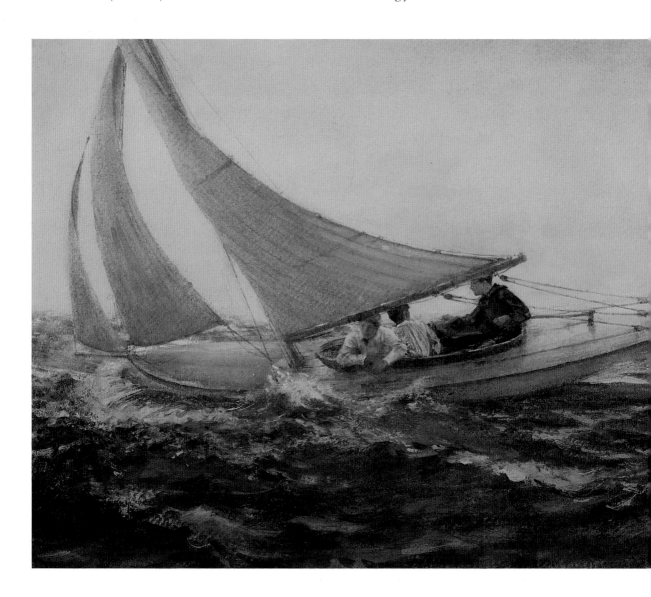

A COMPANION TO VICTORIAN AND EDWARDIAN ARTISTS

Academy of Fine Arts. Although Henshall's historical paintings are now of little interest - a fate he shares with almost all the artists who worked in that sphere - his genre paintings still have much to commend them. His paintings include *A Little Book-worm*, *The Scribe*, *Miriam* and *Alice in Wonderland*. His oil *Is it Time?*, shown right, is typical of his work. The second half of his life was spent in Pinner, Middlesex, and in Bosham, Sussex.

REPRESENTED: BIRMINGHAM, BLACKPOOL, BRISTOL, HULL, LEEDS, MANCHESTER, PRESTON.

John Henry Henshall
Is It Time?
Watercolour, signed and dated 1885. 24 x 16in
Priory Gallery

WILSON HEPPLE
1854-1937

When the artist William Calderon founded his School of Animal Painting in 1894, he realised that there was a desperate shortage of animal pictures ever since Landseer had helped to popularise this form of painting. Winsome kittens and jolly, chubby little puppies at play had become increasingly popular with the picture-buying public so that it became essential for certain types of households to have a picture of this nature on their walls.

Wilson Hepple
The Mischievous Twins
Watercolour, signed and dated 1911. 10 x13½in
Fine Lines (Fine Art)

Wilson Hepple was just one of the many animal artists who came forward to fulfil this need. Born in Newcastle upon Tyne and trained briefly at the Newcastle School of Art, he was largely a self-taught artist who combined landscape and genre painting with his animal studies. If some of his excellently painted animal pictures seem a little 'twee' today, this is because we are far less sentimental than the Victorians, who were capable of weeping copious tears over the death of Little Nell in Dickens' *The Old Curiosity Shop*, for example, and could be equally sentimental about waifs and strays and defenceless animals (see *The Mischievous Twins*, illustrated below).

Hepple lived in Acklington, Northumberland, and painted his landscape and occasional genre scenes locally. His grave is in the local churchyard where his son, the animal artist J. W. Hepple, was also buried when he died two years after his father. REPRESENTED: LAING GALLERY, NEWCASTLE.

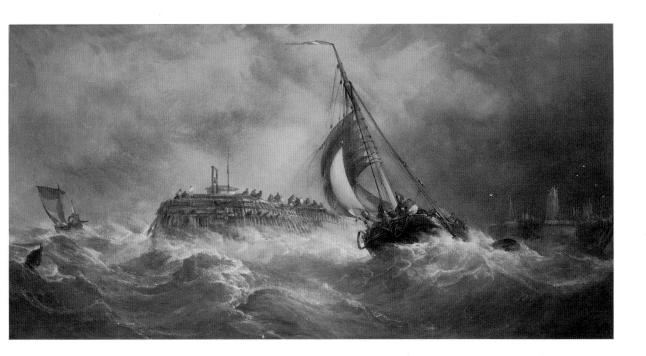

Alfred Herbert
Untitled watercolour. 17½ x 33 ½in
David James

ALFRED HERBERT
1820-61

As he died at a relatively young age, Alfred Herbert's output was small compared with that of most maritime painters. From 1844 until the time of his death, he exhibited only forty-three paintings from his collection in London, three of them at the RA. Like so many nineteenth-century artists, his early death robbed the art world of a first-class painter whose best work depicted ships battling against the elements. He also painted a number of effective beach scenes in Brittany and Holland and several along the Thames estuary. His watercolour of a vessel fighting its way through the turbulent waters of a harbour mouth, illustrated above, which shows some of the dangers Victorian sailors faced, is more spirited than his beach scenes.
REPRESENTED: BLACKBURN, BLACKPOOL, NEWCASTLE, SOUTHEND.

JOHN ROGERS HERBERT, RA
1810-90

John Herbert is remembered for his paintings of scenes of the Holy Land, although he had not visited the East once. He derived his information from books which must have been very reliable, as the acuracy of his drawings was never questioned. Born in Maldon, Essex, Herbert went to the RA Schools in 1826 and started his career illustrating books such as *Legends of Venice*, which was published in 1840. At the age of 26 he was converted to Catholicism and from then on he painted religious pictures. *The Virgin Mary* was bought by Queen Victoria, whose judgement of pictures was not always as sound as it might have been. He was made an Academician in 1860. A bigoted man with uncompromising views on practically everything, he was forced to give up painting during the latter years of his life owing to his failing eyesight.
REPRESENTED: BM, V & A.

he turned to the biblical and historical scenes that were already out of fashion by the turn of the century, so that much of his work was devalued by latter-day critics and writers on Victorian art. Much the same was true of his portrait painting, with which he was very successful. It is said that his portraits lack the charm and quality of his Victorian scenes, but this is belied by the oil painting illustrated opposite, which is more of a portrait than a genre painting.

As a book illustrator Hicks became known as a reliable artist and he obtained a large number of commissions for a wide variety of books, ranging from *Gertrude of Wyoming* and *The Farmer's Boy*, to *Sacred Allegories*.
REPRESENTED: ULSTER.

GEORGE ELGAR HICKS, RBA
1824-1914

George Hicks was born in Lymington, Hampshire, and studied to be a doctor, but he abandoned his medical studies to become an artist. He trained at the RA Schools, where he exhibited forty-four paintings. His work includes *Sea Breezes, Returning from Gleaning, Among Strangers* and *Troubles Not Toil*, all of them painted while he was living in London at 36 Kensington Park Road.

Hicks built two artistic reputations for himself, one as a genre artist and a painter of lively scenes of Victorian life, and the other as a book illustrator. To deal with his paintings first, his scenes from Victorian life were almost as busy and as interesting to study as those of William Frith (see entry). Paintings like *Dividend Day at the Bank, The Post Office* and *Billingsgate* made him a highly popular artist in his time, and his success in this field might have brought him enduring fame if he had continued to paint this type of picture, which is of historical interest to future generations. Instead,

George Elgar Hicks
The Birthday Present
Oil on canvas. 24 x 20in
Priory Gallery

A COMPANION TO VICTORIAN AND EDWARDIAN ARTISTS

FRANK HIND
exh. 1884-1904

Frank Hind was a landscape artist whose work shows the influence of Impressionism. He came from Warwickshire, where he lived at Trent Villa, Avenue Road, Leamington, and later he moved to Correze, France. He exhibited many times, often views of Venice and Holland; among his exhibits were *Church of San Georgio, Venice*, which was always a popular subject with nineteenth-century artists, and *A Wet Day on the Dykes, Holland*. An example of his English landscapes, *Winter Scene*, is illustrated on the left. He also exhibited at least fifteen pictures at the RA. At the time that Hind was painting for exhibitions, it was more of a *cachet* to exhibit at the RA than it had been previously.

Frank Hind
Winter Scene
Pastel. 14 x 21in
Priory Gallery

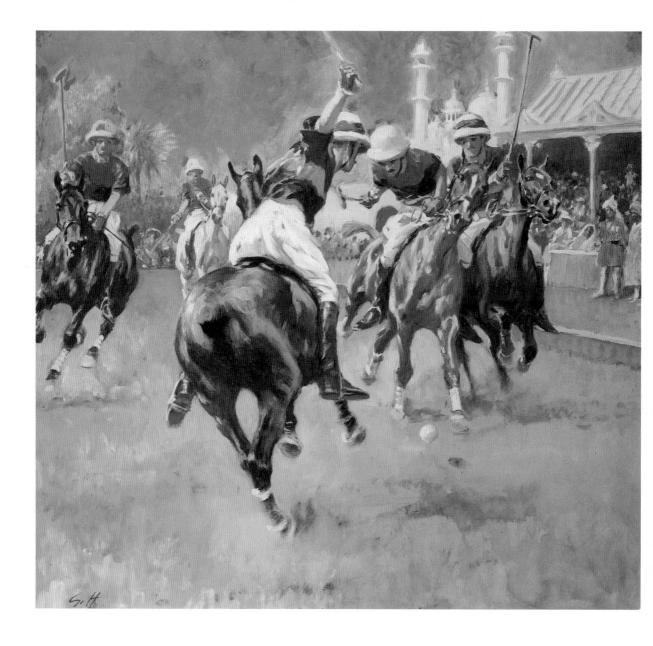

GILBERT JOSEPH HOLIDAY
1879-1937

A sporting artist who had served as a gunner in World War I, Gilbert Holiday developed into an artist who was able to capture the movements of a horse in a way that few other artists could. Lionel Edwards who ranks alongside Munnings as a horse painter, said of this particular aspect of Holiday's work, 'no one can, or ever could paint a horse in action better than Gilbert could'. His first contact with horses was while he was a young boy in St John's Wood, London, when he would watch the Royal Horse Artillery putting their

horses through their paces. He studied a the RA Schools and then worked as a freelance sporting illustrator who soon found work with a number of magazines, including the *Graphic*, the *Illustrated London News* and *Tatler*. He painted in oils, charcoal and watercolours, always taking for his subject the horse in action, either in the hunting field or on the racecourse, or on the polo field, as with his painting of a polo match in India illustrated above, in which the body movements of both man and horse are perfectly caught.

A COMPANION TO VICTORIAN AND EDWARDIAN ARTISTS

Gilbert Joseph Holiday
A Polo Match, India
Pencil, watercolour and gouache
Signed with initials. 14 x 17in
Spink

FRANK HOLL, RA, ARWS
1845-88

Frank Holl was one of those fortunate Victorian artists who was never short of work for his entire professional life, unlike some who rose quickly to fame only to find themselves out of favour later on.

Born in London, the son of the famous engraver Francis Holl, Frank went to the RA Schools in 1860, where he became the most successful student of the year. Between 1864 and 1887 he exhibited seventy-two paintings at the RA. Although he painted many genre pictures such as *The Pawn Shop* and *Return from the Wars*, his real success lay in portrait paintings with sitters such as Millais, Gladstone and John Tenniel, who supplied the illustrations for the first edition of Lewis Carroll's *Alice in Wonderland*.
REPRESENTED: BIRMINGHAM, BRISTOL, LEEDS.

Arthur Hopkins
The Well by the Maytree
Watercolour, signed. 9 x 10¾in
Fine Lines (Fine Art)

ARTHUR HOPKINS, RWS
1848-1930

Arthur Hopkins, the brother of Gerard Manley Hopkins, the poet, was born in London and educated at Lancing College, near Shoreham-by-Sea. After spending a few years working in the City, he decided that the only escape from the drudgery of office work was to take up art. He entered the RA Schools in 1872 and in the same year began to exhibit at most of the main London galleries. *The Well by the Maytree*, shown on p151, was exhibited in 1890, when genre painting had not yet gone out of fashion with the picture-buying public. As well as being a genre painter in oils and watercolours, he was a regular contributor to many of the most popular magazines, including the *Graphic*, the *Illustrated London News, Punch*, *Cassell's Magazine* and the *Quiver*, the latter being a rather dreary but well-illustrated magazine that was still running in the 1930s. He also supplied the illustrations for *The Haunted House* by Wilkie Collins which was published in 1901, during the latter period of Collins' life when he became interested in the occult.

WILLIAM H. HOPKINS
fl. 1853-90 (d. 1892)

A landscape and animal painter who is perhaps best known for his horse studies, William Hopkins exhibited at all the major London galleries between 1853 and 1890. His horse paintings were closely observed and attractively painted, as indeed were his landscapes which embraced farm animals - for example, his oil painting *Commoners* shown opposite.

Hopkins came from Keynsham, near Bristol, and is though to be the father of Hannah H. Hopkins, who painted rustic subjects. He exhibited at the RA thirty-seven times between 1853 and 1890. He later moved from an address in Bath to 2 Elgin Street, Maida Vale, London which was becoming a favourite residential haunt for painters, just as the more Bohemian artists were beginning to opt for Chelsea, Hampstead or Camden Town. Later, he moved to Odiham, Hampshire, which never seems to have been a county favoured by artists.

ERNEST ATKINSON HORNEL
1864-1933

Ernest Hornel was one of the Glasgow School whose distinctive style blended the great traditions of Scottish painting with a decorative form of art from the Far East. The work of the Glasgow School met with opposition at first, but it has now been accepted as part of the mainstream of Scottish art.

Hornel was born in Bacchus Marsh, Australia, but was brought to Scotland at an early age, where he grew up in Kirkcudbright. After studying for three years in Edinburgh and then at Verlat's Academy in Antwerp, he began his career by painting traditional genre and landscape pictures, until he met and came under the influence of George Henry, one of the first of the Glasgow School. From then on his work began to develop into the style for which his paintings have become so well known (see *By the Sea*, above right). The rich colours and broad treatment of his pictures make them immediately recognisable. In 1893 he went to Japan, where he painted a large number of pictures which showed his commitment to this style. When he returned to Kirkcudbright he began to paint a series of pictures, mostly of children playing in flower-decked woods or of rich autumnal landscapes, all of them poetic in mood and splendid in colour. In 1901 he was elected a member of the RSA, but declined the honour. He died in Kirkcudbright on 30 June 1933.
REPRESENTED: LIVERPOOL, NGS.

Ernest Atkinson Hornel
By the Sea
Oil on canvas, signed and dated 1915. 16 x 12in
Priory Gallery

William H. Hopkins
Commoners
Oil on canvas, signed and dated 1875
20 x 30in
Cambridge Fine Art

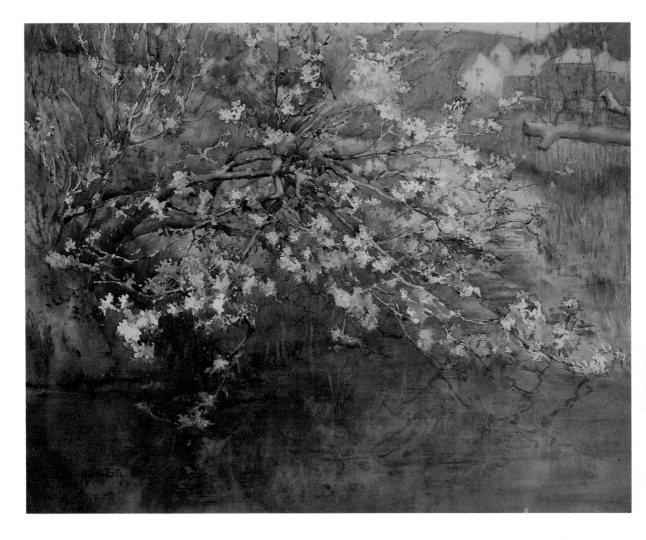

Ethel Horsfall
May Blossom on the River
Watercolour, signed. 16½ x 21in
Fine Lines (Fine Art)

ETHEL HORSFALL, RBA, ASWA, SWA
1871-1919

Often recorded under her married name of Ertz, Ethel Horsfall commenced her painting career as a miniaturist before she became a watercolourist, when she painted attractive scenes, such as *May Blossom on the River*, illustrated above. After living in London, she moved to the appealing Cornish village of Polperro, which had always attracted artists, with its colour-washed cottages that led down to a small harbour sheltered by two sea walls - now sadly spoilt by commercialism. It was there that she met the American artists Edward Frederick Ertz who had decided to settle in England after teaching art in Paris. They were married in 1902 and moved to Devon before they finally settled in Pulborough, Sussex. Ethel Horsfall exhibited from 1897 until the year of her sudden death in London in 1919. Seven of her paintings were shown at the RA.

Abraham Hulk
A Dutch Dogger and Others in a Fresh Breeze
Oil on canvas. 7½ x 10½in
Royal Exchange Art Gallery

ARTHUR HUGHES
1832-1915

Arthur Hughes was one of the chief figures in the Pre-Raphaelite Brotherhood, and his emotive painting *Home from the Sea* is one of the key paintings of the movement. He trained at the RA Schools and began to exhibit in 1849. In 1882 his major painting *Ophelia* appeared, which followed all the ground rules of a Pre-Raphaelite picture, and made him a welcome member of the Brotherhood. He continued to paint such pictures as *The Tryst* and *The Long Engagement*, which helped to sustain his reputation throughout the 1850s and '60s. From 1870 his work seemed to have lost much of that poetic quality that had made him famous, and his popularity began to fade.

Hughes also worked as a book illustrator. He supplied the drawings for the 1869 edition of *Tom Brown's Schooldays* and a number of George MacDonald's fantasies, including *At the Back of the North Wind*, which makes strange reading to anyone not conversant with the odd plotting that often made up Victorian fiction.

REPRESENTED: ASHMOLEAN, BM, MANCHESTER, PRESTON, V & A.

ABRAHAM HULK
1813-97

Although his parents were Dutch, Abraham Hulk was born in London. He studied at the Dutch Academy in Amsterdam and also under the German-born portrait painter Jean Augustin Daiwaille, who died in Rotterdam in 1850. In the early 1830s he visited North America before he returned to Holland. In 1870 he came to England, where he spent the last twenty-seven years of his life. A painter who was master of atmospheric marine scenes, his early work was in the manner of the Dutch tradition of maritime painting. Later his

work became more relaxed in the style of the British school of marine painting. *A Dutch Dogger and Others in a Fresh Breeze*, illustrated on p155, depicts a number of Dutch two-masted vessels, with the sea painted in the style of the Dutch painter Jan Hermanus Koekkoek.

REPRESENTED: THE OLD CUSTOMS HOUSE, LYMINGTON.

WALTER HUNT
1861-1941

An oil painter who specialised in painting animal subjects, generally farmyard animals, Walter Hunt was born in Fulham, London, the son of Charles Hunt, a genre painter. Whereas most Victorian artists portrayed animals as well-fed and glossy-coated, Hunt painted his animals with realism. In *A Devonshire Farmyard* shown opposite, nothing is sanitised in his farmyard scene. The horse is an ancient but well-fed gelding, and there are no pretty young Victorian maids carrying out some farmyard chore, only a young lad feeding the horse. Although some people might consider that it is not a particularly attractive painting, it fetched £21,000 at auction at Bonhams in June 1988. Hunt exhibited twenty-eight paintings at the RA, including *Dog in the Manger* which was bought by the Chantrey Bequest. He lived at Park View, Granville Road, Wandsworth, London.

REPRESENTED: BIRMINGHAM.

WILLIAM HENRY HUNT, OWS
1790-1864

William Hunt was born at 8 Belton Street, now Endell Street, London. From childhood he had deformed legs, his knees and toes being turned in so that he could only walk by shuffling. His deformity was one of the main reasons that he gave up landscape painting and concentrated on still life and figure work. His father was a tinman who apprenticed him at the age of 7 to John Varley, the well-known landscape artist who ended his days in dire poverty. One of his fellow students was John Linnell (see entry) who became one of the most famous of the Victorian landscape painters. Together they would go out sketching, and it was during these excursions that Hunt became interested in painting inanimate objects such as moss and ferns, which he could draw sitting down, rather than having to hobble painfully around in Linnell's wake.

In 1808 Hunt entered the RA Schools, where he was considered to be promising enough to be one of the group of students that was selected to help in the decoration of Drury Lane Theatre which had been seriously damaged by fire in 1809. By 1818 he was earning his living and living at 5 Charles Street, off Soho Square, from where he struggled to paint rural scenery in the suburbs of the city. It was not until 1827 that he began to study fruit and vegetables as a possible source of subject-matter. His first great success in that field was a painting of a vegetable stall lit by a candle - candlelight being a motif he was to use on a number of occasions. His still life studies of speckled eggs on a bank of mossy green became in great demand, which resulted in his nickname 'Bird's Nest Hunt'. It is on these charming studies that his reputation now very securely rests.

It was unfortunate that Hunt chose to concentrate on still life painting, however good his studies were. In an earlier work, *Diffidence*, which is shown opposite, we see a first-class figure artist who seems to have been lost to us for ever once he had changed course in his watercolour painting. The picture has been known at different times as *The Diffident Sitter* or *The Shy Sitter*. Both these titles seem more appropriate than the one it now carries.

REPRESENTED: ASHMOLEAN, BIRKENHEAD, BLACKBURN, BLACKPOOL, BRADFORD, BM, DERBY, V & A.

Walter Hunt
A Devonshire Farmyard
Oil, signed and dated 1902. 20 x 30in
Bonhams

William Henry Hunt
Diffidence
Watercolour and body-colour over pencil, signed
10½ x 8in oval
Sotheby's, Sussex

WILLIAM HOLMAN HUNT, OM, RWS
1827-1910

One of the founder members of the Pre-Raphaelite movement, William Holman Hunt was born in London and entered the RA Schools in 1844. He rose to a position of considerable importance in the art world with his two famous oils *The Hireling Shepherd* and *The Light of the World*. A religious man, he visited the Holy Land for some of his subjects. He was a lifelong friend of Millais, which is perhaps rather surprising when one remembers Millais' long-lasting affair with Effie, the wife of William Morris. A humourless perfectionist who is known to have sat up from four in the morning until dawn so that he could capture on canvas the exact light that came from the first rays of the rising sun, Holman Hunt remained devoted to the ideals of the Pre-Raphaelites until his death.

REPRESENTED: ASHMOLEAN, BM, COVENTRY, MANCHESTER, V & A.

A COMPANION TO VICTORIAN AND EDWARDIAN ARTISTS

LOUIS BOSWORTH HURT
1856-1929

A Derbyshire artist who seems to have favoured Scotland more than anywhere else for his subject-matter, Louis Hurt painted many attractive scenes of the Highlands, more often than not featuring the local breeds of cattle as an important part of the composition. His wife obviously accompanied him on at least some of his trips as occasionally she also painted a Scottish landscape scene, such as *In Glen Shiel, Ross Shire*. Hurt and his wife lived in the attractive market town of Ashbourne, which is often called the gateway to the Peaks, although its charms did not seem to appeal to them as the subject of their paintings.

Hurt was taught to paint by another Derbyshire artist, the landscape painter, George Turner, who was a sound artist but whose work apparently was never exhibited at the RA. Hurt, on the other hand, exhibited thirteen paintings at the Academy. *Through the Pass of Awe* is illustrated here as a representative example of his Scottish paintings.
REPRESENTED: READING.

Louis Bosworth Hunt
Through the Pass of Awe
Oil, signed and dated 1904. 24 x 40in
Bonhams

Robert Gemmell Hutchison
Sailing the Boat
Oil, signed and dated 1914. 14 x 8in
Bonhams

ROBERT GEMMELL HUTCHISON, RSA, RSW
1855-1936

Robert Hutchison, who was born in Edinburgh, was a landscape, genre and portrait painter who worked in oils and watercolours. His work is distinguished by his sympathetic treatment of children, which is never cloying as are so many of the Victorian paintings of children. His renditions of certain aspects of Scottish life also had much to commend them, especially in such paintings as *The Young Laird*, the *Gundy Man* and *Hallowe'en*, which were all composed with the laudable intention of telling a story.

Hutchison studied at the Board of Manufacturers School of Art in Edinburgh, and he first began to exhibit at the RA in 1880. His work shows the influence of some of the nineteenth-century Dutch painters, such as Isaac Israels, which became even more evident after he had made a sketching trip to Holland. However, he remained a Scottish painter to the core who never lived elsewhere than in the city of his birth. He supplied the illustrations for a book, *Reminiscences of Old Scots Folk* written by T. R. Barnett and published in 1913. *Sailing the Boat*, illustrated above, shows the influence of the nineteenth-century Dutch painters and was almost certainly painted in Holland.

FREDERICK WILLIAM JACKSON, RBA
1859-1918

A landscape and marine artist who painted in oils and watercolours, as well as drawing decorative sketches for ceramics, Frederick William Jackson was born in Oldham, where he went to the local art school before studying at the Manchester Academy. He completed his training in Paris under Jules Lefevre, a painter of allegorical and

historical subjects, and the romantic painter Hyppolyte Boulanger, a more suitable teacher for Jackson whose main output was in the field of romantic scenic painting.

Jackson lived at Hinderwell, Yorkshire, and travelled to Italy, Morocco and Russia, and painted various scenes in those countries. He began to exhibit in 1880, mainly at the SS and the RA, where he showed nineteen pictures before 1893. Although he died at the relatively early age of 59, his output was reasonably large and included a number of marine subjects.

REPRESENTED: BRADFORD, MANCHESTER.

Frederick William Jackson
Gathering Blossom
Oil on canvas, signed and dated 1890
18 x 30in
Bonhams

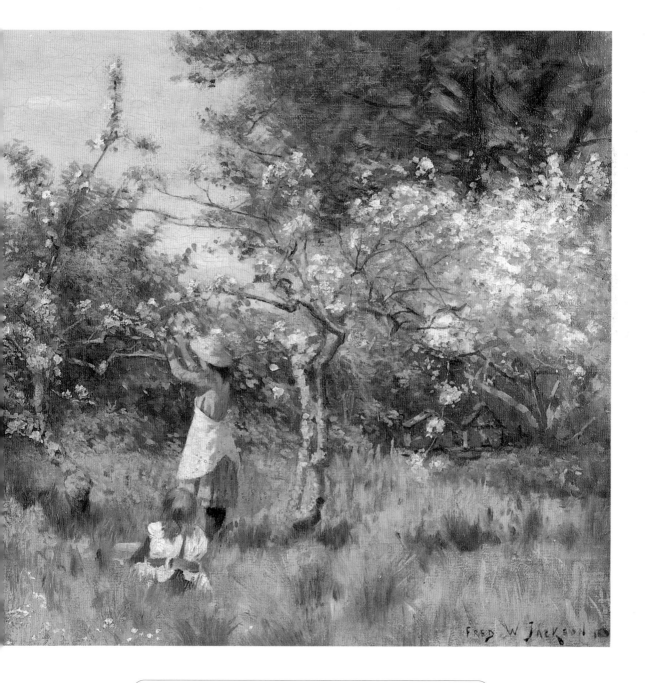

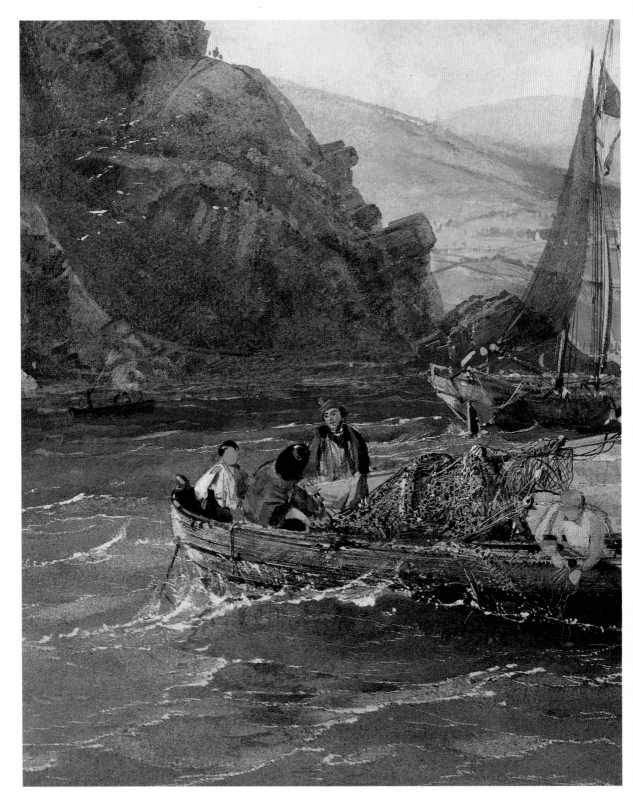

Samuel Phillips Jackson
Fishermen Tending their Nets on a Choppy Sea
Watercolour heightened with body-colour
8 x 6½in. Spink

David James
Atlantic Rollers
Oil on canvas, signed and dated 1882
30 x 50in. Bonhams

SAMUEL PHILLIPS JACKSON, RWS
1830-1904

The Bristol-born artist Samuel Phillips Jackson was the son and pupil of Samuel Jackson, the landscape artist and one of the mainstays of the Bristol School of painting. Samuel Jackson jnr painted landscape and marine subjects around the Devon and Cornish coastline. His early work was done almost entirely in oils, but he later changed to working in watercolours. After 1870, when he left his address in Clifton to settle in Streatley-on-Thames, he worked entirely in watercolours, taking his subjects from the surrounding countryside. His work was much praised by Copley Fielding. Jackson is known mostly for his coastal scenes such as *Fishermen Tending their Nets on a Choppy Sea*, illustrated opposite. He exhibited eighteen paintings at the RA up until 1893 and another 841 at the OWS.

REPRESENTED: BRISTOL, BM, V & A.

DAVID JAMES
1834-92

David James was one of those marine artists who painted 'pure sea' pictures, a term that is applied also to the work of John Brett and Henry Moore, all of whom subordinated everything in a marine painting to capturing the moods of the sea. It is the type of marine painting that leaves the viewer with little else but the sea to look at, which may not be enough for some people, however well it has been painted. In David James' pictures, the sea is everything, either expending its force against the rocks, sending a wall of spray into the air while spume eddies around the base of the rocks, or rolling forward in all its majestic force.

James exhibited at the RA from 1881 to 1892 and he painted mostly along the coast of Cornwall, which was the ideal place to capture the vagaries of the sea, and allowed him to work variations on a theme that could easily become monotonous. In *Atlantic Rollers*, illustrated below, the combination of an interesting sky and the treatment of the sea makes it one of the more interesting 'pure sea' paintings.

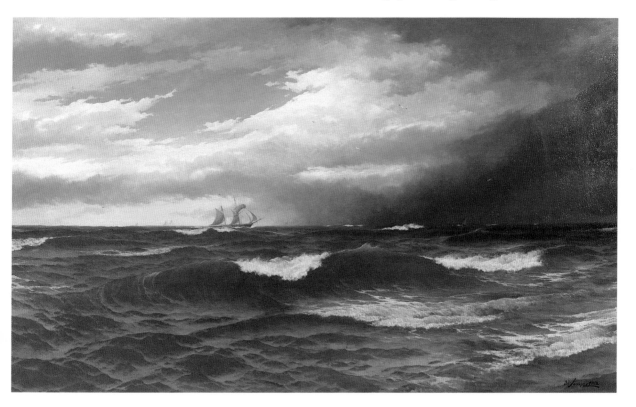

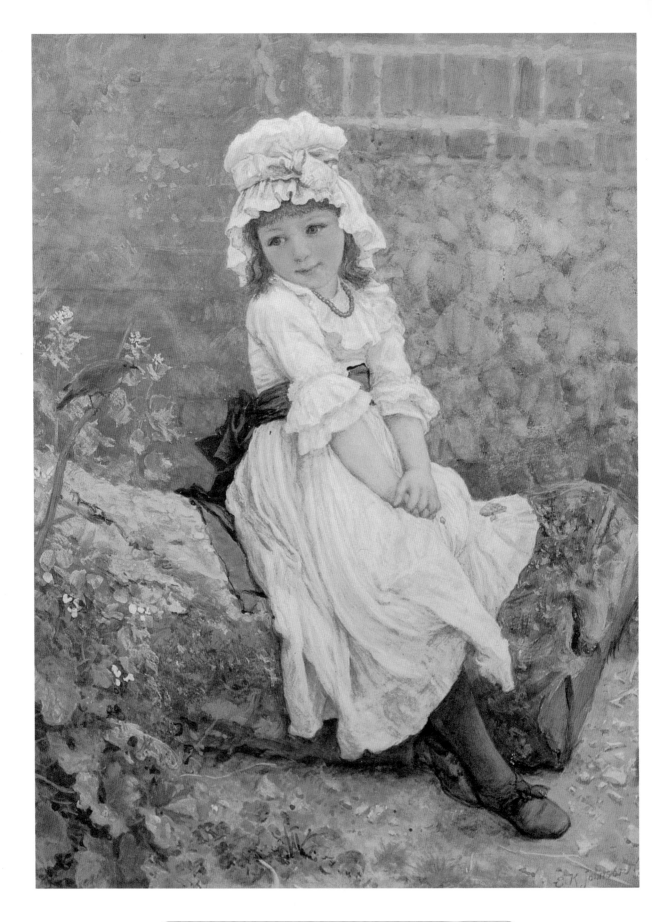

A COMPANION TO VICTORIAN AND EDWARDIAN ARTISTS

Edward Killingworth Johnson
The Robin Redbreast
Watercolour and body-colour,
signed and dated 1880. 12½ x 9½in
Bonhams

EDWARD KILLINGWORTH JOHNSON
RWS
1825-96

Apart from having a few lessons at the Langham Life School, Edward Killingworth Johnson was virtually a self-taught watercolour artist who produced a large number of genre paintings, many of them pictures of little girls in various poses and situations. He was an excellent artist who used pure watercolour in combination with body-colour, a technique in which the two are mixed to give an opaque look to the painting and often called gouache. All his work is highly finished; an example is illustrated opposite.

Born in Stratford-le-Bow, Johnson lived in London for many years before he moved to Halstead, Essex.

JOHN KEELEY, RBSA
1849-1930

A landscape artist who often painted in soft pastel colours, John Keeley was born in Moreton-in-Marsh, Gloucestershire. He studied in Birmingham, where he lived for the rest of his life. He exhibited from 1883, mostly at the RBSA, where he showed more than three hundred of his paintings before his death. For someone who painted so many good pictures, his work seems to be undervalued, and on the rare occasions that examples do come up for auction, they do not fetch high prices. In the example of his work shown below, he chose for his subject sheep shearing, an aspect of rural life that seems to have been neglected by nearly all the nineteenth-century painters of the pastoral scene, even though the sheep shearer, who generally travelled from farm to farm, was an important part of life in the country.

John Keeley
Sheep Shearing at Bidford
Watercolour. 13 x 18½in
David James

LUCY KEMP-WELCH, RI, ROI, RBA, RCamA
1869-1958

Although her life spanned the Victorian and Edwardian periods and continued into the late 1950s, the peak of Lucy Kemp-Welch's career was in the Edwardian era when she was first recognised as one of the finest horse painters of her time. The daughter of a solicitor, she was brought up in Bournemouth, and at a very early age began to sketch when she and her father went on walks in the New Forest. Her first art teacher was Arthur Batt (see entry), but the greatest influence on her was Herbert von Herkomer, one of the first of the great social realists whose reputation had been made with his two paintings, *Hard Times* and *On Strike*, and who was by then running his own

Thomas Benjamin Kennington
The Gold Fish
Oil on canvas. 16 x 22in
Priory Gallery

Academy of Art at Bushey in Hertfordshire, where she enrolled as one of his pupils.

In 1859 Lucy Kemp-Welch had her first RA exhibit, *The Gypsy Horse Drover*. By the following year, after she exhibited *Colt Hunting in the New Forest* at the RA, she was already well on the way to becoming a major figure in the field of horse paintings. In 1907 she bought Herkomer's school, which she attempted to run herself. She probably purchased the school for sentimental reasons, occasioned by her deep regard for

Herkomer, but it proved to be a mistake as her first love was always painting.

In the 1920s Kemp-Welch was still an important figure in the art world, with a reputation that was further enhanced following a tour with Lord John Sanger's Circus, of which she painted a series of scenes that were much admired. At the age of 80 she was still painting and, moreover, was able to submit and have a painting accepted for exhibition at the RA. In the 1950s she lived a life of quiet seclusion until her death in hospital in Watford, near London.

THOMAS BENJAMIN KENNINGTON, RBA, NEAC
1856-1916

A Grimsby-born artist who worked in oils and watercolour, Thomas Benjamin Kennington began his training at the Liverpool School of Art. He completed his training in Paris, where so many nineteenth-century artists went to study once they felt that their work would meet the demanding requirements of the professors of the Académie des Beaux-Arts or the Académie Julian, two of the leading teaching schools in Paris. There is no doubt that many English artists who returned to England were influenced by the nineteenth-century French school of painting, as Kennington undoubtedly was - see, for example, *The Gold Fish* illustrated left. Many of his genre paintings were studies of the English upper-middle classes frozen in a domestic tableau, often with a mother and child as the main protagonists. Kennington exhibited from 1880 to 1916, and also at a number of international exhibitions in Rome and Paris, where he won a bronze medal on two occasions.
REPRESENTED: NATIONAL PORTRAIT GALLERY

GEORGE GOODWIN KILBURNE, RI, RBA
1839-1924

A London genre artist, George Goodwin Kilburne spent five years as an apprentice to the Daiziel brothers, the most famous of the nineteenth-century engravers, He began his career as a wood engraver but changed to genre painting and exhibited for the first time in 1863. In common with many nineteenth-century artists, he was fond of painting young women flirting with their suitors. Many of these paintings were made into prints which became very popular. To use that overworked word when it is applied to nineteenth-century art, his work is 'charming', and painted in what seems a spontaneous manner.

An artist who enjoyed painting interiors, Kilburne's work was much in demand from the weekly and monthly magazines, including *Punch*, the *Windsor Magazine*, the *Quiver* and the *English Illustrated Magazine*.
REPRESENTED: ACCRINGTON, LIVERPOOL.

George Goodwin Kilburne
The Stolen Kiss
Signed watercolour. 6¼ x 4¼in
David James

HAYNES KING, RBA
1831-1904

A landscape and genre artist who was born in Barbados and educated in Bridgetown, Haynes King came to England in 1854. He went to London and found himself a house in Victoria Road, Kentish Town, which was still a desirable area, but which soon changed into a grimy, working-class area once the Midland Railway had interlaced it with railway lines. He studied at Leigh's Academy in Newman Street, where he was surrounded by artists who had taken up residence there. He exhibited at the RA from 1860, but most of his large output was shown at the SS. At one time he shared a house with Thomas Faed, and at a later date with Yeend King (see entries). Many of his cottage interiors were not unlike Faed's, except that his colours were more rich and without that overall brown effect that so many of the earliest artists imparted to their work. His many paintings include *The Anxious Look-out*, *A Stitch in Time*, *My Ain Fireside*, and *The Cottage Door* (see opposite), which originally sold for £35, a ludicrous figure when compared with today's prices. He died suddenly on 17 May 1904, when he was tragically killed by a train.
REPRESENTED: DERBY, V & A.

Haynes King
The Cottage Door
Oil, signed and dated 1864. 15 x 11in
Cambridge Fine Art

HENRY JOHN YEEND KING, RBA, ROI
1855-1924

Henry Yeend King was born in London and spent the first three years of his working life as an apprentice to O'Connor, whose glass painting business was in Berners Street, then part of Marylebone's artistic colony, which was London's first Latin Quarter in the second half of the eighteenth century. He studied first with William Bromley, the genre artist, and later in Paris with Leon Bonnat and Fernand Cormon, both professors at the Ecole des Beaux-Arts. He began to exhibit in 1874, and in 1898 his picture *Milking Time* was bought by the Tate Gallery when he was only 43. He produced many more pictures before his death in 1924, which were often painted *en plein air*. He also painted a large number of garden scenes with a pretty girl as the focus for attention. As he painted in a robust style in which he used strong, bold colours, his garden scenes bear no relation to those of Helen Allingham (see entry), whose colours were far more muted. He was married to the sister of Robert Gallon, the landscape artist. His watercolour illustrated on pp170-1 is typical of his style and reflects the influence of the French school of that period.
REPRESENTED: LIVERPOOL, READING, ROCHDALE, SHEFFIELD.

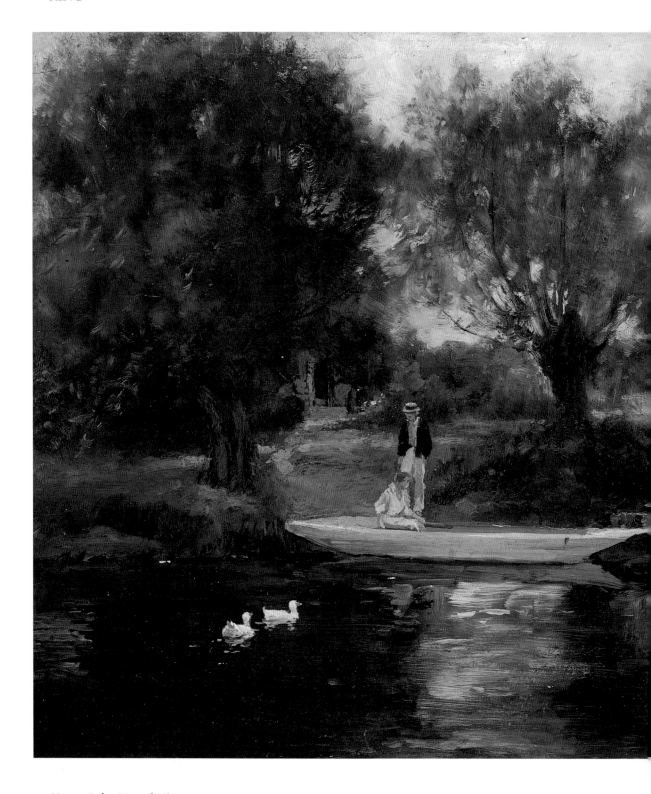

Henry John Yeend King
The Ferry, Clifton, Hampton on Thames
Oil on board, signed. 10 x 14in
Priory Gallery

A COMPANION TO VICTORIAN AND EDWARDIAN ARTISTS

HENRY JOHN KINNAIRD
fl. 1880-1920

A well-known watercolour artist in his day, Henry John Kinnaird was a landscape artist who painted rural scenes in the manner of the prolific landscape artist John Hooper. Kinnaird exhibited in London from 1880, mainly at the RA and the RBA, and he lived for a time in the then fashionable Camden Town area, before the urban spread brought poverty to a region which had once been known for its gracious houses and quiet country lanes. He later moved to Ringmer, near Lewes, Sussex.

Although he painted many river scenes, Kinnaird was most at home painting studies of a rural way of life that was already beginning to change. When he painted his picture of harvesters at work, for instance, (see p172) the traditions of the harvest home had already disappeared for ever.

JOSEPH KIRKPATRICK
1872-c1930

A genre and landscape painter in watercolours, Joseph Kirkpatrick was born in Liverpool and studied at the Liverpool School of Art under John Finnie, the well-known landscape painter and head of the school until 1896. Kirkpatrick continued his training in Paris at the Académie Julian, the best of the French teaching schools after the Académie des Beaux-Arts, where he studied under Gabriel Ferrier (one of the great late nineteenth-century French genre artists) and Adolphe Bouguereau. He exhibited at the RA from 1898 to 1928. Some of his work which portrays humble farming people at work has an earthy quality reminiscent of some of the French nineteenth-century genre artists and to some degree of the paintings of Robert Waite (see entry). Others are lyrical paintings of the countryside in the summertime (see *Picking Poppies*, shown on p173).

Kirkpatrick lived in London for a number of years before he moved to Arundel in Sussex in 1916.

REPRESENTED: LIVERPOOL.

Henry John Kinnaird
A Surrey Cornfield
Signed watercolour
David James

WILLIAM ADOLPHUS KNELL
c. 1808-75

The most important of a family of three maritime painters, William Adolphus Knell seems to have painted everywhere along the coasts of England, France and Holland. He began as an artist who had been greatly influenced by the Dutch School of painters, but later adapted his style to suit the English market in which the works of the Dutch School no longer enjoyed their former popularity. For the most part his paintings were vigorously executed, but they remain rather stylised and show that he had not entirely shaken off the influence of the Dutch School. He exhibited twenty-nine works at the RA and painted two pictures especially for Queen Victoria - *The Landing of the Prince Regent* and *The Review of the Fleet at Spithead*. After living at a number of addresses, he ended his days at 329 Kentish Town Road, London. His paintings include *Life Boat off Ostende, Yarmouth Roads, Portsmouth from Spithead, Off Broadstairs, Squally Weather*, and *Sunset and a Trawling Yawl off Dover Cliffs* shown on p174. Represented: Maritime Museum (Greenwich), NGS.

Joseph Kirkpatrick
Picking Poppies
Signed watercolour. 9¼ x 7in
Fine Lines (Fine Art)

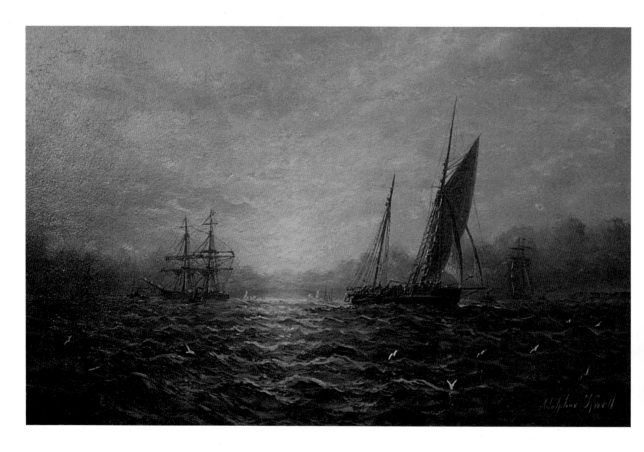

William Adolphus Knell
Sunset and a Trawling Yawl off Dover Cliffs
Oil on canvas. 12 x 18½in
David Cross Gallery

JOHN PRESCOTT KNIGHT, RA
1803-81

A London portrait and genre artist, John Prescott Knight was born in Stafford, in the Midlands, the son of a stage comedian. He came to London as a boy where he began his career working as a junior clerk to a West India merchant. However, with little to do as the business was doing badly, Knight started to occupy his time copying sketches by Samuel West, the portrait and historical painter. He showed them to his father, who was so impressed by the quality of his son's work that he sent him to study at the Sass Academy of Art, a famous drawing school founded by Henry Sass, at one time an indifferent figure and portrait painter, but an excellent teacher. Here he studied under George Clint, the portrait artist. He later became a student at the RA Schools. After painting a number of the celebrities of his day, including Sir Walter Scott, Knight started to appear at the BI with a series of genre paintings, including the appallingly titled *List, ye landsmen, all to me*, which was followed by *The Whist Party*, *Robin Gray* and *Smugglers Alarmed*. He became an Academician in 1844 and from 1848 to 1873 was secretary to the Royal Academy. His best known work at the time, *Waterloo Banquet*, was bought by the Duke of Wellington.
REPRESENTED: BM, V & A.

George Sheridan Knowles
Untitled watercolour
Signed and dated 1907. 21 x 14½in
David James

G. Sheridan Knowles

GEORGE SHERIDAN KNOWLES, RI, ROI, RBA
1863-1931

A London-born artist who worked in oils and watercolours, George Sheridan Knowles painted genre subjects and the occasional historical painting, and exhibited at the RA from 1885. His genre pictures of young women in eighteenth-century costume were sometimes over-sentimental - for example the watercolour of a young girl cuddling a puppy while a kitten vies for attention (see his watercolour shown on p175).

Knowles was a student at the Manchester School of Art and the RA Schools. As an illustrator he supplied drawings to the *Quiver* and the *London Illustrated News* from 1894 to 1899. His paintings include *The Miller's Daughter, The Last Minstrel, A Little Loyalist* and *Maidenhood*.

HENRY HERBERT LA THANGUE, RA
1859-1929

A *plein air* artist of the first order, Henry La Thangue was born in Croydon, Surrey. He attended Dulwich College at the same time as Stanhope Forbes; afterwards he studied briefly at the South Kensington Schools, whose reputation was temporarily in eclipse at the time, leading him to the conclusion that he might be better off at the RA Schools. After winning the RA gold medal in 1879, he completed his studies at the École des Beaux -Arts in Paris under Jean Léon Gérôme, an eminent historical artist who was violently opposed to the Impressionists, even though he remained a lifelong friend of Degas, who was not an Impressionist but exhibited with them sometimes. By the time he left Paris, La Thangue was completely dedicated to the *plein air* painting.

When he returned to England La Thangue opposed the RA in all its forms, seeing it as 'the diseased root from which all evils grow'. Preferring to live in the countryside rather than in London, he moved to the Norfolk Broads, then to Rye, Sussex, before he finally settled in Bosham. There he painted *The Return of the Reapers*, a favourite subject with Victorian painters of the rural scene. Despite his dislike of the RA, he began exhibiting there regularly from 1891. Seven years later his *The Man With the Scythe* was bought by the Chantrey Bequest. This painting, which showed death in the guise of an old reaper with a scythe, combined all the elements of the French School of symbolic painting.

In 1898 La Thangue moved to Graffham, Sussex, where he painted a further series of scenes of farm hands at work, which gave him the opportunity to explore how he might use light and colour to the best effect. As the years passed the countryside began to change and was no longer the peaceful haven he had once known. However, he continued to paint the old rural way of life from memory. A superb example of his work, *The Fisherman*, is shown opposite. He was made an RA in 1912 and died in London on 21 December 1929.

REPRESENTED: BRADFORD, MAIDSTONE.

Henry Herbert La Thangue
The Fisherman
Oil on canvas, signed. 23 x 15in
Duncan R. Miller Fine Arts

Edward Ladell
Black Grapes etc. From Nature
Oil. 9½ x 11½in
Martin Ham

EDWARD LADELL
1821-86

Because of the enormous prices fetched by the work of many of the more famous Victorian artists in the auction rooms in recent years, art dealers have been forced to seek and promote lesser-known painters whose work can be bought and sold at reasonable prices. One of these 'discovered' artists is Edward Ladell, a still life artist whose paintings have become very popular since his work has been brought to the attention of the picture-buying public. Ladell's work is in the Dutch tradition of still life painting - a term derived, incidentally, from the Dutch words *still*

leven, which first came into use in the middle of the seventeenth century. Ladell painted the typical subjects of the still life artist - jugs, bowls and flasks, for example - but he also used marble ledges draped with an oriental rug, which enabled him to add extra colour to a painting. He exhibited regularly at the RA between 1856 and 1885, during which time he showed twenty-one paintings. Ladell was a first-class practioner of still life, but almost nothing is known about his private life except that he probably collaborated with his wife, Ellen Ladell, whose work is almost identical to his. They lived at an address in East Hill, Colchester.

The painting of inanimate objects has now become a branch of art that enjoys the same status as all other forms of painting, thanks partially to the Arts and Crafts movement which did much to overcome the prejudice against the portrayal of still life objects with their slogan 'a well-painted turnip is better than a badly painted Madonna'.

SIR EDWIN LANDSEER, RA
1802-73

The most famous of all the Victorian animal artists, Edwin Landseer was born at 83 Queen Anne Street, East London, the son of John Landseer, the engraver. As John Landseer had always been keenly interested in portraying animals in his engravings, it was inevitable that Edwin's first attempts at art were of sheep, goats and donkeys, which he sketched in nearby fields. Nine of the drawings he produced at the age of 5 are in the V & A. Landseer entered the RA Schools at the age of 13, and the following year he exhibited at the RA his first animal studies entitled *Portrait of a Mule* and *Portraits of a Pointer and Puppy*. There followed a long series of animal paintings and by the time he painted *The Old Shepherd's Chief Mourner* he had already reached the position where he could do no wrong in the eyes of the Victorian public. He made a number of visits to Scotland, which helped to establish the vogue for Scottish painting once his Highland scenes had

been seen in England. Queen Victoria became a great admirer of his work and gradually acquired a large collection of his paintings, as well as commissioning him to paint her dogs.

A less likeable aspect of Landseer's art were his comic animal paintings which the public seemed to demand of him, and which were part of the process he went through in his all-too-successful attempts to humanise animals in his work. In this deliberate pandering to the unexacting and often highly emotional taste of the Victorian public, he sacrificed his enormous talent on the altar of commercialism, which has led to a devaluation of his position among nineteenth-century artists. However, many of his paintings, especially *The Old Shepherd's Chief Mourner* which depicts a grief-stricken sheepdog mourning the death of his master, can still strike a responsive chord with animal lovers today.

Landseer's work was admired from the outset by the RA, and he was made an associate in 1826 when he was 24, the earliest age at which the rules of the institution allowed him to become an associate. He was made a Royal Academician in 1831 and knighted in 1851. The bronze lions which he modelled for Trafalgar Square were unveiled in 1867 and are his most important companion works. His last years were marred by illness and long bouts of depression. He died in St John's Wood and was buried in St Paul's Cathedral on 1 October 1873.

REPRESENTED: BOURNEMOUTH, BM, FITZWILLIAM, V & A, WOLVERHAMPTON

WALTER LANGLEY, RI, RBA, RWA
1852-1922

Although Walter Langley arrived in the Cornish fishing village of Newlyn in 1882, two years before Stanhope Forbes (see entry), he was never regarded by the critics of the time as one of the major Newlyn artists. Among the reasons for this was that Langley was a watercolour artist and therefore received little attention from the critics, who still regarded watercolour painting as an

inferior art form to oil painting. Another reason may have been that Stanhope Forbes did not initially like Langley and was always somewhat condescending about his work. Even when Langley did venture into oils with his *Sunshine and Shadow*, which was bought for the Tate Gallery, Forbes sourly commented: 'Langley is only commencing in oils so he can come prying in here to see how my work gets done.' Stanhope Forbes was probably jealous of Langley and saw him as a rival to his previously undisputed position as leader of the Newlyn artists. (To be fair to Forbes, he never claimed to have founded the Newlyn School, but he was certainly the driving force behind it and did much to promote the work of some of the artists, although Langley was not among them.) Although Langley joined in all the social activities and played the banjo at their concerts, he was never part of the group, partly because he was older than the other artists and partly because he was from a different social background, being born the son of a humble tailor and an illiterate mother.

Langley's mother was the driving force behind his struggle to become an artist. She arranged for him to be apprenticed to a local lithographer when he was 15. After finishing his apprenticeship, he studied at the Kensington Schools and then became a partner in the firm of lithographers where he had taken his apprenticeship. Later he decided to take up painting as a career. By 1882 he had married and was settled in Pembroke Lodge in Newlyn - a cottage which no longer exists. He was elected an RI in 1883 and had begun to exhibit in London from 1880 and continued to do so until 1919, although his work had begun to deteriorate long before that. His genre painting *But oh for the Touch of a Vanished Hand*, which was exhibited in 1888 and is now in the Birmingham Art Gallery, led Forbes to comment 'very bad indeed - a great falling off'. The last word on his paintings perhaps belongs to Henry Tuke (see entry) who described Langley as 'I should think the strongest watercolour man in England'. *Awating the Return of the Fishing Fleet*, illustrated opposite, was painted in Newlyn and shows his realistic style.

REPRESENTED: BIRMINGHAM, LEICESTER, PENZANCE.

Walter Langley
Awaiting the Return of the Fishing Fleet
Signed watercolour, approximately 24 x 45in
Brian Sinfield

SIR JOHN LAVERY, RA, RSA, RHA
1856-1941

Although he was born in Belfast, John Lavery was brought up in Scotland, where he became one of the Glasgow Boys at the beginning of his career. One of the most cosmopolitan of the group, he trained at Heatherley's Academy in London and afterwards painted a number of costume pieces before he completed his studies in Paris at the Académie Julian under Adolphe Bouguereau, who had been a pupil of David, and continued the tradition of French classical painting until the end of the nineteenth century. As his main interest at the time was in *plein air* painting, which was outside the interest of the French *atelier* system, he took advantage of the summer recess to go to Grès-sur-Long where there was an artists' colony whose members were mostly keen supporters of Bastien-Lepage, who had enthusiastically promoted *plein air* painting after it had become central to the work of the Impressionists.

By 1888 Lavery's reputation was already sufficient for him to be commissioned to paint a picture

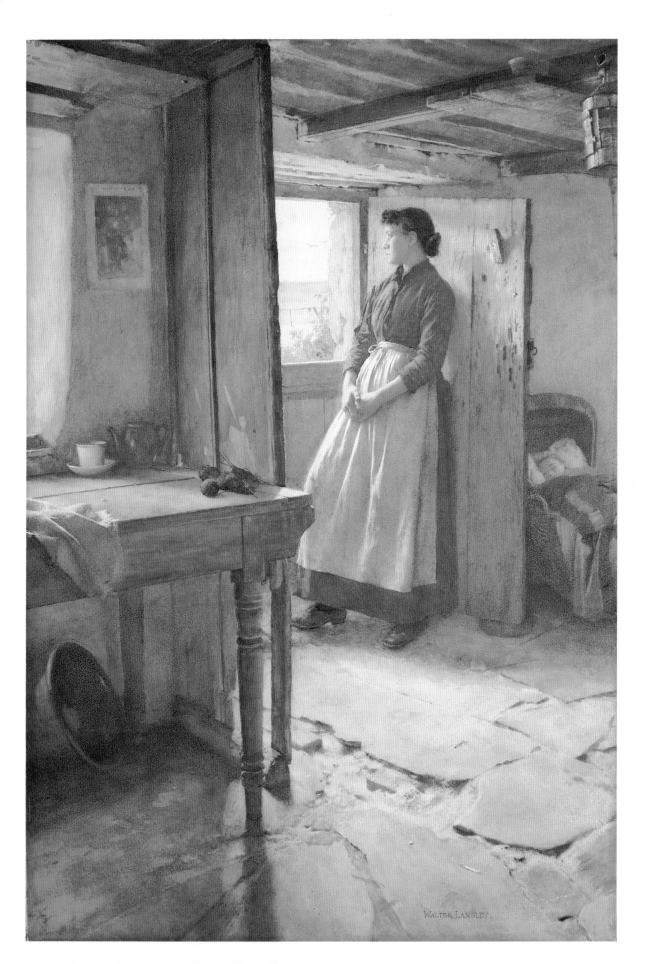

WALTER LANGLEY.

to commemorate Queen Victoria's impending visit to Glasgow. It was a tremendous task since 250 miniature portraits had to be included in it. The picture took him three years to complete and did much to advance his career.

In 1890 Lavery made the first of several visits to Morocco and eventually bought a house outside Tangier where he retreated each year for the winter. The subjects he painted while he was in Morocco were eventually exhibited in London and received a great deal of praise from the critics.

In 1890 Lavery moved to London, where he borrowed a studio from Alfred East (see entry) and turned his attention to portrait painting, while busying himself with various activities, among them helping to mount an exhibition of art which included paintings by Manet and Degas.

By the time World War I broke out, Lavery was an international artist whose work had been exhibited successfully in New York and all over Europe, and in the selection of official war artists, he was automatically chosen. It was a period which culminated in his painting *The Arrival of the German Delegates on HMS Queen Elizabeth, 1918*. This work, which shows the signing of the surrender of the German Navy, is now in the possession of the Imperial War Museum. Lavery was knighted in 1918 and made an RA in 1921. He died in Ireland, loaded with honours, which included his election as a member of the Société des Beaux -Arts, a Cavaliere of the Crown of Italy and Vice -President of the International Society of Sculptors, Painters and Gravers under Whistler. A year before his death in 1941 he published his memoirs, *The Life of a Painter*.

The Beach, illustrated here, fetched £24,000 at auction in 1984.

REPRESENTED: ABERDEEN, IMPERIAL WAR MUSEUM (59).

John Lavery
The Beach
Oil on canvas, signed and dated 1912
on reverse
Spink

Benjamin Williams Leader
The Bird Cage
Oil, signed B. Williams and dated 1856
20 x 17in
Sotheby's, Sussex

BENJAMIN WILLIAMS LEADER, RA
1831-1923

A landscape and occasional painter of genre scenes (see left), Benjamin Williams Leader was enormously popular in his lifetime for reasons which are not always readily apparent. His work could be repetitive and, like so many other landscape artists, he often fell into the trap of painting uninteresting subjects. But, given the right subject, he could capture the 'feel' of the English countryside as few other artists could. One of his best paintings is *February Fill-Dyke*, a study in oils of a bleak stretch of the countryside after a heavy downpour. As a piece of atmospheric painting it rivals anything done by Atkinson Grimshaw (see entry). This huge canvas, which measures 27½ x 71½in, is now owned by the Birmingham City Art Gallery.

Leader was born in Worcester, the son of E. Leader Williams. He reversed his second Christian name with his surname so that he would not be mistaken for other members of the Williams family of painters. He studied at the Worcester School of Design and completed his studies at the RA Schools. He began to exhibit there in 1853, and continued until the age of 91, only a year before his death. He found most of his subjects in the Midlands and Scotland, and was especially fond of painting around Betws-y-Coed in North Wales, an area made famous by David Cox (see entry). Leader may not have been the best painter his era produced, but his lifelong devotion to art deserves respect.

Represented: BIRMINGHAM

EDWARD LEAR
1812-88

Edward Lear is better known for his 'Nonsense' poems than for his landscape paintings. The youngest of twenty-one children, he was born in Holloway, London, and by the age of 15 he was already producing small pictures of birds, which he sold for prices ranging between 9d and 4s. When he was 19 he became a draughtsman at the

Zoological Gardens and in the following year published a book of coloured ornithological drawings done on a large scale, which was the first of its kind to be published in England. The book brought him to the attention of Lord Derby, who was considering writing an ornithological book of his own. He took Lear with him to his estate in Knowsley in Lancashire, where Lear spent the next four years producing the bird illustrations for Derby's privately printed *Knowsley Menagerie*, which is now a very rare and expensive book. Through Lord Derby, Lear acquired a large number of contacts and was able to set up on his own as a drawing master. By 1846 he was teaching art to Queen Victoria. It was during this time that he produced his *Book of Nonsense*.

Lear had begun to travel widely from 1835 and in 1846 he published his *Illustrated Excursions to Italy*, which he dedicated to Lord Derby. His excursions to Greece, Albania, Sicily, Malta, Corsica, Palestine, Syria and Egypt were all systematically recorded in an enormous number of sketches and paintings, including the oil *Philae*, painted in 1873, which is reproduced below.

Lear's output was prodigious, especially as he suffered from ill health. In a working period of twelve months he produced 470 sketches and occasionally he tried to gain academic recognition by painting in oils from them, but his work received little attention from the critics. When he died he left more than ten thousand cardboard sheets of sketches, some of them no more than hurried scribbles, others detailed coloured drawings, which are now eagerly sought. Lear's one regret was that his paintings never achieved the success of his Nonsense poems.

REPRESENTED: ASHMOLEAN, BM, GLASGOW, STOKE-ON-TRENT, V & A.

Edward Lear
Philae
Oil on canvas, signed with
a monogram and dated 1873
91 x 18¼in
Spink

JOHN INGLE LEE
fl. 1868 91

A little-known figure painter who worked in oils, John Ingle Lee is an example of how a good artist became lost among the large number of talented artists who flooded the market with their work during the Victorian period. His oil *Home*, with its red-haired Madonna-like figure dominating the painting, could have been produced by one of the Pre-Raphaelites, and was clearly painted under their influence. It could be said to be a fair example of his work (see opposite).

A London-born artist who lived at Sunnycote, Hampstead Hill Gardens, Lee's work was largely ignored during his lifetime.

ALPHONSE LEGROS, RE
1837-1911

After an unsuccessful career in France as a painter of peasant genre pictures, Alphonse Legros came to England in 1863 at the suggestion of his friend Whistler. He became a teacher at the Slade School of Art, and in 1876 was appointed professor to succeed Sir Edward Poynter (see entry), a post he held until 1892. His work in England ranged from landscapes to strange and highly imaginative paintings which owed a debt to the German medieval masters. Legros' work had a great influence on English art, especially etching, and became the main link between the French and English *avant garde* painters, although his main influence was in the graphic field. He taught etching at the RCA and in 1876 he became Professor of Fine Art at the Slade. He was also a founder member of the Royal Society of Painter Etchers.
REPRESENTED: IPSWICH, SUNDERLAND.

LORD FREDERICK LEIGHTON, PRA, RWS
1830-96

The acknowledged leader of the Victorian classical school of painting, Frederick Leighton was born in Scarborough, the son of a doctor. Unlike most major artists of the nineteenth century he did

John Ingle Lee
Home
Oil on canvas, signed and dated 1869. 31½ x 21in
Cambridge Fine Art

not study at the RA Schools, but received his training in Brussels, Paris and Frankfurt. In 1852 he went to live in Rome, where he moved in a large artistic circle which included Thackeray, Robert Browning and some of the most important French painters of the time. On his return to England in 1855, his historical painting *Cimabue's Madonna Carried in Procession through the Streets of Florence* was shown at the RA, where it received a rapturous reception from the critics and was later bought by Queen Victoria. It was the start of what was to be a glittering career that took him to the very heights of his profession.

Lord Leighton settled in London in 1860 and was made an RA in 1868, when he turned to painting subjects from mythology. His decision to abandon historical paintings coincided with a sudden upsurge of interest in Hellenism; even women's evening wear was influenced, Greek gowns that gave women a new-found freedom of movement becoming fashionable. Leighton suddenly found himself the centre of attention, with his paintings the talk of London. He began to move in the best social circles where he was looked upon as a sort of *wunderkind*. And indeed everything seemed to be in his favour. He was good-looking in a flamboyant way, and was well-educated, well-travelled and a brilliant linguist and of course, he could paint extraordinarily well. It was hardly surprising, therefore, that the public should take him to their hearts and treat every exhibition he held as a major event. He was elected President of the Royal Academy in 1878, and became a baron in 1896, the only English artist to receive this honour. But by then he was a sick man who was suffering from angina. He died in 1896 and after lying in state at the RA, he was buried in St Paul's Cathedral. His will included a bequest of £10,000 to the Royal Academy.

Although at the time of his death Leighton was

something of a national institution, his reputation quickly declined and his work and all that he stood for became objects of derision. For that we must blame perhaps the changing tastes of the public who lost interest in classical art which had been painted mostly by pretentious and stuffy old men who were obsessed with the dead worlds of antiquity.

REPRESENTED: ASHMOLEAN, BM, LEIGHTON HOUSE (LONDON), V & A.

the colouring was always subtle and harmonious; *The Trysting Place*, shown below, which is full of poetic feeling and captures a hot summer's day, is a typical example of his work. Among his most evocative paintings are *A Summer's Evening, Beneath a Willow left Afloat, Amidst the Dew* and *Evening on the Thames: Dew Rising*.

Lewis lived at Cheyne Row in London from 1859 to 1884, and then at Cheyne Walk until his death after a long and painful illness.

REPRESENTED: BEDFORD.

CHARLES JAMES LEWIS, RI
1830-92

A painter in oils and watercolours of landscape and genre scenes whose work was very popular in his lifetime, Charles James Lewis' work first appeared at the RA in 1853; he continued to exhibit there until 1890, when a total of forty pictures had been shown. He was a hard-working and prolific artist who painted many attractive scenes in which

Charles James Lewis
The Trysting Place
Oil on canvas, signed. 20 x 36in
Private collection

JOHN FREDERICK LEWIS, RI, HRSA
1805-76

Born in London, John Frederick Lewis was the son of an engraver, Frederick Christian Lewis. As he studied with Edwin Landseer it is not surprising that his first assays in art were in animal painting, which brought him under the patronage of Queen Victoria. It was not until Lewis went to Spain in 1832 that his style and subject-matter underwent a dramatic change. Apart from the Carlist wars, which provided many subjects, he now painted in brilliant, hard, jewel-like colours that sparkled with light, as a result of which he became known as 'Spanish Lewis'. From 1838 to 1841 he lived in Rome and Greece and then went to Cairo, where he stayed for the next ten years.

Lewis seems to have gone 'native' in Cairo, for when the novelist Thackeray visited him he found the artist living in sumptuous oriental surroundings and dressed in a costume befitting a bey, with

Charles Sillem Lidderdale
Temptation
Oil on canvas. 28 x 37in
City Wall Gallery

a Damascus scimitar at his side. During this period he did not exhibit a single picture and it was generally assumed that he had become a victim of a pervasive lethargy that had robbed him of the will to work. When he returned to England in 1851 the colder climes of the country seemed to galvanise him into action, and in the same year he exhibited *The Harem*. The brilliant colouring and the high finish to this watercolour caused a sensation and earned him lavish praise from John Ruskin. He followed this *tour de force* with a series of oriental scenes which established him as

one of the finest, if not *the* finest, painter of the Far East.

It was not until Lewis' death in Walton-on-Thames in 1876 that it was discovered that he had not been as idle as everyone had supposed during his ten years in Cairo. Among his effects were a large number of highly finished sketches which had obviously been drawn while he was abroad. Ruskin, in his usual authoritative way which brooked no argument, always spoke of Lewis' work with almost unqualified praise. Today, we perhaps see his work as brilliant essays in colour and light which accurately capture a scene in a near photographic way, while never really catching the sights and smells of the real Far East. Even his most famous painting, *The Harem*, surely portrays a glamourised view of life in the orient, rather than reality.

REPRESENTED: BIRMINGHAM, BLACKBURN, FITZWILLIAM, LIVERPOOL, MANCHESTER, V & A.

CHARLES SILLEM LIDDERDALE, RBA
1831-95

A genre artist who lived at 39 Alma Square, St John's Wood, London, for a part of his life, Charles Sillem Lidderdale belonged to the old school of genre painting in which the picture told a story, very much in the style of Thomas Faed's paintings (see entry). He exhibited thirty-six paintings at the RA between 1851 and 1893 and twenty-five at the SS, as well as at a number of the leading London galleries. His domestic subjects were painted in watercolours and in oils; they were well executed and typical of their period, with his characters portrayed on canvas in posed positions, as in *Temptation* which was exhibited at the RA in 1868 (see p189). His paintings include *Beauty and the Beast, Waiting for the Boats, The Maid and the Magpie* and *Waiting at the Stile* - all self-explanatory titles.

W. Stuart Lloyd
Tal-y-Cafn, Near Conway, North Wales
Watercolour, signed. 19½ x 39½in
David James

JOHN LINNELL
1792-1882

A landscape painter of considerable importance, John Linnell was born in London, where his father was a picture dealer and wood carver. He painted his first landscape at the age of 12 when he came to the attention of Benjamin West, the American historical artist who visited England and liked it so much that he made it his home. It was under his patronage that Linnell went to the RA Schools in 1805. Afterwards he studied under John Varley, the landscape painter who numbered David Cox and Copley Fielding among his pupils, but who was to end his days in poverty.

For some years Linnell relied on portrait painting to earn his living, but he was working at a time when landscape painting was becoming very popular and he established himself as a considerable landscapist. His reputation as a landscape artist lasted well beyond the time that he moved from London to Redhill in Surrey, by which time he had married and acquired Samuel Palmer (see entry) as his son-in-law. He lived in Surrey for another thirty years, painting scenes of the surrounding countryside. Much of his work was produced in a distinctive brown tone, as in *The Gleaners' Return*, illustrated on p190. He was proposed as an ARA but withdrew his name and refused ever to have it resubmitted.

REPRESENTED: ASHMOLEAN, BRADFORD, BM, FITZWILLIAM, LEEDS, LIVERPOOL, NEWPORT, ULSTER.

John Linnell
The Gleaners' Return
Oil on panel, signed and dated 1855-7.
13 x 18in
Spink

W. STUART LLOYD, RBA
fl. 1875-1929

Although W. Stuart Lloyd was a watercolourist producing both marine and landscape scenes, his best paintings were landscapes, all of which are pleasant and restful to look at, as, for example, his

watercolour illustrated on p191, in which the draughtsmanship is sound and the colouring pleasing. His marine paintings are another matter and often look like bad examples of Thomas Bush Hardy's work (see entry). Whatever his failings might have been as an artist - and they were few compared to some - Lloyd still succeeded in having 40 of his paintings exhibited by the RA. A prolific artist, who also exhibited another 168 pictures at the RBA and 56 at the RI, his work falls into the middle price range with dealers who seem to have no difficulty in selling his work.

Lloyd ranged fairly widely for his subjects, which include *The Thames at Wargrave, A Devonshire Hamlet, In the Isle of Wight, Rye, Sussex, Broadstairs from the Sands*, and *Evening, Polperro*. His paintings seldom sold for less than £45-£50 during his lifetime, which was a good price in those days and would seem to indicate that he was a popular artist.

Lloyd lived for some years at 10 Fitzroy Square, London, and at other addresses in the city before he moved to Sussex. He lived in Brighton from 1909.

Victorian was, his was just the sort of picture they wanted to see, and his paintings sold well - which probably accounts for the reason that while he was working in London he was able to live in Fitzroy Square, one of the fashionable areas of the city to which many up-and-coming artists gravitated. By the end of the century his work was less popular.

With the resurgence of interest in Victorian painters that occurred in the 1960s, Lloyd's work has enjoyed renewed popularity, and he ranks alongside Thomas MacKay, William Gosling, Henry Kinnaird (see entries) and Arthur Winter Shaw for art lovers who cannot afford to buy, for example, a Birket Foster.

Little is known about Lloyd except that he exhibited at the RA and lived at several addresses, in London, Kent and Sussex. He is more commonly known as Tom Lloyd.

REPRESENTED: CARDIFF, GATESHEAD, GLASGOW, SHIPLEY.

THOMAS JAMES LLOYD, RWS
1849-1910

A London-born landscape artist, Thomas James Lloyd was a watercolour artist who painted attractive country scenes, generally featuring a child and mother in an idyllic country setting. Like so many nineteenth-century rural artists, he painted a sanitised version of the countryside in which the truth was often sacrificed in the interests of painting a pretty picture. Starved of colour as the urban

Thomas James Lloyd
A Summer Afternoon with Grandma
Watercolour, signed and dated 1899. 11½ x 27½in
Brian Sinfield

ALBERT LUDOVICI, Snr, RBA
1820-94

Although a French artist who spent much of his time in Paris, Albert Ludovici lived for some years in London at 2 Upper Albany Street, off Regent's Park. He exhibited a great number of genre paintings in this country, mainly at the SS, where he showed 224 pictures, as well as another 26 at the RA between 1880 and 1897. A painter of varying quality, as with so many artists whose output was large, his work is probably less known than that of his son, Albert, who painted under Whistler's influence. Ludovici Snr's subject-matter was wide-ranging and included such titles as *The Flirt, From the Bavarian Highlands, A Tiger Hunt*, and *The Strolling Savoyard*, which is shown on p194.

NEVIL OLIVER LUPTON
fl. 1851-77

Although he was a competent artist, Nevil Oliver Lupton is not as well known as many other Victorian painters. Born in London in 1828, he lived for some time at Kepple Street, near Russell Square, before he moved to Hertfordshire. He exhibited 42 pictures at the RA between 1851 and 1877, as well as another 62 paintings at the other major London galleries between those dates, nearly all of them being landscape and rustic genre pictures. In the *Art Journal* of 1860 he was praised for his painting of foliage, which seems to have been a feature in his work as is seen in his watercolour on p195, in which the foliage has been carefully delineated. His paintings include *A Watermill near Box Hill, Surrey, Returning from the Market*, and *Haymaking in the valley of the Colne*.

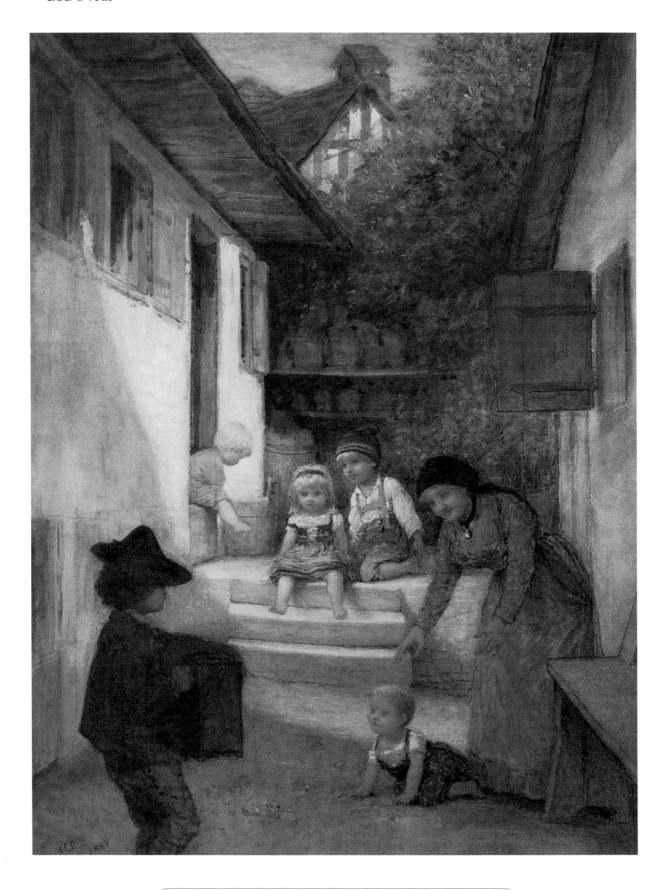

A COMPANION TO VICTORIAN AND EDWARDIAN ARTISTS

Albert Ludovici
The Strolling Savoyard
Oil on canvas. 21 x 16in
Angela Hone

SAMUEL McCLOY
1831-1904

An Irish painter of genre and figure subjects, Samuel McCloy was born in Lisburn, County Down, and was apprenticed to a firm of engravers in Belfast before he studied at the Belfast Government School of Design, where he won a number of prizes. Obviously he must have shown great promise as he was sent to the Training School for Masters at South Kensington. He left the training school in 1854 to become Master of the Waterford School of Art, where he received a salary of £140 per annum. Bearing in mind that he was the only teacher in the school and that he took morning and evening classes, this was a meagre salary. In 1865 he married one of his pupils, the 20-year-old Ellen Lucy Harris, who bore him nine children.

Around 1874 the McCloys moved to Belfast, where they lived at 9 Magdalen Street, a large three-storied house near the university. Although

Nevil Oliver Lupton
The Summer Picnic
Watercolour, dated 1887. 16 x 24in
Priests

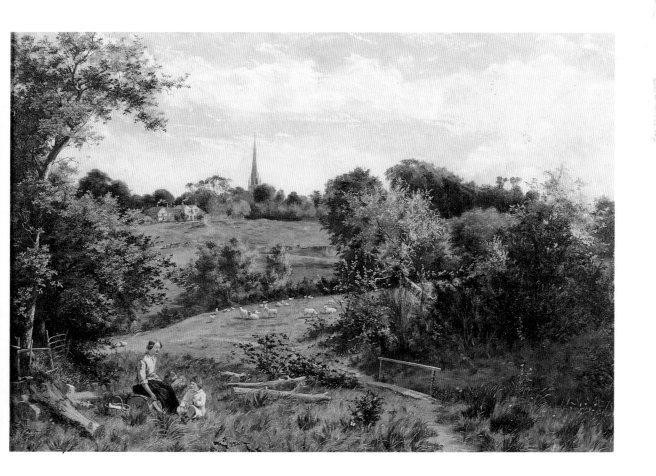

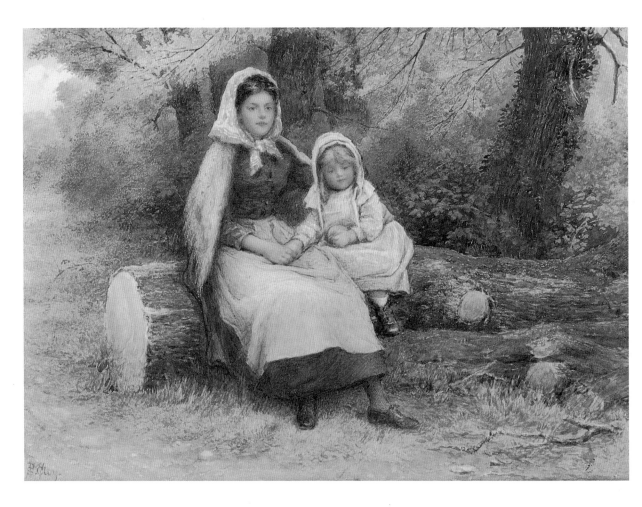

Samuel McCloy
A Seat in the Woods
Watercolour. 9½ x 13in
Fine Lines (Fine Art)

McCloy continued to paint, his main income was from painting figures for illuminated addresses, designing Christmas and greetings cards, and supplying illustrations to Marcus Ward, a well-known Belfast publishing firm. He also designed damask table-cloths for a local firm, but eventually he gave this up as he found the work uninteresting. He also produced many watercolours for an art gallery in London and worked as an illustrator for the *Illustrated London News*. In addition, between 1874 and 1884, he exhibited at the Royal Hibernian Academy and the RBSA.

When an uncle of McCloy died and left him a property at 47 Solon New Road, Clapham, the family moved to London. Strickland's *Dictionary of Irish Artists* records that the family lived there in 1881, but this seems to be incorrect. According to family sources, they moved to England in 1884. Since one of the main reasons that McCloy moved to London was to be near the art galleries in the

city, it is ironic that he exhibited there only very occasionally. By all accounts he was a friendly and jovial man who enjoyed playing games with his children and he often used them as models, bribing them to sit for hours with offers of a farthing or half-penny reward. A typical example of his genre painting is shown left. He died at 117 Fernlea Road, Balham, having been unable to work for the last year of his life owing to ill health.

REPRESENTED: BELFAST, HAWORTH, V & A.

where he painted, rural life had been largely unaffected by the spread of trade unionism, which had become a major force in the lowlands of England since 1870. His watercolour of a pair of farm hands bringing in the last of the harvest was painted in 1890 (see below) and was probably painted in Cornwall, then a remote part of the country where the National Agricultural Labourers' Union had so far been unable to reach.

REPRESENTED: BLACKBURN, LIVERPOOL, WHITBY.

JOHN McDOUGAL
exh. 1880-1934

A Scottish artist who lived in Liverpool for many years before he moved to Anglesey in 1900, John McDougal was a landscape and marine painter who exhibited 26 paintings at the RA, 88 at the RCamA and a number at various important London galleries. He painted widely in Devon, Cornwall and Wales, including Anglesey, where he lived at Caemes Bay, near Amlwch. In the areas

John McDougal
Untitled watercolour, signed and dated 1890
17¼ x 29in
David James

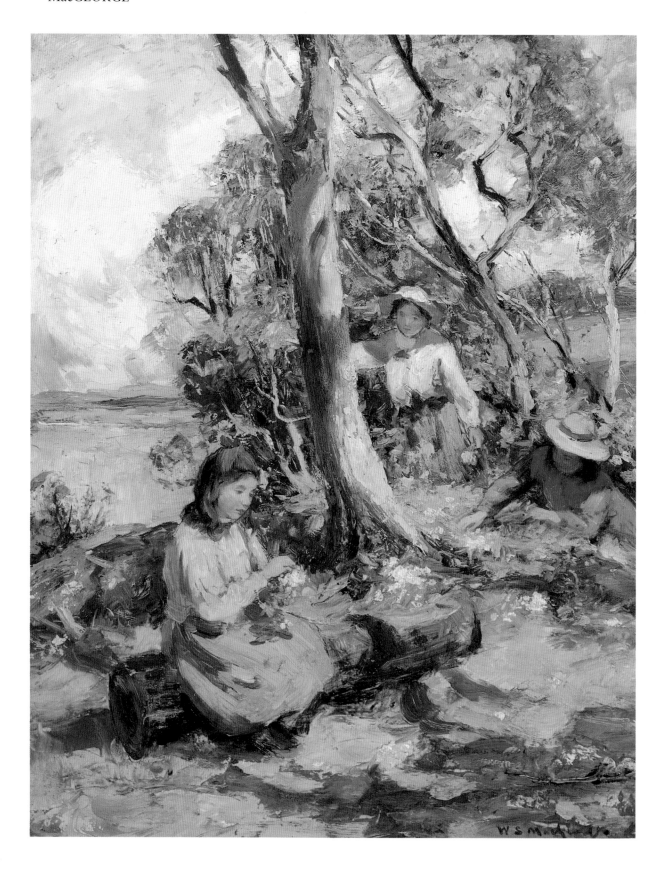

A COMPANION TO VICTORIAN AND EDWARDIAN ARTISTS

William Stewart MacGeorge
The Primrose Gatherers
Oil on canvas, signed and dated 1917. 12 x 16in
Priory Gallery

WILLIAM STEWART MacGEORGE, RSA
1861-1931

The Scottish artist William Stewart MacGeorge was born in Castle Douglas. He studied briefly at the Royal Institution School of Edinburgh, and then went to Antwerp, where he became a pupil of Charles Michel Verlat, the Belgian realist painter who was also teaching Edward Hornel at the time. When Macgeorge returned to Scotland it was to paint in Kirkcudbright, which Hornel had made his home and where he was busy refining his highly personal style (see entry). He began to work under the influence of Hornel's vivid and slightly garish style, although his own work was more low toned and his colouring more varied. Like Hornel, he tended to concentrate on painting studies of children playing in the sun-dappled woods, although occasionally he turned for inspiration to the ballads and folklore of the Borders, painting such pictures as *She Sought him East, she Sought him West* and *The Water-Kelpie*, which were both painted between 1889 and 1900. His studies of children at play included *When the Summer Days were Fine, A Turnip Lantern* and *Hallowe'en.* He exhibited 8 paintings at the RA and 148 at the RSA. *The Primrose Gatherers*, illustrated opposite belongs to the period when MacGeorge was painting at Kirkcudbright under the influence of Hornel, and provides an excellent opportunity to see how their styles varied.
REPRESENTED: GLASGOW INSTITUTION, LIVERPOOL, MANCHESTER.

THOMAS MacKAY
fl. 1898-1913 (died 1916)

Thomas MacKay was a late Victorian artist from Scotland who went to live in Liverpool and worked in semi-obscurity, leaving his studio in Littleton, Cheshire, to paint the countryside around Leamington and Warwick. In 1913, however, he suddenly became a local celebrity when an apprecia-

Thomas MacKay
The Young Angler
Watercolour. 6 x 9in
Priory Gallery

tion of his work appeared in the Liverpool *Courier*. Even then, his work was not sought by dealers until the resurgence of interest in Victorian art in the 1960s, when there were not enough good paintings for sale to supply the sudden demand for genre subjects. Suddenly art buyers became aware that Thomas MacKay's landscapes were worth collecting. Since then his work has been in constant demand. His style is immediately recognisable, a hazy blue being the predominant colour, which gives much of his work a poetic quality. Many of his scenes, including the one shown on p199, were painted along the same river bank, although surprisingly, his work does not become monotonous. Apart from appearing occasionally at the London galleries, his work was exhibited as far afield as Peru and South Africa.

PERCY THOMAS MACQUOID, RI
1852-1925

A painter in watercolours of genre pictures, Percy Thomas Macquoid was the son of Thomas Robert Macquoid, the architectural painter and illustrator. He was educated at Marlborough and studied art at Heatherley's, the RA Schools and in France. He began his career in 1871 when he went to work on the *Graphic*, concentrating first on animal subjects, until he changed to painting genre and historical subjects. He also contributed frequently to the *Illustrated London News*, and did a set of illustrations for *The Bridal of Triermain*, a lengthy narrative poem by Sir Walter Scott.

Among his other interests Macquoid designed costumes for the theatre and was an expert on furniture. In 1905 he produced a four-volume set of books on the subject, entitled *The History of English Furniture*. He is mentioned in an important book, *English Influences on Vincent van Gogh*, which was published by the Arts Council in 1974. An example of his work is shown on the opposite page.

WILLIAM McTAGGART, RSA, RSW
1835-1910

William McTaggart was born on a little farm at Aros, within sight and sound of the Atlantic, and was educated in Campbeltown. Although he became apprenticed to a local apothecary, he was already set on pursuing a career in art, which led him to become one of Scotland's major painters of coastal scenes, as well as a first-class landscape artist. He studied at the Trustees' Academy in Edinburgh, which was then under the directorship of Robert Scott Lauder, a painter of historical and biblical scenes who had done much to advance the reputation of the academy. McTaggart trained for seven years at the academy before he was qualified to earn his living as an artist.

In a sense, McTaggart was one of the first *plein air* artists in this country and was most certainly one of the best. Not even Turner could match his ability to capture the shifting patterns of light over land and sea, nor for that matter his treatment of certain aspects of nature in his countryside scenes. He exhibited at the RSA from 1853 and at the RA from 1886. His worth as an artist was recognised early on in his career in Scotland, but much more slowly in England, where he is now accepted as a major Scottish artist.

REPRESENTED: ABERDEEN, EDINBURGH, GLASGOW, NGS.

JOHN McWHIRTER, RA, HRSA, RI, RE
1839-1911

A landscape painter who worked in oils and watercolours, John McWhirter was born in Slateford, near Edinburgh, and was apprenticed to a firm of booksellers at the age of 13. He disliked his work so much that he left five months later and entered the Trustees' Academy, where he became a close friend of McTaggart, who was also studying there (see entry). He emerged from the school as a landscape artist who painted with great expertise and clarity, and whose work was typical of its period and sometimes a little too pretty for its own good. In 1869 McWhirter

Percy Thomas Macquoid
On the Cliff Top
Watercolour, signed and dated 1883. 10 x 14in
Priory Gallery

settled in London. He travelled a great deal and in 1892 his painting *June in the Austrian Tyrol* was purchased by the Chantrey Bequest. His early Scottish scenes, which were painted in his native surroundings, remain his best work. He exhibited 126 paintings at the RA and also at many other established galleries.

HELENA J. MAGUIRE
1860-1909

Helena Maguire was the daughter of Thomas Hebert Maguire, the well-known historical painter, who also produced lithographs of the royal family which were very popular at the time. She was also the sister of Adelaide Agnes Maguire, a painter of genre pictures and flower studies. Helena Maguire exhibited in Birmingham and Liverpool, at the RA and at most of the other major London galleries from 1881 to 1902. She produced a number of illustrations for children's books. Although she was influenced by Birket Foster, she still retained her own distinctive style that makes her paintings immediately recognisable.

Maguire's genre paintings were always produced in watercolours; reflecting the art-buyers' demands of the Victorian period, they were very sentimental, much in the style of Birket Foster, but far less monotonous as her range of subjects was far wider. Apart from painting pretty rural scenes, she often painted interiors, such as *Her Favourites*, which is typical of any Victorian urban household (see illustration, p202).

Helena Maguire
Her Favourites
Watercolour, signed. 18½ x 13½in
Fine Lines (Fine Art)

HARRINGTON MANN, RP, RE, NEAC, NPS
1864-1937

A Scottish artist who was born in Glasgow, Harrington Mann began his studies in his home town, then trained under Alphonse Legros (see entry) at the Slade School of Art, and finally went to Paris where he studied under Leon Boulanger, a popular romantic artist of the period. He lived in Italy for a while, where he painted a number of realistic pictures of Italian peasants.

Mann began to exhibit his work at the RA and other major London galleries from 1885, and first attracted serious attention with his scenes of Yorkshire fishing villages and a number of paintings that illustrated scenes from the works of Walter Scott.

Moving to London in the 1890s he soon established a wide reputation for his portraits of members of high society, which were painted in the style of Sargent. *The Blue Sash*, illustrated opposite, is thought to be a portrait of Countess von Arnim. He was so successful, in fact, that he was able to maintain an additional home in New York, where he died in 1937.

Mann's daughter, Kathleen, painted portraits and flower studies and married the Marquis of Queensbury in 1926.

Harrington Mann
The Blue Sash
Oil on canvas, signed. 48 x 39in
Bourne Gallery

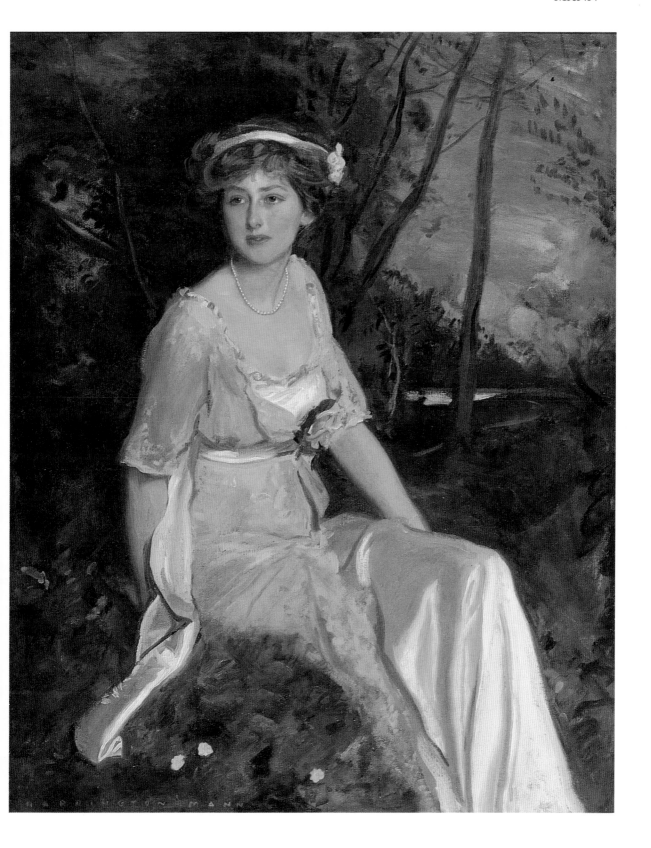

WILLIAM HENRY MARGETSON, RI, ROI
1861-1940

A landscape, genre and figure painter who also did a large number of book illustrations, William Henry Margetson was born in Denmark Hill, London, and was educated in Dulwich College before studying at the South Kensington and RA Schools. He lived and worked in Wallingford, Berkshire, and exhibited from 1881, mainly at the RA, and at the ROI and RI. His forte in book illustrations was for adventure stories of writers like G. A. Henty, Stanley Weyman and Herbert Strang, now almost forgotten names, but best-sellers in their time.

Margetson also worked for *Cassell's Family*

William Henry Margetson
Afternoon Tea
Oil on canvas, signed and dated 1925.
32 x 24in
Priory Gallery

Magazine, the *Graphic* and the *Pall Mall Magazine*. His daughter, Helen Howard Hatton, was also a painter in pastel and watercolours (see entry). *Afternoon Tea*, illustrated opposite, is a superb example of his work as a figure painter, and captures the atmosphere of the 1920s in this study of a young woman waiting for a companion to join her in one of those genteel tea-rooms that were so popular during that period.

ROBERTO ANGELO KITTERMASTER MARSHALL
1849-1923

A London landscape artist who painted in oils and watercolours, Roberto Kittermaster Marshall was the son of Charles Marshall, the highly esteemed landscape painter, and the brother of Charles Marshall jnr, also a landscape painter. Although the critics did not hold either son in the same regard as their father, both were sound craftsmen, especially Kittermaster Marshall, who could portray light with sensitivity, as in his watercolour shown left. He studied under his father and exhibited at the RA and elsewhere from 1867 to 1902, and painted mostly in Gloucestershire, Hampshire, Sussex and Warwickshire. He was essentially a watercolour artist who produced a number of attractive scenes in that medium, such as *On the Little Stour, Worcestershire; Summer Time on the River Test, Hampshire*; and *Rain Cloud over Ebrington*. From 1902 he lived at Herstmonceaux, Sussex.
REPRESENTED: V & A.

Roberto Angelo Kittermaster Marshall
Untitled watercolour. Size not available
David James

Arthur Joseph Meadows
Unloading the Catch
Watercolour, signed and dated 1877. 18 x 32in
The Hallam Gallery

THOMAS FALCON MARSHALL
1818-78

A Liverpool genre artist who painted homely country scenes, Thomas Falcon Marshall's paintings of peasants harvesting, horses, cattle and all the other aspects of farm life were better than many others of that period. Marshall won a painting entitled *Dorothy Vardon*, by William Frith, in the Liverpool Academy Art Union lottery, and it was this painting that made him a great admirer of Frith's work. He was often very helpful towards his fellow artists, but had little or no sympathy for the work of the Pre-Raphaelites.

He began to exhibit at the RA in 1839 and during his lifetime had about sixty paintings hung in the Academy. One of the earliest records of his achievements is the silver medal he was awarded by the Society of Arts in 1840. Two of his best-known paintings are *The Parting Day* and *Sad News from the War*. The Victoria and Albert Museum owns *The Coming Footstep*, which is signed and dated 1847.

On meeting a friend who commented on his healthy appearance, Marshall told him: 'I'm not really well. I'm dying of an incurable complaint.' A few months later he died at the age of 59 at his flat in Kensington.

A COMPANION TO VICTORIAN AND EDWARDIAN ARTISTS

ARTHUR JOSEPH MEADOWS
1843-1907

A marine artist who was greatly influenced by Clarkson Stanfield, Arthur Joseph Meadows is generally considered to be the best of the Meadows family of marine artists. The father of James Edwin Meadows (see entry) and the brother of James jnr, he exhibited at the RA between 1863 and 1872. Although it is not in the same class as that of Clarkson Stanfield, Meadows' work compares very favourably with most of the major nineteenth-century maritime painters. Unlike the painters of the Dutch School, whose waves generally march in orderly procession across the canvas, Meadows produced seas which look as if they might be subject to all the vagaries of the tidal forces. In common with all good marine artists, he had the ability to convey the depth and immensity of the ocean. His shoreline scenes with beached boats lying close to the water's edge, while fishermen unload their catch, were also very effectively executed, as in *Unloading the Catch*, illustrated above left.

REPRESENTED: THE OLD CUSTOMS HOUSE, LYMINGTON.

James Edwin Meadows
Fishing Boats Coming in to Shore
Oil on panel. 18 x 32in
Bonhams

JAMES EDWIN MEADOWS
1828-88

A London landscape artist who also painted a number of marine subjects, James Edwin Meadows was one of three sons who belonged to a painting family headed by James Meadows snr, a highly esteemed marine artist. All the family painted marine landscapes, and James Meadows exhibited twenty-six works at the RA and another fifty-five at the SS. Although his seascapes were well enough painted, he tended to distance the viewer from his subject, which leads one to suspect that he was weak on the intricacies of a ship's rigging (see his painting illustrated above).

(François) Pieter Ter Meulen
Sheep on a Winter's Morning
Watercolour, signed. 13¼ x 20½in
Fine Lines (Fine Art)

ARTHUR MELVILLE, RWS, ARSA, RWS
1855-1904

A Scottish artist who became famous for his scenes of life in the Middle East, Arthur Melville was born at Loanhead in Scotland, but was brought up in East Linton. From a very early age he was obsessed with the idea of pursuing art as a career, and at the age of 20 he entered the schools of the Royal Scottish Academy. He first exhibited at the Royal Scottish Academy in 1875 when he was painting rather dull scenes of Scottish life. By 1881 he was able to finance a trip to the Middle East. He was away for two years and returned with a large number of brilliant watercolours, including *The Call to Prayer* and *The Snake Charmer*, and many others which helped to establish his reputation as a colourful painter of Eastern scenes.

By the time that Melville returned to Scotland, the Glasgow School had appeared on the art scene. His impact on the movement was considerable, although he was too individual a painter to be known as a member of the group. Later, he went to Spain, where he painted a series of avant-garde pictures. His *Bravo Toro* and *Ronda Fair* are two

notable examples. He used colour boldly, almost experimentally, in his attempts to bring life to the scene he was painting; the results are strangely impressive. He contracted typhoid on one of his many trips to Spain and died at Witley, Surrey. REPRESENTED: ABERDEEN, BM, DUNDEE, FITZWILLIAM, GLASGOW, KIRKALDY, LEEDS, LIVERPOOL, V & A.

(FRANÇOIS) PIETER TER MEULEN
1843-1927

Pieter Ter Meulen was a Dutch artist who came to England to exhibit a large number of his pictures, as did Eduard Frere (see entry), and for this reason both artists occasionally rate a mention in the reference books on Victorian art. As little information on Ter Meulen is to be found in art books, the following may be of interest to anyone who comes across his work.

Ter Meulen was born in Bodegrave, Holland, and received his art education from H. and J. J. van de Sande Bakhayzen. His career did not begin in earnest until he settled in La Haye, where he came under the influence of painters such as Isaac Israels, Johannes Bosboom and Anton Mauve, who were all leading members of the Hague School of painters which flourished from 1860 to 1890. Despite all these influences on his work, he was still able to maintain a highly personal style, and like Thomas Sidney Cooper (see entry), he specialised in painting sheep against rural backgrounds. His paintings include *Shepherd and his Flock on the Dunes*, *The Return of the Flock*, *Young Herdsman and his Flock*, *The Passing of Spring*, and *Sheep on a Winter's Day*, one of the many watercolours that he exhibited in England (see illustration opposite). He exhibited in this country from 1882 to 1912.

Thomas Rose Miles
Coming Storm
(one of a pair) Oil on board, signed. 7 x 8in
Royal Exchange Art Gallery

THOMAS ROSE MILES
fl. 1869-88

When Thomas Rose Miles was painting his sea-scapes, going to sea was a hazardous operation for any fishing boat. Sudden gales could rip the sails to shreds and the sea could become a dangerous enemy once a storm had started to brew up. Miles was a master in capturing a wild sea on canvas and was probably the best nineteenth-century marine artist at painting this subject. In *Coming Storm*, a fishing lugger under reduced canvas is being driven before a stiff breeze, while the lowering clouds of an approaching storm hurry across the sky. Despite Miles' undoubted power as a marine painter, he exhibited only six paintings at the RA and another sixteen at the SS. He obviously earned a good living from his paintings, as he moved from his address in Kentish Town, London, which began to lose its social status in the 1880s, to 64 Charlotte Street, off Fitzroy Square, which became a popular district for many prosperous artists.
REPRESENTED: THE OLD CUSTOMS HOUSE, LYMINGTON.

SIR JOHN EVERETT MILLAIS, PRA, HRI, HRCamA
1829-96

The story of John Everett Millais and the Pre-Raphaelites is one from which none of the artists concerned emerged with their reputations unscathed. Millais himself, who acted the role of the persecuted and misunderstood artist throughout an episode that shocked the art world, sometimes showed a less than likeable side to his character, which art historians have accepted as merely the result of his fanatical devotion to his art, rather that as the actions of a supremely selfish man.

The early part of Millais' life was conventional. Born in Southampton but brought up in Jersey, he came to London with his parents in 1837 and entered Sass' Academy of Art the following year. He continued his studies at the RA Schools, where he formed a lasting friendship with Holman Hunt which was to change the course of his professional and private life. He first exhibited at the RA in 1846 at the age of 16. Millais' painting *Pizarro Seizing the Inca at Peru*, now in the V & A, gave no indication of the artist he was to become after his momentous meeting with Holman Hunt and Rossetti in Millais' house in Gower Street, when the Pre-Raphaelite movement was born. The impact of their work on art is too well recorded to describe here, except to point out that Millais was by far the most accomplished of the Pre-Raphaelites, and produced such masterpieces as *Ophelia, The Woodman's Daughter, Mariana,* and *Christ in the House of His Parents* – a painting that was widely considered blasphemous and so controversial when it was first shown that it almost ended the Pre-Raphaelite movement before it had started. Using the platform of his magazine *Household Words*, Charles Dickens poured forth a torrent of abuse, and even *The Times'* critic felt impelled to say: 'Millais' principal picture is, to speak plainly, revolting. The attempt to associate the Holy Family with the meanest details of a carpenter's shop, with no conceivable omission of misery, dirt, or even disease, all finished with the same loathsome minuteness, is disgusting. . . . ' Even the staid columns of the *Athenaeum* described the picture as being 'a pictorial obscenity'. If one reads only some of the abuse that was hurled at the painting, one is left wondering why this perfectly innocuous picture should have caused the outrage that it did. Fortunately, Ruskin, in an act of generosity, leaped to the picture's defence, and the tide of critical and public opinion began to swing the other way. By the time that Millais exhibited *The Huguenot* in 1852, both the critics and the public were completely won over.

Millais showed a brutal disregard for the welfare of one of his models, Miss Siddall, who he used for his painting *Ophelia*, when he forced her to lie for hours in a bath, long after the lamps which had been intended to keep the water warm, had gone out. As a result, Miss Siddall was taken ill and Millais had to pay the doctor's bill. He was similarly inconsiderate to his wife Effie (formerly unhappily married to Ruskin) years later, when he forced her to pose for him in an unheated room for three bitterly cold December nights, while he

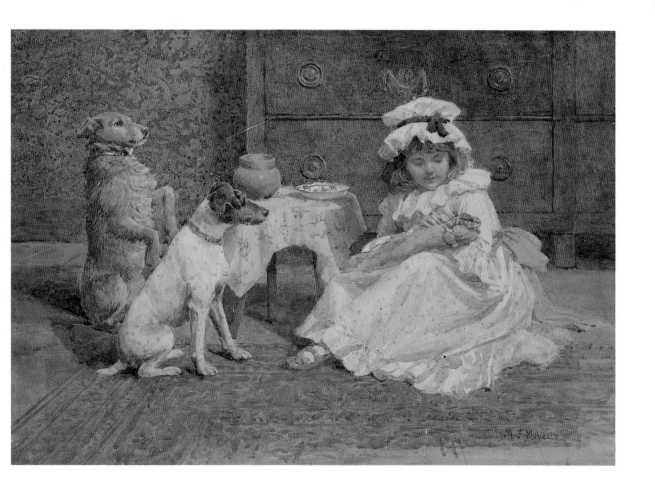

Mariquita Jenny Moberly
Attentive Admirers
Watercolour, signed. 14 x 20½in
Priory Gallery

struggled to capture the light of the moon on her lightly clad body for his painting *The Eve of St Agnes*.

After painting *The Boyhood of Raleigh*, *Bubbles* and *The Yeoman of the Guard*, Millais turned to portrait painting with great success, numbering Gladstone and Tennyson among his famous sitters. It was said that he was earning £30,000 a year at the time. He was elected to the RA in 1863, and made a baronet in 1885 and became president of the RA only months before his death from lung cancer.

REPRESENTED: ASHMOLEAN, BEDFORD, BM, BIRMINGHAM, GLASGOW, MANCHESTER.

MARIQUITA JENNY MOBERLY
fl. 1855-1903

Better trained than most of the women artist of her period, Mariquita Moberly was born in Deptford, Wiltshire. She trained in Germany and then in Paris, where she studied under Carolus-Duran, a landscape, genre and historical artist of the first order, who received the Legion of Honour for his services to art. She returned to England a talented and versatile artist who could turn her hand to any type of painting: portraits, figure studies, landscape and genre scenes - she painted them all with equal ease. She exhibited at the RA, the RHA and the RI as well as in galleries abroad. She lived in Mitcham, Surrey.

Moberly's watercolour *Attentive Admirers* is one that people either detest on sight or like as a charming piece of Victoriana. If its approach seems arch and sentimental, the blame lies with Landseer (see entry) who started the vogue for animal paintings.

JOHN MOGFORD, RI
1821-85

A member of a Devon family which included several painters, John Mogford was born in London and studied at the Government School of Design which was housed in Somerset House. He excelled in painting coastal scenes along the shores of Wales, Scotland, Devon and Cornwall. Although he is well known and admired for his coastal scenes, Mogford is less known for his detailed landscapes, which were influenced by the Pre-

Raphaelites. He became a member of the RI in 1867, where he exhibited nearly 300 paintings, and he showed another 33 at the RA. A hard-working artist, Mogford's pictures reached as far as Australia in his lifetime, where they enjoyed the same popularity as they did in England. A particularly fine example of his work, *St Michael's Mount*, is illustrated below. He was married to the daughter of Francis Danby, the landscape artist, and they lived at 2 Eaton Terrace, Haverstock Hill, London.
REPRESENTED: NOTTINGHAM, V & A.

John Mogford
St Michael's Mount
Watercolour. 12½ x 20in
David James

John Henry Mole
Starting for Home
Watercolour, signed and dated 1865. 19½ x 33in
Priory Gallery

JOHN HENRY MOLE, VPRI
1814-86

A landscape artist who painted in watercolours, John Henry Mole was born in Alnwick, Northumberland. He began his career as a clerk in a solicitor's office, but decided to become an artist. He first worked as a miniature painter and in 1845 had an exhibition of his miniatures at the RA. Although he had some success with his miniatures, Mole changed to landscape painting in watercolours. Like Birket Foster, he used a stipple technique, but with less success. His subjects were simple and lacked the charm of Birket Foster's painting, but at least they were far less cloying, even if they were sometimes repetitive.

Initially Mole painted in and around his own territory in the North, but later he ventured southwards to Surrey and then to Devon for his subjects. He exhibited at the NWS, where he showed no less than 679 of his paintings, as well as exhibiting 11 times at the RA in his early career. He became vice president of the RI in 1884. *Starting for Home*, illustrated above, is very similar to *Bringing in the Catch* by William Shayer (see pp272-3).
REPRESENTED: HAWORTH.

BAXTER MORGAN
exh. 1905-34

The son of Alfred Morgan, who painted a wide variety of subjects ranging from still life to landscape and genre painting, Baxter Morgan was a landscape artist whose work is unjustly neglected these days. As a landscape painter who painted realistic and unromanticised scenes of rural life, he had a sensitivity for light and shade which is normally found only in the *plein air* artists. Despite his obvious talents, he exhibited little of his work in the major galleries, although they were very accessible to him, living as he did at 30 Palewell Park, East Sheen, in the suburbs of London. *The Hay Wain* is a fine example of his work which captures the farming situation in the first part of the twentieth century, when the male labour force working on the land had fallen from one in five to one in ten, a situation that had been brought about in part by the lure of higher industrial wages (see illustration below).

Morgan was the brother of Ethel M. Morgan, the miniature painter, and of Alfred Kedington Morgan, a landscape painter who was also the art master at Rugby School.

Baxter Morgan
The Hay Wain
Watercolour. 18 x 22in
Priory Gallery

JOHN MORGAN, RBA
1823-86

An excellent genre artist who used children a great deal for his subjects, John Morgan was the son of the London artist Frederick Morgan, who also painted genre pictures in which children were prominently featured. Morgan jnr also painted a large number of historical and biblical pictures. Inevitably, his historical paintings such as *Ann Boleyn Alarmed at the King's Favour* and *French Soldiers Describing their Battles*, are of little interest today, except to academics. He exhibited sixty-six paintings at the RA and another twenty-six at the SS. He spent the latter part of his life at 25 St Helen's Road, Hastings. Of his many genre paintings, his oil *The Kite* is perhaps one of his best (see opposite).

REPRESENTED: GUILDHALL, LIVERPOOL, V & A.

John Morgan
The Kite
Oil on canvas. 48 x 38in
Private collection

WALTER JENKS MORGAN, RBA, RBSA
1847-1924

A genre artist and illustrator, Walter Jenks Morgan was born in Bilston, Staffordshire. He came to Birmingham to serve an apprenticeship under Thomas Underwood, a lithographer, and also to study at the Birmingham School of Art, where he won a scholarship which gave him the opportunity to study for another three years at the South Kensington Schools. He worked in oils and watercolours (see p218), but started his career as an artist by working as an illustrator for the *Graphic* and the *Illustrated London News*; he also worked as a book illustrator for *Cassell's*, whom he supplied with a number of drawings, mostly of children and domestic subjects. He began to exhibit his work at the RA from 1879. Between 1884 and 1887 it seems that he visited Spain, Tunis and Algeria, as he is recorded as having painted a number of pictures in those places, namely *Street in Tunis, Street in Algiers, An Arab Café, The Towers of the Alhambra, Snow and Flowers, The Sierra Nevada, From the Gardens of the Alhambra* and *Old Moorish Courtyard*. After he had been elected an RBSA in 1890, he returned to Birmingham, where he became the president of the Birmingham Art Circle and of the Midland Art Club. He was married to Mary Vernon Morgan, a fruit, flower and landscape artist who exhibited from 1880 to 1927.

REPRESENTED: BIRMINGHAM.

Walter Jenks Morgan
The Beach Party
Watercolour, signed and dated 1882
9½ x 13½in
Fine Lines (Fine Art)

William James Müller
Arab Merchants
Oil on canvas, signed. 25½ x 21¼in
Spink

WILLIAM JAMES MÜLLER
1812-45

An English landscape and figure artist who died of a heart attack at the age of 33, William James Müller was the son of the curator of Bristol Museum. His father had intended him to become an engineer, but when he saw that his son had a talent for painting, he sent him to study under J. B. Pyne, the Bristol landscape artist. By 1833 he had exhibited his first picture at the RA, *The Destruction of Old London Bridge, Morning*. After visiting Germany, Italy and Switzerland, he re-

turned to England and pursued a successful career as an artist, painting in both oils and watercolours. He visited France with a healthy commission to produce a series of forty drawings of the principal monuments of the Renaissance period in the northern and central parts of the country. In 1838 he travelled to Greece and Egypt with an architectural expedition and returned with a large portfolio of work, which included the superb study in oils of a group of Arab merchants illustrated on p219.

Although by the 1840s Müller had already painted a number of landscapes around Norfolk, Suffolk and North Wales, it was his oriental studies which established his reputation, and they often sold for huge sums that were often beyond their value. The public's enthusiasm for these paintings was not immediately shared by the RA, whom Müller had come to dislike intensely because of their failure to appreciate his work.

In May 1844 Müller returned to his studio in Charlotte Street, London, and settled down to paint a number of large pictures of which he hoped the RA might accept at least some. Although both the RA and RI did exhibit his work, his dislike of both institutions remained. He exhibited at the RA from 1833 to 1845.

In 1845 Müller returned to Bristol to continue his work, but by then he was already a sick man with a weak heart caused by overwork. He was engaged in painting a flower subject in oils when he suddenly collapsed and died of a heart attack.

If Müller was disappointed that he was not made an RA, time has redressed the balance to some degree. His work can be seen now in many of the provincial art galleries, and his painting *An Eastern Street* is on show in the Tate Gallery.
REPRESENTED: GUILDHALL, TATE.

WILLIAM MULREADY, RA
1786-1863

The son of a leather breeches maker, William Mulready was born in Ennis, County Clare, Ireland, but spent his childhood in Dublin before the family moved to London and settled in a house near Leicester Square. In 1800 he became a student at the RA Schools, and by the time he was 15 he was already supporting himself by drawing book illustrations and painting scenery for the theatre, an occupation pursued by many artists to help them over difficult times. During this period he canvassed for pupils and was fortunate enough to find himself teaching a number of notable people, including Isabella Millbank, who became the wife of Lord Byron.

In 1803 at the age of 17, Mulready married the elder sister of John Varley, the famous watercolour artist. The marriage was disastrous and the couple separated six years later. Mulready first exhibited at the RA in 1804, and for a long time he was a follower of David Wilkie. Although his oil *The Water Carrier*, shown opposite, is undated, it must surely have been painted when he was under Wilkie's influence. In 1841, however, his style changed and he began to work in bright, luminous colours on a white ground, every detail being painted with meticulous care. As a result, some people considered him to be a precursor of the Pre-Raphaelites. He was elected an RA in 1816, when he was only 30.

Mulready also produced book illustrations, including the drawings for Walter Scott's *Peveril of the Peak*, a robust adventure story for which his delicate style was perhaps ill suited, and also for Goldsmith's *The Vicar of Wakefield*.
REPRESENTED: BM, BURNLEY, GLASGOW, V & A.

William Mulready
The Water Carrier
Oil on canvas. 12½ x 9½in
Spink

SIR DAVID MURRAY, RA, PRI, RSW, HRSA
1849-1933

A landscape painter who was born in Glasgow, David Murray spent the first eleven years of his working life in business before he decided that he would like to take up painting as a career. After attending the Glasgow School of Art, he painted in Scotland for several years, gradually developing that broad and vigorous style that has become the hallmark of his work. In 1882 he went to England, where he painted in the Lake District and in the southern counties. For a while his work lost something of its customary glow, although a large number of his landscapes, including *Willow, In Summer Time* and *The Meadow Mirror*, still retained much of his old warmth. One of the first scenes he painted in England, *My Love has gone a-Sailing*, was bought by the Chantrey Bequest, as was his later work *In the Country of Constable*. He worked for some time in Italy and was made an RA in 1906. He died at the age of 84, by which time he was known as the grand old man of British art. Two years before his death he said that a 'landscape painter should be the happiest man alive', a statement that must be echoed by many landscape painters who had spent their lives working in the open air.

REPRESENTED: BIRKENHEAD, GLASGOW, NGS.

MAUD NAFTEL, ARWS, ASWA, SWA
1856-90

Of all the nineteenth-century flower artists, Maud Naftel is not only one of the best, but also one whose work did not become popular until flower paintings began to be promoted by dealers in the late 1980s. The result is that the price of Naftel's work has steadily risen. She preferred to paint flowers in their natural surroundings or as an example of 'the wild garden'. This term was coined by William Robinson in his book of that name, published in 1870, in which he created the idea of a garden that gives the impression of flowers growing in a wilderness, even though they have actually been carefully tended – the painting illustrated opposite is an example.

Maud Naftel was the daughter of the Guernsey artist Paul Jacob Naftel, and the sister of Isabel Naftel, who also painted flower subjects. Her mother, also known as Isabel, was a painter of genre, landscape and flower studies. Maud first began to exhibit at the Dudley Galleries in 1877, after studying at the Slade School of Art, and also in Paris under Carolus-Duran, the French landscape and genre artist. She published a book in 1886 entitled *Flowers and How to Paint Them*.

REPRESENTED: LIVERPOOL.

Maud Naftel
Mrs Birch's Garden, Betws-y-Coed
Watercolour, signed and dated 1881. 7½ x 5½in
Fine Lines (Fine Art)

Maud Naftel. 1881.

Frederick Nash
The Thames at Southwark
Oil on board. 5½ x 8½in
Spink

FREDERICK NASH
1782-1856

A watercolour painter of landscape and architectural subjects, Frederick Nash was born in Lambeth, London, and received his art education from Thomas Morton, the topographical artist. His work first appeared at the RA from 1800 onwards, but he exhibited there only occasionally. He is known primarily as a painter of architectural subjects, which seems a pity as his *Thames at Southwark* shown above gives a marvellous picture of the nineteenth-century scene. Turner described Nash as the first architectural artist of his day, and with that influential voice behind him it was not surprising that he should be in great demand by publishers of topographical works. He illustrated a vast number of works, including *History of London* by T. Pennant (1805), and also published many of his writings and sketches himself, including *Twelve Views of the Antiquities of London (1805-10)* and *Picturesque Views of the*

City of Paris and its Environs (1819-23). He always sketched at morning, midday and evening.

In 1816 Nash went on a series of sketching tours around Europe, and between 1827 and 1841 he travelled around Britain, often accompanied by Peter De Wint (see entry). In 1834 he moved from London to Brighton, Sussex, where he spent the remainder of his life.

REPRESENTED: BLACKBURN, BRADFORD, EASTBOURNE, NOTTINGHAM, V & A.

WILLIAM ANDREWS NESFIELD, RWS
1793-1881

William Andrews Nesfield was by no means the only army officer who took up painting seriously, but he was surely the only one who pursued no less than three successful careers before his death. He was born the son of the rector of Brancepeth, County Durham, and after being educated at Winchester and Trinity College, entered the army and served under Wellington in the Peninsular War and then became the aide-de-camp to Sir Gordon Drummond in Canada. After retiring from the army he began to paint in watercolours, and eventually became a member of the OWS. He was a landscape artist with a seeming obsession for painting waterfalls, which led Ruskin to refer to him as 'Nesfield of the radiant cataract'. When he retired from painting in 1852, he became a professional landscape gardener, and helped to make many major improvements to the Horticultural Gardens at Kew and St James' Park, London. He also planned the gardens at Alnwick and Arundel. He died at the age of 87 in London.

JOHN TRIVETT NETTLESHIP
1841-1902

An animal artist and illustrator, John Trivett Nettleship was born in Kettering, Northamptonshire, and was educated at Durham School before he entered his father's law firm. However, he soon became bored with the law and decided to take up art. He studied at Heatherley's and then at the Slade School of Art. He exhibited at the RA from 1874 to 1901, and made a name for himself with a series of savage paintings that include *Devouring a Peacock, On Guard* and *The Last Leap but One*, a lively study of a cheetah preparing to make a kill, which were painted when he was in India. It was his vigorous style that made him the ideal contributor to *Boy's Own Paper*, and for illustrating books such as *Among the Carnivora*, which was published in 1885. He wrote an interesting book on George Morland, the eighteenth-century genre artist, and another on the poems of Robert Browning.

REPRESENTED: ASHMOLEAN.

ERSKINE NICOL, RSA, ARA
1825-1904

Erskine Nicol was a rarity among artists, because his portrayals of Irish peasant life were painted with an unflagging sense of humour that becomes wearing to the viewer through a repetition of the same jokes.

Born in Leith, Scotland, Nicol began as an apprentice to a house-painter. He attended the Trustees' Academy in 1838, and from there went to Dublin, where he stayed for four years, painting his humorous studies of Irish peasant life. He came to England in 1862, but continued to make an annual trip to Ireland. He gave up painting in 1885 and went to live in Scotland before he finally settled in Feltham, Middlesex, where he lived until his death.

REPRESENTED: ABERDEEN, DUNDEE, V & A.

JOHN SARGEANT NOBLE, RBA
1848-96

A student at the RA Schools and a pupil of Landseer (see entry), John Sargeant Noble has always been classified as a sporting artist, although his horse studies are few and far between, and his paintings of hunting dogs make the animals look as if they would be more at home by the fireside than out in the fields. He exhibited at the RA between 1875 and 1895, during which time forty-six of his paintings were shown, and another ninety-six at the BI. He was one of the few artists who painted otter-hounds (see illustration, opposite), which were depicted with brutal realism, unlike his studies of endearing dogs, thus revealing another side to this normally gentle painter. *The Otter Hunt*, which was painted in 1890, shows a pack of hounds about to tear an otter to pieces and is not for the tender-hearted.

Noble lived in London from 1871 to 1889, when he moved to Heywood House in New Malden, Surrey.

REPRESENTED: BIRMINGHAM, V & A.

ERNEST NORMAND
1857-1923

Ernest Normand painted a variety of subjects – landscape, genre, portrait, historical and classical – but was only really successful with his classical paintings which were produced under the influence of Alma-Tadema (see entry). His painting *Playthings* was selected as the picture of the year when it was shown at the RA in 1886. Normand was married to Henrietta Rae, who also painted classical and historical pictures, and together they exhibited at the RA each year until World War I. Of the two artist, Henrietta was the better painter but they both had successful careers. They were friendly with Lord Leighton, who was a neighbour in Holland Park, London.

Ernest Normand had a sound art training, having first studied at the RA Schools, before he continued his training in Paris under Benjamin Constant, who was well known for his oriental

John Sargeant Noble
Otter-Hounds Outside a Kennel
Watercolour, signed. 29½ x 24½in
Sotheby's, Sussex

studies, and under Jules Joseph Lefebvre, who specialised in painting nudes. After 1900, Normand turned to painting bibilical subjects in which naked slave girls were often an important feature, but frequently his work descended into the realm of titillation.

REPRESENTED: BRISTOL, OLDHAM, SOUTHPORT, SUNDERLAND.

JOHN WILLIAM NORTH, ARA, RWS
1842-1924

A London landscape and genre artist who also drew illustrations for the *Sunday Magazine, Good Words* and the *London Illustrated Magazine*, John William North was born in Walham Green and studied at the Marlborough House School of Art before he was apprenticed to J. W. Whymper, the wood engraver. He worked for the Dalziel brothers' firm of engravers and exhibited from 1889. He was a great friend of Frederick Walker, who died young of tuberculosis. Together they made several sketching trips around the English countryside, and spent the winter months of 1873-4 in Algiers. A far better painter of landscape scenes than of genre pictures, North almost ruined himself by trying to market a special type of paper for watercolour painting. He illustrated a number of books, including *The Illustrated Book of Sacred Poems, Wayside Posies* and a book of Longfellow's poems. He died in Washford, Somerset.

REPRESENTED: ASHMOLEAN, BM, BRISTOL, HARROGATE, NGS, ULSTER, V & A.

WILLIAM EDWARD NORTON
1843-1916

An American marine artist who worked in oils and watercolours, William Edward Norton came to England, where he lived at 23 Camden Road, London. He exhibited fifty paintings in Britain, thirty-four of them at the RA. Although he is not considered a major marine artist, he could portray light with sensitivity, and the Peabody Museum in Salem, Massachusetts, purchased five of his paintings. He painted mainly around the Dutch and French coasts, as well as along the Thames. In *Early Morning on the Thames*, illustrated below, the sun has just begun to break through the morning mists, illuminating a laden barge in a patch of sunlight.

William Edward Norton
Early Morning on the Thames
Oil on canvas. 9 x 11in
Royal Exchange Gallery

HENRY NELSON O'NEIL, ARA
1817-80

A great favourite with the public during the Victorian period, Henry Nelson O'Neil was an historical painter who was born in St Petersburg, Russia, and came to this country at the age of 6. He entered the RA Schools in 1836, where he became a friend of Alfred Elmore, a genre and historical painter of some standing, and of Richard Dadd (see entry). He began to exhibit his work from 1838 at the RA, where he showed ninety-four paintings, as well as another thirty-four at the BI before his death. His two greatest successes were *Eastward Ho*, which was shown in 1857, and its only slightly lesser companion piece, *Home Again* (1859), which is reproduced opposite. The Crimean War and the Indian Mutiny had given a new life to genre painting in this country, but few works were as successful as O'Neil's two paintings, the first showing troops embarking to take part in the suppression of the mutiny and the other showing them coming home down the gang-plank. Both pictures were highly emotive for the Victorians, who had read the harrowing accounts of the horrors that had taken place during both campaigns. Nothing that O'Neil painted after that period made the same impact as those two paintings on the people who saw them when they were first painted.

O'Neil also painted a number of landscape scenes and wrote several booklets on art, including *Modern Art in Britain and France*. From all accounts he was a pleasant and sociable man, although Thomas Sidney Cooper (see entry) detested him and referred to him as 'the Great Unwashed'.

Henry Nelson O'Neil
Home Again
Oil on canvas. 53½ x 44½in
Christie's, London

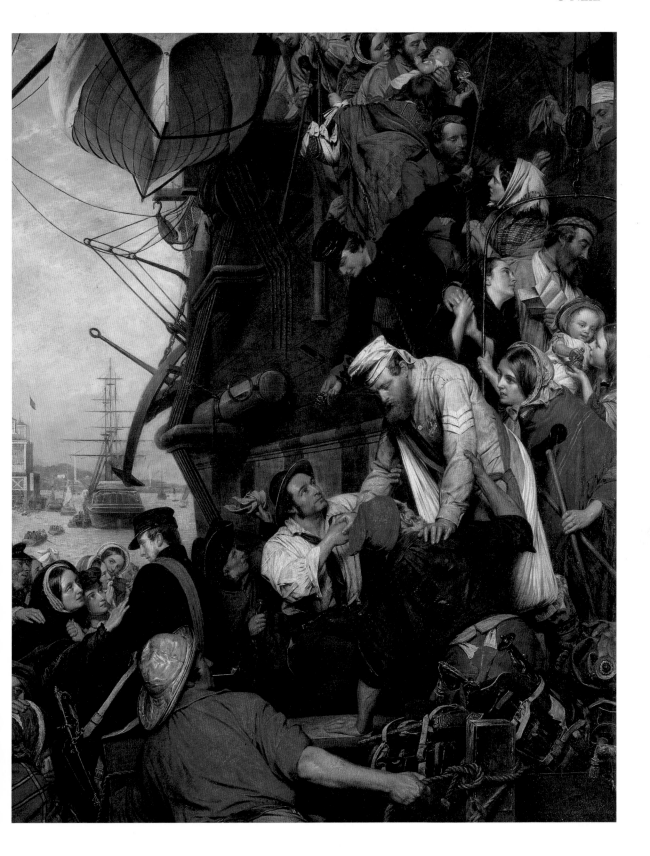

GEORGE BERNARD O'NEILL
1828-1917

An Irish painter who was born in Dublin, George Bernard O'Neill was a genre artist who specialised in painting studies of children that oozed with charm. For the first part of his career he was a prolific painter who exhibited seventy paintings at the RA from 1847 to 1893, but for the last twenty years of his life he did not exhibit a single picture. His work in many ways is typical of the sort of genre painting in which the sentimentality of the subject-matter is of paramount importance. In *New Playmates*, shown below, he included a dog and puppies, to ensure that the painting would appeal to as many viewers as possible.

O'Neill lived for many years in London, first at South Kensington and later at Woolwich, where he died at the age of 89.

REPRESENTED: GLASGOW, LEEDS, WOLVERHAMPTON.

William Quiller Orchardson
Housekeeping on the Honeymoon
Oil on canvas. 34½ x 26½in
Edward Cross Fine Paintings

George Bernard O'Neill
New Playmates
Oil, signed and dated 1895. 13½ x 17½in
Sotheby's, Sussex

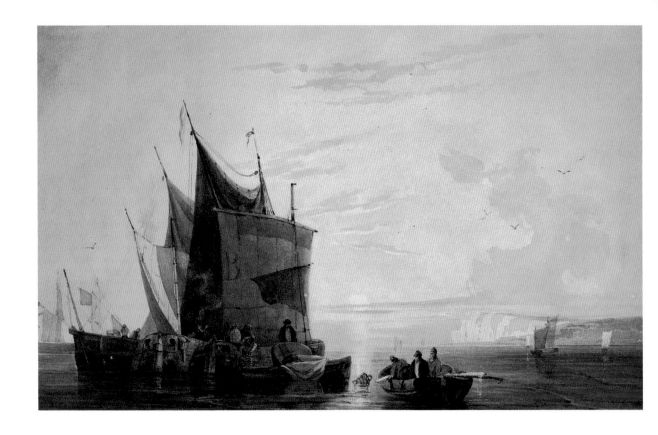

SIR WILLIAM QUILLER ORCHARDSON
RA, HRSA
1832-1910

Samuel Owen
Shipping off the South Coast on a Calm Sea
Pencil and watercolour with body-colour
5½ x 9in
Spink

A leading exponent of genre painting, Sir William Quiller Orchardson was among the best of genre artists. Although he was born in London, the son of a tailor and an Austrian, he received his art training at the Trustees' Academy in Edinburgh, where his teacher was Robert Scott Lauder, a lecturer of real genius who had guided the destinies of Thomas Faed, John MacWhirter and many other artists who later became world famous. Initially, Orchardson had wanted to be a painter of historical subjects, and he began his career by painting a series of scenes from the works of Shakespeare. By the time he returned to London in 1862 he was already a consummate craftsman who conceived his pictures in purely pictorial terms, although even as late as the 1870s he was still painting Regency scenes, such as *Housekeeping on the Honeymoon* shown on p231, and *The Tender Chord*, a simple but effective painting depicting a woman in Regency costume standing beside a piano.

In 1880 Orchardson became famous for his painting *Napoleon on Board the Bellerophon*, which was made into a print that adorned countless walls in lower middle-class houses . It was not until he began to paint his *Marriage de Convenance* series (1884-6) that his work blossomed with his dramatic use of space to highlight a situation. At the time it was argued that his canvases were not full enough, but such criticism came from those who had missed that point. He was probably one of the greatest of the situation painters, and it is for his scenes of nineteenth-century upper-class life that he will be remembered. He was knighted in 1907 and for many years lived in London.
REPRESENTED: MANCHESTER.

SIR WILLIAM ORPEN, RA, RWS, RHA, RI, NEAC
1878-1931

One of the greatest portrait painters of his time, William Orpen was born at Stillorgan, County Dublin, and entered the Metropolitan School of Art in Dublin at the age of 11. He remained there until 1897, when he enrolled at the Slade School of Art in London. By the turn of the century he was already being recognised as a master of brush work, whose portraits were being ranked along-side those of John Sargent, William Strang and Charles Wellington Furse. Orpen was only 22 when he painted *The Mirror*, a simple but highly effective study of a young woman with a mirror on the wall beside her in which is reflected a diminished image of the artist before his easel at the opposite end of the room.

In 1901 Orpen married Grace Knewstub and settled down to make what was to be an outstanding career as a portrait painter. He first exhibited at the RA in 1908, by which time he was already being earmarked as the natural successor to Sargent. Although it soon became obvious that he was going to be a portrait painter for the rest of his life, he continued to explore other areas of painting as a sideline to his main work. During this period he exhibited nudes as well as *plein air* landscapes.

At the end of World War I, in which he had been an official war artist, Orpen continued with his portrait painting and soon became the most fashionable portrait artist of his day, seldom earning less than £45,000 a year, which enabled him to keep a home and a studio, both in London and in Paris. It was while he was living in Paris that he painted his masterpiece, *Le Chef de l'Hôtel Chatham, Paris*, which received a great deal of lavish praise at the time, and is still one of the most interesting of all his paintings. He was made an RA in 1920.

REPRESENTED: ASHMOLEAN, IMPERIAL WAR MUSEUM, NGS.

Harold Sutton Palmer
The Stream
Watercolour. 14 x 10in
Priory Gallery

SAMUEL OWEN
1768-1857

One of the best of the early Victorian marine painters, Samuel Owen's work is much in the spirit of Turner, with its flamboyant technique and powerful painting. He worked mostly in watercolours and painted fishing and coastal scenes. Unfortunately, he gave up painting early in life, so that his work rarely comes up for auction, and as a result he has been a neglected artist. However, his work can be seen in many of the major art galleries. He exhibited eight paintings at the RA. His watercolour shown opposite is representative of much of his work. The same composition (reversed) appeared as a lithograph by F. Noel, entitled *Le Matin* after Bonington. Owen's watercolour may therefore be a replica of Bonington's watercolour which so far remains untraced. Owen died at Sunbury-on-Thames on 8 December 1857.

REPRESENTED: BM, CARDIFF, LEICESTERSHIRE, V & A.

HAROLD SUTTON PALMER, RI, RBA
1854-1933

Harold Sutton Palmer showed such an ability for drawing at a very early age that there was never any doubt as to what his future occupation would be. Born in Plymouth, he began his career by attending the South Kensington Schools for two years, during which time he won a gold medal. Leaving the school he devoted his skills almost entirely to painting still life studies, but he then changed to painting landscapes in watercolours, a genre to which he remained faithful for the rest of his life. He began to exhibit at the RA from 1870. Although he lived in London, he spent most of his time travelling around Britain looking for subjects to paint; among the places he visited were Berkshire, the Lake District and many part of Scotland. Probably because of its proximity to London, he visited Surrey the most often.

From 1880 until 1920 Palmer held many one-man shows in England and one in New York. Although his name cannot be included with the best watercolourists of his period, he was a highly skilled painter, conventional in his vision perhaps, but never less than highly professional in everything he painted. He supplied the coloured illustrations for several books, including *Rivers and Streams of England, Bonnie Scotland* and *The Heart of Scotland*.
REPRESENTED: V & A.

SAMUEL PALMER, RWS
1805-81

Samuel Palmer was born in London, the son of a bookseller. Although he was a delicate child, he was already exhibiting at the RA and the RI when he was only 14. Early in his life he met John Linnell, who introduced him to John Varley, William Mulready and William Blake, a strange, visionary genius whom he met in 1824 when he was living in Shoreham, Kent. Although he proved to be one of England's most original landscape artists, Palmer at this time was still struggling to

Samuel Palmer
A Farm near Princes Risborough, Buckinghamshire
Charcoal and watercolour, heightened with white. 13½ x 17½in Spink

make a living from teaching and exhibiting the pictures that he had made on his sketching tours around Britain, which were painted mostly around Devon, Cornwall and North Wales.

In 1837 he married Linnell's daughter Hannah, who also painted landscapes, but who suffered a great deal of ill health after a series of miscarriages. The couple toured Italy for their honeymoon and stayed there for two years. It was generally thought by critics that when Palmer returned to England there was a falling-off in his work, and often they unfairly laid the blame on Linnell's influence. It was a point of view that was widespread at the time and when he was at the height of his success in later years. In 1853 Palmer was elected a member of the English Etching Club and he was working on a series of plates to illustrate Virgil's *Ecologues* when he died in Reigate, Surrey. The book was completed by his son A. H. Palmer, and was published in 1883. Like so many nineteenth-century artists, Palmer experienced many difficult years. In one of his letters he wrote that his work as a teacher was one of being 'unappreciated and ridiculed', and of 'taxing his strength to the utmost to benefit my family'. He was first and foremost a pastoral painter, and one of the best of his period. his watercolour shown on pp234-5 was painted when he spent a month at Princes Risborough in 1845.

REPRESENTED: BIRMINGHAM, BIRKENHEAD, BLACKBURN, BM, MANCHESTER, V & A.

EDMUND THOMAS PARRIS
1793-1873

A genre, landscape and portrait artist who was born in Marylebone, London, Edmund Thomas Parris served with a firm of jewellers before he was admitted into the RA Schools. In the same year, two of his paintings, *The Butterfly* and a view of Westminster Abbey, were shown at the Royal Academy. Between 1816 and 1874 another twenty-six of his paintings were exhibited there. One of his paintings, *Lay of the Minstrel*, which had a great success when it first appeared, was bought by Sir Robert Peel and realised only 8 guineas

when it was later sold in 1900. He made a sketch of Queen Victoria during one of her visits to Drury Lane Theatre and painted large pictures of her at her coronation; he also sketched the funeral of the Duke of Wellington. In many ways his style of painting was best suited for book illustrating which he did often for the books of the then fashionable novelist Lady Blessington. He illustrated three of her books: *Flowers of Loveliness, Confessions of an Elderly Gentleman* and *Confessions of an Elderly Lady*. He also restored James Thornhill's paintings in the dome of St Paul's

REPRESENTED: BIRMINGHAM.

ALFRED WILLIAM PARSONS, RA, RI, PRWS
1847-1920

A landscape painter who specialised in painting gardens, Alfred Parsons was born in Beckingnham, Somerset, the son of a doctor who was a gardening enthusiast and an expert on perennial flowers and rock plants. He came to London in 1865, when he took a job as a post office clerk to support himself while he studied at the South Kensington Schools in the evenings. He first exhibited at the RA in 1871, and from 1874 his paintings were shown there every year until his death. His first great success came in 1867 with *When Nature Painted All Things Gay*, which was bought by the Chantrey Bequest and is now in the possession of the Tate Gallery. He contributed illustrations to the *English Illustrated Magazine, Harper's Magazine*, and the *Daily Chronicle*. During the 1880s and 1890s he produced a number of charming studies for such books as *God's Acre Beautiful* (1880), *Poetry of Robert Herrick* (1882), *Sonnets of William Wordsworth* (1891) and *The Warwickshire Avon* (1892).

In 1885 Parsons visited the village of Broadway in the Cotswolds, where he made friends with Edmund Gosse and Henry James, who loved the village and wrote of Parsons' work that 'it would be strange if the words "Happy England" should not rise to the lips of the observer of Mr Alfred Parsons' numerous and delightful studies of the gardens, great and small of this country'.

Alfred Parsons
A Kitchen Garden
Watercolour, signed and dated 1906. 10 x 14in
Fine Lines (Fine Art)

Parsons made an extended visit to Japan and afterwards held an exhibition of his Japanese paintings at the Fine Art Society. By this time he was a well-known painter of gardens, and as a result was asked by the Edwardian botanist Ellen Ann Willmott to paint her collections of roses in her gardens in Great Warley, Essex, and on the border of the Italian riviera. By the time he had completed the commission he had painted 150 watercolours which were published in a book entitled *The Genus Rosa*. He was made an RA in 1911 and died in Broadway on 16 January 1920. One of his many garden paintings is reproduced above.

REPRESENTED: V & A.

CAROLINE PATERSON
d. 1919

Caroline Paterson, whose work often appears under her married name of Sharpe, has always been overshadowed by her sister Helen Allingham (see entry), so much so that only one of the standard reference books on Victorian artists even mentions her, and then only briefly. She remained largely unknown until the late 1980s, when dealers suddenly became aware of her artistic qualities. In recent years, some of her paintings have fetched astounding prices.

Caroline Paterson lived in Hampstead, London with her husband, Sutton Sharpe, the etcher, and she exhibited in London and the provinces from 1880 to 1889. Although many of her paintings were influenced by her sister, generally she painted in far brighter colours and on a larger scale. Her paintings include *So Glad to see you Better, The Rabbit's Hutch, Cat's Cradle, A Cottage near Cuckfield, The Young Physicians* and *Captured*

Unawares, in which she painted a young girl gleefully tying a sleeping boy to his chair, and *The Garden Path* which is reproduced below. This charming painting shows her as a superb water-colourist and is such a marvellous example of a cottage garden scene that one cannot help wondering why her work was neglected for so long in favour of Allingham's cottage gardens, which seem almost colourless by comparison.

Caroline Paterson
The Garden Path
Watercolour, signed. 16 x 15in
Priory Gallery

SIDNEY RICHARD PERCY
1821-86

The son of Edward Williams, the landscape artist, Sidney Richard used the name of Percy to distinguish himself from the other members of his family who also changed their names for the same reason. One of the most popular and prolific landscape painters of the Victorian period, he painted in many places around Britain, although he seems to have favoured Wales in particular. Many of his oils are extremely effective - for example *Evening Light*, in which the light from the dying sun bathes the mountain-tops in a golden glow (see illustration, pp240-1). He exhibited more than three hundred paintings during his lifetime, forty-eight of them at the RA. Initially he lived in Fleet Street, London, but he moved to various addresses in the city.

ARTHUR PERIGAL, RSW, RSA
1816-84

A Scottish landscape artist, Arthur Perigal painted panoramic scenes of the Highlands which often showed them as lonely and unfriendly. The son of Arthur Perigal, the historical and portrait painter, he was born in London but eventually went to Scotland, where he lived in Edinburgh for the rest of his life. He spent many winters in Italy and painted a number of oils there which are in direct contrast to his austere scenes of the Scottish countryside, especially *The Grand Canal, Venice*, and *Pompeii in Eruption*, which he painted on location while the volcano was erupting. His many paintings include *An Evening in Skye, Arran, Early Summer in the Lowlands*, and *On the Tweed*, shown below.

REPRESENTED: DUNDEE, PAISLEY.

Arthur Perigal
On the Tweed
Oil, signed and dated 1866. 26 x 41¼in
Sotheby's, Sussex

Sidney Richard Percy
Evening Light
Oil on canvas. 16 x 24in
Priory Gallery

A COMPANION TO VICTORIAN AND EDWARDIAN ARTISTS

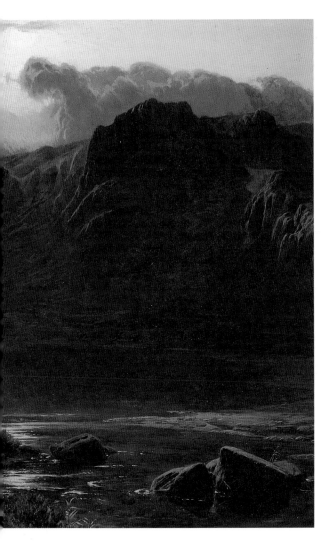

ALFRED PERRY
exh. 1847-81

A landscape artist and painter of animal studies, Alfred Perry was well known for a series of pictures that he painted in Italy around the environs of Rome and Naples, in which he often included farm animals to add interest to his scenes. His Italian paintings include *Roman Pack Carriers Crossing the Campagna, Roman Peasants Returning from Market*, and *A Scene in the Roman Campagna*. He also painted the occasional landscape in Kent in his later years when he moved from London to Plumstead. More rare are his pure animal studies, such as the example shown below, in which two horses are taking advantage of the shade beneath the trees on a warm summer's day. He exhibited thirty paintings at the RA between 1847 and 1878.

REPRESENTED: V & A.

Alfred Perry
Untitled watercolour. 13 x 20in
David James

JOHN PETTIE, RA
1839-93

John Pettie was born in Edinburgh but was brought up in East Linton, near Haddington in Lothian. When he said that he wanted to be an artist his parents sent him to Edinburgh to stay with his uncle, Robert Frier, a well-known art teacher. At the age of 17 he entered the Trustees' Academy, where he struck up a lasting friendship with Sir William Orchardson (see entry). His first exhibited picture was *The Prison Pet*, which was shown at the Royal Scottish Academy in 1858. In 1862 he was lured to London by the offer of £100 a year for drawing an illustration each month for the magazine *Good Words*. It was hardly a fortune, working out at a little over £8 a drawing, but at least it was a regular source of income. Fortunately, Pettie gained a footing in the art world almost at once, and he abandoned illustration work almost as soon as he had fulfilled his contract. As a painter of historical pictures he seemed to delight in painting scenes that were full of action, but surprisingly, when occasionally he produced book illustrations it was for gentle subjects such as *Touches of Nature by Eminent Artists* and *Good Words for the Young*. In 1891 he began to suffer from a tumour on the brain which led to his death in Hastings, Sussex, in 1893.

REPRESENTED: ASHMOLEAN, GLASGOW, V & A.

SIDNEY PIKE
fl. 1880-1907

A London artist who lived at 35 St Saviour's Villas in Herne Hill Road, Brixton, Sidney Pike began to exhibit at all the major galleries and at the RA from 1880. Although he painted genre pictures, he preferred to paint landscapes, in which he captured the atmospheric effects that differentiate seasons of the year. Particularly effective are *Autumn*, *Early Spring*, and *Winter*, which is shown opposite, their titles being unusually succinct for the Victorians and Edwardians, who preferred much longer titles.

Around 1880 Pike moved to Taplow, Buckinghamshire, where he stayed until 1882. He then moved to Christchurch, Hampshire, but in 1884 he returned to London - he was yet another of that restless band of painters who never seemed to settle permanently.

GEORGE PINWELL, RWS
1842-75

A watercolour painter of genre and historical subjects, as well as being one of the leading illustrators of his time, George Pinwell was born in High Wycombe, Buckinghamshire. His father, a prosperous builder, died while George was still a child, and he was brought up by his mother, a coarse and illiterate woman. He began his career working for a firm of embroiderers, for whom he was a designer. When his mother remarried he found that he no longer had to support her as well as himself, and he was able to go to St Martin's Lane School until he joined Heatherley's School of Art. He began to exhibit from 1865, mostly at the Dudley Galleries and at the OWS. Pinwell was fascinated by the colour and texture of clothing, investing his crinolined figures in particular with an enormous amount of charm and fluidity of line. It was therefore inevitable that he began to obtain a large amount of commissioned work for magazines, which included drawing a hundred illustrations for the *Illustrated Goldsmith* in 1864. In an effort to cope with the constant stream of commissions, he neglected his work as a watercolourist. There was hardly a magazine for which he did not draw, and inevitably the strain took its toll, and his health began to decline in 1873. In 1875 he made a belated attempt to recover his strength by visiting Tangier, but it was too late, and on his return to London on 8 September 1875, he died at the age of 33. One of his best watercolours was *The Strolling Players*, a charming rural scene which is said to include portraits of the artist and his wife.

REPRESENTED: ABERDEEN, BEDFORD, BM, MAIDSTONE, V & A.

Sidney Pike
Winter
Oil on canvas, signed and dated 1907. 23 x 19in
Bourne Gallery

Alberto Pisa
Holmwood, Surrey
Watercolour, signed. 12 x 14in
Fine Lines (Fine Art)

ALBERTO PISA
1864-1931

Originally a landscape artist, Alberto Pisa eventually turned to painting garden scenes in watercolours, the medium that artists generally employed when such pictures became the vogue in the 1890s. One of Pisa's many paintings was done in his own grounds in Holmwood, Surrey, where the garden was planned and laid out to give the impression of careless disorder, a form of landscape gardening that was created by the idea that plants, foliage and blooms should merge together. The fashion for garden scenes, which had engaged the attention of such artists as Helen Allingham, Arthur Rackham, and Vicat Cole, Caroline Paterson and Beatrice Parsons, lasted until the 1930s, when it began to lose its fascination. Garden scenes were always a great favourite with the royal family.

Queen Alexandra was known to have bought twenty paintings by Henry Sylvester Stannard, and Queen Mary bought one by Theresa Stannard. Understandably, such scenes had wide appeal for the English, a nation of garden lovers.

FRANK HUDDLESTONE POTTER, RBA
1845-87

A London genre painter whose father was a solicitor, Frank Huddlestone Potter did not decide to take up painting until some years after he had left school. Eventually, he enrolled as a student at Heatherley's School of Art before he went to the RA Schools. He then studied in Antwerp, but so disliked the methods of teaching that he soon returned to London where he tried to earn his living as an artist. He first exhibited at the RA in 1870, but his *Study of a Girl's Head* was virtually ignored. Undiscouraged, he continued to exhibit regularly at the Society of British Artists, until *A Quiet Corner* was exhibited at the Grosvenor Gallery in 1878, where it attracted a great deal of attention. Sadly, he died on the day of the exhibition; he had never been a fit man and his health had steadily declined. His work was never really appreciated in his lifetime. His painting *Girl Resting at a Piano* was bought by the Tate Gallery.

SIR EDWARD POYNTER, PRA, RWS
1836-1919

For much of his artistic life, Sir Edward Poynter, the neo-classical painter, lived under the shadow of Lord Leighton, and as a result his work was unjustly neglected. Furthermore, his talents never quite matched those of Lord Leighton and Alma-Tadema, even though at times he could be a superb artist, as with his *Cave of the Storm Nymphs*, which is one of his finest academic paintings (see p247). It was bought in 1981 for £203,500, one of the most expensive Victorian pictures ever sold at that time. Unlike Leighton, whose flamboyant lifestyle matched his outgoing personality, Poynter was a reserved, cantankerous man who was unable to change with the times, with the result that his work was dismissed as pretentious and uninteresting. When Lord Leighton died, Poynter took over the role of President of the Royal Academy, where he remained for over twenty-two years, until many people began to wonder if he would ever retire. He resigned finally when he was over 80, but only because he was almost blind.

Edward Poynter was born in Paris, the son of an architect, and after being educated at Westminster and Ipswich Grammar School, he went to Rome, where he met Lord Leighton. Having decided to take up art as a career, as a direct result of meeting Leighton, he studied in Paris under Gleyre, who had been a penniless artist before he opened an atelier, when he rapidly became a famous teacher.

In 1859 Poynter returned to London, and for the next few years struggled to make a living from his painting with indifferent results. He desperately needed the RA to take one of his pictures in order to establish his name. Eventually *Faithful Until Death* was accepted by the RA in 1865. This picture, which shows a Roman soldier doggedly remaining at his post during the destruction of Pompeii, was a great success, and still remains Poynter's most famous work. This was followed by *The Catapault* and *Atlanta's Race*. Among his famous paintings are *The Fortune Teller* and *The Meeting between King Solomon and the Queen of Sheba*.

Although by 1894 his powers were beginning to decline, he was still made the Director of the National Gallery and an RA in 1896. By 1900, however, his paintings began to be repetitious and uninteresting. When the end finally came there were some deeply felt sighs of relief from a large number of people who felt that he had already long overstayed his welcome.

REPRESENTED: BM, BRADFORD, LIVERPOOL, MANCHESTER, NEWCASTLE, V & A.

VALENTINE CAMERON PRINSEP, RA
1838-1904

Born in Calcutta, the son of an Indian civil servant who was able to afford a house in Holland Park, one of the most fashionable areas of London, and to send his son to Haileybury, Valentine Prinsep was also fortunate enough to have as his teacher, G. F. Watts, an historical and portrait painter, now regarded as one of the foremost of the Victorian artists. Watts, who seems to have been a permanent guest in the Prinseps' home - a meeting-place for all the major artists, poets and writers of the day - eventually suggested that Valentine should go to Paris to complete his art education under Gleyre, who was considered by English students to be the best art teacher in France.

Prinsep returned to England and exhibited a hundred pictures at the RA from 1862 to 1904. A versatile artist and a very wealthy one after his marriage to the well-connected Florence Leyland, he painted historical subjects and portraits. He also tried to paint classical and biblical subjects, but the results were dull and no match for the more inspired flights of imagination to be seen in the works of the most famous trio of classical painters, Alma-Tadema, Frederick Leighton and Poynter. In 1876 Prinsep was commissioned by the Indian government to paint the durbar that was held to proclaim Queen Victoria the Empress of India. The result was a gigantic canvas, *At the Golden Gate*, which was a worthy, but yet another dull painting in the worst traditions of the RA.

REPRESENTED: SHEFFIELD.

SAMUEL PROUT
1783-1852

A justly celebrated painter in watercolours, Samuel Prout was born in Plymouth. As a child he suffered a serious case of sunstroke which affected him for the rest of his life, making him subject to severe headaches that confined him to his room for several days before he recovered. He went to the local grammar school where he met and became a

Sir Edward Poynter
The Cave of the Storm Nymphs
Oil on canvas, signed and dated 1903.
57½ x 43½in
Christie's, London

close friend of Benjamin Haydon (see p12). Samuel Prout's father was a bookseller in Plymouth, and it was in the bookshop that the young artist met John Britton, the antiquarian, who was visiting the city. Impressed with the sketches that Prout showed him, he suggested that he should do some architectural drawings around the area. These proved to be a dismal failure because of Prout's inability to get the right perspective and proportions, a problem which he tried to rectify by studying perspective. He was so pleased with the results that he visited Britton in London. Prout stayed with Britton for two years until he thought the artist good enough to supply the drawings for his book *Beauties of Britain*. Ill health dogged Prout again and in 1805 he returned home. When he returned to London he settled in 55 Poland Street. To support himself he painted marine pictures for a London dealer named Palser, who began by paying him 2s 6d for a small drawing, but later increased the fee to 5s. It was a difficult period for Prout, who had to struggle to exist, supplementing his meagre income from painting by giving art lessons and publishing a number of small books on drawing.

Prout did not begin to establish his reputation until 1818, during one of his more prosperous periods, when he visited the Continent. There he made a series of drawings and watercolours of any quaint market place or street he came upon, always finding in each subject he painted some picturesque feature to draw the eye and make the picture more visually interesting. When he re-

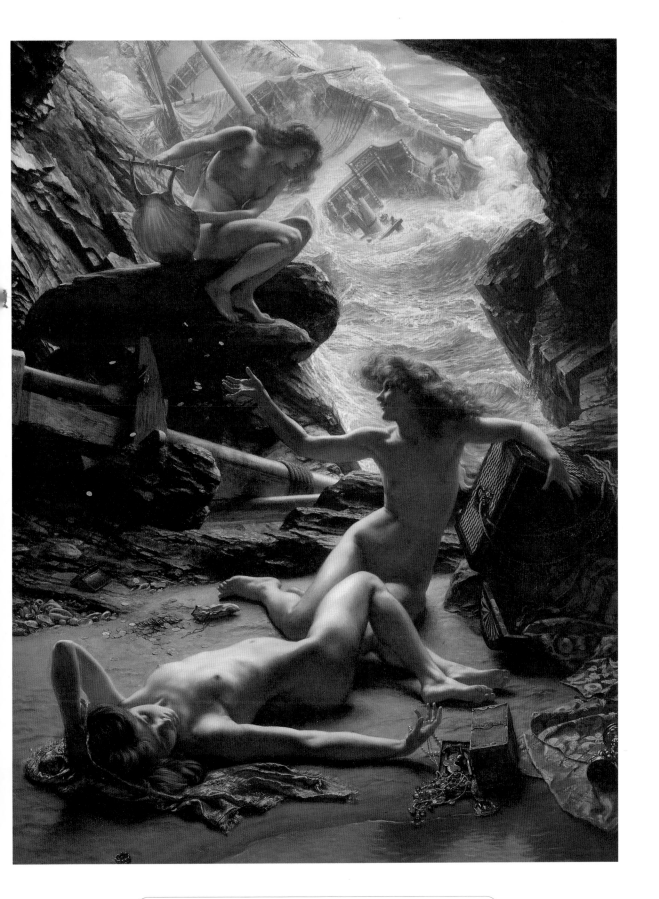

turned home and began to show his work, Ruskin was the first to comment on his paintings in the following glowing terms:

> We owe to Prout, I believe, the first perception and certainly the only existing expression, of precisely the characters which were wanting to old art; of that feeling which results from the influence, among the noble lines of architecture, of the rent and the rust, the fissure, the lichen and the weed, and from the writing upon the pages of ancient walls of the confused hieroglyphics of human history.

Putting aside the complicated prose style, it was a generous statement from Ruskin who, whatever his faults might have been, was always one of the first to give praise when he thought it was warranted.

Despite his constant ill health, Prout was able to look back on a life in which he had been Painter in Water-colour to William IV and Queen Victoria, and had been acclaimed as the finest of all the architectural artists. He could also claim early on that he had fully explored the uses of lithography which had been patented in this country until 1800 by Alois Senefelder, the Austrian inventor, who brought it to comparative perfection before his death in 1834; it was a process that allowed an artist to work directly with chalk on stone, instead of having to rely on acid biting into a plate, which sometimes resulted in disaster if it was not properly applied. Prout used lithography with great success on the plates in his books entitled *Illustrations of the Rhine* (1824), *Facsimiles of Sketches Made in Flanders and Germany* (1833) and *Sketches in France, Switzerland and Italy* (1839).

An aspect of Prout's work which is much more interesting to those who are not greatly interested in Gothic architecture and views of crumbling ruins and old houses, are his sea scenes, which he painted in this country and abroad. A striking example is shown opposite, and makes one wish that he had done more in this genre.

REPRESENTED: ABERDEEN, ASHMOLEAN, BIRKENHEAD, BLACKBURN, BM, DUDLEY, EXETER, FITZWILLIAM, LEEDS, MANCHESTER, V & A.

Samuel Prout
Fishermen Pulling in a Boat near a Jetty
Pencil, brown ink and watercolour. 7¼ x 10½in
Spink

Thomas Pyne
The Bridge at Sandwich
Watercolour, signed and dated 1888. 13¼ x 20in
David James

THOMAS PYNE, RI, RBA
1843-1935

A landscape artist who generally painted in muted colours, Thomas Pyne was taught art by his father, the watercolourist James Baker Pyne, who was regarded as the better artist. Thomas Pyne jnr painted in many parts of England and Wales and exhibited at the RA and at the SS, where he showed at least 110 pictures.

His paintings are quiet and relaxed and one gradually grows fond of them, unlike the work of more dynamic painters which can pall with over-exposure. His watercolour shown above is typical of his understated style. He lived in London for some years and later in Dedham, near Colchester in Essex. He was the brother of Annie C. Pyne and Eva Pyne, who both painted flower studies.
REPRESENTED: DONCASTER, V & A.

A COMPANION TO VICTORIAN AND EDWARDIAN ARTISTS

LOUISE J. RAYNER
1832-1924

An architectural and topographical artist who painted a large number of street scenes in many of the major cities and towns of England, Louise Rayner was one of five daughters of a topographical artist. An example of her work is illustrated below. She was born in Derby, and after studying art under her father, exhibited at the RA from 1852 to 1886, and painted widely in this country until she finally set up as an art teacher in Chester, Cheshire. When she retired from teaching she went to live in St Leonard's-on-Sea, Sussex, where she lived until her death. Although all her sisters painted, only Francis and Margaret, who also produced architectural scenes, made a name for themselves.

REPRESENTED: BIRKENHEAD, CHESTER, COVENTRY, NEWPORT, READING.

Louise Rayner
Foregate Street, Chester
Watercolour. 16½ x 22½in
City Wall Gallery

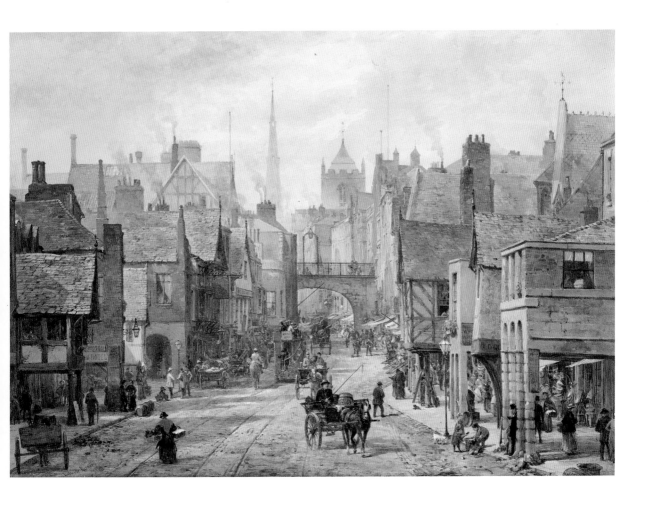

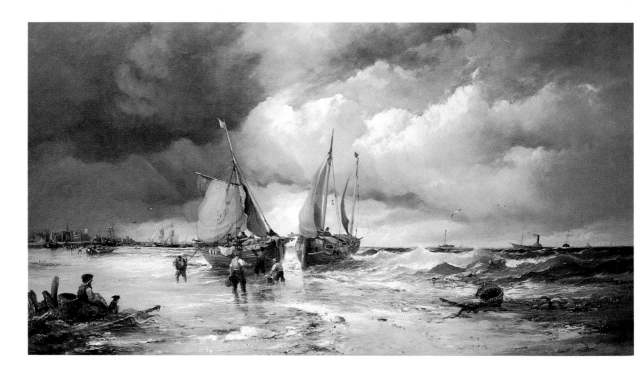

WILLIAM JAMES DURANT READY
1823-73

Born in London, William Durant Ready was one of those entirely self-taught artists who seem to be more common among marine painters than among genre and landscape artists. The son of a customs house clerk, he was a timid and retiring person who never made any serious attempt to promote his work, although he was a very proficient marine artist, as can be seen from his oil *Unloading the Catch*, shown above. His shy personality explains why he exhibited only one picture at the RA, and accounts for the reason that he never acquired a wide reputation. Nor was his cause helped by the fact that he did business with only one dealer for most of the time, which clearly limited the number of potential art buyers who might view his work.

At some unknown date Durant went to America, where he stayed for five years. He painted in both oils and watercolours, which he always finished on the spot. Because of his shy and retiring nature he made only one friend in his life – Charles Roberts, the architectural painter. Durant's personality conspired against him with the result that his name is less well known than it should be. For some reason known only to himself, he signed his paintings W. F. Durant, or D. W. R., or in some cases, W. R.

William James Durant Ready
Unloading the Catch
Oil, signed and dated 1888. 35½ x 62½in
Sotheby's, Sussex

RICHARD REDGRAVE, RA
1804-88

A genre painter and landscape artist who also worked as a book illustrator, Richard Redgrave was born in Pimlico, London, and began his career as an assistant to his father, who was associated with Bramah, the inventor of the hydraulic press. He entered the RA Schools in 1825 when he was 21, but did not attract any real attention until 1836, when he exhibited *Gulliver at the Farmer's Table*. An earnest young man, he was dedicated to the cause of art education, and in 1847 was heavily committed and associated with the Government School of Design, which was the first national art school sponsored by the state and which had over four hundred students registered at the beginning of the 1850s. The emphasis of Redgrave's teaching was on ornamental design rather than on the actual mechanics of painting.

In 1855 Redgrave became Director of the Art Division at the South Kensington Museum. Two years later he was also the surveyor of the Queen's

A COMPANION TO VICTORIAN AND EDWARDIAN ARTISTS

Pictures. In 1861 he was brought into a dispute with the London art unions, who ran what amounted to a lottery for the general public to win a painting. When the activities of the art unions were questioned by Lord Montague, Frith and Redgrave were called in to arbitrate. Frith thought the art unions, of which there were several throughout the country, had done much to promote art, while Redgrave considered that they had encouraged 'slop work'.

Redgrave used the Bible and English poetry as source material for his book illustrations, which were included in such titles as *Songs of Shakespeare*, *Favourite English Poems* and *Book of English Ballads*. Because of the demands of his various occupations, Redgrave produced a relatively small number of paintings. He also produced two useful books, *An Elementary Manual of Colour* and *A Century of Painters of the British School (1866)*, which was written in conjunction with his brother Samuel. He exhibited 141 pictures at the RA, of which probably the most famous was *The Governess*, which is in the Victoria and Albert Museum, although he did paint some attractive landscapes around his country home.

Redgrave's last years were marred by blindness, but shortly before his death his sight was restored by an operation and he was thus able to enjoy what was left of his life.

REPRESENTED: BM, V & A.

HENRY REDMORE
1820-87

A member of the Hull school of painting who spent his whole life in the city, Henry Redmore ranks alongside James Ward as one of the best of the Hull maritime artists during the nineteenth century. Usually working in his studio in Hull's Regent Street, he produced a complete series of paintings which were originally sketched along the Humber and Yorkshire coasts, and in many cases showed the influence of the seventeenth-century school of Dutch marine painting. His

Henry Redmore
Unloading the Catch
Oil, signed and dated 1888. 24½x 37½in
Sotheby's, Sussex

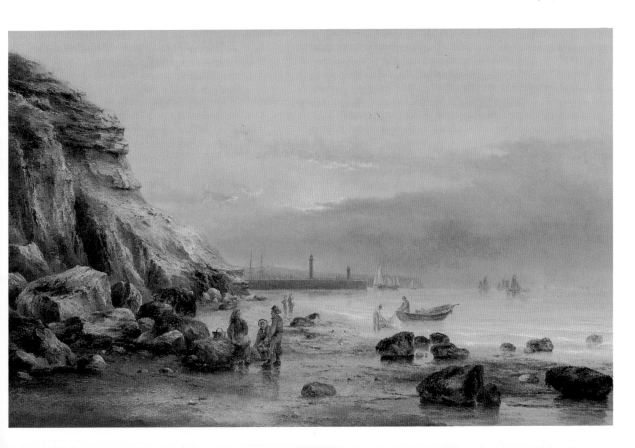

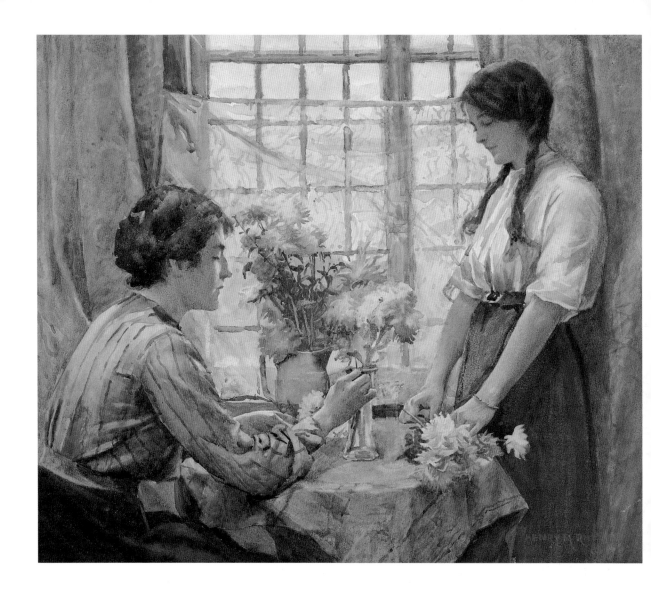

work was either completely unknown or unappreciated until an exhibition of his oil paintings was held in London in 1971. After the exhibition his work was discussed on television, as a result of which his reputation and the value of his paintings increased. *Unloading the Catch*, shown on p253, was painted in the Dutch manner, and is one of a pair, as was much of his work. *Fishing Ground in the North Sea* and *A Calm on the Humber* the only two paintings to be exhibited at the RA, did not enhance his reputation at the time.

Redmore's son, E. K. Redmore, was also a marine artist, but he was never as good as his father. However, occasionally his work rises so much above his usual standard that one cannot help wondering if his father had not assisted with the painting.

Henry Meynell Rheam
Arranging Flowers
Watercolour, signed. 18 x 24in
Priory Gallery

Frank Richards
Homework
Watercolour, signed. 30 x 20in
Priory Gallery

A COMPANION TO VICTORIAN AND EDWARDIAN ARTISTS

HENRY MEYNELL RHEAM, RI
1859-1920

The son of a Quaker family, Henry Meynell Rheam was born in Birkenhead, Cheshire, and was exhibiting in London in 1887 just before he went to live in Polperro, Cornwall, and near the fishing village of Newlyn, where he was lured by Stanhope Forbes who persuaded him to join the local cricket team for their annual match against St Ives. Rheam lived in Cornwall for most of his life, ending his days in Penzance. Although he was by no means one of the best of the Newlyn artists, his work has always been very popular, especially his studies of the children of the local fishing families, although some were painted in dull colours. In *Arranging Flowers*, illustrated on p254, he tackled a different subject in contrast to his fishing scenes. He exhibited at all the leading London art galleries and at the RA from 1887, and also at the Walker Art Gallery in Liverpool and in Birmingham.
REPRESENTED: PENZANCE.

FRANK RICHARDS, RBA
fl. 1883-1925

A Birmingham artist who moved to Lulworth, Dorset, in 1885, and then went to live in Newlyn in 1892, Frank Richards was a genre watercolour artist and one of the lesser figures of the Newlyn School. Unlike most of the Newlyn artists, he had no great attachment to the village, which he saw only as good material to sketch rather than as a pleasant place in which to live. In an article in the *Studio* in 1895, he described Newlyn as 'a fishy and smelly and a somewhat lazy place'. It was not the sort of remark that was likely to endear him to the Newlyn residents, who were fiercely parochial. Despite this, he was friendly with everyone, including the fishing community who had come to accept the artists' colony in their midst with a mixture of awe and amusement, and were happy to allow them into their cottages to paint. In Richards' painting illustrated on p255, he portrays a fisherman's daughter doing her homework among her father's nets which are drying in their humble home.

Richards left Newlyn in 1897 and went to London, where he stayed for five years, before he moved to Wareham in Dorset and finally ended his days in Bournemouth. He exhibited from 1883 to 1925, but only three pictures were accepted by the RA.

JOHN ISAAC RICHARDSON, RI, ROI
1836-1913

A genre and landscape artist who worked entirely in watercolours, John Isaac Richardson was born in Newcastle, the son of Thomas Miles Richardson, the landscape artist who organised the first fine art exhibition in the North of England. According to *Graves*, Richardson first exhibited at the RA in 1846, when he was only 10 years old. He was the brother of Charles Richardson and Thomas Miles Richardson jnr, who were both landscape painters who worked in watercolours. An example of Richardson's watercolours, *The Young Herbalist*, is illustrated opposite.
REPRESENTED; NEWCASTLE.

John Isaac Richardson
The Young Herbalist
Watercolour, signed with initials and dated
1881. 14½ x 10½in
Fine Lines (Fine Art)

SIR WILLIAM BLAKE RICHMOND, RA
1842-1921

A painter and sculptor and the brother of George Richmond, who became one of the leading portrait painters of his time, William Blake Richmond went to the RA Schools in 1861, after some initial coaching by John Ruskin. Like his brother, he also became a successful portrait painter. Following the death of his wife he went to Italy, where he met Lord Leighton, who tried to lure him in the direction of neo-classical painting. When he returned to England he remarried and although he was anxious to follow Leighton's advice, he decided to concentrate on portrait painting. This was a wise decision, because at the turn of the century neo-classical painting was widely derided. Richmond's list of sitters was formidable, and included Robert Browning, Charles Darwin, Gladstone and Bismarck, which testifies to his popularity as a portrait artist. He was made an RA in 1895, having exhibited at the Academy from 1857. He received his knighthood in 1897.

CHARLES RICKETTS, RA
1866-1931

Painter, lithographer, wood engraver, stage designer, sculptor and publisher - Charles Ricketts was all of those things, as well as being a collector of Japanese paintings, old master drawings and valuable objets d'art. He was born in Genoa, the son of the marine artist Charles Robert Ricketts, and was brought up in France and Italy. He studied a the Lambeth School of Art, where he met Charles Shannon (see entry), who became a close friend. With £500 he inherited from his mother he founded the Vale Press in 1896 and produced eighty-three beautifully bound books, some illustrated by himself. Seven years earlier he had gone into partnership with Shannon and produced the magazine the *Dial*, together with the aid of a band of artists who helped to promote it as a protest against the unintelligent and often appalling examples of book production that were becoming increasingly prevalent. The Vale Press lasted from 1889 to 1897, but its publications were less effective and had less impact than those that came from the Kelmscott Press of William Morris.

Ricketts and Shannon remained close friends throughout their lives, and were nicknamed 'Orchid' and 'Marigold' by Oscar Wilde.

Ricketts did not begin to paint seriously until he was nearly 40, which places his painting squarely in the middle of the Edwardian period. He was most influenced by the work of Delacroix and Gustave Moreau, which combined exotic and often fantastic detail in mythological subjects. Ricketts' paintings were essentially romantic in conception and perhaps play no major part in the history of art, although some are in public collections. His painting *Don Juan Challenging the Commander* can be seen at the Royal Academy. In the latter part of his life, Ricketts worked increasingly at scene designing and sculpture.

REPRESENTED: ASHMOLEAN, BM, FITZWILLIAM, LEEDS, MANCHESTER, READING, V & A.

BRITON RIVIERE, RA, RE
1840-1920

A genre artist who was born the son of a drawing master at Cheltenham College, Briton Riviere was educated at Cheltenham and Oxford, before he went to London, where he began his career as a humorous illustrator for *Punch* and a number of American magazines. He claimed that he turned to painting in 1858 because one of his eyes had been permanently damaged by the close work of his magazine illustrations. Initially he was attracted to the work of the Pre-Raphaelites and tried to work in their manner. However, all his paintings were rejected by the RA, most probably because he had fallen under the influence of the London Scottish Group which consisted of half a dozen young Scottish painters who had migrated to London to make their fortunes. They were using broken colour, a form of painting in which a textured brushwork is used. Riviere had adopted this method, but it was completely at odds with the work of the Pre-Raphaelites. Turning his back on them, Riviere changed to animal painting with

considerable success, and he was soon seen as the natural successor to Landseer (see entry). It has been said that Riviere showed a sympathetic understanding of animals in his paintings and that he avoided giving them human traits as Landseer had done. This may be the case, but what he did do was to treat them in a sentimental manner. His painting *Fidelity*, which depicts a dog gazing with devotion at his grieving master, is in the direct traditions of Landseer's *The Shepherd's Chief Mourner*, which was painted more than thirty years before. Riviere's paintings were calculated to appeal especially to dog lovers, just as Landseer's had been, and many engravings were made of them. Although all his pictures are very well painted, they did nothing to further the cause of serious animal painting, but rather served only to devalue it.

Riviere studied under John Pettie, the Scottish artist, from whom he learned the textured brush technique, and William Orchardson (see entry). He exhibited eighty-two paintings at the RA, including his famous *Beyond Man's Footsteps*, which was bought by the Chantrey Bequest in 1894. He was made an RA in 1880, and at least one of his paintings is to be found in most of the public galleries.

REPRESENTED: BM, BLACKBURN, BURY, MANCHESTER, V & A.

DAVID ROBERTS, RA
1796-1864

Known as the Scottish Canaletto, David Roberts was born in Stockbridge, near Edinburgh, the son of a shoemaker. After serving an apprenticeship as a house-painter, he joined a travelling circus, as a scene painter, which was a reliable source of income for artists who were waiting for better opportunities to come their way. After working at the Edinburgh Pantheon and at the Theatre Royal,

Glasgow, Roberts worked at the Drury Lane Theatre, London, where he met the well-known marine artist William Clarkson Stanfield (see entry). He exhibited at the RA from 1826 to 1864 and at a number of other galleries in London, and eventually he became known as one of the best topographical artists of his generation. He was elected to the RA in 1841, and later travelled widely, publishing a number of illustrated books by himself, such as *Picturesque Sketches in Spain during the years of 1832 and 1833*, and *Views in the Holy Land, Syria, Arabia, Idumae, Egypt and Nubia*. His Middle East views were printed by lithograph after they were drawn on stone, and were sold on subscription. He also designed the sets for the London production of Mozart's *Il Seraglio*, organized to coincide with the Great Exhibition of 1851.

REPRESENTED: ABERDEEN, BM, FITZWILLIAM, GLASGOW, LEEDS, MANCHESTER, NGS.

PERCY ROBERTSON, RE
1869-1934

A landscape artist and an etcher, Percy Robertson was born in Bellagio, Italy, the son of Charles Robertson, who was also a landscape painter. He exhibited at all the London galleries from 1887, including the RA. He painted many views of the Thames and various other scenes in the vicinity, including his elegaic and interesting view of Westminster Bridge, when the horse bus was the only threat to life for the unwary (see p259). The bridge was rebuilt in 1854-62 by Thomas Page, although it had not greatly changed when Robertson captured it on canvas. It had always played an important part in the lives of Londoners since it was first opened in 1752, an edict declaring that anyone caught damaging it was likely to be sentenced to death without benefit of clergy. Even Wordsworth was prompted to eulogise about it in 1892 with a poem which began:

Earth has not anything to show more fair
Dull would he be of soul who could pass by
A sight so touching in its majesty;

Thomas Sewell Robins
Untitled watercolour, signed and dated 1869.
13½ x 22½in
David James

THOMAS SEWELL ROBINS
1814-80

Thomas Sewell Robins has always been a favourite painter with buyers of marine paintings, as far back as Victorian times when his work was almost as popular as it is now. He was a London artist who often portrayed scenes that were full of dramatic situations, such as ships running before the wind through tumultuous waters or about to go down during a storm. He painted to satisfy the tastes of the Victorians, most of whom preferred the portrayal of high drama at sea rather than meticulously detailed pictures of becalmed ships resting on still waters, which would probably appeal to sailors, or to those with a knowledge of the sea. When he did paint a quiet scene, Robins always created a busy picture - for example, his watercolour illustrated on p261, which was painted along the Dutch coast. Apart from his vigorous seascapes and scenes taken from the foreshore, he also painted a number of picturesque river scenes.

Robins was trained at the RA Schools, where his teachers were Thomas Phillips, the portrait painter, and his lecturer on perspective the great J. M. Turner. He painted along the whole length of the English coast, and also around the coasts of Calais, Genoa, Elba and Holland. Although he is known mainly as a watercolourist, Robins also painted a number of oils, some of which were exhibited at the RA between 1829 and 1874. The main outlet for his work, however, was the New Watercolour Society, where he exhibited 317 paintings.

REPRESENTED: BIRMINGHAM, BRIGHTON, MARITIME MUSEUM (GREENWICH), PORTSMOUTH.

FREDERICK CALEY ROBINSON, ARA, RWS, RBA, ROI
1862-1927

A painter of idyllic scenes, illustrator and poster designer, Frederic Caley Robinson was born in Brentwood, Essex, and studied at St John's School of Art before he went to the RA Schools. He completed his studies at the Académie Julian in Paris, one of the most important training schools in Europe. He began his career by painting marine subjects until he came under the influence of Burne-Jones (see entry), when he turned to decorative painting, which no doubt helped him to obtain the post of Professor of Figure Composition and Decoration at the Glasgow School of Art (1914-24). He also designed the decor and costumes for Maeterlinck's *Blue Bird*, which was staged at the Haymarket Theatre in 1909, as well as designing a series of posters for the London, Midland and Scottish Railway. He exhibited twenty-eight paintings at the SS from 1877 to 1893 and is well represented in many public collections at home and abroad. He worked in Paris from 1903 to 1906, and died in London.

REPRESENTED: ASHMOLEAN, BM, FITZWILLIAM, MANCHESTER, MARITIME MUSEUM (GREENWICH), V & A.

DANTE GABRIEL ROSSETTI
1828-82

Dante Gabriel Rossetti was undoubtedly the most inspired of the Pre-Raphaelites, with his personal vision of the medieval world of the Arthurian legends which he painted with an intensity never before seen in art, with the exception perhaps of the visionary paintings of William Blake.

Rossetti, whose full baptismal name was Gabriel Charles Dante, was the son of an Italian refugee who became professor of Italian at King's College, London. The young boy was himself educated at

King's College and then went to Carey's Art Academy from where he obtained admission in 1845 to the RA Schools. However, he left the RA Schools in disgust at their teaching methods, which he considered to be hidebound and reactionary. After spending a short time studying under Ford Madox Brown, whose work he greatly admired, Rossetti shared a studio with Holman Hunt. Rossetti's association with Brown and Hunt led to the birth of the Brotherhood, as the Pre-Raphaelites called themselves. Formed in 1848, when Victorian art was in a reactionary period, the work of the Brotherhood flew in the face of convention headed by the RA, who saw the tremendous visual impact of their painting as a vulgar tilt against all the established conventions of art which so far had followed, or at least had attempted to follow, the ground rules laid down by the Academy. The subsequent protests against the Brotherhood were only stilled when the influential and greatly respected John Ruskin came to their rescue with a spirited defence of their work. But by then the damage had been done, and from then Rossetti never exhibited again, contenting himself instead with selling his paintings through private dealers. When his wife, Elizabeth Siddal, committed suicide, the intensity that marked so much of his work disappeared, and he became a somewhat mechanical painter, although he was still highly successful.

The circumstances that surrounded the death of Elizabeth Siddal have never been fully explained, although it has been claimed that Rossetti drove her to her death. A red-haired beauty, she was first his model and then his mistress before she became his wife. She was then forced to play the role of an unattainable goddess while Rossetti associated with prostitutes in private. His love for Elizabeth was genuine enough, but it was rooted in a form of high romanticism which had little to do with everyday living. When he confessed to her that the intense love he felt for her would become even stronger if she were to die, she took him at his word. Trapped in an unreal world of romantic passion, she made her escape by taking an overdose of laudanum. She was only 31.

Rossetti was prostrate with grief at the funeral. In a gesture worthy of the final scene in some grand opera, he placed a copy of all his unpublished poems in her coffin - only to have them retrieved some years later and sent to the printers for publication. Despite all his talk of everlasting love for Elizabeth, he later had a long-standing *affaire* with Jane Morris, the wife of William Morris.

In his later years, when all his passion was spent and he was becoming senile, Rossetti went to live in Birchington-on-Sea, where he became an almost total recluse and obsessed by a persecution mania. (See also biographies of Holman Hunt, Ruskin and Millais.)
REPRESENTED: BIRMINGHAM, BM, MANCHESTER, V & A.

ALEXANDER M. ROSSI
exh. 1880-1905

A genre artist who occasionally painted portraits, Alexander Rossi lived in Preston, Lancashire, before he moved to London. He lived at numerous addresses, which seems to indicate his growing affluence as a painter - one of his later addresses was 177 Adelaide Road in fashionable St John's Wood. He exhibited at the RA from 1871 to 1903, when forty-seven of his pictures were exhibited. He painted many charming studies of children and young girls, including *Gathering Marguerites*, which is illustrated opposite. His many paintings include *A Midsummer Walk, Little Rivals, Without a Mother, A Quiet Nook* and *After the Bathe.*

Alexander Rossi
Gathering Marguerites
Watercolour, signed. 30 x 22½in
Fine Lines (Fine Art)

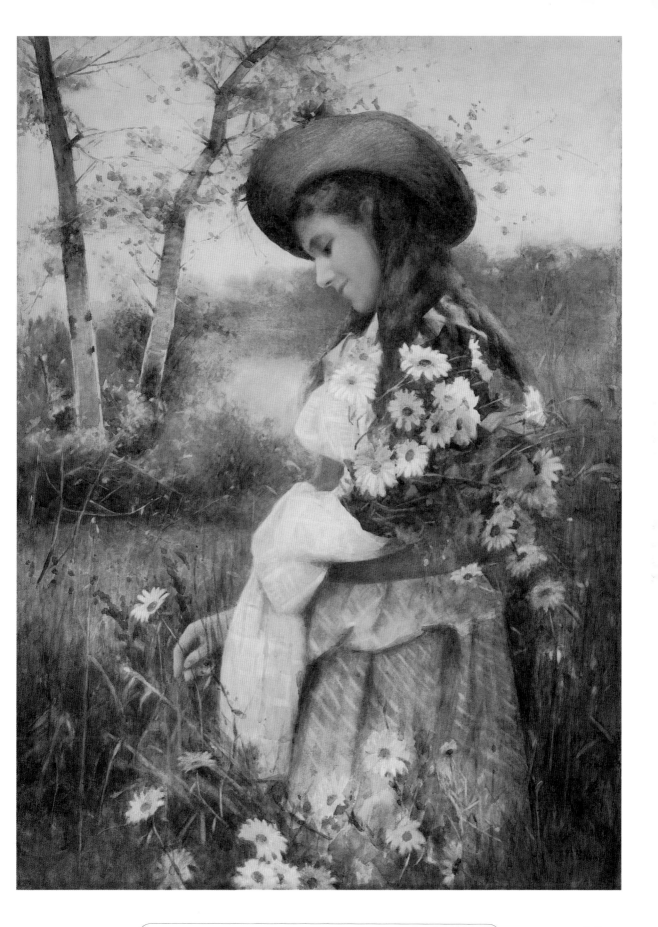

CHARLES EDMUND ROWBOTHAM
1856-1921

A member of a painting family, Charles Edmund Rowbotham was the son of Thomas Charles Leeson Rowbotham, a talented watercolourist whose work had been praised by Ruskin. He was born at 14 Norfolk Villas, Westbourne Grove West, London, and by the time that the family had moved to Shepherd's Bush in 1877, Charles had decided that he was going to be an artist and was already helping to fill in the figures in his father's landscapes. When his watercolour, *Near Bramber, Sussex*, was shown at the Royal Society of Artists, he broke away from his family and went on a series of sketching tours. In 1884 he married, and with his wife toured Switzerland, Italy and the French Riviera. It was during this period that he produced his best work, which included his watercolour painted on the shores of Lake Como (see opposite) in which his fondness for blue is apparent.

Returning to England Rowbotham lived at several addresses until he settled in 1889 at 1 York Villas, Brighton, where later he held an exhibition of his work in the Pavilion. By then, however, he was suffering from heart trouble, although this did not stop him from moving again in 1913 to 22 Vincent Street in Addiscombe, near Croydon, Surrey. His heart condition grew steadily worse, and in 1921 he suffered a serious heart attack while he was on the way to his club. He was taken to the Croydon hospital on 14 January 1921, where he died, at the age of 64, leaving behind three children. The existing reference books on Victorian artists have ignored his work almost completely.

REPRESENTED: CARDIFF, V & A.

Charles Edmund Rowbotham
Lake Como
Watercolour, signed and indistinctly dated
7½ x 6in
Fine Lines (Fine Art)

JOHN RUSKIN, HRWS
1819-1900

Although he is better known as the leading art critic of his day, John Ruskin was also a talented watercolour artist who had studied under Copley Fielding and James Duffield Harding (see entries). The landscapes that he painted in Italy and Switzerland were executed with a sure and light touch, while his drawings, mainly of architectural subjects, were highly detailed studies of rock formations and plants.

In 1843 Ruskin brought out the first volume of his *Modern Painters*, in which he began his defence of Turner which continued for years before he wrote his touching epitaph. When his books *The Seven Lamps of Architecture* (1848) and *The Stones of Venice* (1851-3) were published, his position as England's leading art critic became unassailable. After his separation from his wife Effie, who deserted him for Millais (see entry), he became passionately interested in social reform. Soon afterwards he began to suffer from a mental illness which made him unreliable as a critic and finally led to his notorious attack on Whistler (see entry). Towards the end of his life he retired to Brant Wood, Coniston, in the Lake District, where he lived until his death.

Ruskin's *Modern Painters* is still used by art students and historians, although his work is verbose and pretentious, and his portentous pronouncements are often meaningless. None of his contemporaries, however, was capable of matching his critiques, overblown as they often were. The *Art Journal* and most of the art magazines of his day seemed incapable of giving serious evaluations of any work of art, and contented them-

selves with writing a series of platitudes intermingled with fulsome praise and a dash of religious thought. The result has been that for all his faults, Ruskin still remains the only serious critic of the Victorian age who can be referred to confidently. It is worth remembering, too, that he alone supported Turner's work when support was most needed.

REPRESENTED: ASHMOLEAN, BIRKENHEAD, BIRMINGHAM, BM, CONISTON, FITZWILLIAM, GLASGOW, KENDAL, SHEFFIELD.

GRACE SAINSBURY
1888-1917

A London landscape, figure and painter of country scenes, Grace Sainsbury is a little-known watercolourist whose work deserves to be better known than it is. She exhibited nine paintings at the RA between 1891 and 1904, and is a typical female genre artist in that she painted with great delicacy and a light touch, which made watercolours the ideal medium for her work. The charming example of her work opposite was painted at a much later period and displays all the best characteristics of her painting.

ANTHONY FREDERIC SANDYS
1832-1904

A Pre-Raphaelite painter who was born in Norwich, the son of a minor member of the Norwich School of painting, Anthony Frederic Sandys did not attend the RA Schools as has been stated in some publications, but was given his art education by local teachers. He then went to London where he met Rossetti and Holman Hunt, who had a powerful influence on his work once he had joined their circle. His earliest exhibit at the RA, a portrait in watercolours of a local Norwich worthy, was in 1851. His first exhibits in oils were shown ten years later, and during this period he worked regularly for a number of magazines such as the *Cornhill, Good Words,* the *Quiver* and

Grace Sainsbury
Telling the Time
Watercolour, signed and dated 1895. 14 x 10¼in
Fine Lines (Fine Art)

Argosy, as well as illustrating *The Shaving of Shagpat,* a series of Eastern fantasies by George Meredith, which were not noteworthy. He spent the last sixteen years of his life as a paraplegic, after suffering a spinal complaint. Sandys' talents were not greatly appreciated during his lifetime, which still remains the case today.

ELLEN SANFORD, ASWA
exh. 1886-1921

An artist who painted still life, animal and bird studies, and genre pictures, Ellen Sanford exhibited fifty-five paintings at the Society of Female Artists which was established in 1857 in Oxford Street, London, as part of a movement among women painters to be recognised as artists in their own right. Initially, the society received an enthusiastic reception from the press, but not from male painters, who saw its formation as yet another attack against the bastions of their privileges, and the polite nod in its direction given at first by the RA and the establishment was soon replaced by indifference and a total lack of support from the quarters that really mattered.

But at least by the time that Ellen Sanford was painting, women were allowed to exhibit at the RA, and she was able to show there and at the other London galleries, which had come to realize that a work by a woman artist sold just as well as a painting by a male artist. Her genre paintings included *Grow Old Along with Me* and *Love's Young Dream.*

Although Ellen Sanford originally came from Somerset, she is known as a Surrey artist who lived in Carshalton for many years before she moved to a cottage in Redhill, Surrey. She apparently later moved to Oakley, near Dorking.

JOHN SINGER SARGENT, RA, RWS, HRSA
1856-1925

One of the great portrait painters of the late Victorian and Edwardian periods, John Singer Sargent was born in Florence, the son of an American physician from Boston. He was educated in Italy and Germany and received his art training in Paris under Carolus-Duran, who was one of the first teachers to turn the ideas of his contemporaries and students away from the Italian, Flemish and Spanish schools of painting. He first exhibited in the Paris Salon in 1879 and then visited Spain, and in 1882 exhibited *Jaleo*, his famous painting of flamenco dancers. He settled in London in 1886 at 31 Tite Street, a much favoured street of artists and writers. Between 1890 and 1907 he was the most fashionable portrait painter of his day, and the sum of his work during that period resulted in a now unrivalled collection of studies of some of

Frank Scarborough
Whitby Bay
Watercolour. 12¼ x 16½in
Susan and Robert Botting

the dominant personalities of late Victorian and Edwardian society, who were often portrayed with a merciless and unflattering eye. He was made an RA in 1897 and by 1907 had accumulated a sufficiently large fortune to enable him to pursue his true interest in painting - that of landscape painting in watercolours, to which he began to transfer his allegiance from about 1900. He was official war artist during World War I, when he painted *Gassed* for the ministry.
REPRESENTED: ASHMOLEAN, BRADFORD, BM, IMPERIAL WAR MUSEUM, MANCHESTER.

FRANK W. SCARBOROUGH
fl. 1890-1939

Frank Scarborough belongs to that group of Edwardian artists who worked until the 1930s, and includes such well-known marine artists as Charles Napier Hemy, William Lionel Wyllie and Charles Dixon. Apart from Hemy, who was in a class of his own, Scarborough was probably the most interesting artist of the group, because his work was painted in an Impressionistic style that owed nothing to the traditional school of marine painting, but was influenced by the work of Albert Marquet or Camille Pissarro's *The Docks of Rouen, Morning*.

A London artist who settled in Lincoln in 1908, Scarborough painted mainly in watercolours, often taking as his subject -matter the busy shipping in the Pool of London, where ocean-going liners battled for space with soot-grimed tugs and barges in the murky waters of the Thames. On other occasions he painted quiet atmospheric pictures, which were often done in the late afternoon when he captured the different reflections on the water, as in *Whitby Bay*, shown opposite.

JOHN CHRISTIAN SCHETKY
1778-1874

John Christian Schetky was a larger-than-life character who was fortunate enough to find his niche early in life as a famous art teacher and marine artist. Later he became a painter in watercolours to William, Duke of Clarence, as well as a marine painter to George IV, William IV and Queen Victoria. Unlike so many of the marine artists of his time who died young and in dire poverty, Schetky lived to the grand age of 96 and went to his grave a rich man.

Born in Edinburgh, Schetky was taught art by Alexander Nasmyth, the Scottish landscape painter. His first position was that of teacher of drawing at the Royal Military College in Portsmouth, where his bluff manner and cheery disposition soon endeared him to his pupils. A man of immense height, which was emphasised by his ill-fitting clothes, he became known to his pupils as 'Sepia Jack' because of his fondness for using a coppery brown wash in his paintings.

Schetky remained at the Military College for twenty-five years until the Admiralty announced their intention of closing the school. He then became Professor of Drawing at the East India College at Addiscombe, Surrey, where he stayed until his retirement in 1855. He continued to paint, however, and even at the age of 82 made another of his many trips abroad to sketch along the coasts of Spain and Portugal. He also continued to exhibit at the RA until two years before his death. In the words of one of his pupils, 'Mr Schetky was as good an old fellow as ever lived'. After his death his widow wrote a biography of his life called *Ninety Years of Work and Play*. An example of his work is illustrated on pp270-1.
REPRESENTED: MARITIME MUSEUM (GREENWICH).

Deal Sep. 19
1867

The Albion
a Deal Boat - Sep. 1869 ~ 9th Sept. 1864

John Christian Schetky
Deal Castle
Watercolour
Spink

CHARLES SHANNON, RA, ARPE
1863-1937

A figure and portrait painter, as well as a lithographer, Charles Shannon was born in Sleaford, Lincolnshire, the son of a parson. He studied wood engraving at the Lambeth School of Art where he met Charles Ricketts (see entry), which led to their life-long friendship and collaboration on the *Dial*. At the beginning of his career he supported himself by teaching at the Croydon Art School for four days a week before he became a portrait painter when he lived with Ricketts. His work was more Venetian in style than Edwardian, no doubt because he was a great admirer of Tintoretto and Titian. Both he and Ricketts were dedicated collectors, often reducing themselves to near penury to obtain a set of Japanese watercolours or prints, or other pictures that took their fancy. In time they acquired a remarkable collection which later went to the Fitzwilliam Museum in Cambridge. In 1929 he seriously injured himself when he fell from a ladder while hanging a picture and

Deal Castle – Sep: 19 - 1867 -

for the last eight years of his life was unaware of his surroundings and unable to recognize his friends when they visited him.

REPRESENTED: BM, BIRMINGHAM, LINCOLN, V & A.

WILLIAM SHAYER
1788-1879

A landscape and animal artist who also painted coastal scenes, William Shayer was born in Southampton. A self-taught artist, he painted mostly in Hampshire and around the New Forest. He was extremely prolific and painted 426 known paintings in his lifetime, often exhibiting up to 12 pictures a year, mostly at the SS, where he showed 338 pictures. His work is generally of a high standard and can be seen at its best in his paintings of shore scenes which depict boats and fishermen, as *Bringing in the Catch* on pp272-3.

Shayer belongs to the tradition of George Morland, and if he has any fault, it lies in his tendency to overwork certain formulae. He sometimes collaborated with Edward Charles Williams on large scenes which generally feature gypsies. His son William also painted coastal scenes and signed them W. Shayer, which has created a certain amount of confusion among art dealers today, even though William Shayer jnr was an inferior painter. The situation has not been helped by the fact that some Shayer pictures that turn up for auction are copies. Shayer died in Shirley, near Southampton.

REPRESENTED: GUILDHALL.

A COMPANION TO VICTORIAN AND EDWARDIAN ARTISTS

William Shayer
Bringing in the Catch
Oil on canvas. 28 x 38in
Haynes Fine Art

BENJAMIN SIGMUND
fl. 1880-1904

A watercolour artist who painted occasionally in oils, little is known about Benjamin Sigmund, except that he exhibited thirty-four paintings at the RA between 1883 and 1891, and also at some of the major London galleries and at the Royal Scottish Academy. He originally came from London, but lived at several addresses, including Barnstaple in north Devon and later in Maidenhead, Berkshire.

A landscape painter of charming rural scenes, Sigmund painted in an immediately recognisable style which relied a great deal on delicate colouring. His many watercolours include *In the Evening Light*, *Children in the Woods Amid the Windings of a Woody Glade*, and *Child Outside Cottage with Chickens*, which is illustrated on p274. His work suddenly became very popular in the late 1970s and has remained so ever since.

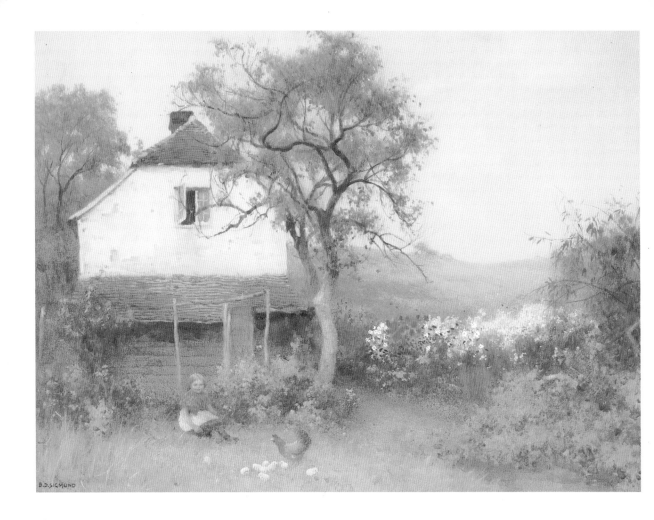

Benjamin Sigmund
Child Outside Cottage with Chickens
Watercolour, signed. 11½ x 15½in
Fine Lines (Fine Art)

CHARLES SIMS RA, RWS
1873-1928

The name of Charles Sims has always been linked with those of Charles Shannon and Charles Ricketts, with whom he lived for many years (see entries). Although Sims became an RA and is given respectful attention in some reference books, he has become an under-rated artist, whose studies of young children playing in a world of Arcadian innocence (see opposite) are now unfashionable. He worked in oils, tempera and watercolours.

Charles Sims was born in Islington, London, and was sent to work in Paris at the age of 14. After three unhappy years there he returned to England and went to the South Kensington Schools to study art. He continued his studies at the Académie Julian in Paris and completed his training at the RA Schools, where he received the Landseer Scholarship.

From 1889 to 1897 he worked with Shannon and Ricketts on the influential magazine the *Dial*. For some years afterwards he was occupied with painting pagan themes, but suddenly he produced six canvases that recall the work of William Blake and his visionary outlook on the world. His work was unconventional for the RA at that time, which was still only concerned with maintaining the old traditions. Despite this, he was made an RA in 1916, an official war artist in 1918, and finally keeper of the RA from 1920 to 1926. Despite his success as an artist he must nevertheless have been an unhappy man, for he committed suicide on 13 April 1928 in St Boswell, Scotland.
REPRESENTED: BRADFORD, LEEDS, MANCHESTER.

Charles Sims
Exaltation of a Flower
Watercolour, signed. 9½ x 8½in
Fine Lines (Fine Art)

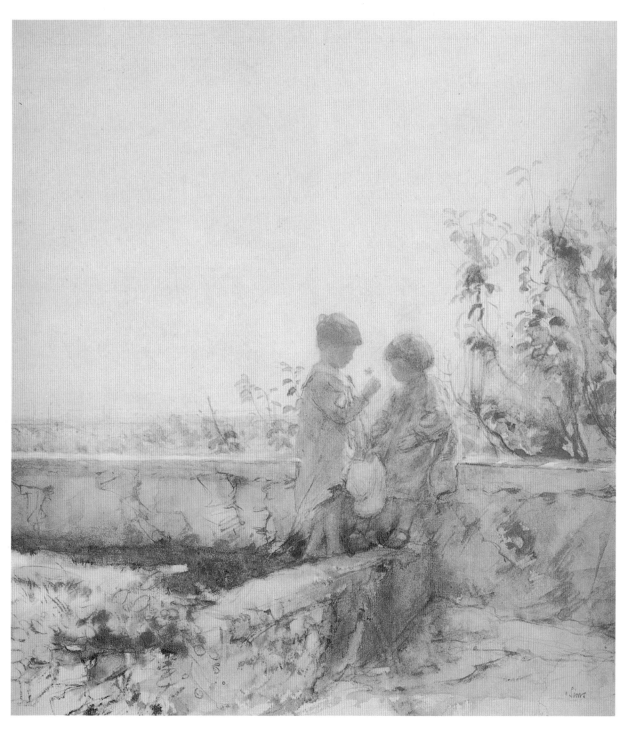

WILLIAM SIMPSON, RI, FRGS
1823-99

William Simpson, who came from a humble background, was born in Carrick Street, Glasgow, and was apprenticed to a firm of local lithographers at the age of 14, before he decided to take up painting. He went to London in 1851 where he found work with Messrs Day & Sons, who were the foremost lithographers of their time. His first job with them was to produce a view of the Great Exhibition of 1851. Three years later he began what was to be a colourful career as a topographical and architectural artist. When he was offered a commission by Messrs Colnaghi to paint forty-eight watercolours for a book entitled *Seat of War in the East*, which had been prompted by the outbreak of the Crimean War, he accepted it immediately, thereby becoming the first artist to accept a war assignment. After he had completed this commission his name was made and he was known thereafter as Crimean Simpson. For the next forty years he covered every war operation and political event that occurred. After he had painted a picture of Balaclava for Queen Victoria, he received many more commissions from her, which put the final seal of approval on his painting. Over the years he accumulated a mass of work in the way of watercolours and sketches, and used many of them in books and magazines. He died in Willesden, London, and four years later his biography by Clement and Hutton was published. REPRESENTED: BIRKENHEAD, V & A.

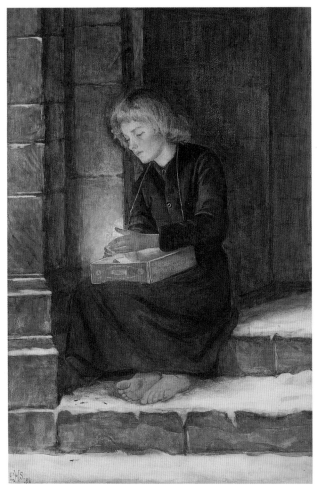

Edith Heckstall Smith
The Young Match Seller
Watercolour, signed with initials and dated
1886. 25 x 16½in
Fine Lines (Fine Art)

EDITH HECKSTALL SMITH
fl. 1884-90

A painter of figure and genre subjects, Edith Heckstall Smith lived at Connaught House, Beckenham, Kent, and exhibited four paintings at the RA, and another six at the SS. Her genre paintings include *Idling, Toil and Trouble, Holiday Time*, and *The Young Match Seller*, which is shown above. *The Young Match Seller* comes near to the work of Samuel McCloy, who painted a number of pictures of the London poor. This was a favourite subject with Victorian artists, many of whom had become deeply concerned about the plight of the needy since the introduction of the new Poor Laws, and used their paintings to bring the public's attention to their desperate plight. Unfortunately, the only answer the Victorians had to the problem was either to lock the destitute away in the Poor House or to give them charity, accompanied by a religious homily. When Smith painted this picture in 1886, the situation was as severe as it had been during the early days of Queen Victoria's reign.

GEORGE SMITH
1829-1901

A genre painter and a product of the RA Schools, and a pupil of Charles West Cope, RA, a painter of historical and biblical subjects, George Smith was first employed by Cope to help him with painting some of the frescos in the new Palace of Westminster. His first painting to be exhibited was *The Gypsy Girl*, which was shown at the BI in 1847. From that date until his death he exhibited seventy-eight paintings at the RA and many more elsewhere. In many ways his work resembles that of Thomas Faed (see entry) in its colouring and treatment. It was the type of genre painting that was very popular before the Victorians began to prefer genre pictures that presented a highly romanticised version of country life in direct opposition to the realities of the rural scene.

REPRESENTED: NOTTINGHAM, ROCHDALE, V & A.

George Smith
Tea-time
Oil, indistinctly signed and dated 1882.
24½ x 29½in
Sotheby's, Sussex

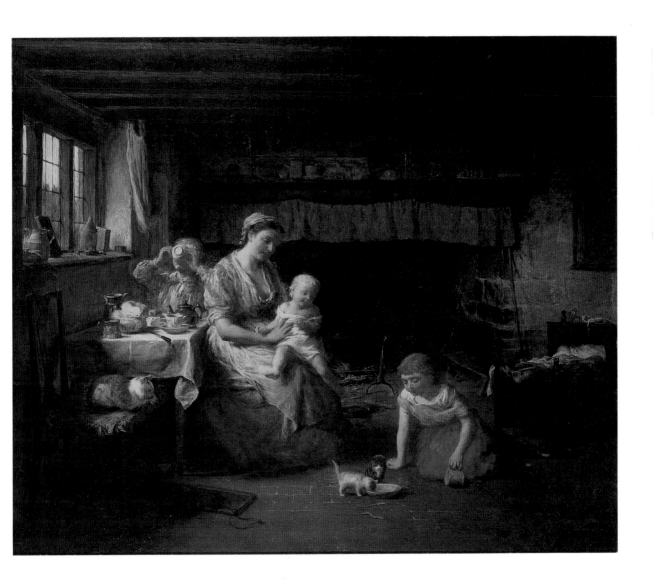

REBECCA SOLOMON
1832-86

For a long while John Ruskin had a poor opinion of women artists, and was quite blunt about it. He voiced his opinion in a letter to Ann Blunden, a figure and landscape painter whose work he later came to admire, in which he wrote 'as far as I know women painters *always* let their feelings run away with them, and get to painting angels and mourners when they should be painting brickbats and stones'. It is doubtful that he would have said the same to Rebecca Solomon, who had no time for painting 'ladylike' subjects. An historical and genre artist, she painted dramatic subjects such as *The Arrest of a Deserter* and *Fugitive Royalists*. Her brother Simeon (see entry) became a social outcast after he had been arrested for homosexual practices, and Rebecca herself gave cause for comment when people became aware that she drank too much. She exhibited at the RA from 1852 to 1869, and after that date did not exhibit. She died of alcoholism.

SIMEON SOLOMON
1840-1905

A Pre-Raphaelite painter who entered the RA Schools in 1855, Simeon Solomon was a brilliant artist who had a glittering career ahead of him until he was attacked in print by Robert Buchanan who said: 'English Society goes in ecstasy over Solomon's pictures - pretty pieces of morality such as who are dying by the Breath of Lust. . . .' He ranted on: 'Mr. Solomon was one of those who lend actual genius to worthless subjects and thereby produces monsters.' It was all part of the Bible-thumping and canting morality of the time, which saw evil in the most harmless statement in print or in a painting. Solomon could easily have survived such criticism and enjoyed a successful career had he not been arrested for homosexuality, which confirmed the public's opinion that artists led debauched lives. By 1873 Solomon's career was over almost before it had begun, and he was reduced to selling pastels of biblical subjects for a guinea apiece. He spent much of his life in St Giles Workhouse in Holborn, where he died of alcoholism.

WILLIAM CLARKSON STANFIELD, RA
1793-1867

William Clarkson Stanfield towers above almost all the maritime artists of the Victorian era for the sheer power of his paintings, in which he portrayed all the elements of marine painting that the Victorians demanded. Large seascapes depicting scenes of activity either in the way of busy shipping crowding around a port or coastline, or sailing ships battling their way through storms, or actually descending to the bottom of the ocean - these were the principal ingredients of Stanfield's paintings, and the Victorians loved them. An example of his work is illustrated opposite.

Stanfield was born in Sunderland, the son of James Stanfield, the writer of *Essay in Biography*, which had a wide readership when it was first published. William started his working life as a sailor and seems to have spent much of his time on board sketching, until he found himself pressed into the navy. It was during his navy years that he met Captain Marryat, who became an author in 1830, and almost from the start of his writing career enjoyed a phenomenal success with his tales of the sea. Seeing some of Stanfield's work, he advised him to take up painting as a career as soon as he could free himself from the navy. Stanfield was discharged in 1818 when, by a rare stroke of luck, he received an injury that was only of a temporary nature, but seemed serious enough at the time to rate him as unsuitable for further naval duties.

Stanfield began his art career modestly enough as a scene painter, and worked for a number of small theatres until he was able to get a similar position at the Drury Lane Theatre in London. He worked there for twelve years, gradually building up a reputation as one of the best scenery painters. In the meantime, he was also establishing himself as a major marine artist, and by 1820 was exhib-

iting at the RA, where he showed 135 paintings during his lifetime. His capacity for work seemed endless. Apart from his work at the Drury Lane Theatre, he painted a total of 178 known paintings and produced a number of engravings and illustrations for books, including some of those by his old friends Captain Marryat and Charles Dickens. He also made frequent trips abroad and led a busy social life in the company of his friends, including Dickens, who became very fond of him after he had painted some of the amateur theatrical productions which took place in his home. Stanfield married twice and had twelve children, two by his first marriage and ten by his second. Although his health declined towards the end of his life, he continued to work and showed a painting at the RA only a few months before he died. He was buried in the Catholic cemetery at Kensal Green, London. He remains to this day the undisputed master of British maritime painting.

REPRESENTED: MARITIME MUSEUM (GREENWICH), WHITBY.

William Clarkson Stanfield
The Wreck
Watercolour and body colour. 11 x 16⅜in
Spink

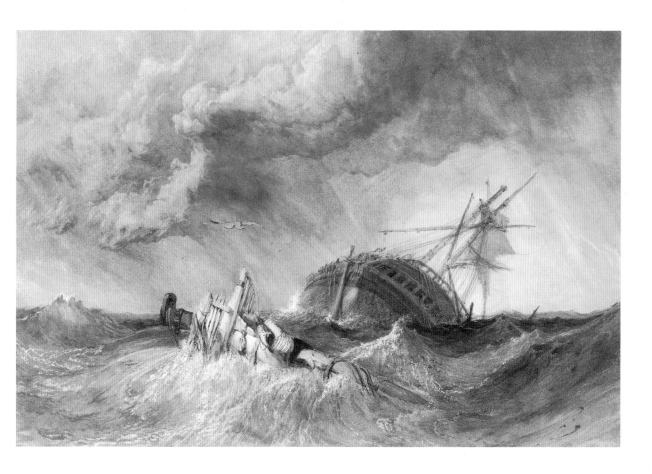

CHARLES JOSEPH STANILAND, RI, ROI
1838-1916

A London genre artist and illustrator who painted in both oils and watercolours, Charles Joseph Staniland was born in Hull and studied at the Birmingham School of Art, Heatherley's, and the South Kensington and the RA Schools, before he decided that he was ready to embark on a career as an artist. He became a painter of first-rate genre pictures and of historical subjects, and exhibited at all the main galleries in London. But gradually he changed from painting historical subjects to producing illustrations for a large number of magazines, which was probably his main source of income. Much of his work was done for the boys' magazines, *Chums* and the *Boy's Own Paper*, or for books such as Henty's *The Dragon and the River* and other rousing adventure stories. It is all the more surprising to come across an idyllic watercolour which he painted to illustrate one of Tennyson's poems (see opposite). More of a genre picture than an illustration, it was exhibited at the Royal Institute of Paintings in Watercolour in 1883. Staniland was also a frequent contributor to the *Illustrated London News* and the *Graphic*, and elicited praise from van Gogh when he was in England.

REPRESENTED: SUNDERLAND, V & A.

Charles Joseph Staniland
The Lotus Eaters
Watercolour, signed and dated 1883.
29½ x 48in
Priory Gallery

EMILY STANNARD
1803-85

Emily Stannard, née Coppin, originated from Norwich, Norfolk, where most of her work was done. She was an excellent still life artist whose work consisted mainly of meticulously painted studies of fruit and flowers in the Dutch manner. Her still life of dead game shown opposite is not to everybody's taste, nor is it the ideal painting to hang on the walls of the living-room, but it is an unbeatable example of *still leven* painting, disregarding the work of the Dutch masters of the genre. This style of painting fell out of fashion in England for decades, and only re-established itself in the nineteenth century.

REPRESENTED: NORWICH CASTLE MUSEUM.

Emily Stannard
A Still Life with Game
Oil on panel. 9½ x 12½in
Spink

Henry Stannard
Pretty Cottage with Ducks
Signed watercolour. 9 x 13½in
Fine Lines (Fine Art)

HENRY STANNARD, RBA
1844-1920

The son of the artist John Stannard (1794-1882) and a member of the Stannard family of artists, Henry Stannard jnr was a sporting and landscape painter who was born in Woburn, Bedfordshire. He studied at the South Kensington Schools and eventually established his own school of art in Bedford in 1887. He was first and foremost a sporting artist and he published a number of illustrated books on birds, which feature a great deal in his work. He was a member of the Dudley Art Society and contributed illustrations to various sporting magazines such as the *Encyclopaedia of Sport*, *Sporting and Dramatic News* and *Bailey's Magazine*, as well as supplying illustrations on decor and birds to the *Illustrated London News*. *Pretty Cottage with Ducks*, one of his country scenes which is shown above, bears a superficial resemblance to the work of his son Henry John Sylvester Stannard (1870-1951).
REPRESENTED: GREAT YARMOUTH.

GOURLAY STEELL, RSA
1819-94

The Scottish animal artist Gourlay Steell was born in Edinburgh, the son of a wood carver and engraver, and the brother of the sculptor Sir John Steell. Although he studied for a time at the School of the Board of Manufacturers, the most important part of his training was at the Trustees' Academy under Sir Robert Scott Lauder, who trained some of the best-known Scottish artists of the nineteenth century.

Steell began to exhibit at the RSA at the age of 14, and within a few years had become so well known as an animal painter that he was recognised as the Scottish Landseer. He did a great deal of book illustration in his early years and modelled animals that were reproduced by the local silversmiths. When he was appointed painter of the Highland and Agriculture Show, and then 'Animal

Gourlay Steell
The Elder's Collie
Oil, signed and dated 1883. 26½ x 24½in
Phillips

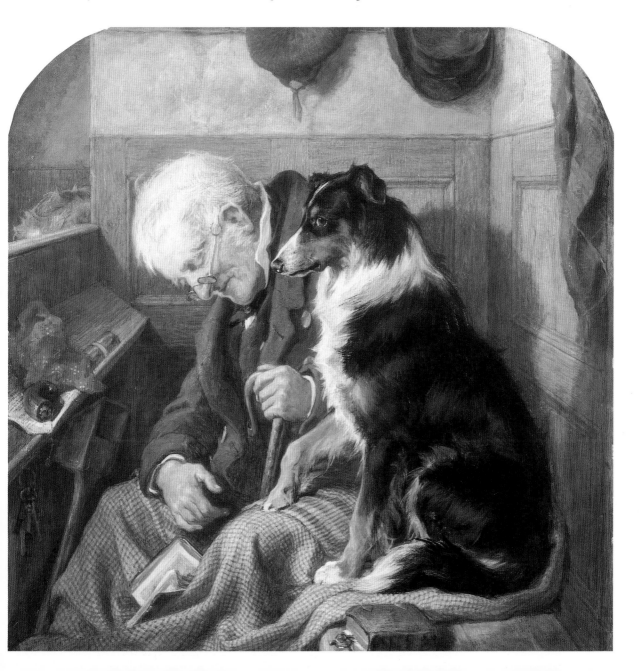

Painter for Scotland' by Queen Victoria, his position in the world of Scottish art was assured. Rather strangely, in James Caw's book *Scottish Painting, Past and Present*, he dismisses Steell by saying that 'His work was a narrow and conventional view of a picture maker. . . and even in his best time he did not grasp the pictorial possibilities of his material'. *The Elder's Collie*, shown on p283, contradicts that statement. It may be conventional in its subject-matter, but it is refreshingly free of the sort of sentimentality that marred so much of Landseer's work. Caw's opinions were certainly not shared by many art buyers at the time, as Steell received a very large number of commissions to paint animal studies. Many of his paintings are in royal collections. He was made curator of the National Gallery of Scotland in 1882, a post he retained until his death in 1894.

REPRESENTED: EDINBURGH.

FRANCIS STOCK
fl. 1875-82

A London artist who lived in Regent Street, Francis Stock painted fruit and genre pictures, a form of art that had its honourable antecedents in Holland during the sixteenth and seventeenth centuries, and reached its zenith in the work of such artists as Pieter de Hooch, Jacques Metsu, Terborch and Vermeer, all of whom delighted in painting scenes of their daily life. Such pictures enjoyed a considerable vogue in England in the nineteenth century, although by then the subject-matter was painted in an over-sentimentalised manner. Stock was no exception with his paintings, such as *Little Gretchen, Please to Ring the Top Bell, Hard Times* and *Christmas Comes But Once a Year*, which all tended to bring the medium into disrepute. But like most of the Victorian genre painters, Stock also produced a number of charming figure studies (see opposite). He exhibited seventeen paintings at the RA, one at the SS, and another thirty-seven at various exhibitions. His RA exhibits included *The Foundling* and *St Valentine's Day*.

Francis Stock
Girl with Caged Bird
Watercolour. 13½ x 9½in
Fine Lines (Fine Art)

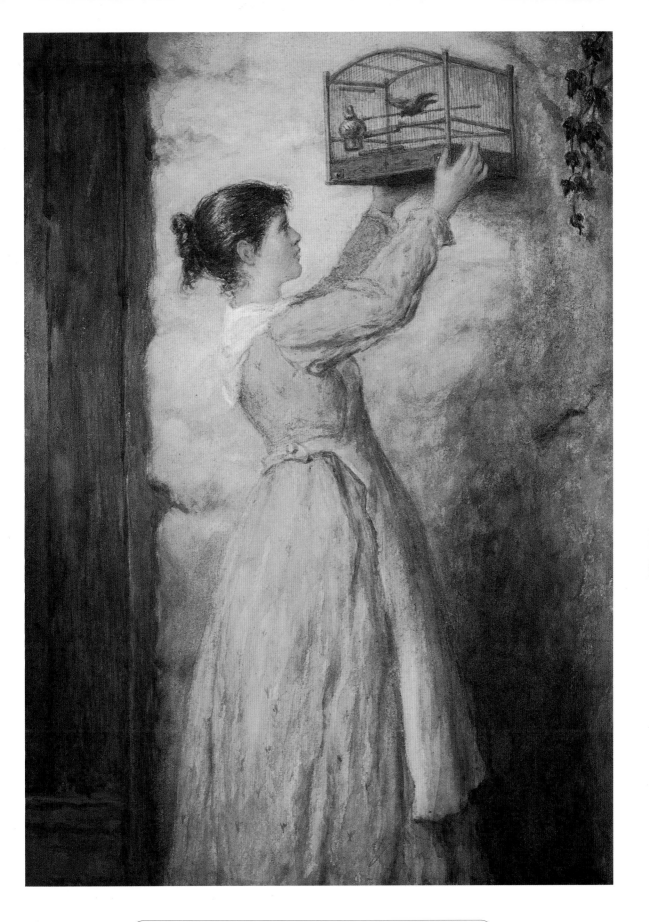

ARTHUR CLAUDE STRACHAN
1865-c1935

Philip Eustace Stretton
When the Cat's Away
Oil, signed. 30 x 25in
Bonhams

By the latter part of the Victorian period, garden painting had become one of the most popular subjects for the artist who went into the countryside looking for his subject-matter. Arthur Claude Strachan was therefore only one of the many artists who painted pictures of this kind, which were often the gardens of farm labourers in which flowers were allowed to grow in wild profusion.

Strachan was born in Edinburgh and lived at a series of addresses around Warwickshire, Worcestershire and Cheshire, which has made it difficult to obtain a great deal of information about him. He studied in Liverpool and spent much of his time there, exhibiting a large number of his pictures at the Walker Art Gallery. He also lived for some time in Minehead, Somerset, before he returned to Scotland, where his last known address was in Glasgow. His work was popular in his lifetime, and has been even more so since the 1980s.

Arthur Claude Strachan
A Village Lane
Watercolour, signed. 14 x 21in
Priory Gallery

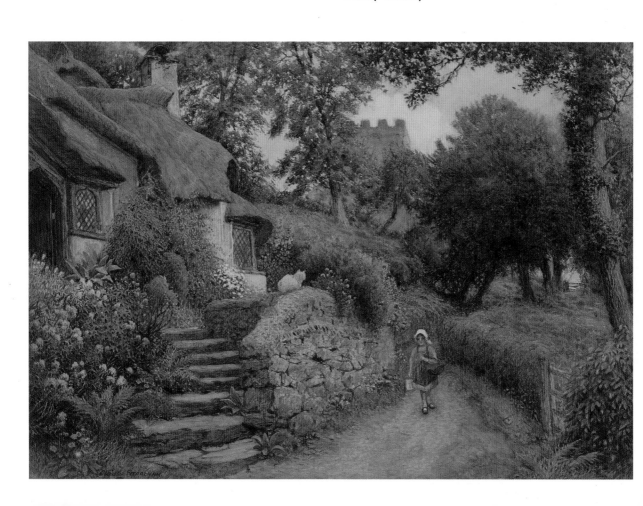

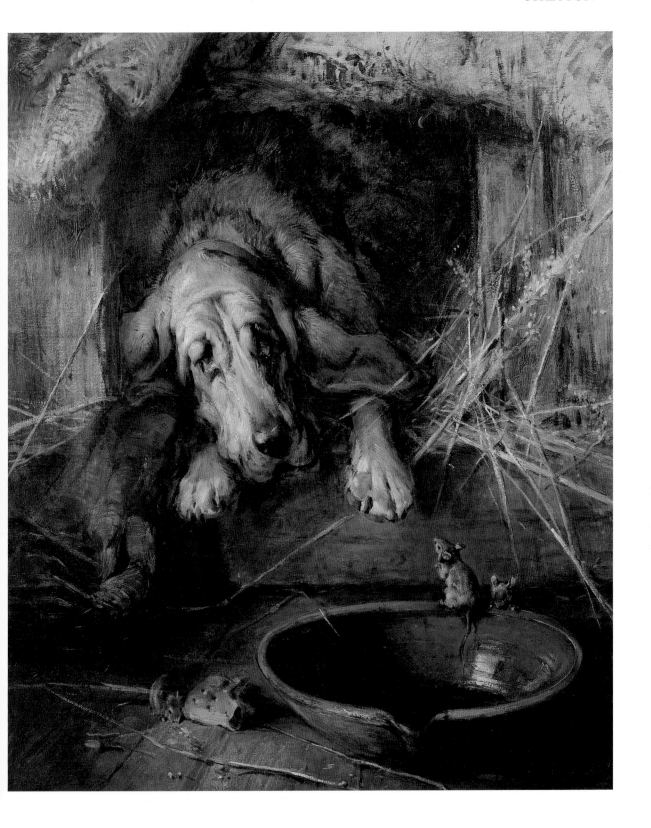

·PHILIP EUSTACE STRETTON
fl. 1884-1919

Philip Stretton's work as an animal artist was far removed from most of the sentimental paintings of the Victorian artists who had fallen under the influence either of Landseer, or the teacher William Calderon, who had founded a School of Animal Painting in 1881. His studies gradually moved away from the old style of Victorian animal paintings, to pictures that were much more acceptable to the rapidly changing tastes of the Edwardians. He was particularly good at painting large, lugubrious-looking dogs (see p287), although he did not confine himself to painting dogs. One of his best paintings was *In Danger*, in which a weasel is set to pounce on a nest of fledgling birds.

He exhibited thirty-two paintings at the RA,

J. Woodhouse Stubbs
In a Forest Garden at Ashdown, Crowborough, Sussex.
Watercolour, signed. 21 x 27in
Bourne Gallery

another forty at the ROI, and many others at most of the major London galleries.

Stretton lived originally at Mona Terrace, Wellington, Shropshire, before he moved south to Cranbrook in Kent.

ALFRED WILLIAM STRUTT, RCamA, RBC, ARE
1856-1924

Alfred William Strutt was born in Taranaki, New Zealand, the son of William Strutt, the genre and animal painter. He studied under his father until he came to England to attend the South Kensington School of Art. He became an animal and genre artist and portrait painter, and worked in oils and watercolours. He exhibited at the RA and at most of the major London galleries as well as in Paris and at various colonial exhibitions. He accompanied King Edward VII as official artist on a hunting trip to Scandinavia, and occasionally did magazine illustrations, principally rural scenes for the *Illustrated London News*. He was a popular artist in his time, and many of his paintings were made as engravings. He lived in Wadhurst, Sussex.

Harriet Sutcliffe
Gathering Plums
Oil on canvas, signed. 37½ x 23in
Brian Sinfield

J. WOODHOUSE STUBBS
fl. 1875-1904

A watercolour artist who was a teacher at the Government School of Art in Sunderland, County Durham, J. Woodhouse Stubbs specialised in painting flower studies, although he also painted landscape and figure subjects. He exhibited ten paintings at the RA, nine at the Royal Society of Arts, Birmingham, and another seven at the Walker Art Gallery in Liverpool. In the painting shown opposite, poppies, pansies and delphiniums are painted growing in their natural state, with the distant landscape acting as a form of backdrop, which gives the picture a three-dimensional look. Stubbs moved to Norwich in 1904, but after that date nothing is known of him.

HARRIET SUTCLIFFE
exh. 1881-1907

Very little is known about Harriet Sutcliffe, despite the tremendous amount of research that has been done on both the Victorian and Edwardian artists. A genre and figure painter, Sutcliffe's work is highly detailed and shows solid craftsmanship in every brush-stroke. For an example of her work, see above.

Sutcliffe lived in Hampstead for a long time, although her last known address seems to have been at Harrow Weald in Middlesex.

LEGHE SUTHERS
1856-1924

Leghe Suthers came from Southport, Lancashire, and studied in Antwerp under Charles Michel Verlat, who was primarily an animal painter with a preference for painting deer. By 1883 Suthers had joined the Newlyn School of artists, but he did not make the same impact on the public that others of the group did, although judging from his genre painting shown opposite, his work matches up well against some of the more prominent names of the group. Even Stanhope Forbes, who was very critical of some of the work produced by the Newlyn artists, spoke well of Suthers' work and was on very good terms with him. Suthers exhibited seven paintings at the RA, between 1885 and 1895. He left Newlyn in 1900, when he seems to have disappeared from the painting scene.

JOSEPH HAROLD SWANWICK, RI, ROI, RCamA
1866-1929

Apart from Munnings, no artist painted heavy horses better than Joseph Harold Swanwick, whose often lyrical studies of this type of horse returned to favour after a ploughing competition held in the 1970s in Kent attracted five thousand people. The popularity of this competition made people realize how useful heavy horses could be on the land, even though they had been superseded by mechanisation. Since the 1970s, Swanwick's popularity has steadily increased, especially among art buyers who cannot afford the price of Munnings' work.

Swanwick was born in Middlewich, Cheshire, and studied under Alphonse Legros, a naturalised Englishman who taught at the Slade School of Art in London (see entry). He then completed his training at the Académie Julian in Paris. He exhibited fifty paintings at the RA from 1889 to 1929. He died in Wilmington, Sussex, where he had lived since 1907 (see p292).

Leghe Suthers
The Visit
Oil. 63¼ x 33½in
Sotheby's

Joseph Harold Swanwick
Noon Day
Watercolour, signed. 8 x 12in
Priory Gallery

GEORGE HILLYARD SWINSTEAD, RBA, RI
1860-1926

George Swinstead was the son of the landscape painter Charles Swinstead, and the brother of Alfred Hillyard Swinstead and Frank Swinstead. He first appeared at the RA in 1882, when his painting *By Appointment* was exhibited. He was shown at the RBA from 1908. Although he continued to paint genre pictures and portraits throughout much of his life, he later increasingly painted coastal and harbour scenes, such as the example illustrated opposite, in which the reflection of the sails of the fishing boats on the water is used imaginatively and to great effect.

George Hillyard Swinstead
Fishing Boats, Polperro
Oil on canvas, signed. 31 x 20½in
Bonhams

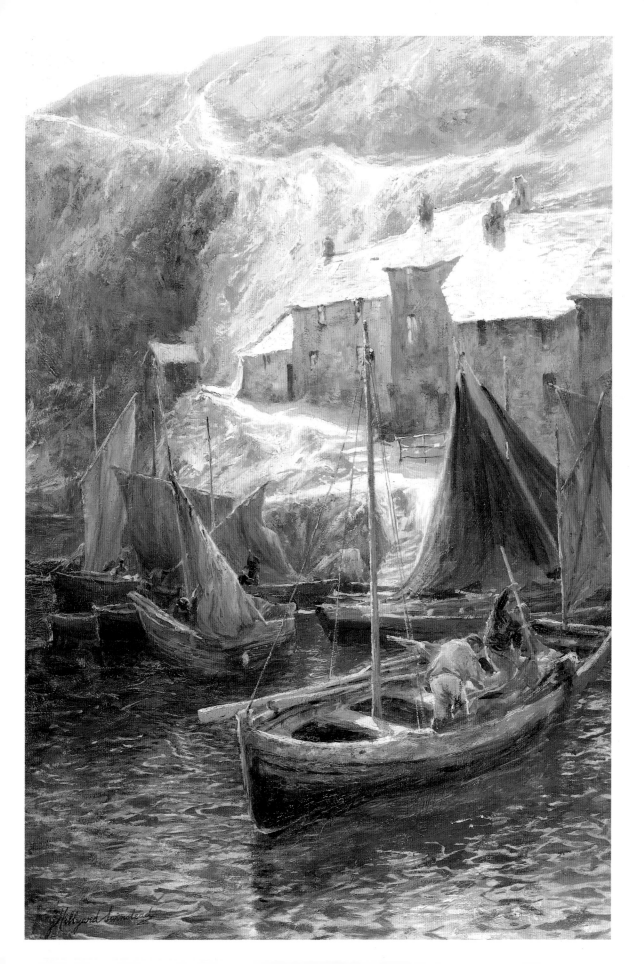

Algernon Talmage
Out with the Hunt
Oil on canvas, signed. 20 x 24in
Brian Sinfield

ALGERNON TALMAGE, RA, ROI, RWA, ARE
1871-1939

Born in Fifield, Oxfordshire, Algernon Talmage studied art under Hubert von Herkomer, the well-known painter of genre scenes who made his reputation with *On Strike* when it was first exhibited in 1891. After he had completed his studies, Talmage moved to St Ives, Cornwall, where he lived for many years and opened an art school. He held his first exhibition in 1907 at the Goupil Gallery. After spending some years in Canada, where he was appointed official war artist, he returned to England to live in Romsey, Hampshire, where he died on 14 September 1939.

Although he painted a variety of subjects in oils

and watercolours, Talmage's forte lay in painting hunting scenes and horse portraits, a field in which there were many excellent artists during the Edwardian period. He painted in a loose but highly effective style that won him many admirers, although the considerable reputation he built up for himself during his lifetime has since waned. He was elected an RA in 1929, and his paintings are to be found in many public collections.

pher, and examples of his work in this field as well as a number of his watercolours are to be seen at the National Maritime Museum.

Although Taylor sometimes painted a ship broadside (see below), his work is far too sophisticated to be associated with the pier artists, whose paintings were generally done from a shoreline or pier and were often naïvely executed. His watercolours include *A French Fruit Boat off Southend, Vessels Running into Great Yarmouth* and *Fishing Craft off the Maplin Light.*

CHARLES TAYLOR JNR
fl.1841-83

A watercolourist who lived at 6 Scarsdale Terrace, London, Charles Taylor jnr painted mainly marine subjects and a few landscapes, on estuaries, or along the tidal length of the Thames. His style was not unlike that of Thomas Goldsworth Dutton, with whom he sometimes collaborated on paintings. He exhibited at the RI from 1846 to 1866 and at the RA from 1846. He was also a lithogra-

Charles Taylor jnr
Untitled watercolour. 16½ x 27½in
David James

Stephen Taylor
Three Cavalier King Charles Spaniels on a Rug
20 x 27in
Bonhams

John Frederick Tennant
Weighing a Buoy: River Fog Clearing Off
Oil on canvas, signed and dated 1851
Polak Gallery

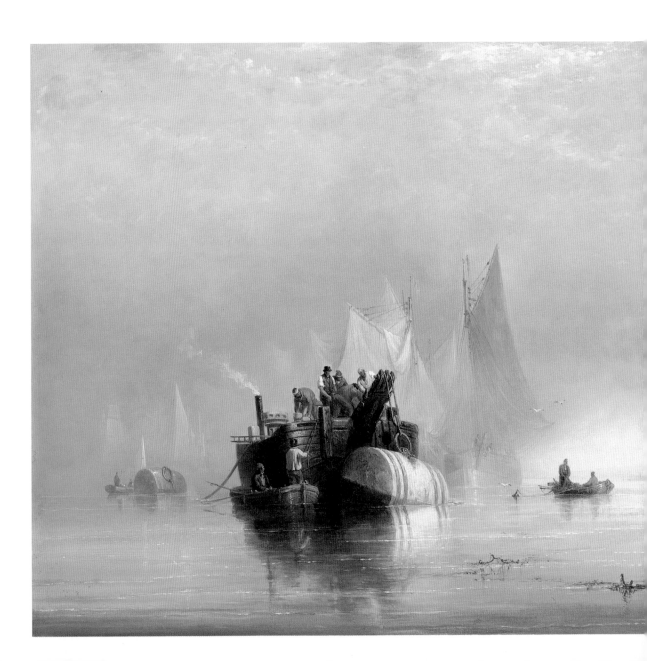

STEPHEN TAYLOR
fl. 1817-49

A painter of dead game and animals in general, Stephen Taylor's work seldom comes up for auction, even though he produced a considerable number of paintings. He was working at a time when the worst excesses of the Georgians were over, and a new humanitarian attitude towards animals had begun to replace the senseless brutalities of bear-baiting and cock-fighting. It was a period, however, in which domestic animals were treated without that excessive sentimentality that occurred a little later with the rise of the middle-classes and their desire to emulate Queen Victoria's well-known devotion to her pets.

Taylor was still capable of painting a brutally realistic picture, such as his RA picture *The Tiger Cat Pouncing upon an Indian Pheasant*, but he often made concessions to the changing taste of the public by painting non-controversial animal studies, such as his picture of three Cavalier King Charles Spaniels, which is illustrated opposite. The three dogs are obviously pets, but are portrayed without any of the sentimental fudging that occurred soon afterwards in the work of many animal artists.

Taylor exhibited forty-eight paintings at the RA, twenty-nine at the BI and forty-two at the SS, as well as at various other well-known galleries. He lived in Winchester, Hampshire.

JOHN FREDERICK TENNANT
1796-1872

John Frederick Tennant was largely a self-taught watercolour artist who painted landscape and figure scenes, although he began his career as a painter of historical scenes which were taken mainly from the works of Sir Walter Scott. He also painted in oils, and is far better known for his landscape and coastal scenes than for his historical paintings, which are of little interest to modern dealers. He exhibited eighteen paintings at the RA between 1820 and 1867, the main body of his large output being shown at the SS, where he exhibited 140 pictures. Much of his life was spent either in Devon or Wales.

As a landscape artist Tennant may have echoed the feeling among artists that painting a landscape scene was far more difficult than painting a marine subject in which only the sun, sea, sky and shipping had to be dealt with. His oil shown left, in which the river fog is gradually dispersing, leaving the barge and its occupants clearly defined, surely confounds this view. The painting was shown at the BI in 1851, a year after it was painted.
REPRESENTED: BETHNAL GREEN, BM, V & A.

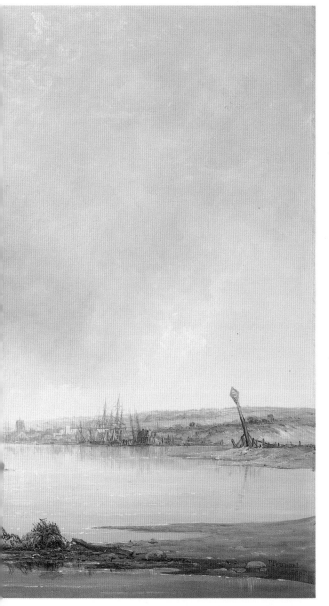

297

HENRY TERRY
exh. 1879-1920

A genre and figure artist, Henry Terry belongs to the old school of painting, even though he was still working in the first two decades of the twentieth century when great changes were taking place in the art world. Even his titles are remarkably old-fashioned, and give the impression that he was a true Victorian at heart, and therefore something of a dinosaur by the time he died in 1920. Such titles as *A Stickler for Privilege, A Most Potent Grave and Reverend Signor*, and *In Disgrace*, shown on p299, are all titles that are unlikely to lure a dealer to the auction rooms. Between 1879 and 1893, he exhibited thirteen pictures at the RA, nineteen at the SS and twelve at the RWS. He lived in Brixton, London and later in Tetsworth, Oxfordshire.

ISA THOMPSON
exh. 1882-1912

A landscape and genre painter who worked in both oils and watercolours, Isa Thompson was mainly self-taught. She was born in Sunderland, but spent most of her life in nearby Newcastle-upon-Tyne, or at Cullercoats, Northumberland, and first exhibited at the Gateshead Fine Arts Industrial Exhibition in 1883. In 1885-6, she exhibited at the SS, where her pictures included a watercolour, *Jack and his Mates*. In 1882 her painting *Blossom* was accepted at the RA, and she continued to show at various other galleries, including the RBA, the RMS and the RSA until 1912.

In the mid-1890s Thompson became the second wife of Robert Jobling, the genre and marine painter, and thereafter signed her work with her married name, possibly because she and her husband often worked together on a painting. Her favourite haunt for painting was the fishing village of Staithes. Most of her work is competent and assured, and typical of its period (see *Springtime*, right). She died at Whitley Bay.

Isa Thompson
Springtime
Oil, signed. 29½ x 19½in
Brian Sinfield

Henry Terry
In Disgrace
Watercolour, signed and dated 1885
23½ x 22in
Sotheby's, Sussex

JACOB THOMPSON
1806-79

A talented landscape artist, Jacob Thompson was
born in Cumberland and first came under the
patronage of Lord Lonsdale, who met him while
he was serving his apprenticeship with a house-
painter. Thanks to Lord Lonsdale, Thompson was
sent to see Sir Thomas Lawrence, who helped him
to obtain a place at the RA Schools. After his
studies, he returned to Cumberland and lived in
Hackthorpe, where he remained for the rest of his
life. He painted altarpieces for the Church of St
Andrew's in Penrith and exhibited at the RA,
where he exhibited twenty-seven paintings, as
well as at the BI and SS. A retiring man, Thompson
visited London as little as possible, and always
returned with great relief to his native Cumberland.

ARCHIBALD THORBURN
1860-1935

An animal artist who specialised in painting game
birds, Archibald Thorburn was born in London,
the son of Robert Thorburn the Scottish miniatur-
ist. He was educated at Dalkeith and Edinburgh
before he returned to London, where he took up
residence at 25 Stanley Gardens in Belsize Park.
He later married the daughter of C. E. Mudie,
whose circulating libraries were the forerunner of
our public libraries and had enormous influence
on the British publishing industry at the time. A
meticulous though rather unimaginative water-
colour artist, Thorburn's work only became more
interesting when he changed from portraying birds
to other forms of animal life, such as his watercolour
shown on p301. His bird paintings, however, have
always been popular in sporting circles.

Thorburn was also a successful illustrator of
books about birds, and wrote a number of these
himself as well as contributing regularly to the *Pall
Mall Magazine*, the *English Illustrated Magazine*
and the *Sporting and Dramatic News*. His books
include *British Birds, A Naturalist's Sketch Book*
and *Game Birds and Wild Fowl of Great Britain
and Ireland*.
REPRESENTED: BM, V & A, WOBURN.

Archibald Thorburn
Misty Weather on the Tops
Watercolour, signed and dated 1902.
21½ x 29½in
Spink

JAMES JACQUES JOSEPH TISSOT
1836-1902

Born in Nantes, James Tissot's remarkable career
can be split into three phases. In the early part of
his life he first came on the Paris art scene after
studying at the Ecole des Beaux-Arts, when he
attracted attention in 1861 with his *Faust and
Marguerite* which was bought by the French
government for the Luxembourg Gallery. This
work was followed by a series of studies of beautiful
French women, which he exhibited under the
overall title *La Femme de Paris*. He was already a
popular figure in the boulevard and café life of the
city when his career was interrupted by the Franco-
Prussian war, in which he fought bravely.

The second phase of Tissot's career developed
after the war when he left Paris to settle in London,
where he studied etching under Seymour Haden
before he became a caricaturist for *Vanity Fair*,
which always carried a cartoon as a separate
feature. He then embarked on his series of now
famous genre paintings in which he re-created the
social life of the upper middle-classes with their
gala receptions, balls and social gatherings. Dur-
ing this time he met the divorcée Mrs Katherine
Newton, who became his mistress and shared his
house in St John's Wood. He used her as his model

and was deeply attached to her. Her death at the age of 28 was a terrible blow and one from which he never fully recovered. Grief-stricken, he sold his house and returned to Paris, where he did not appear at his old haunts.

In an attempt to assuage his grief, Tissot turned to religion for solace and went to Palestine and began to paint incidents from the life of Christ, thereby entering the third stage of his professional career, this time as a religious artist. When he returned to Paris in 1895 he brought with him 350 drawings, which were exhibited in Paris and London, and were published in two volumes by the firm of Lemercier, which paid him the hefty sum of 1,100,000 francs. After this he painted scenes from the Old Testament which were noted for their careful detail more than for the quality of their religious emotion. He died in the Abbey of Bouillon while he was still engaged on this series.

Anyone who was fortunate enough to attend the exhibition of Tissot's work that was held at the Barbican in London in 1984-5 will remember for a long time the impact of his paintings when they are seen *en masse*.

REPRESENTED: DUBLIN, GUILDHALL, LEEDS, V & A.

RALPH TODD
1856-1932

Ralph Todd is among the better known of the Newlyn artists, together with Scott Tuke and Walter Langley (see entries). Originally a London painter who lived in Tooting, which was described in those days as 'a very pretty district of hills and woods and tiny streams', Todd was a landscape and genre artist who had already exhibited in 1880 before he moved to Newlyn in 1883. When Stanhope Forbes moved there in the following

year the two artists became friends, although Forbes did not have a high opinion of his companion's work, saying of him that 'he has no art in him and were he to paint forever would do no real good work'. Later, he admitted that Todd's painting had improved greatly since he had been in Newlyn, but by then Todd was in a fairly desperate financial situation. His father had remarried and had become so besotted with his new wife that he squandered a small fortune on her and had cut off his son's inheritance money. With no one else to turn to for financial help, Todd wrote again to his father asking for assistance; the curt reply he received told him that he could pawn the shirt off his back and paint signboards for all his father cared. Todd decided that his only hope was to give up painting and marry a rich widow. Although he married the following year, he had not found a wealthy wife. His attachment to Newlyn was never deep, although he sems to have enjoyed

Ralph Todd
Rigging the Cutter
Watercolour, signed. 21 x 15in
Priory Gallery

himself while he was there. He left Newlyn in the 1890s and finally settled in Helston, where he lived from 1912 until his death in 1932.

Todd exhibited only three paintings at the RA, the best known being *The Prodigal's Return*, a melodramatic picture, as were so many of Todd's paintings. More typical of his watercolours painted in Newlyn is *Rigging the Cutter*, shown opposite. REPRESENTED: PENZANCE.

FRANCIS WILLIAM TOPHAM
1808-77

Born in Leeds, Francis William Topham was forced to become a self-taught artist after his father refused to pay for art lessons. Instead he apprenticed him to a relative who owned a business as a writing engraver. Around 1830 Topham went to London, where he found himself employment as a heraldic engraver with a small publisher which produced pocket books which were in vogue at the time. Topham was allowed to draw some of the illustrations for the books, which encouraged him to venture out into the streets of London, where he began to find his models among the poor. The street musicians, beggars and gypsies whom he encountered as he wandered through the city appealed to him as an artist, and he became a specialist in painting low life.

In 1844 Topham went with Alfred Fripp to Ireland, a place where his talent for capturing the picturesque was given full rein. When he exhibited his Irish paintings in London his work received instant recognition. In the winter of 1852-3 he went to Spain, which resulted in a series of Spanish paintings, including *A Gypsy Festival, Fortune Telling in Andalusia* and *The Andalusian Letter Writer*. In 1860 Topham returned to Ireland, this time in the company of his brother Francis William Warwick Topham, who became a successful painter. The paintings he made on that trip were exhibited in London the following year. He visited Spain in 1864, and returned to England in 1876, but by then his health was beginning to fail. The journey proved too much for him and he collapsed when he reached Cordoba, where he died on 31 March 1877. He was later buried in the local Protestant church. His painting *The Wayfarers*, illustrated on pp304-5, was almost certainly painted in Andalucia.
REPRESENTED: BIRKENHEAD, BM, GUILDHALL, READING, V & A.

A COMPANION TO VICTORIAN AND EDWARDIAN ARTISTS

RAYMOND TUCKER
exh. 1852-1903

Originally a Bristolian who lived at 18 Hampton Terrace, Clifton, Raymond Tucker was a landscape artist who occasionally painted a portrait study. Around 1859 he moved to London, where he resided off the King's Road, Chelsea, before he moved in 1860 to Pimlico, which was not a popular residential area for the more wealthy artists of the day. As his fortunes prospered, Tucker moved to Charlotte Street, near Fitzroy Square, an area which the Pre-Raphaelites had made their domain at much the same time. Like so many artists, including, 'surprisingly, Helen Allingham, Tucker occasionally painted a beach scene, such as *Children Sailing Boats*, shown on p306, which, judging by the style of the hats, was probably painted in Brittany. His liking for the sea led him to paint a number of near-maritime subjects, including *Going Trawling, Preparing the Net, Chip Gatherers on the Beach near Bootle, near Liverpool*, and *Preparing for the Herring Season*.

Tucker exhibited at most of the major galleries and at the RA from 1852, where he showed three works, including *Upon the Lonely Hills of Cumberland*. After leaving London, he moved to Sandhurst, Kent.

HENRY SCOTT TUKE, RA, RWS
1858-1929

After Stanhope Forbes, Henry Scott Tuke is probably the best known of the Newlyn artists. Born in York into a Quaker family, he went to the Slade School of Art in London before studying in Italy and then in Paris, where his teacher was Jean Paul Laurens, an excellent teacher who had won high honours in his country for his carefully researched historical paintings. In 1883 Tuke took a studio in Passy, one of the residential quarters in Paris, where he met a number of the important writers of the day, including Oscar Wilde, and the painter John Singer Sargent, to whom he took an instant dislike.

Francis William Topham
The Wayfarers
Watercolour, signed. 20¾ x 37¾in
David James

When Tuke returned to England, he made several long visits to Newlyn before he settled in Falmouth. Although he is always identified with the Newlyn School, his work is far removed from their style of painting. Instead of painting studies of the local fishing folk, he had become obsessed with the male nude - he even brought his own male model with him from London, a young Cockney named Walter Shilling. His fellow artists took in their stride his preoccupation with the male nude, but the public were shocked and affronted when the pictures were first exhibited. This, coupled with his love of sailing and boat racing, was enough to set him apart from his fellow artists.

The best aspect of Tuke's work lay in his boating scenes (see *The Waterman and His Boat* on p307), from which it is evident that basically he was a *plein air* artist who revelled in catching the interplay of sunlight on the waters. His most famous painting was *All Hands to the Pumps*, which was exhibited in 1889 and bought by the Chantrey Bequest and is now on loan to the National Maritime Museum from the Tate Gallery. His *August Blue* was also bought by the Chantrey Bequest. In all he exhibited forty-three paintings at the RA, but not all were marine subjects.

REPRESENTED: FALMOUTH, MARITIME MUSEUM (GREENWICH), PENZANCE.

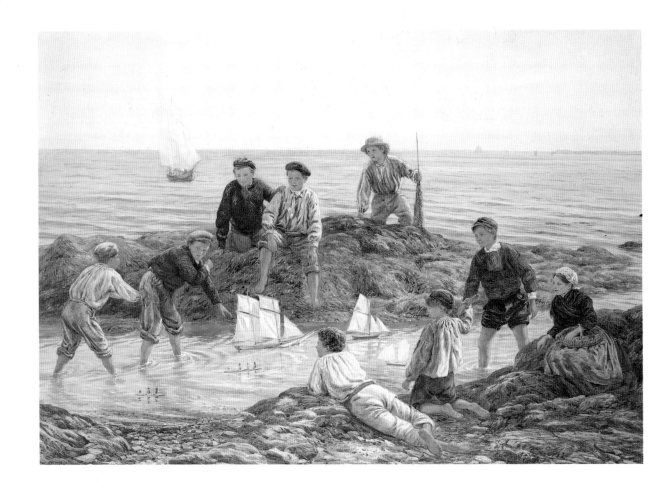

Raymond Tucker
Children Sailing Boats
Watercolour, signed. 19 x 28in
Fine Lines (Fine Art)

JOSEPH MALLORD WILLIAM TURNER, RA
1775-1851

So many books have been written on J. M. W. Turner that the details of his life are easily obtainable. For those who do not want an in-depth study of the man and his work, the following information should be of help.

Joseph Turner was born in London, the son of William Turner, who kept a barber's shop at 26 Maiden Lane. His childhood was a desperately unhappy one, the cause of which was the uncontrollable temper of his mother, who eventually became insane; the experience probably contributed to his unsociable and eccentric behaviour later in life. He was given an education of sorts in the east Kent coastal town of Margate. By the time that his schooldays were over he was already receiving art lessons from various obscure teachers, until he went to Sandy's School of Art in St Martin's Lane. In the spare time that was left to him he coloured prints for engravers, washed in

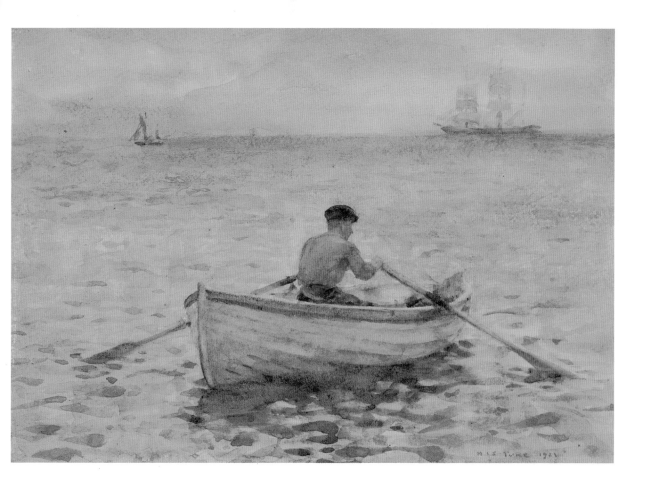

backgrounds for architects and made drawings for Dr Monro for 'half a crown and his supper'. In 1789 he became a student at the RA Schools and then worked for a short time for Joshua Reynolds with the intention of becoming a portrait painter, although his plan was thwarted when Reynolds died soon afterwards and he no longer had the master to teach him.

After carrying out a number of topographical commissions for the *Copper Plate* magazine and the *Pocket Magazine*, Turner began to exhibit at the RA, which looked after him well for most of his life. In 1793 he turned for the first time to painting in oils. He had come on the scene when literature and art were at a low ebb and fortunately he was able to attract the attention of the critics. The vicious attacks on his work were to come later. He became an RA in 1802 and was appointed Professor of Perspective in 1808, which served to hinder his progress as a painter rather than to help him further his career. His father joined the household where he remained for the next thirty years,

Henry Scott Tuke
The Waterman and his Boat
Signed watercolour, dated 1921. 7½ x 9½in
Royal Exchange Gallery

acting as his son's general factotum whose duties included preparing the canvases and warding off unwelcome visitors. After his father's death in 1830, Turner became a recluse, although he had purchased a house in Twickenham as well as maintaining his house in Harley Street, mostly as a showcase for his work. Between 1829 and 1839 he sent fifty-five pictures to the RA for exhibition, painted many others on private commission, and made four hundred drawings for engravers.

Turner's enormous output was occasioned in part by avarice, although there have been many recorded acts of unpredictable generosity. His famous painting *The Fighting Téméraire* was exhibited in 1839, and was followed by two other sea pictures, *The Slave Ship* and *Peace; Burial at*

Sea. The paintings that followed belong to the years of his decline, and in 1850 he exhibited at the RA for the last time. He settled in a small house in Chelsea overlooking the river, where he was looked after by Mrs Booth, his landlady from his early Margate days with whom he had obviously maintained contact for all those years. He stayed there until his death on 18 December 1852.

Like so many painters of note, Turner's work was often savagely attacked, both by the critics and by his fellow artists. After his death it was found that he had bequeathed to the nation more than three hundred oils and nearly 20,000 drawings. His fortune of over £140,000 was left to found a charity for the support of male artists who were born in England, of English parents only – a clause that would raise a few eyebrows today – and who were in need of financial assistance.

His watercolour shown above is little more than a sketch, but it contains all that is necessary to recognize that everything that needs to be said about the scene is there.

REPRESENTED: ASHMOLEAN, BEDFORD, BIRKENHEAD, DERBY, EXETER, FITZWILLIAM, GLASGOW, LEEDS, LINCOLN, MANCHESTER, NOTTINGHAM, TATE, V & A.

Joseph Mallord William Turner
The Wetterhorn from near Rosenlau
8 x 12½in
Brian Sinfield

Louis Wain
Study of a Tabby Cat
Oil on panel, signed with monogram, dated 1912. 8 x 9in
Bonhams

LOUIS WILLIAM WAIN
1860-1939

The story of Louis William Wain is a tragic one. A cat artist whose work was known and loved by thousands of art lovers, his sudden decline from success to confinement in a lunatic asylum is a harrowing saga, which was redeemed only by the kindness of the nation who responded to his desperate plight by raising a subscription which allowed him to end his days in a private nursing home, where he continued to paint cats that grew more and more bizarre as the years went by.

Wain was born in London and studied at the West London School of Art, where later he taught for a short while. He began to draw cats in 1883, having joined the staff of the *Illustrated Sporting and Dramatic News* the previous year. He stayed with this magazine for three years before he moved to the *Illustrated London News* in 1896. By then his humorous drawings had become immensely popular, and his *Louis Wain Annual* which appeared in 1901 sold in its thousands, right up to 1921, and cemented his reputation for the first cat

artist of his time. In 1907 he went to New York, where he stayed for the next three years, producing two strip cartoons entitled *Cat About Town* and *Grimalkin*.

Although he was a hard-working artist, Wain had always been considered something of an eccentric. His madness, however, did not seriously begin to manifest itself until the early 1920s, when he was living at 41 Brondesbury Road, Kilburn, where his behaviour became so alarming that a doctor was called, who diagnosed schizophrenia. In June 1924 Wain was certified insane and taken to the Middlesex County Hospital in Tooting. A subscription was raised on his behalf, as a result of which he was sent to the far more pleasant atmosphere of the Napsbury Hospital near St Albans, where he spent the last fifteen years of his life, dying in July 1939. Wain is not an artist whose success is measured by the number of times he exhibited at the RA, but rather by the affection that was felt for the man and his work throughout the country. The example of his work shown on p309 is a rare Louis Wain picture - a serious study painted in oils.

REPRESENTED: V & A.

ROBERT THORNE WAITE, RWS
1842-1935

A landscape artist who was born in Cheltenham, Robert Thorne Waite was educated at the local grammar school before he studied art at the Science and Art Department, South Kensington, in 1860. He began to exhibit ten years later at the RA and also at the SS and the OWS, where he showed most of his paintings. His oils of the countryside, which were mostly painted around the South of England, were realistic studies of country life which made no concession to the romantic image that people liked to see in their paintings and which was the vogue right up to the Edwardian period. His watercolour *Haymaking*, shown below, is a typical example of his unsentimental approach to the rural scene, with its figures depicted at work in the distance rather than shown in the foreground with the women labouring happily alongside their menfolk, as occurred with a great number of paintings that were popular at the time.

FREDERICK WALKER, ARA
1840-75

A watercolour artist who painted genre pictures, Frederick Walker was born in Marylebone, London. His father, a jewellery designer, died when Frederick was only 7, leaving the rest of the family in very poor circumstances. He entered an architect's office at 15 and then was apprenticed to an engraver. In later life he claimed that he had tried to work for the Dalziel brothers, a noted firm of engravers who, according to Walker, refused to engage him, but the brothers always denied this. He later studied art at Leigh's Academy and at the RA Schools.

In 1860 the editor of *Once a Week*, who was always looking for promising young artists, received a visit from a very shy, delicate-looking young man who was no more than 5ft 4in tall. The visitor was Walker. The result was that he went away with a commission to draw twenty-four illustrations for the magazine and was later commissioned to produce another twenty-nine, which appeared in the magazine in 1861. In 1863 he began to exhibit at the RA and a year later at the SS. As an illustrator his output was enormous. He contributed to such magazines as *Everybody's Journal* (1860), *London Society* (1862), and the *Cornhill Magazine* (1862-66). In addition, he did book illustrations for Dickens' *Hard Times, The Ingoldsby Legends*, Thornbury's *Legendary Ballades*, and many others. His watercolours and oils were evocations of simple pastoral life, seen with a romantic eye. He died of tuberculosis at the age of 35.

REPRESENTED: ASHMOLEAN, BM, FITZWILLIAM, MANCHESTER, V & A.

Mary Waller
Portrait of Nancy Tooth
Oil. 44 x 36in
Bonhams

Robert Thorne Waite
Haymaking
Oil on canvas, signed. 12 x 18in
Priory Gallery

MARY LEMON WALLER
exh. 1861-1931

A portrait artist whose work is in the direct tradition of Gainsborough and Joshua Reynolds, Mary Waller's work is seen at its best when she painted young women and children. She studied at the RA Schools and later married Samuel Edmund Waller, the genre and animal painter, who also worked as an illustrator for the *Graphic*. If her portrait studies seem to flatter her sitters, it is probably because most of her work was commissioned, and no painter wishes to jeopardise his or her livelihood by painting an unflattering portrait

(an exception to this generalisation being John Singer Sargent, see p268, who showed the true face of a sitter behind the public mask, and who was rich and successful enough to portray the truth rather than to falsify his art). Mary Waller was, nevertheless, a highly competent portrait painter who exhibited forty-six paintings at the RA and at a number of the major London galleries. *Portrait of Nancy Tooth*, shown on p311, was painted and exhibited at the RA in 1906.

GEORGE STANFIELD WALTERS, RBA
1838-1924

Born in Liverpool, the marine artist George Stanfield Walters was the son of Samuel Walters, also a marine artist who may well have taught his son to paint. George, however, proved to be a far better artist than his father. He exhibited more than 400 paintings during his lifetime, 340 at the SS and another thirty-four at the RA, apart from the numerous other important galleries which took his work. He painted mainly in watercolours and often used a subtle pink to depict a sunrise or a sunset in his marine scenes, which were generally painted from the shoreline or along an estuary. Almost all of his work was either painted on the south or east coasts of England, or along the shores of Wales or Holland. His watercolour *Autumn Mists*, shown below, with its delicate use of pink which does much to enhance what otherwise might have been a routine marine painting, is representative of his work.

REPRESENTED: BOOTLE, MARITIME MUSEUM (GREENWICH).

George Stanfield Walters
Autumn Mists
Watercolour. 13½ x 19½in
David James

RICHARD WANE
1852-1904

A landscape and genre painter, Richard Wane was born in Manchester and orphaned at the age of 14, when he was taken care of by his brother, a leading photographer in Douglas, Isle of Man. He employed Richard in his business, while allowing him enough spare time to pursue his interest in landscape painting. After studying for some time under Frederic Shields, the Pre-Raphaelite painter, he went to the Manchester Academy and began to exhibit at the RA from 1885. By then he had settled in Deganwy, North Wales, where he spent the next seven years before he went to live in Dulwich, London, in 1890. The last years of Wane's life were spent in Liverpool. The paintings he exhibited at the RA were mostly coastal scenes which were painted off the coast of Wales, and generally featured fishing folk prominently. Both his daughter Ethel and his son Harold became artists.
REPRESENTED: LIVERPOOL, WOLVERHAMPTON.

JAMES WARD, RA
1769-1859

An animal painter and engraver, James Ward was born in London, the son of a drunken fruit merchant. After studying engraving he issued a number of mezzoprints of horses and landscapes. As a result he was made Painter and Mezzoprint Engraver to the Prince of Wales. In 1817 he gave up engraving and turned to genre painting and rustic scenes, until he became influenced by George Stubbs, when he turned to animal painting. Unwisely, he then decided to paint massive historical pictures for which his talents were ill-suited. By 1830 his powers began to decline and the last years of his life were embittered by his financial difficulties and his battles with the RA, to which he was eventually forced to apply for a pension.

Ward's dramatic animal paintings such as *Bulls Fighting* and *Fighting Horses* have tended to obscure the fact that he also painted a number of very romantic landscapes in oils and watercolours, one of the most famous being *Gordale Scar, Yorkshire*, which is now owned by the Tate Gallery. He exhibited at the RA from 1795 to 1855, when he showed 298 paintings; another ninety-one were shown at the BI. He was made an RA in 1811.
REPRESENTED: ASHMOLEAN, BIRKENHEAD, BRADFORD, BM, FITZWILLIAM, LEEDS, MANCHESTER, TATE.

EDMUND GEORGE WARREN, RI, ROI
1834-1909

A landscape artist, Edmund George Warren was the son of the well-known painter Henry Warren, who specialised in painting Eastern scenes. He began to paint at the age of 18 and was soon exhibiting work at many of the London galleries and at the RI, where he began to exhibit from 1852; he also exhibited at the NWS, where he showed 157 pictures. Warren soon attracted the attention of the critics, John Ruskin condescendingly admitting that his paintings were skilfully executed, but that he found them 'mechanical'. Having said that, he added sardonically: 'their webs of leafage are pleasant fly traps to draw public attention, which, perhaps, after receiving, Mr Warren may be able to justify by work better worthy of it'. Such was Ruskin's power in the art world at the time, that words like those could ruin an artist unless he changed his ways to conform to Ruskin's idea of what was a good painting. There is no doubt that Warren liked to paint trees with the sun shining through the foliage, but even if this did make some of his pictures a little monotonous, the skill of his technique can still be admired (see p314).

Edmund George Warren
Through the Gate
Watercolour, signed. 17½ x 13½in
Sotheby's, Sussex

Frank Wasley
Romance
Watercolour, signed. 20¼ x 28in
Fine Lines (Fine Art)

FRANK WASLEY
exh. 1880-1914

A watercolour artist who also painted in oils, Frank Wasley specialised in painting marine subjects, but he also produced a number of landscape scenes such as *Romance*, shown opposite, which has a Turneresque quality to it. Even so, his work was not fully appreciated until the 1970s, when dealers and public alike suddenly became aware that his Venetian scenes and others were worth collecting.

Some of Wasley's marine subjects, especially his harbour scenes, with their figure work of women standing on jetties, are practically excellent impressionist paintings. His oils in particular were painted in a free and powerful style. He exhibited at the RA, the RI and the RBSA. Although he is generally considered to be a North Country artist, he moved around the country a great deal, first to Whitby, then to Weston-Super-Mare, Littlehampton and also to Henley-on-Thames.
REPRESENTED: MARITIME MUSEUM, GREENWICH, WHITBY.

JOHN WILLIAM WATERHOUSE, RA, RI
1849-1917

One of the leading figures of the Victorian school of painting, John William Waterhouse was born in Rome, the son of parents who were both artists. Although he had lived in England while he was studying at the RA Schools, his true love was Italy, to which he returned many times throughout his life. His first exhibit was of a Cairo street scene, reminiscent of the paintings of Frederick Goodall (see entry).

Waterhouse had always been interested in the history and legends of Greece and Rome, and it was therefore almost inevitable that he should become deeply involved in the revival of interest in the classics, which was led by Alma-Tadema (see entry), who was then at the height of his career and whom Waterhouse admired. It was a field of painting to which his romantic style of painting was highly suited.

Waterhouse began to exhibit at the RA in 1881, when his painting *Saint Eulalia* was shown to the public and did much to set him on course for what was to become a highly successful career. In 1883 he married and moved with his wife to Primrose Hill. Soon afterwards he became friends with a number of Newlyn artists who had moved to the Primrose Hill area who shared a common interest in *plein air* painting, which was to have some influence on his later paintings. However, his famous picture *The Lady of Shalott*, which was exhibited in 1888 and is now in the Tate Gallery, seems to have been influenced more by the work of the Pre-Raphaelites.

Like so many of the classical painters, Waterhouse became obsessed with the idea of capturing on canvas the Victorians' conception of the *femme fatale* - a beautiful woman who was also an enchantress, capable of leading men to their doom. Waterhouse portrayed the *femme fatale* in such paintings as *Ulysses and the Sirens*, *La Belle Dame Sans Merci*, *Naid* and *Mermaid*. The idea of the *femme fatale* was also used by a number of lesser Victorian novelists, and reached its height with Robert Hichens' best-selling novel *The Garden of Allah*, which was published in 1904.

From 1900 to 1917, Waterhouse exhibited almost every year at the RA, by which time the classical painting had become passé and out of favour. But even then he found no shortage of buyers among financiers and businessmen who were often more interested in buying either a good investment for the future, or a picture that was, to the Victorian mind, mildly titillating.

Spring, shown on p316 is a watercolour - a medium in which Waterhouse painted only fourteen pictures out of a total of 393 recorded works. Painted in rich, beautiful colours, it sems regretable that he did not paint watercolours more frequently. Although it is undated, an earlier version of this painting was done in 1900 under the title *The Primrose Gatherers*.
REPRESENTED: OLDHAM, MANCHESTER, TATE.

John William Waterhouse
Spring
Watercolour with body-colour, signed.
9 x 6in
Bonhams

SIR ERNEST ALBERT WATERLOW, RA, PRWS
1850-1919

Sir Ernest Waterlow painted idyllic landscape scenes which captured the essence of the English countryside without idealising it to the degree that Birket Foster often did. His career as a painter was never less than a successful one, unlike those of artists like Sir Edward Poynter and Lord Leighton, whose work initially received critical acclaim, but was later rejected and often ridiculed (see entries). Waterlow was educated in Heidelburg and Lausanne and entered the RA Schools in 1872, where he won the Turner Gold Medal in the following year. He began to exhibit at the RA the same year and a little later at the SS and other leading galleries in London and the provinces. His work was influenced by George H. Mason and Fred Walker (see entry) and the French School of naturalistic painting, seen at its best in the works of the Barbizon School, which took its name from a village some thirty miles from Paris and which became a centre for *plein air* painting. He was knighted in 1902.

REPRESENTED: BIRMINGHAM, NEWCASTLE, TATE.

Ernest Albert Waterlow
Untitled watercolour
23¼ x 35in
David James

Henry Watson
Helen in Pink
Watercolour. 14 x 10in
Priory Gallery

HENRY WATSON, RWS, ROI, RWA
1871-1936

A landscape figure painter, Henry Watson was born in Scarborough, Yorkshire, but spent his early childhood in Winnipeg, Canada. When he returned to Scarborough it was to become a student at the local school of art, where he stayed from 1884 to 1888, and eventually received a scholarship to the RCA, where he received another scholarship, this time one which allowed him to travel. He also attended the Lambeth School of Art and began to exhibit at the RA from 1896. Watson came to public attention at the time that the Impressionists were making their impact on the art world, and his own paintings reflect their influence. He painted in France, Scotland and Wales, and taught at the Polytechnic in Regent Street, London, from 1913. He also contributed illustrations to the *English Illustrated Magazine* and the *Lady's Pictorial Magazine*. His work was of a high enough quality for the Tate Gallery and the Victoria and Albert Museum to own some of his paintings, which may also be seen in a number of other public collections. In 1985, his oil painting *The Picnic* was sold for £31,500.
REPRESENTED: MANCHESTER, TATE. V&A

JOHN DAWSON WATSON, RWS, RBA
1832-92

A watercolour artist and illustrator, John Dawson Watson studied at the Manchester School of Design and at the RA, and began to exhibit at the Academy from 1853 until shortly before his death. He painted genre scenes which often portray young children, as did so many Victorian genre artists

George Frederick Watts
A Bust Portrait of a Pretty Young Girl
Oil, signed and dated 1880. 26 x 21in
Bonhams

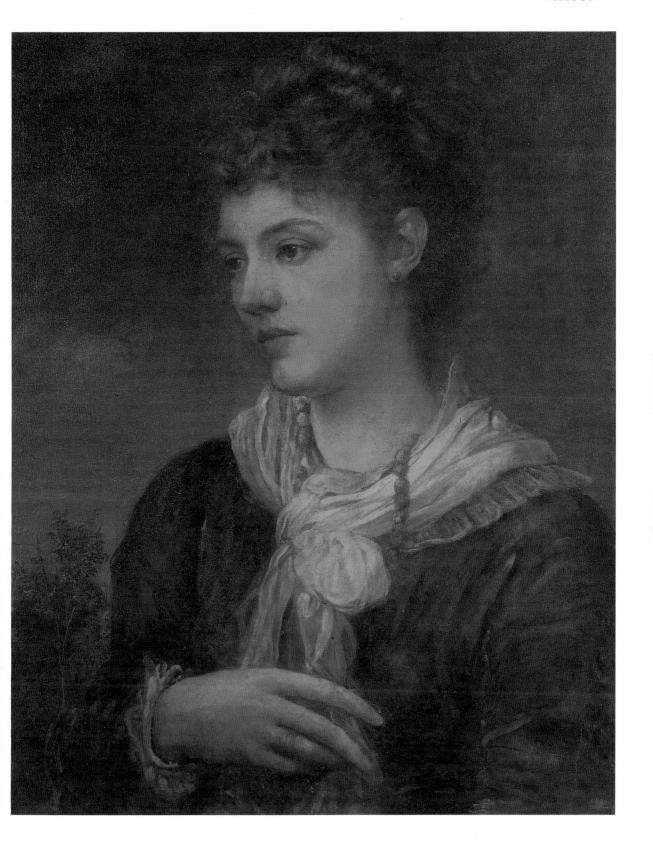

who eagerly satisfied the popular demand for this type of painting. Most of his paintings are done on a small scale and reflect the influence of the Pre-Raphaelites in their use of vibrant colours and detailed work. Watson came to London in 1860, when he began to seek work as an illustrator and, as such, became one of the many important artists who combined their painting with illustrative work for the many magazines that flourished. He became a reliable and popular illustrator, whose figures were often influenced by the Pre-Raphaelites, and in particular the work of Millais. He was at his best when painting and drawing rustic scenes. Apart from drawing for magazines such as the *Graphic* and *People's Magazine*, he also supplied the illustrations for a large number of books.

REPRESENTED: BEDFORD, MANCHESTER, NEWCASTLE, V & A, WORCESTER.

GEORGE FREDERICK WATTS, OM, RA
1817-1904

A portrait painter and sculptor, George Frederick Watts was born in London, the son of a piano-maker. Initially he wanted to become a sculptor, and at the age of 10 he was apprenticed to William Behnes. However, in 1835, at the age of 18, he went to the RA Schools, where he remained for only a short period, and thereafter was mainly self-taught. After he first exhibited *The Wounded Heron* at the RA, painting became his main preoccupation. When his picture *Caractacus* won a £300 prize, he used the money to finance a trip to Italy, where he stayed with friends in Florence. He did not return to England until 1847, when his painting *Alfred* won the first prize of £500 in a House of Lords competition.

In 1850 Watts visited the home of Valentine Prinsep's parents in Holland park (see entry), supposedly for a three-day visit, but instead he stayed for thirty years. The Prinseps seem to have borne the situation cheerfully, and it no doubt gave them a certain cachet in the Bohemian circles in which they moved, which included such writers and painters as Thackeray, Dickens, Rossetti and Burne-Jones. Fortunately, Watts was a man of frugal habits. Although he had been depressed and unhappy when he had moved in with the Prinseps, Watts blossomed in this strange household, where notable writers and painters were treated with reverence. As a portrait artist, his gallery of eminent Victorians is unsurpassed: included among his sitters were the poets Tennyson, Swinburne and Browning, the artists Millais, Lord Leighton, Walter Crane and Burne-Jones; others were Sir Richard Burton, John Stuart Mill and Garibaldi, to mention only a few. His portrait of an unknown girl is illustrated on p319. He finally left the Prinseps' home in 1875 and moved to the Isle of Wight. In 1864 Watts married the actress Ellen Terry, who was only 16, although the marriage was short-lived, and he remarried in 1886 when he moved to Limnerslease, near Guildford. He was a modest, hard-working artist who twice refused a baronetcy and other honours, including an offer to become the president of the Royal Academy, although he did accept the Order of Merit. His work as a sculptor exists in the Cecil Rhodes Memorial, Cape Town. His chief work as a sculptor is the heroic figure of a man on horseback known as *Physical Energy*, casts of which are on the Cecil Rhodes estate and in Kensington Gardens, London.

REPRESENTED: BRISTOL, CROMPTON (WALKER GALLERY), DUBLIN, GUILDFORD, MANCHESTER, NORWICH.

WILLIAM HARRIS WEATHERHEAD, RI
1843-1903

A genre artist who lived in Kentish Town, London, William Harris Weatherhead painted scenes of suffering, abject poverty and squalor - a form of pictorial moralising which was popular with the Victorians. Some of Weatherhead's titles were in keeping with the prevailing mood in Victorian England – *Weary Life, The Wounded Knight, Sad Thoughts* and *Eyes to the Blind* – although not all his work depicted scenes of misery.

A highly prolific watercolour artist, Weatherhead began to exhibit at all the major galleries from 1863. He had 99 pictures shown at the RI and 19 at the RHA, but he exhibited only twice at the RA. His watercolour above, painted in the dull colours which many of the Victorian artists favoured when they portrayed sombre subjects, is fairly representative of his work.

William Harris Weatherhead
When the Fishing Fleet is Away
Watercolour. 27 x 35in
City Wall Gallery

GEORGE WEATHERILL
1810-90

Born in Staithes, Yorkshire, George Weatherill was the son of a farmer. He began his career as a solicitor's clerk at Whitby, where he lived for most of his life. He later moved to the banking company of Messrs Simpson and Chapman, where he became chief cashier. His service with the bank continued until 1860, when the pressure of work, coupled with his commitment to watercolour painting in his spare time, led to the breakdown of his health, and he was forced to retire. From then on until his death at the age of 80, he confined all his attention to watercolour painting.

Weatherill was a self-taught artist who nevertheless managed to develop a masterly technique that is seldom seen in artists with no formal training, especially in the field of maritime painting, where many painters were little better than primitives, or pierhead artists as some were called. He was a great walker, and on one occasion walked the twenty-one miles from Whitby to Scarborough to attend a church service, before walking back again to Whitby – a marathon for a man who was not in the best of health, and which necessitated his getting up at 5am and returning late at night. His great patron was the county alderman, R. E. Pannett, who collected over the years a large selection of Weatherill's paintings, which are now housed in Whitby Art Gallery, having been bequeathed by Pannett when he died in 1890. Weatherill signed approximately half his work and reserved dated signatures for what he considered were his most important paintings. A useful booklet by Colin P. Bullomore on the Scarborough painters gives a full list of the Weatherill paintings in the local collection. *Unloading Boats near Whitby* is illustrated below.

George Weatherill
Unloading Boats near Whitby
Watercolour, signed. 8½ x 13½in
Brian Sinfield

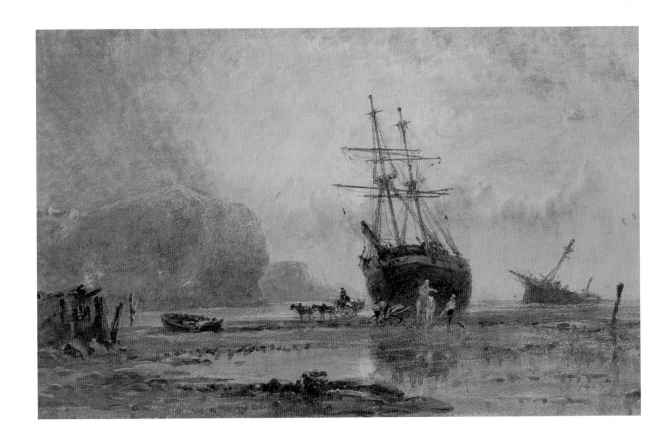

JAMES WEBB
1825-95

A well-recorded artist, James Webb was born in Chelsea, London. A highly popular painter, He is noted for his liking of dramatic scenes, of which there are many, although none is cheap to buy. He produced a large number of coastal paintings, both in England and in Holland, where the example of his work shown above was painted. He also painted in various parts of Europe, especially in the Mediterranean, where he used far brighter colours than when he painted in northern climes. One of the striking characteristics of much of his work was the way that he used old buildings such as Bamburgh Castle and St Michael's Mount as a backdrop.

Webb exhibited at the RA from 1853, and for most years until 1888, while he also exhibited at the SS and the New Watercolour Society. One of his paintings of Bamburgh Castle is with the Tate Gallery, while others are in the Australian art galleries of Adelaide and Melbourne.
REPRESENTED: MARITIME MUSEUM (GREENWICH), TATE.

James Webb
On the Beach: Two Fishing Boats and a Group of Women
Oil on panel. 9 x 14in
Royal Exchange Gallery

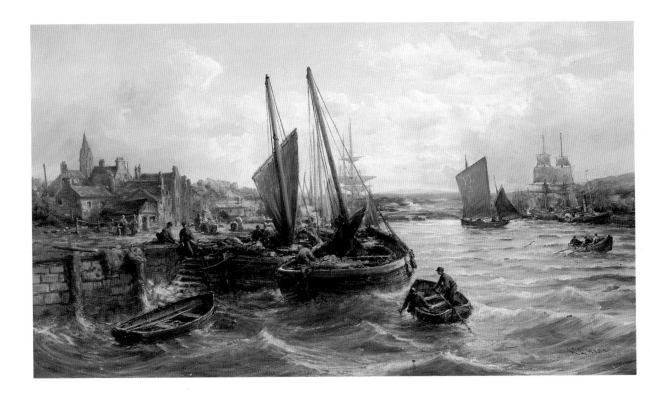

William Edward Webb
Fishing Boats in Peel Harbour, Isle of Man
Oil on canvas, signed. 22 x 38¼in
Royal Exchange Gallery

WILLIAM EDWARD WEBB
c.1862-1903

A Manchester marine artist, William Edward Webb tried to break with the formalised traditions of nineteenth-century maritime painting in much the same way that Turner had done before him, but with an almost spectacular lack of success. Eventually he committed suicide at the age of 41, having struggled for years without ever achieving the fame that came to far lesser artists.

Webb was particularly fond of portraying the harbours of Peel and Douglas. His paintings may lack the slick professionalism of some of his alleged peers in the maritime field, but his work has a welcome integrity, unlike, for example, that of Thomas Bush Hardy, who was capable of working on four paintings at once when he was in need of money. Webb, however, did not have that capability. Although he was a prolific painter, he and his family led a life of poverty, even though he exhibited thirty-two oils at the Manchester City Art Gallery, which should have won him the recognition he so desired. Had he painted scenes of storms and shipwrecks at sea which the Victorians

loved so much, he might have fared better.

The example of Webb's work illustrated opposite is an animated harbour scene and features a number of fishing boats, with one under sail and an oddly rigged brig in the background. The effects of the light breaking through the clouds and casting a pearl-like sheen on the water are particularly effective.

HERBERT WILLIAM WEEKES
fl. 1856-1908

A London artist, Herbert William Weekes was the son of the sculptor Henry Weekes. Although it is not known where he received his art training, it was obviously a sound course of study as he became a first-class watercolour artist. He is well known for his often humorous studies of animals, which are generally portrayed in anecdotal situations. In this respect his choice of subjects was best suited to books and magazine illustrations, although he did very little work of this nature, apart from supplying illustrations to the *Illustrated London News* in 1883. He exhibited at a number of the London galleries from 1856. His painting *Where's Mother?*, illustrated right, is a particularly good example of his work, which often featured donkeys and ducks.

Herbert William Weekes
Where's Mother?
Watercolour. 21 x 17in
Mistral Gallery

HARRISON WILLIAM WEIR
1824-1906

An interesting animal artist who numbered Charles Darwin among his friends, Harrison William Weir was educated in Camberwell, London, before he studied colour printing under George Baxter, who was celebrated for his invention of a method of printing in oil colours, which he had marketed with great success. Weir soon found that the work was not to his liking and he left to pursue what he had decided was his true interest - the painting of wild birds.

Weir exhibited at the RA from 1843 to 1880, and also at the Old Watercolour Society where he

showed a hundred paintings. He gradually gained a reputation for his studies of birds and animals which was far greater than that of Archibald Thorburn (see entry), who was no more than a capable bird artist. He drew for the *Illustrated London News* and other magazines, and for many books on birds, including *Poultry and All About Them*, a large work which he wrote himself and for which he drew the illustrations. His sentimental pictures of cats and dogs were less successful, probably because he tried to imitate Louis Wain (see entry) who had already cornered the market in that field. He died in Appledore, Kent.

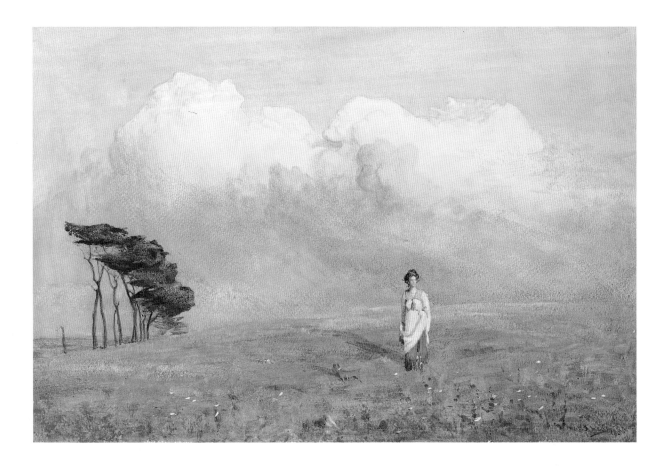

Edward Francis Wells
On the Downs
Watercolour. 14 x 21in
Priory Gallery

EDWARD FRANCIS WELLS
exh. 1897-1938

An exceptionally fine landscape artist who also painted portrait studies, Edward Francis Wells was a London artist who went to live in Milton Abbas, Blandford, Dorset, in 1938. He received his art education at the Slade School of Art in London, and also at the RA Schools, where he won the Thomas Creswick prize in 1899. He travelled in Corsica and Italy and exhibited eight pictures at the RA and others at the ROI, RI and at a number of the other important picture galleries, including the RHA. Wells' windswept landscape, *On the Downs*, shown above is a striking example of his work, in which he uses space to emphasise the dramatic impact, which isolates its single figure in the immensity of a lonely rural landscape.

PHILLIP WESTCOTT
1815-78

An artist who painted portraits, landscapes and historical scenes, Phillip Westcott was born in Liverpool. He was left an orphan at an early age and was later apprenticed to the Liverpool picture restorer, Thomas Griffiths. By 1843 he was already established as a painter in Liverpool, and was made treasurer of the local academy in 1865. His local success as a portrait painter tempted him to try his luck in London, a move that proved a disaster, as he had little success in the South. Towards the end of his life he went to live in Manchester.

Although portrait painting was his chief work, Westcott had strong inclinations to landscape painting, and at one period he refused commissions in order to devote himself to it. He rented a cottage in Cookham, where he painted many Thames subjects, and later a house in Norfolk where boating became his chief form of relaxation. His landscapes were principally in watercolour, and from 1848 to 1861 he exhibited at the RA.

JOHN ALFRED WHEELER
1821-1903

The sporting artist John Alfred Wheeler was born in Andoversford, near Cheltenham, Gloucestershire, the son of a stone cutter. At the age of 19 he enlisted as a private in the 2nd Queens Corps, where he began to acquire his thorough knowledge of horses which he put to good use when he was forced to leave the army owing to ill health. The family retired to Bath in 1854, when Wheeler took up painting, something he had wanted to do when he was young, but had been discouraged from doing by his parents. During the next twenty-five years that he spent in Bath, he painted a number of military scenes, a large number of hunting pictures and horse portraits.

In 1877, Wheeler moved to Hanwell in the London area, where he built a house named Bath Village. It was at Hanwell that he painted *The Beaufort*, an enormous canvas in which he included 130 people and a large number of horses and hounds. This was followed by another large painting, *The Meet of the Coaching Club, London*, which was made into a print. He painted many race horses and hunting scenes as well as a number of pictures that had been commissioned by the rich gentry, including Baron Rothschild. As a relaxation from the demands of his large canvases, he also painted several small pictures, such as the oil shown below. He was the father of James Thomas Wheeler and Alfred Wheeler, both of whom became painters.
REPRESENTED: BATH.

John Alfred Wheeler
Terriers
Oil on canvas. 10 x 16in
Priory Gallery

JAMES ABBOT McNEILL WHISTLER, PRBA
1834-1903

James Whistler is often described as an Impressionist, but his work should not be confused with that done by the French Impressionists such as Monet and Pissaro, who sought to paint the rich colours of nature. Whistler's paintings, on the other hand, were done in a low key. Like most painters of note, his work was often attacked, but usually for the wrong reasons. Whistler generally responded to these criticisms with anger, which later resulted in his downfall. A great wit and a dandy, he was one of the most controversial figures of his time. When an art critic in the 1860s ventured to say that Whistler's *Symphony in White* included other colours besides white, the artist replied vehemently in print: 'Does this wise person expect white hair and chalk faces? Does he believe that a symphony in F contains no other note, and must be a repetition of F F F?. . . Fool!'.

A portrait and landscape painter who worked in oils and watercolours, Whistler was born in Lowell, Massachusetts, USA. In 1855 he went to Paris where he produced his famous sets of French and Thames etchings. Under the influence of Japanese art, he began to paint his famous Nocturnes during the 1870s. One of them, *Nocturne in Black and Gold - the Falling Rocket* was immediately attacked by Ruskin, who had become totally unreliable. He described the painting as 'a pot of paint flung in the public's face', and Whistler sued him for libel. In the case that followed, everything seemed stacked against Whistler . The day that Lord Leighton was due to appear as a witness on Whistler's behalf, was also the day on which he was to receive his knighthood at Windsor, so he was unable to support his friend in court. The Attorney General said that with the present mania for art it had become the fashion among people to admire the incomprehensible, and it was not a mania to be encouraged, while Burne-Jones, acting for the defence, stated that the picture was an admirable beginning, but simply a sketch, and was not worth the 200 guineas that Whistler was asking for it - a sentiment that had more than a measure of truth to it. Frith also thought that the price was ridiculously high. The judge awarded Whistler one farthing damages but no costs. Ruskin's costs were paid by subscription, but Whistler was made bankrupt. In 1892 he left England for France, where he established his own Académie Carmen, which he ran from 1898 to 1901.

REPRESENTED: ASHMOLEAN, FITZWILLIAM, GLASGOW, MANCHESTER, V & A.

JOHN WHITE, RI, ROI
1851-1933

A landscape artist who was born in Edinburgh, John White and his family emigrated to Australia in 1856, where he was brought up and educated in Melbourne. He returned to Edinburgh in 1871, where he studied at the RSA Schools and in 1877 he began to exhibit at the RA, the SS, the NWS and elsewhere. His paintings portray the idyllic; they are slightly sentimental and a little too pretty for modern taste, although the quality of his craftsmanship has never been questioned. A prolific painter, he painted forty pictures for the RA and exhibited 190 at the RI, 106 at the ROI, and another 43 at the RBA. He also painted the occasional marine subject and portrait study. He moved to Beer, in Devon, in 1877 and lived there for many years.

John White
Milking Time
Watercolour, signed. 21½ x 14½in
Sotheby's, Sussex

SIR DAVID WILKIE, RA
1785-1841

David Wilkie was born at Cults, Fifeshire, the son of a clergyman who was minister of the parish. The young boy could draw after a fashion before he could read or even talk, and when he went to his first school he began to make portraits of his schoolmates, who paid him in marbles or pencils. When he was 14, he was sent by his father to the Trustees' Academy for Art in Edinburgh, where he almost failed his examinations. In 1804 he returned home, where he began to paint *Pitlessie Fair*, which he later sold. In May 1805 he went to London, where he took lodgings at 8 Norton Street, off the Portland Road. He entered the RA Schools the following year. From then onwards Wilkie's life was one of unending success. Many of

Sir David Wilkie
Portrait of Admiral Walker, Commander of the
Turkish Fleet
Watercolour, signed and dated 1840
18¼ x 10½in
Spink

his paintings were shown at the RA and brought record crowds. He was elected an RA in 1811 at the age of 26. His painting, with the self-explanatory title *Chelsea Pensioners Reading the Gazette of the Battle of Waterloo*, broke all attendance records and was eventually bought by the Duke of Wellington.

Wilkie was influenced by Rembrandt and some of the other seventeenth-century Dutch artists, although his work was regional in its content. When he set his characters against a rural background his pictures veered towards the humorous

and anecdotal rather than the lyrical. Accepting his talents, one of the secrets of Wilkie's success lay in his ability to please. As he wrote on one occasion, 'to know the taste of the public and to learn what will please the employer - is to an artist the most valuable of knowledge'. With many artists this would have been a dangerous precept to follow, but in Wilkie's case his art was not debased by trying to please the public (see p 329).

Like so many eighteenth- and nineteenth-century painters, Wilkie made the Grand Tour, first to Europe, and at a much later stage of his life, to the Holy Land. On his return journey he was taken ill and died within sight of Gibraltar. He was buried at sea and the ceremony was commemorated by Turner in *Peace – Burial at Sea*.

REPRESENTED: ABERDEEN, BEDFORD, BM, FITZWILLIAM, NGS, V & A.

DANIEL ALEXANDER WILLIAMSON
1823-1903

A Liverpool landscape and genre painter, Daniel Alexander Williamson was the son of the artist Samuel Williamson. He left Liverpool in about 1847 and went to London where he took up residence at 20 Elizabeth Terrace, Liverpool Road, Islington. Because of an accident which left him crippled for nine years, he did not keep up his connections with the Liverpool Academy, although he regularly submitted paintings to its exhibitions. He was strongly influenced by the Pre-Raphaelite movement, and when he left London to settle in North Lancashire in about 1860, he painted a number of small pictures in the Pre-Raphaelite manner. His early work was in oils, but from about 1870 he worked entirely in watercolours; at the latter part of his career he reverted to oils. His watercolours date from the early 1870s and are painted in a broad, simple style that nevertheless has a poetic quality. His last development was towards soft, hazy landscapes, which were mostly painted in monochrome.

REPRESENTED: LIVERPOOL.

FREDERICK WILLIAMSON
fl. 1856-1900

A landscape painter who originally lived in Goswell Road, Islington, London, before he moved to Farncombe Villas in Godalming, Surrey, Frederick Williamson was one of the more successful watercolour artists who flourished during the second half of the nineteenth century. He could portray the countryside with feeling, and was able to paint cattle far more competently than Thomas Sidney Cooper, whose work became blunted by painting repeatedly what was essentially the same subject. *Witley Common*, illustrated opposite, is a particularly good example of his work, with its fine detail of the countryside as it turns its autumnal shades of brown, while sheep rest peacefully on a seldom-used, quiet pathway.

Williamson exhibited at many of the major galleries, including the RA, where he showed thirty-seven pictures. Most of his landscapes portray cattle or sheep.

REPRESENTED: BIRKENHEAD, V & A.

CHARLES EDWARD WILSON
1854-1941

A rustic watercolourist of great charm, Charles Edward Wilson was born in Whitwell, Nottinghamshire, and received his art training at the Sheffield School of Art. Later he won a number of competitions and was twice awarded a silver medal from the South Kensington Museum. He prepared an album of drawings for the Prince of Wales, and then worked in Paris for the *Journal de L'Art*. It was during the early part of his career that he shared a cottage in Surrey with Carlton Alfred Smith (see entry), which led to a similarity in their work. He exhibited from 1891 at all the major galleries, including the Walker Gallery in Liverpool, while a hundred paintings were accepted for hanging by the RA.

Wilson was particularly fond of using the same boy for many of his studies during a certain period of his life; he also like to depict a young girl outside the door of a country cottage, as in *Little Chicks*,

Frederick Williamson
Witley Common
7 x 12in
David James

Charles Edward Wilson
Little Chicks
Watercolour. 10 x 7in
Fine Lines (Fine Art)

illustrated on the right.

Wilson's work has become immensely popular since the 1970s, and there has been an adequate supply of his work to meet the demand. Although he is well known in the art world and with buyers of Victorian and Edwardian pictures, no real attempt has been made to evaluate his work, an omission which now seems overdue for correction.
REPRESENTED: V & A.

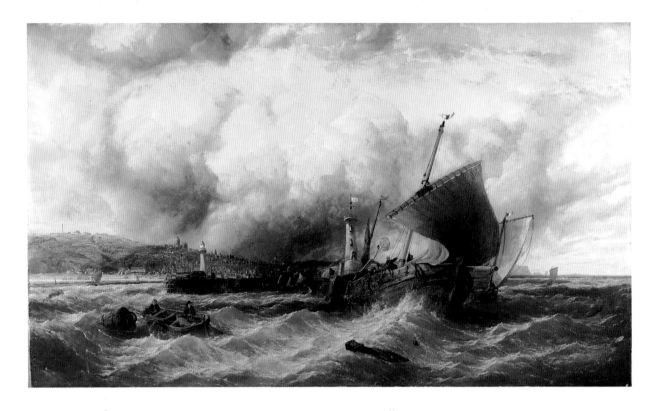

John James Wilson
Fishing Luggers in Boulogne Harbour
Oil on canvas. 42 x 72in. Bonhams

GEORGE WILSON
1848-90

A Scottish artist, George Wilson was born in Cullen, and educated there and in Aberdeen. After spending a few years at Edinburgh University, he studied at the RA Schools and then at the Slade School of Art in London. After completing his training, he remained in London, which he used as a base from which to travel, rather than as a home.

A landscape and figure painter, Wilson's work seldom sold in his lifetime, and when it did, it was to a small coterie of admirers who bought his paintings at prices far below their real value. For many years he suffered from a gastric disease which often made it impossible for him to work for long periods, and from which he eventually died at the age of 43. Although he could not be described as a great landscape artist, he was very good at painting woodland scenes which were almost Pre-Raphaelite in their intensity.
REPRESENTED: ABERDEEN, BM.

JOHN JAMES WILSON
1818-75

A marine artist who began his career as a landscape painter, John James Wilson was the son of the famous marine artist John H. ('Jock') Wilson. He refused to paint marine pictures until six years before his father's death in 1855. He then abruptly changed from landscape to marine painting, on which he concentrated until the end of his life. Although John Wilson's work lacked the subtlety of his father's painting, it was nevertheless vigorous, bright and attractive (see his oil illustrated above) and compares favourably with the work of many of the better artists of his time. A prolific painter, he exhibited five hundred paintings between 1831 and 1875, including fifty-five which were shown at the RA.

A case has been put forward that Wilson also painted under the name of J. Mundell, which Denys Brook-Hart supports in his *British 19th Century Marine Painting*. Certainly the paintings by both these artists have a remarkable similarity in their style of brushwork.

EDMUND MORISON WIMPERIS, VPRI
1835-1900

A London landscape artist who painted in waterolours, Edmund Morison Wimperis was born in Chester. At the age of 14 he was apprenticed to a wood engraver and illustrator, and continued his studies with Birket Foster. Wimperis began his career by producing a great number of illustrations for the *Illustrated London News* before he turned almost entirely to landscape painting. Initially, his work shows the inevitable influence of Birket Foster, reflected in his frequent use of Foster's method of stipple. However, his brushwork suddenly changed after he came under the influence of Thomas Collier, with whom he went on many sketching and painting expeditions during the 1870s and 1880s. He exhibited from 1859 at the RA, SS and the NWS, and elsewhere, and was made VPRI in 1895. Although Wimperis painted many windswept landscapes, his watercolour shown below is, unusually, a tranquil river scene. REPRESENTED: BM, BRADFORD, MANCHESTER, V & A.

Edmund Morison Wimperis
Bury Church and Ferry, Sussex
Watercolour, signed and dated 1898.
9½ x 13½in
Brian Sinfield

WILLIAM LINDSAY WINDUS
1822-1907

A painter of strong Pre-Raphaelite tendencies, William Lindsay Windus was a Liverpool-born artist who came from a family that had long been resident in North Lancashire. Passionately fond of art even as a boy, he came to the attention of William Daniels, the Liverpool genre painter, who told Windus' parents that he would teach him 'to draw a head as well as any man in Liverpool'. Unfortunately, the lessons did not last long, and Windus completed his studies at the Liverpool Academy. His earliest known picture was of a little black boy, which was painted in 1884 and discovered in the chimney-piece of a farmhouse. Windus made his debut at the RA in 1856 with *Burd Helen*, a painting that received no attention until Rossetti forced Ruskin along to see it, whereupon Ruskin praised it as the 'second best picture of the year'. Windus' other well-known 'Pre-Raphaelite' painting was *Too Late*, which shows a little girl bringing a man to the bedside of a girl dying of consumption. The picture was

Peter De Wint
Cutting Corn
Pencil and watercolour. 12½ x 19½in
Spink

critically savaged by Ruskin, which so upset Windus that it discouraged him from painting anything else except a few sketches. Too much has been said in praise of Ruskin, whose bland comments could ruin an artist; nor was his vicious attack on Windus entirely justified as the painting was no weaker than a number of other paintings that Ruskin had praised.

REPRESENTED: BIRKENHEAD.

PETER DE WINT
1784-1849

A now famous watercolour artist, Peter De Wint was born in Stone, Staffordshire, the son of a physician who was descended from a Dutch family. Although he intended to follow in his father's footsteps as a doctor, De Wint decided that he would be far happier as an artist. He studied first under John Raphael Smith, an engraver, where he met the Lincolnshire historical painter William Hilton, the brother of the woman he was to make his wife. He joined the Royal Academy Schools in 1807, and later joined the Water-Colour Society, where he exhibited most of his work for many years. It was an eventful year as he came to London and became a successful teacher, as well as painting a series of landscapes, for which he seldom went further than Lincolnshire, to which he had always been attracted. He painted only very occasionally in oils, and it is for his watercol-

William Tatton Winter
The Signpost
Watercolour, signed. 17 x 17in. Bourne Gallery

ours that he is best known. Even so, his paintings are so eagerly sought after that it prompted one writer to comment in 1831 that De Wint's work was so 'congenial. . . that not only his larger works, but every scrap from his pencil is sought after with avidity'.

A modest man, De Wint generally avoided painting anything that veered towards the over-dramatic, which was something of a fault in an artist catering for a public whose artistic tastes lay towards high drama. He painted with an often deceptive simplicity, as can be seen from *Cutting Corn*, illustrated on p334, although this is one of his many watercolours that he deliberately left in a sketchy state and worked up later for exhibition.
REPRESENTED: FITZWILLIAM, V & A.

WILLIAM TATTON WINTER, RBA
1855-1928

A watercolour artist who was born in Ashton-under-Lyne, Lancashire, William Tatton Winter was one of six children who were all born under the surname of Winterbottom. He later changed his name to Winter to avoid confusion with another northern artist. His family was not without its misfortunes. First William was abducted by his nurse, who fled with him to Liverpool, where she was caught as she was about to board a ship bound for Australia. Then William's father and his eldest brother were killed in the American Civil War after they had gone to the United States to seek their fortunes. Mrs Winter was left to bring up the rest of her family alone, which she did to the best of her ability by selling second-hand clothes from a stall in Ashton market. Despite the hardships it involved, she managed to have William educated privately for a while before he went to the local elementary school. When he left school he worked in a barber's shop and then in a draper's store, when he first began to develop his talent for drawing.

David Woodlock
Young Brood
Watercolour. 12 x 8in. Priory Gallery

William Winter went to the Manchester Academy of Fine Arts in the 1870s, and soon afterwards became an art teacher. After touring through Belgium and Holland, he studied under Charles Michel Verlat, whose own work was greatly influenced by Courbet. He then moved to Harpur Hill, near Manchester, where he painted a series of rainswept landscapes. Eventually he moved to Carshalton, Surrey, before he settled finally in Reigate, Surrey, where he spent the last thirty years of his life. He now lies in Reigate Cemetery alongside his wife and two sons.

Winter exhibited 32 paintings at the RA, 294 at the RBA, 43 at the RI, and 274 at the Walker Gallery in Liverpool, as well as showing at other major galleries, including the Paris Salon. His work has tended to be underrated, especially his windswept landscapes which are reminiscent of Corot. An example of his work is shown on p335.
REPRESENTED: BRADFORD, MANCHESTER.

DAVID WOODLOCK
1842-1929

Born in County Tipperary in southern Ireland, David Woodlock was a watercolour artist who painted country cottages and gardens, and who used the technique of applying watercolour to wet paper, which resulted in the colours running together, so that the detail was blurred to great effect. The technique was used in such a way as to make his work look very different from that of Helen Allingham (see entry) and others of the same school of cottage and garden painting.

Woodlock left Ireland to study art at the Liverpool Academy and was later the founder member of the Liverpool Sketching Club. He began to exhibit from 1880, chiefly at the RA, the RI and the RBA. Although he lived in Sheffield and Leamington, Warwickshire, for short periods, his true home, once he had left Ireland, was Liverpool, where he became a member of the Liverpool Academy of Arts. He usually included some form of figure work in his watercolours, all of them done in a near Impressionistic style, as in *Young Brood* shown opposite.

GEORGE WRIGHT
1860-1942

A sporting artist who was born in Leeds, George Wright was one of a family of five children, which also included Louise Wright who made a small reputation for herself as a pioneer of fashion after she had worked on a number of fashion paintings with her younger brother, Gilbert Scott Wright, who worked with her on the illustrations for one of Harrod's fur catalogues. Nothing is known about George Wright's early life, training and early paintings, although a number of oils in monochrome are known to exist. In later years, when he was at the height of his popularity, many of these monochromes were coloured and then marketed at vastly inflated prices.

In 1901 George Wright moved to Rugby, where he stayed for several years before he moved to Oxford. He painted racehorses and hunting scenes with the pack in full cry, and coaching scenes such as *A November Morn* shown above, which combined the two major elements of his work – the

George Wright
A November Morn
Oil, signed. 14 x 20in
Polak Gallery

hunt on the track of a fox, with a coach passing by. Although many of his paintings were made as prints, it is rather surprising that he was not taken up more by the sporting magazines of his day. He worked with his brother on a number of paintings, although his brother was the lesser artist, and they also worked together on a number of calendars.

Arthur Charles Wyatt
Ann Hathaway's Cottage
Watercolour. 30 x 20in
Priory Gallery

A COMPANION TO VICTORIAN AND EDWARDIAN ARTISTS

ARTHUR CHARLES WYATT
exh. 1883-1908 (d. 1933)

The London-born artist Arthur Charles Wyatt began to exhibit at the major London galleries from 1883, chiefly at the RI, the RBI and the RA, where he showed five paintings, including *Ann Hathaway's Cottage*, which is illustrated on p339. This boldly executed scene of a garden which had probably been laid out in Elizabeth I's reign, is different in style from the more conventional paintings of Helen Allingham and Claud Strachan, and all the other nineteenth-century painters of cottage gardens. Because he began as a landscape artist rather than as a cottage garden painter, and was working in the Edwardian period, he probably felt no obligation to follow the well-trodden path of what had become a very conventional and commercial style of painting, and chose instead to paint in a style reminiscent of Edward Killingworth Johnson, a genre artist who painted realistically, with every detail carefully delineated. If nothing else, it makes a refreshing change from those countless cottage scenes, which all look very much like one another.

REPRESENTED: BM, BIRKENHEAD, FITZWILLIAM, MANCHESTER, NEWPORT, NGS, V & A.

FRANCIS JOHN WYBURD
b. 1826 (fl. 1846-93)

A London genre artist who painted a large number of single figure subjects, Francis John Wyburd was educated in Lille, France. He became a pupil of Thomas Fairland, a lithographic artist, and then studied at the RA Schools in 1848. He did not travel a great deal, except for a sketching trip to Italy in the 1850s in the company of George Edwards Hering, the landscape painter. Wyburd exhibited from 1848 to 1893, during which time he showed two paintings at the RA, twenty-five at the RBA, and supplied the illustrations for a book *The Poetry and Pictures of Thomas Moore*, which was published in 1845.

Wyburd's single portraits of women were idealised studies of females (see *The Love Tale*, p340), which had nothing in common with the realistic portraits of an artist like George Chinnery (see entry). His paintings include *Margaret Catchpole* (1851), *Esther (1875)*, *Sits in her own Sequestered Bower (1878)* and *La Tristesse* (1880).

Wyburd lived at 41 Bryanston Street, near Portland Square, and died some time after 1893.

Francis John Wyburd
The Love Tale
Oil on board, signed. 9½ x 8in
Bonhams

William Wyld
The Degona, Venice
Watercolour, signed. 7 x 9½in
Spink

WILLIAM WYLD, RI
1806-89

A London landscape painter and lithographer, William Wyld's interest in art began while he was secretary to the British consulate in Calais. After studying under the important watercolour artist Thomas Louis Francia, he went to Paris where he met Richard Parkes Bonington, and Horace Vernet, with whom he went on a sketching tour of Italy, Spain and Algiers. As a result of this trip he produced a book entitled *Voyage Pittoresque dans la Regence d'Alger*, (1833) which he dedicated to Vernet, and which contained fifty of his own lithographs. This was followed by another book, *Monuments et Rues de Paris*, which contained twenty of his lithographs, which were very much in the style of Bonington.

Although he worked occasionally in oils, Wyld

is best known as a watercolour artist, a medium which he and Bonington did much to promote in France after Francia introduced it into that country. He exhibited only three pictures at the RA, the main bulk of his paintings being shown in England at the NWS, where he exhibited 206 pictures. He painted landscape views of England and France and of other parts of Europe, especially Venice, including the fine example of his work which is illustrated on p342. He was awarded two medals in the Paris Salon and was made a member of the Legion of Honour for his services to art. He lived mostly in Paris, where he died on Christmas Day, 1889.

REPRESENTED: BIRKENHEAD, BM, FITZWILLIAM, MANCHESTER, NGS, NEWPORT.

WILLIAM LIONEL WYLLIE, RA, RI
1851-1931

A London-born artist whose career straddled the late Victorian and early Edwardian periods and well beyond, William Lionel Wyllie preferred painting anything that was connected with the sea. He was the son of William Morison Wyllie, a genre artist, and the brother of Charles William Wyllie, also a good marine artist but who never achieved the fame of his brother. After spending a somewhat unsettled childhood moving between England and France, where his father had bought a second home in the coastal town of Wimeraux, near Boulogne, he was sent to Heatherley's School of Art in London, before he went to the RA Schools, where he won the coveted Turner Medal. Afterwards he was made marine painter to the Royal Victoria Yacht Club in Ryde on the Isle of Wight.

Wyllie exhibited his first painting at the RA in 1868, and from then on he became a regular exhibitor at all the major London galleries. He was already well-established when his famous picture of tugs and barges at work which he titled *Toil, Glitter, Grime and Wealth on a Flowing Tide* was bought by the Chantrey Bequest, an accolade which had set many an artist on the road to fame. However, unlike most marine artists who tended

William Lionel Wyllie
The SS Peshawa
Watercolour with bodycolour, signed.
8½ x 16½in
Spink

to specialise in one form of shipping, Wyllie painted any marine subject that came his way, which ranged from spritsail barges, warships cleaving the waters and racing yachts, to humble fishing-boats. In 1889 *The Battle of the Nile* was purchased by the Chantrey Bequest, which added still further to his reputation. By then he had bought the Tower House in Old Portsmouth, from which vantage point, overlooking the harbour, he painted many of his future pictures. Both he and his wife were keen yacht racers, often against such formidable opposition as Uffa Fox. He loved the Thames, and used his own barge as a travelling studio. In 1909 his career reached its peak when he was made an RA.

Few marine artists were so active and versatile as Wyllie. When he died in Hampstead, London, five thousand watercolours were found in his studio; these were purchased for the National Maritime Museum, which eventually opened its doors to the public for the first time in 1937. He exhibited 26 paintings at the RA, 107 at the Abbey Gallery, 374 at the Dowell Gallery, 188 at the Fine Art Society, 150 at the Leicester Gallery, 26 at the RBA, 9 at the RI, 19 at the ROI and 3 at the RSW, and other pictures at lesser galleries. Although he painted in oils, his true love was watercolours (see p343 for an example of his work).

REPRESENTED: BM, BRISTOL, FITZWILLIAM, LIVERPOOL, MARITIME MUSEUM (GREENWICH)

Bibliography

The books listed here are those most readily available and are either still in print, or obtainable from public libraries on order, or are available in reference rooms. Anyone wishing to delve more deeply into the life and work of a particular artist will need to go to the British Museum or to the London Library.

GENERAL

Bell, Quentin *Victorian Artists* (Routledge & Kegan Paul,1967)

Brook-Hart, Denys *British Nineteenth Century Maritime Painting* (Antique Collectors' Club, 1974)

Brook-Hart, Denys *20th Century Maritime Painting* (Antique Collectors' Club, 1981)

Caw, James *Scottish Painting Past and Present 1620-1900* (Studio Vista, 1981)

Cordingly, David *Marine Painting in England 1700-1900* (Studio Vista, 1974)

Daly, Gay *Pre-Raphaelites in Love* (Collins,1989)

Fox, Caroline and Greenacre, Francis *Artists of the Newlyn School 1880-1900* (Newlyn-Orion)

Gaunt, William *Painting in Britain. The Restless Century* (Phaidon, 1972)

Gaunt, William *Marine Painting, An Historical Survey* (Secker & Warburg, 1975)

Halsby, Julian *Scottish Watercolours 1740-1940* (B. T. Batsford, 1986)

Hardie, Martin *Watercolour Painting in Britain Volume III. The Victorian Period* (B. T. Batsford, 1969)

Hardie, William *Scottish Painting 1837-1939* (Studio Vista, 1980) Reprinted 1990

Maas, Jeremy *Victorian Painters* (Barrie & Rockliff, 1969)

Reid, Forrest *Illustrators of the Sixties* (Faber and Gwyen,1928)

Reynolds, G. *Painters of the Victorian Scene* (Batsford, 1952)

Rosenthal, Michael *British Landscape Painting* (Phaidon, 1952)

Short, Ernest *A History of British Painting* (Eyre & Spottiswoode, 1953)

Spender, Michael *The Glory of Watercolour* (David & Charles, 1987)

Vincent, Adrian *100 Years of Traditional British Painting* (David & Charles, 1989)

Vincent, Adrian *19th Century Maritime Watercolours* (David & Charles, 1989)

Vincent, Adrian *Victorian Watercolours Children* (Michael Joseph, 1987)

Vincent, Adrian *Victorian Watercolours – Rural Life* (Michael Joseph, 1987)

Wood, Christopher *Olympian Dreamers – Victorian Classical Painters* (Constable, 1983)

Wood, Christopher *Victorian Panorama. Paintings of Victorian Life* (Faber & Faber, 1976)

Wood, Christopher *Paradise Lost. Victorian Paintings 1850-1914* (Century Hutchinson, 1987)

BIOGRAPHIES

For easy reference the name of the artist is placed first.

Aldin, Cecil Roy Heron , *Cecil Aldin. The Story of a Sporting Artist* (Webb & Bower, 1981)

Aldin, Cecil (autobiography 1934) *Time I Was Dead*

Alma-Tadema, Lawrence Vera G. Swanston, *Sir Lawrence Alma-Tadema* (Ash & Bower, 1977)

Condor, Charles R. Rothenstein, *The Life and Death of Condor* (1938)

Dadd, Richard David Graysmith, *Richard Dadd* (1975)

Holman Hunt, William Diana Holman Hunt, *My Grandfather - His Wives and Loves* (1969)

Lavery, James (autobiography) *The Life of a Painter* (1968)

Lear, Edward Vivien Noakes, *The Life of a Wanderer* (1968)

Millais, John Everett Mary Lutyens, *Millais and the Ruskins* (1968)

Palmer, Samuel Carlos Peacock, *Shoreham and After* (1968)

Rossetti, Dante Gabriel A. I. Grieve, *The Art of Dante Gabriel Rossetti* (1973)

Tissot, James Christopher Wood, *Tissot* (Weidenfeld and Nicholson, 1986)

Turner, Joseph, M. W. Andrew Wilton, *Turner and His Time* (Thames & Hudson, 1987)

DICTIONARIES

Bryan , M. *Dictionary of Painters and Engravers* (George Bell and Son 1903)

Houfe, Simon *Dictionary of British Book Illustrators and Caricaturists 1800-1914* (Antique Collectors' Club, 1978)

Mitchell, Sally *Dictionary of British Equestrian Artists* (Antique Collectors' Club, 1985)

Royal Society of British Artists 1824-1893 and the New English Art Club 1888-1917 (Antique Collectors' Club, 1975)

Dictionary of British Artists 1880-1940 (Antique Collectors' Club, 1976)

Paviere, Sydney H. *Dictionary of Sporting Artists* (F. Lewis, 1965)

Paviere, Sydney H. *Dictionary of Landscape Artists* (F. Lewis, 1968)

Walters, Grant *British Artists Working 1900-1950* (2 volumes) (Eastbourne Fine Art, 1975)

Wood, Christopher *Dictionary of Victorian Artists* (2nd edition) (Antique Collectors' Club, 1978)

CATALOGUES

Every art museum issues a catalogue of its permanent collection which is revised from time to time as the museum acquires new additions. These catalogues are modestly priced and are generally available on request. The museums also hold catalogues of special exhibitions of an artist's work which are available for examination only. Some of these which may be of interest to the reader are listed below:-

Brown, Ford Madox Catalogue of an exhibition organised by the Walker Art Gallery, Liverpool (1965)

Dyce, William Catalogue of the Dyce Centenary Exhibition held at Thomas Agnew & Son (1964)

Frith, William Powell Catalogue for an exhibition of Frith's paintings held at the Whitechapel Art Gallery (1951)

Goodman, Albert Catalogue, Laing Gallery, Newcastle (1968)

Landseer, Sir Edwin Catalogue of Royal Academy Exhibition of Landseer's paintings and drawings (1961). Catalogue picture book of English painting, Manchester Art Gallery (1951). Catalogue of Pre-Raphaelite Paintings, Manchester Art Gallery (1952). Catalogue of Victorian painting, Arts Council exhibition (1962)

Tissot, James Jacques Exhibition catalogue. The Barbican 1984-5.

Waite, Robert Thorne Catalogue of the artist's work for an exhibition at the Bourne Gallery, Reigate.

Watts, George Frederick Exhibition catalogue. Whitechapel Art Gallery (1974)

Index of Artists

Acknowledgements

The assistance of the following art dealers and auctioneers in lending photographs for this book is gratefully acknowledged.

Bonhams (Auctioneers),
Montpelier Galleries,
Montpelier Street,
London SW7 1HH.

Susan and Robert Botting,
38 Firs Avenue, Felpham,
Nr. Bognor Regis,
West Sussex PO22 8QA.

Bourne Gallery,
31 Lesbourne Road,
Reigate, Surrey RH2 3DG.

Cambridge Fine Art,
Priesthouse, 33 Church Street,
Little Shelford, Cambridge CB2 5HG.

Christie's (Auctioneers),
8 King Street,
St James's, London SW1 6QT.

City Wall Gallery,
1 City Walls,
Off Northgate Street, Chester CH1 2JG.

David Cross Gallery,
3A Boyces Avenue, Clifton,
Bristol BSB 4AA.

Edward Cross Fine Painting,
128 Oatlands Drive, Weybridge,
Surrey KT 13 9HL.

Fine Lines(Fine Art),
The Old Rectory, 31 Sheep Street,
Shipston-on-Stour, CV36 4AE.

The Hallam Gallery,
325 Upper Richmond Road, West,
East Sheen, London SW14 BQR.

Martin Ham,
Sandpits Farm, Powick,
Worcester WR2 4RY.

Haynes Fine Art of Broadway,
The Bindery Galleries,
69 High Street,
Broadway, Worcester WR12 7DP.

Angela Hone,
The Garth, Mill Road, Marlow,
Bucks SL7 1QB.

David James,
3 Halkin Arcade, London SW1 8JJ.

Duncan R. Miller,
11 Wedderburn Road,
London NW3 5QS.

Mistral,
12 Market Square,
Westerham, Kent TN16 1AW.

Moss Galleries,
238 Brompton Road, London SW3 2BB.

Phillips (Auctioneers),
Blenstock House, New Bond Street,
London W1Y OAS.

Polak Gallery Ltd,
21 King Street, St James's,
London SW1Y 6QY.

Priests,
The Malt House, Digbeth Street,
Stow-on-the-Wold,
Gloucestershire GL54 1BN.

The Priory Gallery,
The Priory, Station Road,
Bishop's Cleeve,
Nr. Cheltenham, Glos. GL52 4HH.

Royal Exchange Gallery,
14 Royal Exchange,
London EC3V 3LL.

Brian Sinfield Gallery,
Grafton House,
128 High Street,
Burford, Oxon OX18 4QU .

Sotheby's (Auctioneers),
Summers Place, Billingshurst,
Sussex RH14 9AD.

Spink & Son Ltd,
5, 6 & 7 King Street,
St. James's, London SW1Y 6QS.

Walker Galleries Ltd,
6 Montpelier Gardens,
Harrogate, North Yorkshire HG1 2FL.